Honoring and remembering those who preceeded us is as important as the here and now.

In the firm belief that many have paved the way for better photojournalism for this generation, we owe them the respect of thanks.

Sometimes, unfortunately, we get caught up in the big names, in the spotlight events, in the glamour of traveling the highway. We forget that along this road, there were many folks who helped us make our way.

To that end, this year's annual, the 23rd in a series dating back to 1976, is dedicated to the NPPA members who died during 1997.

They deserve our thanks and our honor.

The Best of Photojournalism
Number One/1976

GERALD BROWN, *Freelance/Arkansas City, Kansas*

DOM DEDOMENIC, *Gateway Associates/Monroeville, Pennsylvania*

RUSSELL EGNOR, *Director of News Photo Division/U.S. Navy/Washington, D.C.*

ERVIN HESS, *Retired, Whiting, New Jersey*

MICHAEL HORN, *Self-employed/Port Charles, New York*

ARTHUR HOUGH, *Retired/Mesa, Arizona*

RICHARD MAHAN, *Atlanta Journal Constitution*

GEORGE ROONEY, *Providence Journal-Bulletin/Providence, Rhode Island*

A.J. SANDONE, *Scranton Tribune/Scranton, Pennsylvania*

RON TINDIGLIA, *Self-employed/Harrison, New York*

GAYLORD WHITAKER, *Singer Education Systems/Rochester, New York*

The Best of Photojournalism
Number Twenty-three/1998

THE BEST OF PHOTOJOURNALISM #23

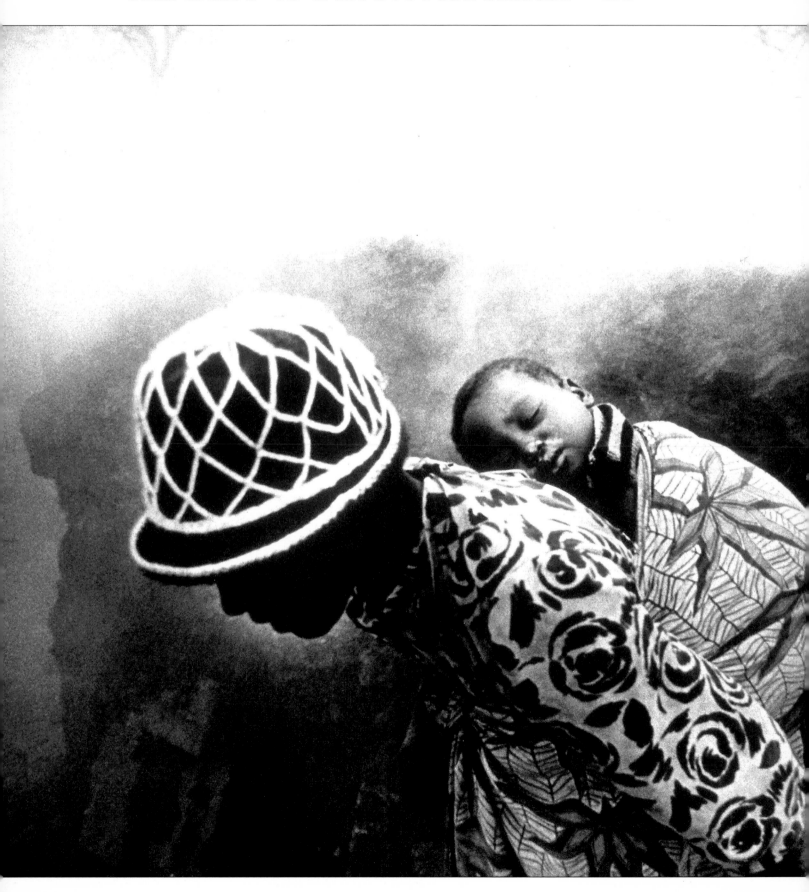

THE YEAR IN PICTURES: 1997

THIS ANNUAL, THE TWENTY-THIRD IN A SERIES PUBLISHED SINCE 1976, IS BASED ON AND EDITED FROM AWARD-WINNERS IN THIS YEAR'S COMPETITION.

THE 55TH ANNUAL PICTURES OF THE YEAR COMPETITION, WAS JUDGED THIS YEAR FROM FEBRUARY 16TH TO MARCH 4TH, 1998, AT THE MISSOURI SCHOOL OF JOURNALISM IN COLUMBIA, MISSOURI.

PICTURES OF THE YEAR IS THE LARGEST PHOTOGRAPHY COMPETITION IN THE WORLD, AND WAS SPONSORED AGAIN THIS YEAR BY:

THE NATIONAL PRESS PHOTOGRAPHERS ASSOCIATION AND THE MISSOURI SCHOOL OF JOURNALISM

POY IS SUPPORTED BY GENEROUS GRANTS TO THE UNIVERSITY FROM:

CANON, U.S.A., INC.
AND
KODAK PROFESSIONAL

PRINTED AND BOUND IN THE UNITED STATES OF AMERICA BY JOSTENS PRINTING AND PUBLISHING DIVISION, TOPEKA, KANSAS 66601.

THE PHOTOGRAPHS APPEARING IN THIS BOOK HAVE BEEN USED WITH THE PERMISSION OF THE HOLDERS OF THE RIGHTS THERETO AND MAY BE SUBJECT TO SEPARATE COPYRIGHT.

THIS BOOK MAY NOT BE REPRODUCED IN WHOLE OR IN PART, IN ANY FORM OR BY ANY MEANS, ELECTRONIC OR MECHANICAL, INCLUDING PHOTO-COPYING, RECORDING, OR BY ANY INFORMATION STORAGE AND RETRIEVAL SYSTEM NOW KNOWN OR HEREAFTER INVENTED, WITHOUT WRITTEN PERMISSION FROM THE PUBLISHER.

9 8 7 6 5 4 3 2 1
DIGIT ON THE RIGHT INDICATES THE NUMBER OF THIS PRINTING.

LIBRARY OF CONGRESS CATALOGING-IN-PUBLICATION NUMBER 97-76127

ISBN 0-7624-0335-7

THIS BOOK MAY BE ORDERED BY MAIL FROM THE PUBLISHER. PLEASE INCLUDE $2.50 FOR POSTAGE AND HANDLING. BUT TRY YOUR BOOKSTORE FIRST!

RUNNING PRESS BOOK PUBLISHERS
125 SOUTH 22ND STREET
PHILADELPHIA, PENNSYLVANIA
19103-4399

On the back cover, above
■ From a story entitled "Life in Prison." These prisoners, hoes held high, are required to work the fields of a prison farm. More from this story, **page 210.**

ANDREW LICHTENSTEIN, SYGMA/ U.S. NEWS & WORLD REPORT
AWARD OF EXCELLENCE, MAGAZINE ISSUE REPORTING PICTURE STORY

On the front cover
■ From a story entitled "Ali." In a look at the private world of Muhammad Ali, his positive attitude and gracious demeanor throughout his ordeal with Parkinson's disease have earned him the respect of many. Here, he visits a local McDonald's to the delight of a patron. More from this story, **page 228.**

CAROL GUZY, THE WASHINGTON POST
FIRST RUNNER-UP, NEWSPAPER PHOTOGRAPHER OF THE YEAR

At left ■ From an essay entitled "A Broken Landscape: HIV and AIDS in Africa." A woman makes bricks for her house while carrying her child. In the Matibi district of Zimbabwe, more than 37% of pregnant mothers test HIV-positive. More from this essay, **page 240.**

GIDEON MENDEL, NETWORK PHOTOGRAPHERS
JUDGES' SPECIAL RECOGNITION CANON PHOTO ESSAYIST

MaryAnne Golon **N M**

DIRECTOR OF PHOTOGRAPHY, U.S. NEWS & WORLD REPORT

(Golon joined U.S. News in 1996. Previously, she worked for TIME Magazine as a deputy picture editor. During the Gulf War, MaryAnne served as the on-site photo editor for TIME and LIFE magazines, and she coordinated the photo coverage of the Olympic Games from 1984 to 1996.)

"I was incredibly surprised by the difference in the newspaper category and the magazine category... I hadn't expected that there would be such a huge difference in those two categories and my already strong respect for newspapers now grows..."

Keith Jenkins **E**

DIRECTOR OF PHOTOGRAPHY, AMERICA ONLINE

(Before becoming Photo Director at America Online in September of 1997, Keith served as the Director of Photography at WashingtonPost.com, the online site of The Post. A portfolio of his work is part of the permanent collection of the Smithsonian Museum of American Art.)

"The things that I find the most lacking across the board really in people who are working now online...is an understanding of where the medium is and where it is going...it is not necessarily coding, it is not necessarily a good understanding of technology, but I think, the ability to process the information that is going through."

Torsten Kjellstrand **N M**

STAFF PHOTOGRAPHER, THE SPOKESMAN-REVIEW

(Kjellstrand recently joined the staff of The Spokesman-Review in Spokane, Washington. Previously, he worked for three years as one half of a two-person photo department at The Herald in Jasper, Indiana. In 1996, Torsten won the Newspaper Photographer of the Year title as a result of his work at The Herald.)

"The message we've sent with this group of pictures, I think, I hope, is that wherever you are, if you are a good photographer, you can make good pictures... and that's your job. We have negated all the excuses that we hear for not making good pictures..."

Brian Storm **E**

LEAD MULTIMEDIA EDITOR, MSNBC

(Brian received his masters degree in photojournalism from the Missouri School of Journalism. He began working at Microsoft as a picture editor for MSN News in July of 1995 and is now responsible for all audio, photo and video components of the MSNBC web site.)

"We need great journalists to get involved in the revolution [referring to new media] that is happening. We need people who are concerned about how story-telling evolves in this medium to make these decisions..."

Marianne Fulton **M**

CHIEF CURATOR, GEORGE EASTMAN HOUSE

(Marianne has organized and launched more than 75 exhibitions. Currently, she is organizing two shows for Photokina '98 and is corresponding editor for the new Digital Journalist homesite on the Internet.)

"I come out of the background of theater and I was told early on that if you want to be an actor, you should act, anywhere. Start anywhere. And I think that's what photographers have to do; they have to make pictures. And beyond that they have to show other people their pictures and talk about them."

THESE COMMENTS WERE ORIGINALLY RECORDED BY MISSOURI PHOTOJOURNALISM STUDENTS DURING THE COMPETITION JUDGING IN COLUMBIA, MISSOURI FROM FEBRUARY 16 TO MARCH 4, 1998.

Lynn Johnson N

FREELANCE, PITTSBURGH, PENNSYLVANIA
(During Lynn's career, she has received five World Press Photo awards, the Robert F. Kennedy Journalism Award for coverage of the disadvantaged, and two awards from Pictures of the Year.)

"The thought that's foremost in my mind is a kind of plea to photographers who are working today not to look at the winner or winners and search for some clue, some template in terms of subject or style to emulate… everyone should try to be true to their own style, their own community, to maybe take this material and enjoy it and celebrate it and learn from it, but not to abandon their own way."

Jose Azel M E

PRESIDENT, AURORA AND QUANTA PRODUCTIONS
(Jose has been a freelance photojournalist for magazines such as National Geographic, Smithsonian, LIFE, TIME, Sports Illustrated and Geo. In 1993, together with Bob Caputo, he co-founded Aurora and Quanta Productions, a photojournalism group dedicated to photo-reportage and new media communication.)

"There's really a great feeling to look at some of these images… And to see things brought forth in a way you would never expect a camera and a lens to be put in that position, and that time, under those conditions… to create that emotional effect."

Tom Kennedy N M E

DIRECTOR OF PHOTOGRAPHY, DIGITAL INK
(A 1972 graduate of the University of Florida, Tom began his career as a staff photographer at The Orlando Sentinel Star. He also worked as a picture editor at The Philadelphia Inquirer and, from 1987 to 1997, he served as Director of Photography at the National Geographic Society.)

"Photography's value as a universal language is reaffirmed by what we've seen here… I think it gives us an opportunity to see very clearly the things that are present in so many lives and so many disparate places that are both unique, and at the same time, universal… in a more complete fashion than other media presented."

Claude Cookman N

PROFESSOR, INDIANA UNIVERSITY SCHOOL OF JOURNALISM
(Claude, who received his Ph.D. in the history of photography from Princeton University, has taught at Indiana since the fall of 1990. His professional career included twelve years as a picture editor at the Associated Press in New York, The Louisville Times and The Miami Herald. He shared in the 1975 Pulitzer Prize awarded to the photo staff of the Times and Courier-Journal.)

"… People often want to know what the judges are looking for. I think we were looking for fresh vision and I think the fresh vision that we saw was what got rewarded."

Gail Fisher N M

SPECIAL PROJECTS PICTURE EDITOR, LOS ANGELES TIMES/ORANGE COUNTY
(Gail joined the Times in 1983 after working at the San Bernardino (California) Sun for three years. She was awarded the Robert F. Kennedy Journalism Award for outstanding coverage of the problems of the disadvantaged, and she won the Community Awareness Award at last year's POY competition for her story "Shelter on Stage.")

"There were just a lot of very powerful images, a lot of powerful stories, really great story lines, and a lot of good issues, I think, were explored…"

Judging panel photos by Missouri student Emilio Banuelos and PJ23 editor Randy Cox

Below ■ From a story entitled "A Hopeful Peace." Questions linger as to the lasting nature of peace in Bosnia. Many residents say they are just happy to be alive, to hold onto an apartment in a shelled out building, to experience the joy of a carefree drive. While many have fled the country never to return, some will stay.

"It's our home," one said, "I want to live here forever." In Serbia, the more isolated portion of the country, these men are happy not only to have a car, but gas to put in it.

NANCY ANDREWS, THE WASHINGTON POST
FROM THE NEWSPAPER PHOTOGRAPHER OF THE YEAR PORTFOLIO AND THE FIRST PLACE GLOBAL NEWS PICTURE STORY. (THE CHAPTER DISPLAYING SELECTS FROM NANCY'S PORTFOLIO BEGINS ON **PAGE 14.** SELECTS FROM HER GLOBAL NEWS PICTURE STORY ARE ON PAGE 202.)

Below ■ From an essay entitled "Journey to Safo." The 3,500 members of the Hausa tribe that call Safo home are a people struggling to stay in their age-old homes, determined to hang onto tradition and to life itself. Here, the Wanzame, the barber, performs such operations as male and female circumcisions, tooth extractions and uvulectomies, which are thought to relieve "blockages."

EUGENE RICHARDS, NEW YORK CITY FREELANCE
FROM THE FIRST PLACE CANON PHOTO ESSAYIST PORTFOLIO. SELECTS BEGIN ON **PAGE 44.** EUGENE IS ALSO THIS YEAR'S MAGAZINE PHOTOGRAPHER OF THE YEAR. SELECTS FROM THAT PORTFOLIO BEGIN ON **PAGE 30.**

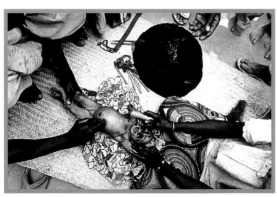

Again, The Washington Post's photographers dominate POY

The biggest news of POY55 is the unprecedented domination of the contest by The Washington Post. Not only did The Post sweep the newspaper portfolio competition with wins by Nancy Andrews *(first),* Carol Guzy *(second),* Michael Williamson *(third)* and Dudley Brooks *(fourth),* the paper claimed a total of 24 awards, 14 more than any other newspaper and a record number in the history of the contest. Half of these were ranked awards *(first, second or third places).* Nine Post photographers contributed to this amazing performance. The next closest competitor, *The Commercial Appeal,* claimed a total of 10 awards, including two firsts, two seconds and two thirds.

Interestingly, all of the Post's awards were for photography. Most newspapers that won multiple honors placed in editing as well as shooting categories. *The Post* entered no editing categories.

With these successes, Post photographers have tied *The Denver Post,* each claiming six Newspaper Photographer of the Year titles, for the most top portfolio honors in the history of the contest. Past Post Photographers of the Year are Guzy *(1996, 1993, 1990),* Williamson *(1995)* and Lucian Perkins *(1994).*

Washington, D.C. also is the home of this year's most decorated magazine, *National Geographic,* which collected a total of 14 honors. The next closest competitor, *LIFE* magazine took 11 awards. The Associated Press won a total of seven, more than any other agency.

Consistency and persistence characterized the performance of another perennial POY winner, Eugene Richards. This year Richards became the most decorated photographer in the history of the contest by becoming Magazine Photographer of the Year for the third time as well as winning his third Canon Photo Essayist title. He is the only photographer to win three of POY's top five awards for photography. Richards received the Kodak Crystal Eagle award in 1992.

As is often the case in the contest, captions and presentation played a large role in the decisions of judges. All winning newspaper and magazine portfolios combined great photography with content-rich,

well-written captions, tight editing and thoughtful sequencing. In the case of Richards' photographs – many of which depicted complex subject matter that was not obvious from a reading of only the images – captions provided the context required to appreciate both his Magazine portfolio and Canon Photo Essayist entries.

Community Awareness Award submissions continued to broaden the definition of "community" with superior reporting, technique and presentation. First place winner Scott Lewis of the Copley Newspaper weekly, *Fox Valley Villages/60504*, won with a portfolio of work that was shot entirely on assignment. Every image had been published. Made up of a diverse collection of news and feature singles and stories, the presentation entitled *"Kids, cul-de-sacs and the New American Dream"* was masterfully edited to portray life in a middle-class suburb.

Special Recognition awards in this category included a lavish Zen-like color portrait of the northern Minnesota wilderness surrounding the home of freelance photographer Jim Brandenburg. His entry included portions of an essay that was started on the autumnal equinox and completed on the winter solstice. Brandenburg disciplined himself to make only one picture each day. The complete work consists of 90 images, every frame that he shot.

Another special recognition in this category examined a family being pulled apart by AIDS; a fourth depicted life in a low-income city neighborhood. These four different, outstanding essays suggest that growing numbers of sensitive and gifted photographers are exploring the worlds outside their own front doors. A record 61 entries competed for the Community Awareness Award this year.

The Kodak Crystal Eagle Award for Impact in Photojournalism went to New York City photographer Jacques Lowe for his documentation of the political and personal life of John F. Kennedy, which began in 1958 during Kennedy's first campaign for public office and continued until his assassination. Former NPPA President Bill Luster in his nomination letter noted that Lowe had shed light on the inner workings of America's most powerful people and paved the way for noted presidential photographers Yoichi Okamoto *(Lyndon Johnson)*, David Hume Kennerly *(Gerald Ford)* and others. The Overall Excellence in Editing winner, *The Commercial Appeal* of Memphis, fared well throughout the editing division categories by combining strong photography, captions and display

CONTINUED, NEXT PAGE

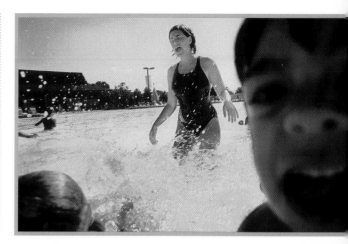

Above ■ From an essay entitled "Kids, Cul-de-Sacs and the the New American Dream." The far eastern neighborhoods of Aurora, Illinois are a place where children grow up with an abundance of educational, extracurricular and athletic opportunities. Here, Brainna Timothy urges her students "big kicks, now little kicks" in the beginnning swimming class at Phillips Park pool.

SCOTT LEWIS, FOX VALLEY VILLAGES/60504
FROM HIS FIRST PLACE COMMUNITY AWARENESS AWARD PORTFOLIO. SELECTS BEGIN ON **PAGE 74.**

Below ■ Jacques Lowe was the personal photographer of John F. Kennedy in his quest for the Presidency and, later, during the White House years. Here, in the fall of 1959, candidate John F. Kennedy chats with two supporters on his arrival at the Portland, Oregon Airport where he is otherwise ignored.

JACQUES LOWE, NEW YORK CITY
FROM HIS KODAK CRYSTAL EAGLE AWARD FOR IMPACT IN PHOTOJOURNALISM. SELECTS BEGIN ON **PAGE 58.**

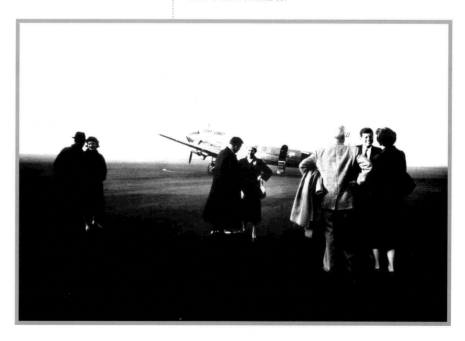

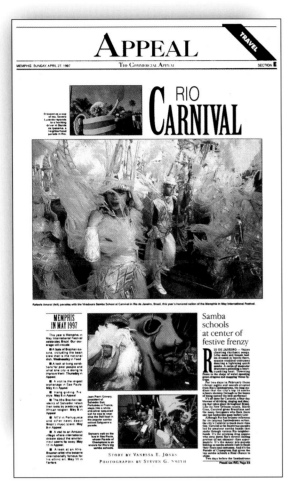

Above ■ A page from one of the editing entries of The Commercial Appeal in Memphis, Tennessee. This newspaper won a total of ten awards in this year's POY competition, including seven in picture-editing.

THE COMMERCIAL APPEAL WAS CHOSEN AS THIS YEAR'S WINNER OF THE ANGUS MCDOUGALL OVERALL EXCELLENCE IN EDITING AWARD. SELECTS FROM THEIR EDITING WINNERS BEGIN ON **PAGE 90.**

Right ■ A cover from one of the editing entries of National Geographic. This magazine won a total of 14 awards in this year's POY competition, including five in picture-editing and nine in photography.

NATIONAL GEOGRAPHIC MAGAZINE'S PICTURE-EDITING WINNERS ARE DISPLAYED ON **PAGE 106.** AWARD-WINNING SINGLES AND PICTURE STORIES APPEAR ON **PAGES 148, 150, 152, 153, 159, 162, 178, 180 AND 223.**

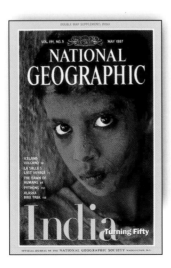

■ CONTINUED FROM PREVIOUS PAGE

typography with economical and tasteful design. Their exceptional section fronts and special projects enabled them to edge out other papers with larger news holes.

All of the Newspaper portfolio, Magazine portfolio, Canon Photo Essay and Kodak Crystal Eagle winners were black & white photographs; only the Community Awareness winner was shot in color. Observers questioned POY judges about the choice of black & white vs. color during post-judging discussions. The consensus was that it's much more difficult to make documentary color photographs, particularly of people, in which the color enhances the message. Well-composed, active shots of wonderful situations can be destroyed by distracting colors. In fact, over the years, many POY winners have converted images shot on color film to black & white slides for entry to the contest. Most of *The Washington Post* winners, though entered in black & white, had been shot on color negative emulsions.

Contest organizers were disappointed in the decline in total number of entries from 1,855 in 1997 to 1,722 this year. Magazine sports submissions also decreased from last year when special awards for Olympics coverage were offered. Only three magazine sports portfolios were submitted. Since judges felt none measured up to winners in the comparable newspaper division category, no awards were given.

Due to the perennially low participation by magazine sports photographers, the directors of the contest are considering moving all sports categories to the general division where newspaper, agency, freelance and magazine photographers all may submit. Such a move would not penalize newspaper sports shooters, whose winning entries have been consistently excellent. Meanwhile, magazine photographers who continue to find POY meaningful can still compete. This also would simplify contest logistics. POY55 contained 55 categories which required 13 full days of judging by ten photographers, editors and educators organized into three different panels. It has become nearly impossible for one judge to experience the entire contest; only Tom Kennedy did so this year.

Altogether 248 editors and photographers won 284 awards for single, story and portfolio entries. This is down significantly from last year when a total of 376 awards were given. I believe this difference is due in part to fewer entries but mainly to a greater gap between exceptional work, which usually gains recognition, and everything else. This panel did not appear to be overly critical compared with previous panels.

During discussions at the end of newspaper division judging the jurors asked themselves and spectators why this might be so.

The switch from bromide enlarging to digital editing was proposed as one reason photographers may not be mastering more of the subtleties of shooting and editing. One observer noted that when he was a young professional, peer review occurred routinely around the darkroom sink as they watched each other's images emerge in the Dektol. Discussions about technique and subject matter came naturally in the course of getting out the next day's paper.

Joe Elbert, *Washington Post* Assistant Managing Editor/Photography, had this in mind when he designed the Post's digital darkroom. There, the entire staff works shoulder to shoulder at editing workstations arranged much as were enlargers around the darkroom sink. Each station is shared by two photographers. Perhaps this has something to do with the unparalleled success enjoyed by *Post* photographers in recent years.

Many individuals enter Pictures of the Year. Approximately one-third of NPPA members participate at least every other year. Thus, the range of quality is great. Many entries are very good – work you'd be proud to put in your portfolio or print on the front page of your newspaper. However, to reach the ranks of winners requires some special spark of originality and imagination. Flawless technique and composition is a must. So is rich and compelling content. Prize-winning photos tend to connect readers with life on the other side of the lens. Idiosyncrasies of subjects, not clever camera work, convey the impression that here is a thing not seen before. This is what judges seek. Unfortunately, this is what too many entries lack.

For the first time, POY winners and the comments of judges were posted on the Internet. Thus, the invaluable learning opportunity experienced by those who work with or visit POY now may be shared by like-minded people throughout the world. To see most of this year's winning photos and listen to the judges' comments check out www.poy.org on your favorite internet browser.

Through this shared exper-ience Pictures of the Year does more than simply anoint the latest crop of celebrity photographers. By opening the doors to the jury room, all are allowed to observe both the wisdom, and the subjectivity, that influence the selection process.

Hopefully, this will enable each of us to do our own jobs better and make more appreciative – and more critical – the readers upon whom we all depend.

◀ **Bill Kuykendall,**
Director, Pictures of the Year

A COMPLETE LISTING OF ALL THE PHOTOGRAPHERS, EDITORS AND PUBLICATIONS WHO ENTERED THIS YEAR'S PICTURES OF THE YEAR COMPETITION CAN BE FOUND ON **PAGES 253** AND **254.**

Above ■ The opening screen of this year's Pictures of the Year expansive web site. Point your browser at:

www.poy.org

THIS YEAR'S POY WEB SITE SIGNIFICANTLY ADDS TO YOUR OPPORTUNITY TO SEE THE AWARD-WINNING WORK OF SO MANY PHOTOGRAPHERS AND EDITORS. THE SITE HAS ACCOMPLISHED SOMETHING THE ANNUAL "BEST OF PHOTOJOURNALISM" BOOK SERIES HAS ALWAYS WANTED TO DO: DISPLAY EVERY WINNING IMAGE FROM EVERY WINNING ENTRY. THE SITE ADDS TO THE BOOK EXPERIENCE BY OFFERING AUDIO OF THE JUDGES' COMMENTS ON THE ENTRIES AND INCLUDES SHORT VIDEOS OF THE JUDGING DELIBERATIONS. AS THE ONLY PHOTOJOURNALISM CONTEST IN THE WORLD OPEN TO THE PUBLIC, THE WEB SITE HAS CAPTURED THE SPIRIT OF THE CONTEST BY MAKING IT ACCESSIBLE TO ALL.

THE WEB SITE WAS PRODUCED BY MISSOURI GRADUATE STUDENT BRIAN LUKANIC, AS HIS MASTERS PROJECT, AND HIS ASSISTANT JANEL RHODA, A RECENT GRADUATE OF THE MISSOURI SCHOOL OF JOURNALISM. OTHER HELPERS INCLUDED GRADUATE STUDENT JANE HWANG AND TIPPI THOLE, ANOTHER RECENT GRADUATE.

(TO ENJOY THEIR EFFORTS USE A 4.0 BROWSER, EITHER NETSCAPE OR INTERNET EXPLORER, AND DOWNLOAD REALAUDIO 5.0.)

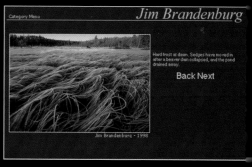

Above ■ The opening screen of a section on freelance photographer Jim Brandenburg's Community Awareness essay entitled "North Woods Journal."

The king of artists would be the photographer

At the turn of the century famed American portrait painter, James Abott McNeill Whistler said "The imitator is a poor kind of creature. If the man who paints only the tree, or flower, or other surface he sees before him were an artist, the king of artists would be the photographer. It is for the artist to do something beyond this: in portrait painting to put on canvas something more than the face the model wears for that one day; to paint the man, in short, as well as his features."

News photography has always been a business of the moment. Time is a rare commodity in a business measured mostly by the day. Given those time constraints, the photojournalist's challenge has always been to visually report the complexity of the people we cover – to show, as Whistler put it, the totality of our subjects, thereby gaining a richer understanding of them.

It has been a difficult year for our profession. Public perception of news photographers is, perhaps, at an all-time low – the probable result of the death of Great Britain's Princess Diana and the notion that her desire to escape the never-ending scrutiny of photographers, was the cause.

It is fitting that the NPPA-University of Missouri

Pictures of the Year Competition eschews the quick and easy image. It is not an easy task, and it is the extraordinary photographer who is capable of accomplishing it.

Look hard through this book and count the number of celebrity images. Here, excellence *is not* measured by the notoriety of the subject.

Take a hard look at the stories of Newspaper Photographer of the Year (POY) Nancy Andrews: a father, divorced, struggling to raise his daughter; a cat lady who adopted 115 cats rather than see them euthanized; the struggle of the first women of Virginia Military Institute; the celebration of religious life in a 10-mile stretch of Maryland.

View the stories of this year's Magazine POY, Eugene Richards: a Philadelphia police officer mourning the loss of his co-worker and friend; the effects of chemical pollution on Mossville, Lousiana; a story on New York City's only home dedicated exclusively to children who are HIV infected.

In each of these stories, there is a depth of coverage, achieved not through exploitation, but by compassion. The subjects, as the judges said during the contest, are treated with dignity and empathy.

The collective work of this book is not just a collection of the year's *best* news photography. It is also a collection of the *best kind* of work – visual poems, if you will – the kind of work that is capable of uplifting the human spirit as well as opening the mind.

■ David R. Lutman
NPPA President, 1997-1998

■ The chapter on the web sites and cd-rom winners, above, begins on page 110.

A glimpse at the wonder and the beauty of their souls

Photographers are lucky! We get to share some of the biggest moments in people's lives. Every story we cover and every photo we shoot is important to someone. As photographers, we may be assigned to our 100th high school football game, but for those kids, it is probably the first time they have been in the paper or on TV. It's a big moment for them and that should be important to us. The tape we shoot will be saved on VHS to be played and replayed for proud relatives and friends. The pictures we take will be cut out and framed. That photo will be put in scrapbooks and taped on refrigerators. We have captured a moment in someone's life.

Every photographer is different. We are made up of different races, religions, backgrounds and chromosomes. This affects how we view the world. As communicators, we show people the world as we see it. We take people places they would never go and show them people they would never meet. As journalists, we must realize that we are shooting not only with a lens, but with a point of view. As journalists, we work toward portraying our subjects fairly and accurately. Opinions about issues and people will be formed from our photography.

The photographers in the "Best of Photojournalism" annual show us some of the most important moments

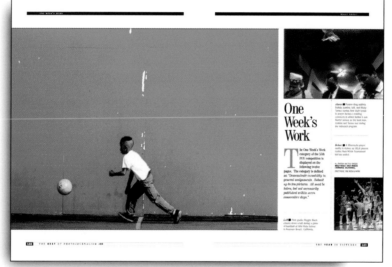

■ The chapter displaying the winners in the One Week's Work category begins on page 188. It's filled with the captured moments of everyday life. As Linda suggests, many of these probably will be taped on scrapbooks and refrigerators.

in history. They also show us someone or something that other people might overlook. These photographers show us what others don't.

The work of the 1997 National Press Photographer Association Photographer of the Year, Nancy Andrews, has exceptional depth and sensitivity.

During the 1997 Flying Short Course, Nancy was a member of the faculty. At each stop, people were drawn to her. There were long lines of seasoned professionals and admiring students waiting for the chance to talk with Nancy and to show her their portfolios. This isn't just because of the stunning images she shows us. People love her because Nancy is passionate about both photography and her subjects. It is reflected in Nancy's work and in Nancy herself. As my grandma used to say, *"she's the genuine article!"*

Nancy says: "Some people believe that when you take their picture, you capture a piece of their soul. But I believe the soul that the film captures is actually the soul of the photographer, not the soul of the subject. If you were to look at the life's work of a photographer, you would see a picture of their soul."

I would like to thank Nancy Andrews and the other outstanding photographers in the "Best of Photojournalism" book for allowing the rest of us a glimpse at the wonder and the beauty of their souls.

■ **Linda Asberry-Angelle,**
NPPA Vice-President, 1997-1998

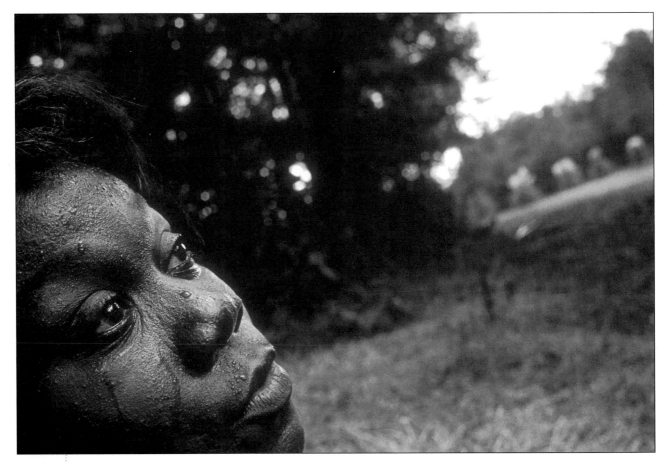

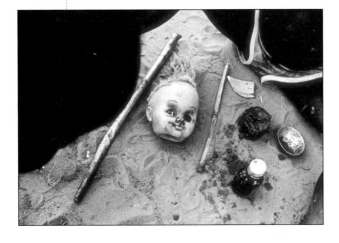

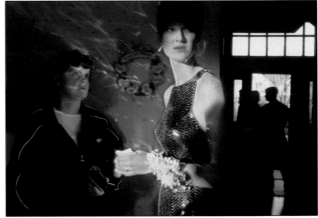

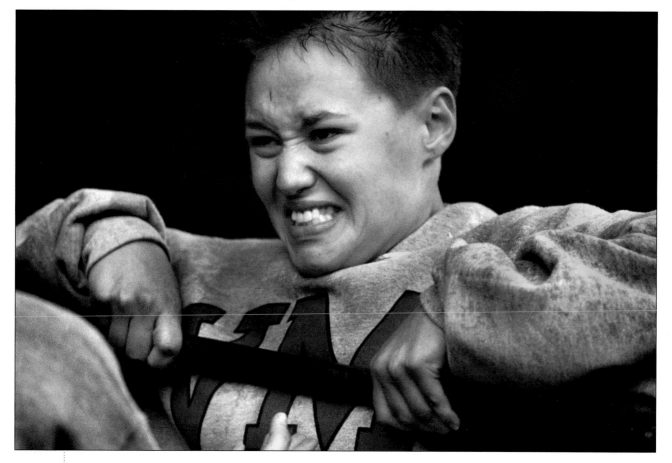

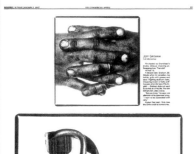

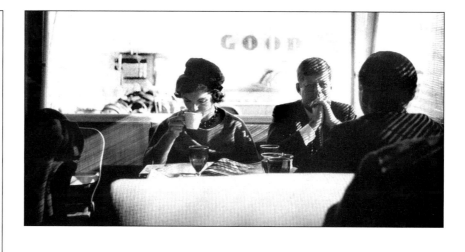

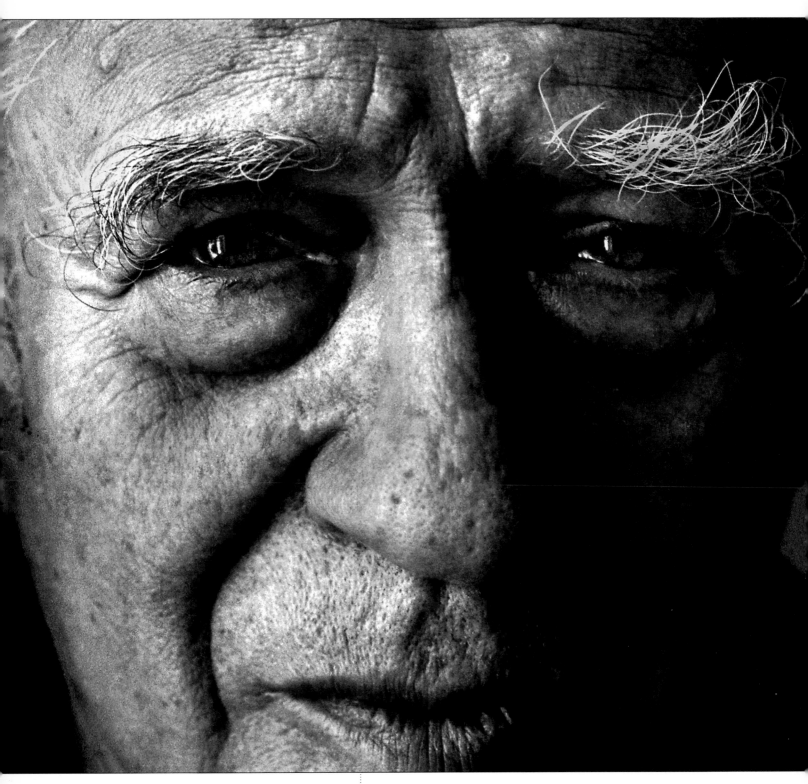

Above ■ A portrait of author Norman Mailer
made while he was promoting his latest book,
a re-write of the Bible.

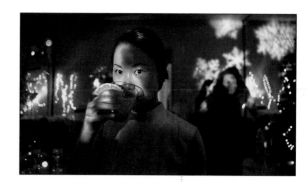

Nancy Andrews

NEWSPAPER PHOTOGRAPHER OF THE YEAR

Nancy Andrews is a staff photographer at The Washington Post. This is the first time she has won the award, although she is the sixth Post staff photographer since 1990 to be named Newspaper Photographer of the Year. Nancy, 34, has made pictures for The Post for eight years. Prior to the Post, she worked at The Free Lance-Star in Fredericksburg, Virginia. In 1994, Harper Collins published her first book, *"FAMILY: A Portrait of Gay and Lesbian America."* Nancy's second book, *"Partial View: A Personal Look Inside Alzheimers"* will be published in 1998 by Southern Methodist University Press. Nancy grew up on a farm in Caroline County, Virginia. She credits the influence of her high school biology teacher, Eleanor Tenney, for her career in photo-graphy. In college she was photo editor and then managing editor of the University of Virginia's student newspaper, The Cavalier Daily. In 1985, Nancy worked as a summer intern for The Charlotte Observer. Nancy graduated from Virginia with a degree in economics in 1986.

Above ■ Mei Ling stands in the light of a snowflake in the "Winter Wonderland Party."

THE FOLLOWING 16 PAGES DISPLAY A SELECTION FROM NANCY'S 63-PICTURE PORTFOLIO.

NOT INCLUDED HERE IS A GLOBAL NEWS PICTURE STORY WHICH WON FIRST PLACE. SEE **PAGE 202.**

TWO SINGLE PHOTOS FROM THAT SAME STORY WON AWARDS OF EXCELLENCE IN THE GLOBAL NEWS CATEGORY. SEE **PAGES 128, 202.**

Right ■ More and more older women are becoming Bat Mitzvah. Here, at the Hebrew Home of Washington, students ranging in age from 80 to 98 stroll to class in front of the Torah in the recreation room.

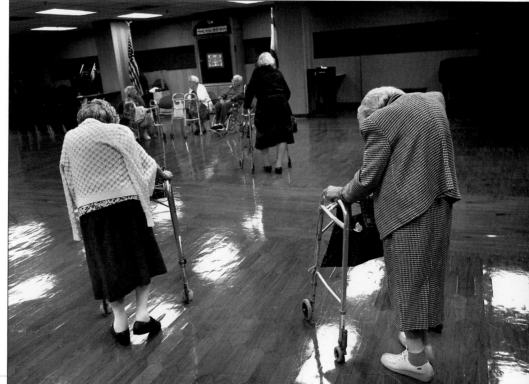

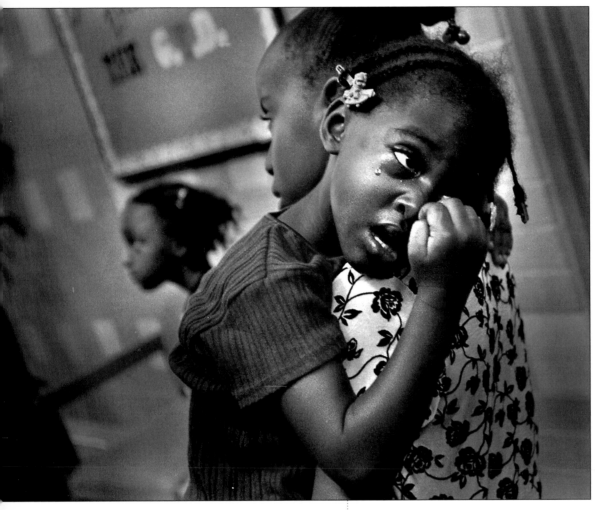

Above ■ Shawantee, cries because she doesn't want to go home from the daycare program in Washington, D.C. This photo was made for a story about the lack of funding and management to operate the public school system in the city.

Below ■ Forty-two Ukranian children who live down wind from Chernobyl stayed with American families for six weeks this summer. It's a time for them to eat, play and get fresh air as well as learn about U.S. customs. From left, Lyana Doubovik, Sonya Trus and Sveta Karvatskaya play in the back of a Suburban.

NANCY ANDREWS

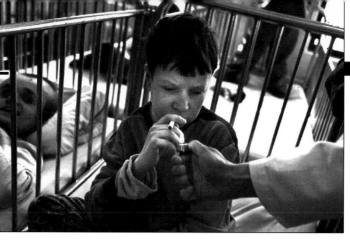

Below ■ Competitors in the boys age 8-and-under group, wait as the winners are called out for the 25-meter freestyle.

THIS PHOTO ALSO WON FIRST PLACE IN THE SPORTS FEATURE CATEGORY.

Left ■ People live in these cribs all their lives at the Pazaric, Bosnia home for children. Here a nurse offers a light to a patient.

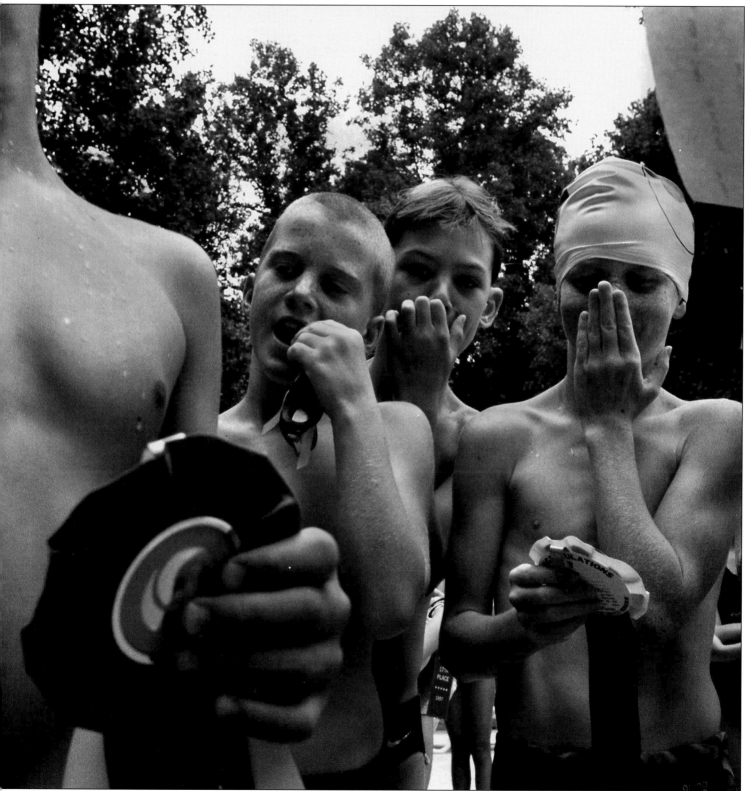

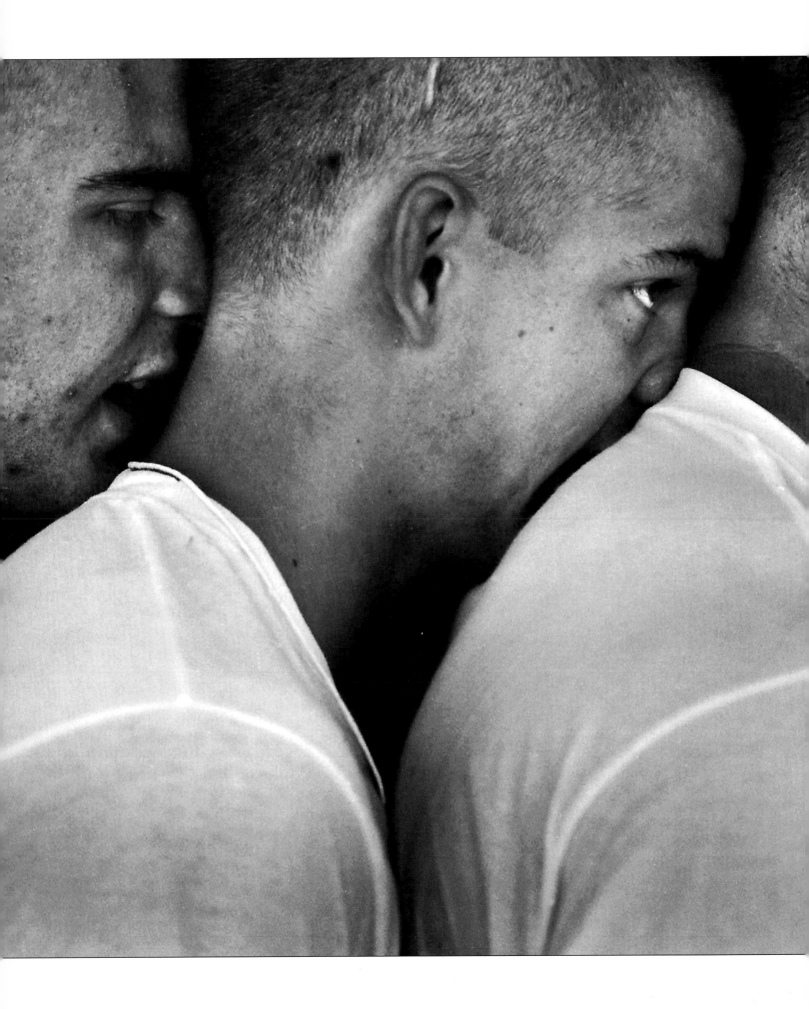

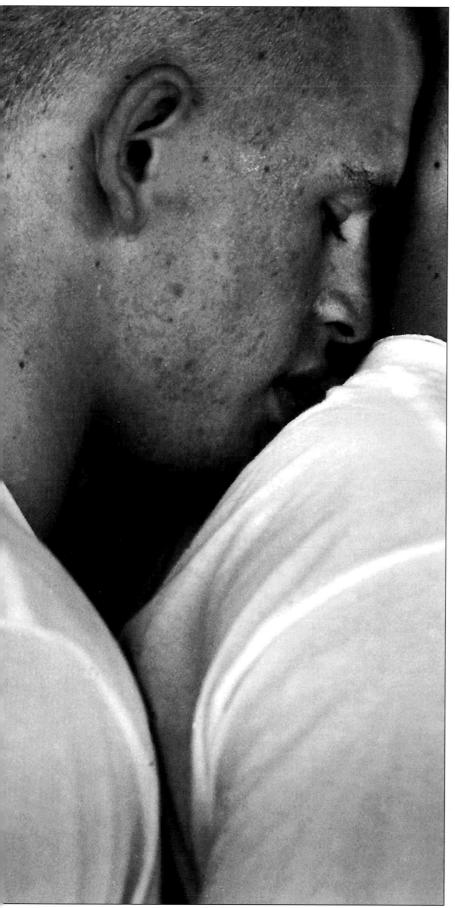

Above ■ Army sergeants Perkel and Braden trade backrubs after a long day's work. In Bosnia, males and females often sleep in the same tent, such as this one at Camp McGovern. With known problems of sexual harassment and gender relations in the United States Army, the newspaper examined the relationship between Army men and women while actually working, rather than training.

Left ■ The last all-male class at Virginia Military Institute lines up "nuts to butts" during ritualized hazing of men attending the school. The college lost its case before the Supreme Court, thus forcing both VMI and The Citadel to admit women.

Below ■ The white-gloved cadets at Virginia Military Institute take down the United States flag during the sunset retreat ceremony.

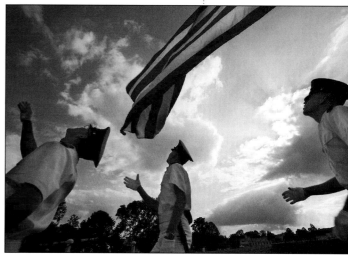

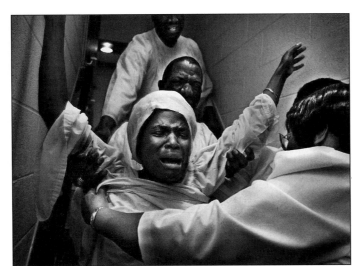

Left ■ Renee Johnson, after being baptized, rushes into the arms of Mother Arlgo Jordan who has been catching shivering Christians for fifteen years, as a member of the Baptismal Committee.

Below ■ Co-workers share some fun and excitement during an office Christmas party.

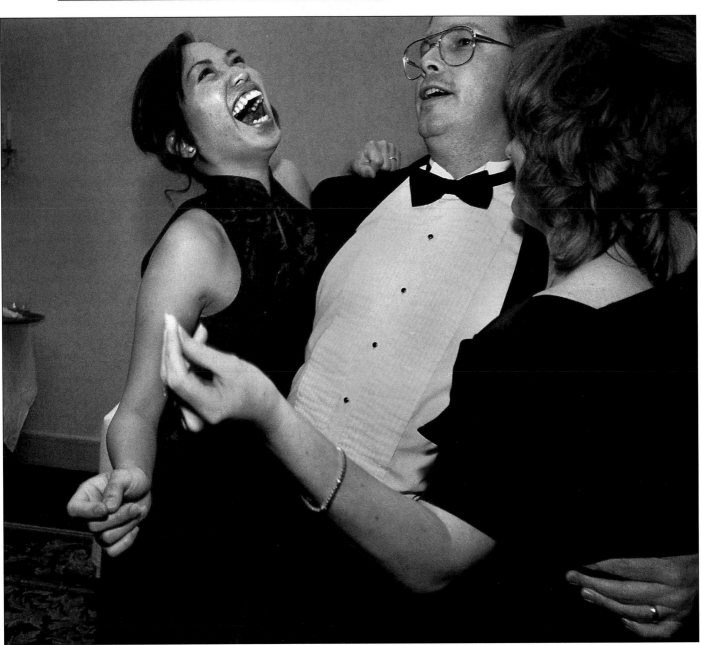

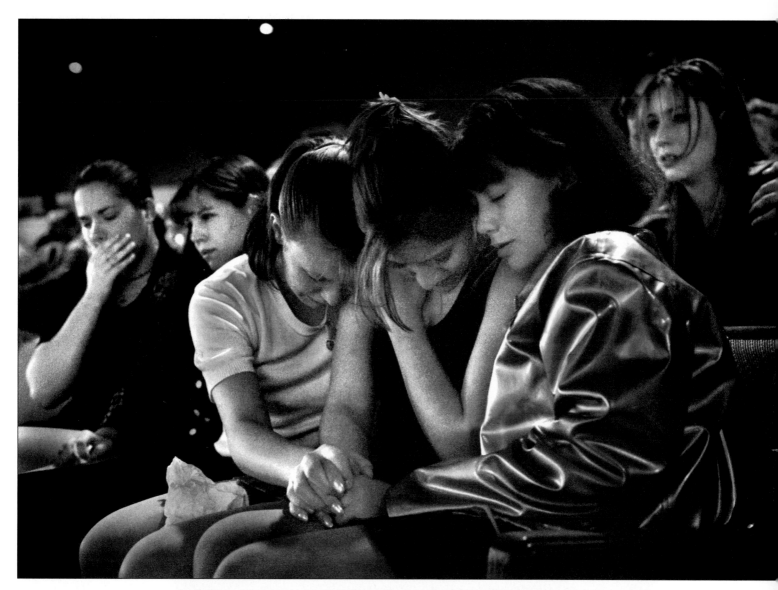

Above ■ Teenagers grieve for classmates, Kristin and Katie Lisk, who vanished from their home and were later found dead near a river. "We miss them a lot," said one of the teens.

Right ■ City religious leaders lay their hands on Washington, D.C., delegate Eleanor Holmes Norton before she returns to Capitol Hill to fight for D.C.'s home rule. Congress had just given the appointed Finanacial Control Board more powers over elected officials.

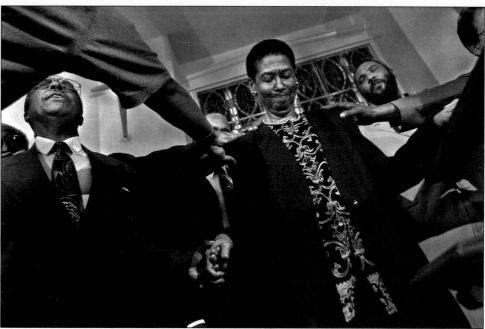

Feline Haven

"Her family," as Kristen Kierig calls her 115 cats, includes strays, victims of divorced families and even a cat abandoned by a police officer killed in the line of duty. Since discovering that thousands of unwanted cats were killed annually by shelters, she adopted them. Now she devotes not only her home, but her life to their care and feeding.

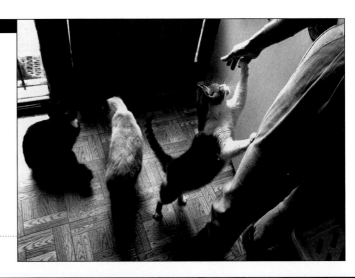

Right ■ Toby paws for attention while Gregory and Jeffrey look on.

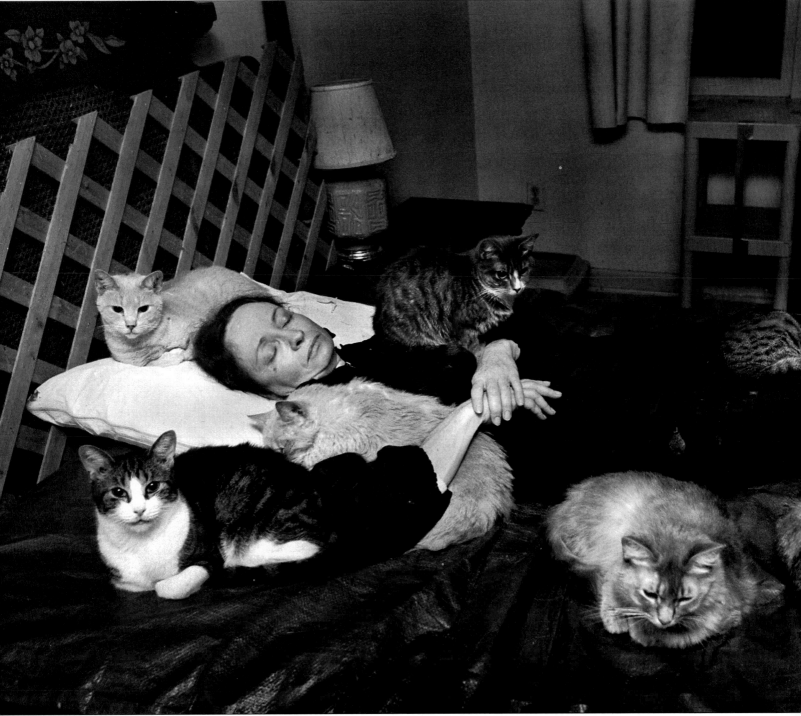

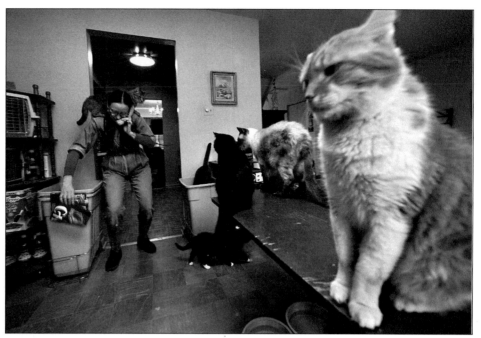

Below ■ Surrounded by some of her cats, Kierig sleeps in her clothes on a tarp-covered bed. She only gets five hours of sleep each night, rising at 1:30am to clean litter boxes and feed the animals before going to work.

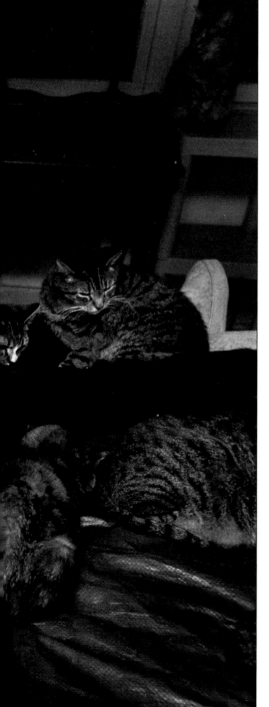

Above ■ While some cats pay her no mind, Kierig empties the trash with one cat on her shoulder and a phone to her ear.

Below ■ Wearing a mask to protect herself from dust, Kierig gives each litter box the smell test before moving on to other chores.

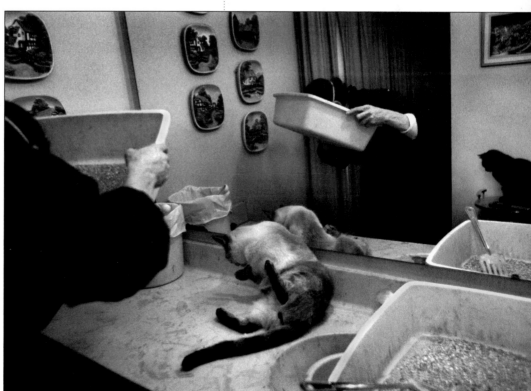

Historic Entrance

After fighting almost ten years to keep women out, Virginia Military Institute admitted its first females in August of 1997. VMI had contended that women would disrupt the school's regimen and would not survive their "adversative" method of training. It was the VMI case that went to the U.S. Supreme Court and also held the fate of South Carolina's Citadel. When the Court ruled against the school in 1996, The Citadel opened its doors immediately, whereas VMI took more than a year to enroll its first female cadet.

Above ■ The Institute is filled with tradition and ritual. Stonewall Jackson taught at the school, and the school's cadets actually fought in the Civil War. As tradition dictates, a cadet sentry guards the barracks at all times.

Below ■ Four upperclassmen "welcome" Megan Smith on her first day of life as a "Rat." VMI previously trained its cadets to always tip their hats to women. They were concerned that cadets would be unable to yell at women and would treat them too lightly. That, they feared, could change the whole character of the school if women enrolled.

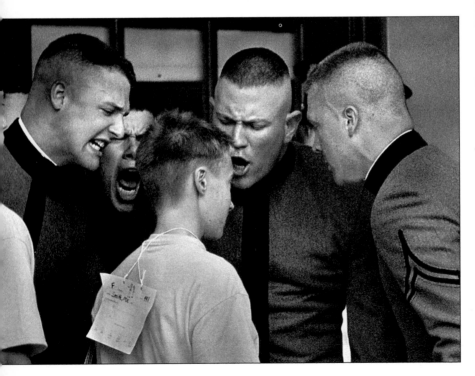

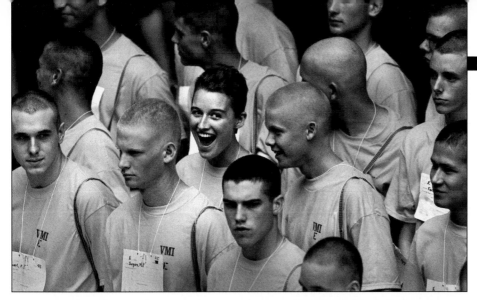

NANCY ANDREWS

Left ■ Part of beating the VMI system of harassment is to maintain cohesion with your fellow "Rats" and keep a sense of humor. Tennille Chisholm, center, and her brother "Rats" seemed to be doing just fine.

THIS PHOTO ALSO WON AN AWARD OF EXCELLENCE IN THE GENERAL NEWS CATEGORY. THIS PICTURE STORY ALSO WON SECOND PLACE IN THE NEWS PICTURE STORY CATEGORY.

Below ■ Mia Utz strains as she pulls on a bar during the "Rat Challenge" obstacle course. All cadets must be able to pass the VMI fitness test, which was not altered for females.

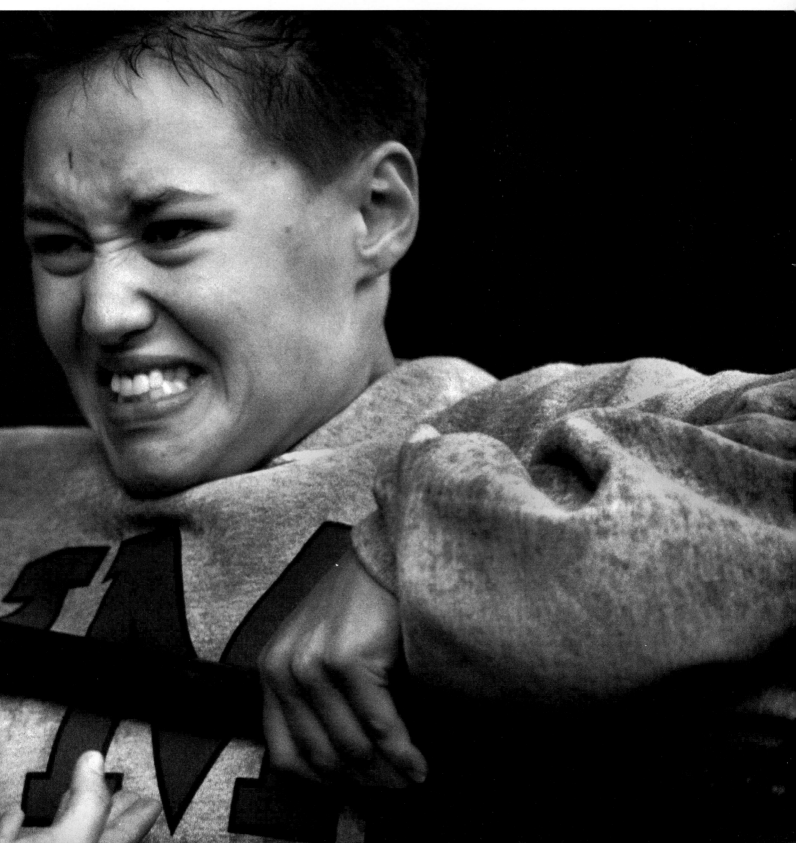

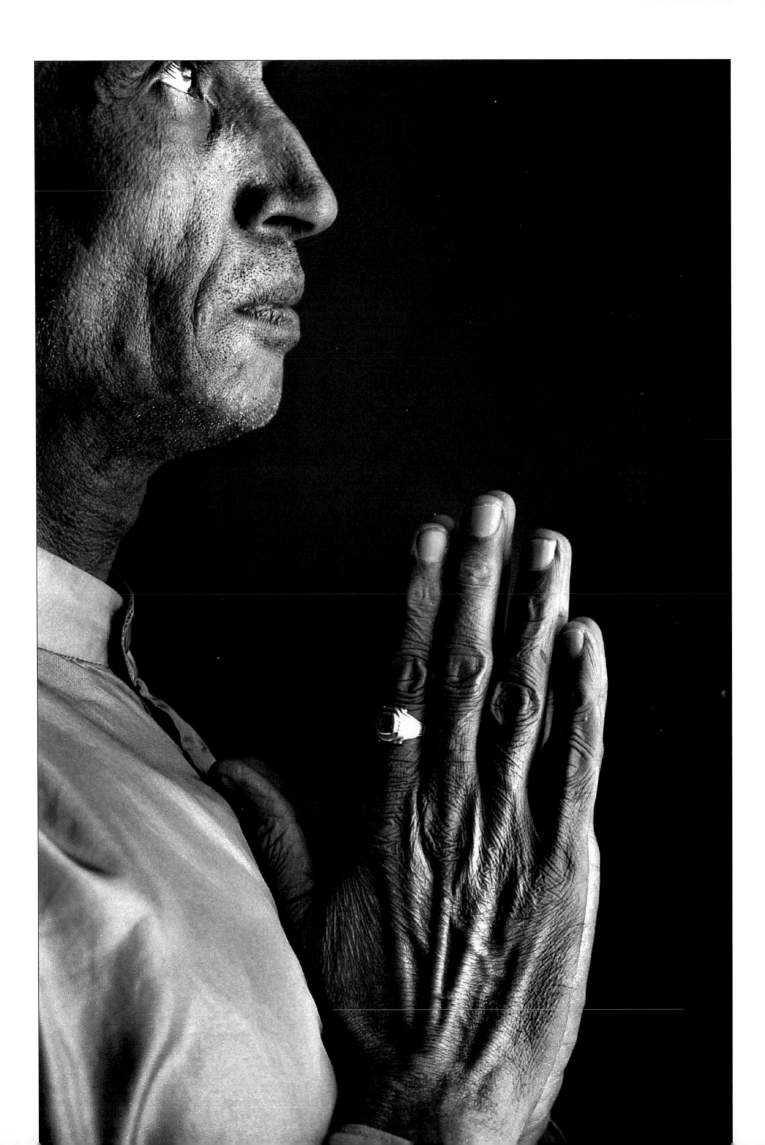

Religious Row

A ten-mile stretch of New Hampshire Avenue in Montgomery County, Maryland is home to more than 30 places of worship. Reflecting many of the religions and peoples in America today, the highway passes a diversity of sacred places: Hindu temples, Muslim mosques and 29 Christian churches. These Christian churches alone represent a variety of cultures and faiths such as Spanish Seventh Day Adventist, Korean Presbyterian, Jehovah's Witnesses and Ukranian Orthodox.

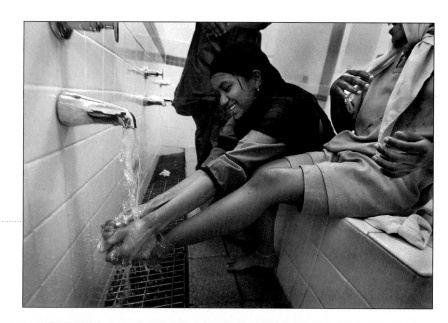

Left ■ A Hindu monk from one of the three temples along the road prays during the afternoon session.

Right ■ Young girls wash their feet before the afternoon call to prayer at the Muslim school.

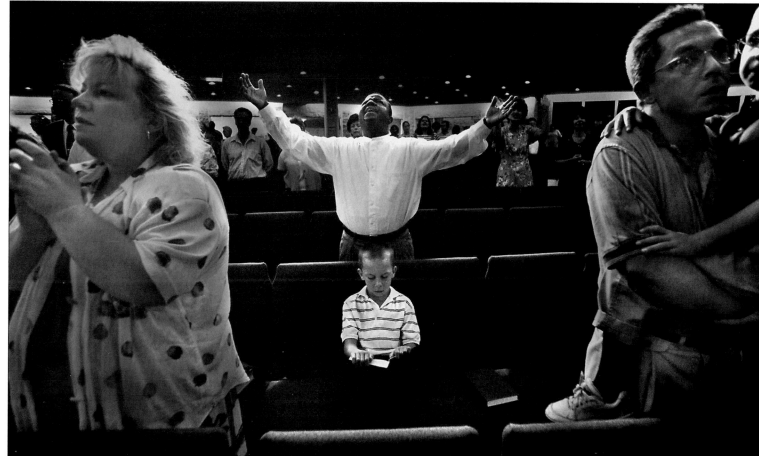

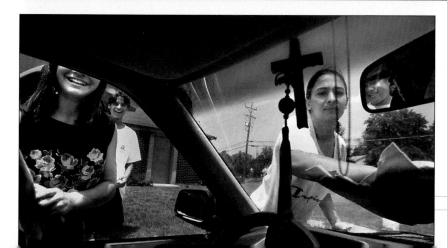

Above ■ Of the places of worship along the avenue, the majority are Protestant Christian churches built within the last ten years.

Left ■ Teens at the Spanish Seventh Day Adventist Church wash cars to earn money for a missionary trip.

Every day is Father's Day

This story depicts the life of Clyde Jackson, a divorced father, and his five-year-old daughter Tiffany. A dedicated father, Jackson wears a golden ring labeled "Dad" on his wedding finger to signal his commitment as a dad.

Above ■ Every night while kneeling by the sofa, father and daughter together recite the 23rd Psalm, "The Lord is my shepherd..."

Below ■ Tiffany holds her father's ringed hand. She gave him the ring for last year's Father's Day. He wears the ring on his wedding finger telling all who notice, "I am married to my children."

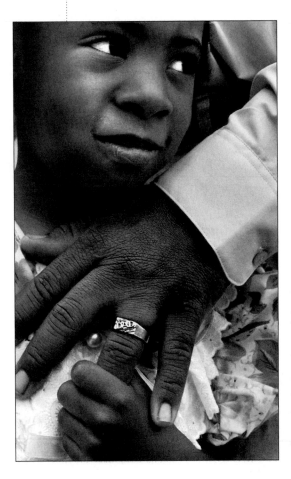

Left ■ After church, Tiffany tries on her Dad's shoes. They didn't fit.

Below ■ Tired, Clyde Jackson leans against the wall while ironing Tiffany's skirt for school.

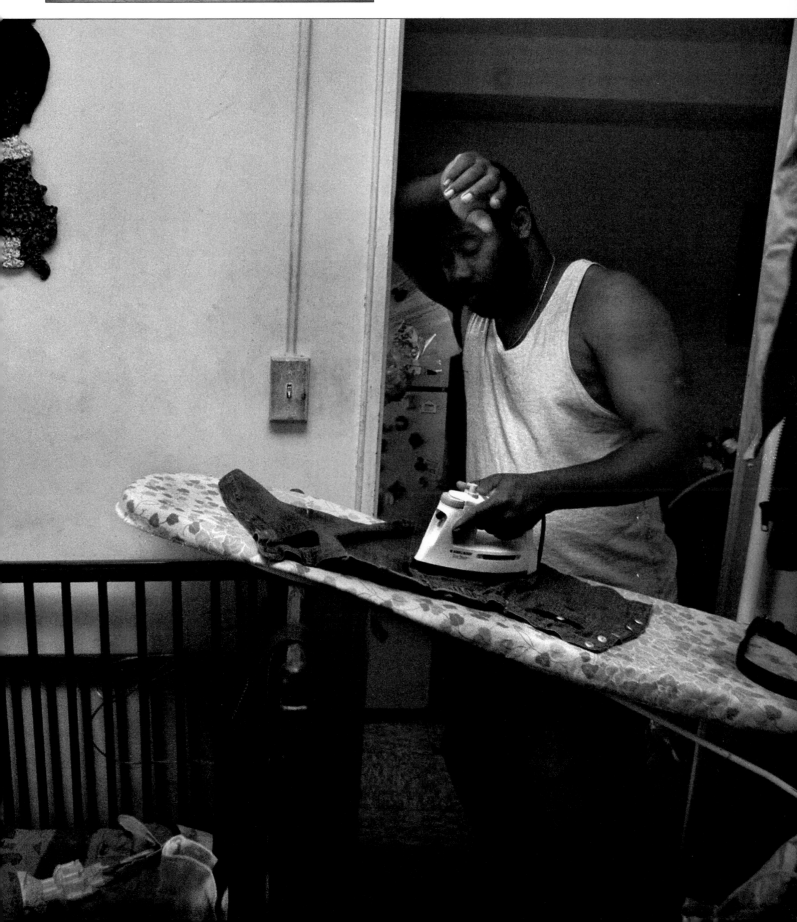

Eugene Richards

MAGAZINE PHOTOGRAPHER OF THE YEAR

Eugene Richards is a freelance photographer based in New York City. This year, Richards became the most decorated photographer in the history of the Pictures of the Year competition by becoming Magazine Photographer of the Year for the third time as well as winning his third Canon Photo Essayist title. He is the only photographer ever to win three of the top five awards in photography. In 1992 he received the Kodak Crystal Eagle Award.

Born in 1944, Richards is also a writer, teacher and is the author of nine books. He is the recipient of the Leica Medal of Excellence and has also received the Guggenheim Fellowship, the W. Eugene Smith Memorial Award, a Hasselblad grant and three fellowships from the National Endowment for the Arts. His books have resulted in awards from Nikon and the International Center of Photography. And he received the Kraszna-Krausz Award for Photographic Innovation in Books as well as the 1995 Oliver Rebbot Award from the Overseas Press Club.

THIS 14-PAGE CHAPTER DISPLAYS A SELECTION FROM EUGENE'S 80-PICTURE MAGAZINE PHOTOGRAPHER OF THE YEAR PORTFOLIO. RICHARDS ALSO WON THIS YEAR'S CANON PHOTO ESSAYIST AWARD. HE HAS NOW WON BOTH AWARDS THREE SEPARATE TIMES. A SELECTION FROM HIS CANON PORTFOLIO BEGINS ON **PAGE 44**. AN EDITED VERSION OF THE CANON ESSAY WAS ALSO INCLUDED IN THIS MAGAZINE PORTFOLIO. ADDITIONALLY, EUGENE WON FIRST PLACE MAGAZINE FEATURE PICTURE AND AN AWARD OF EXCELLENCE IN MAGAZINE GLOBAL NEWS. THOSE ARE PART OF BOTH HIS MAGAZINE PORTFOLIO AND HIS CANON ESSAY. THEY ARE DISPLAYED IN THE CANON CHAPTER.

Right ■ Only the staff of ICC, a residence for children with HIV and AIDS in New York, attended the wake for four-month-old Amos. The police could not find his mother, a drug addict. The morning of the funeral, the child's casket was placed on the front seat of the hearse. A cousin, who had never met Amos, sat in the back.

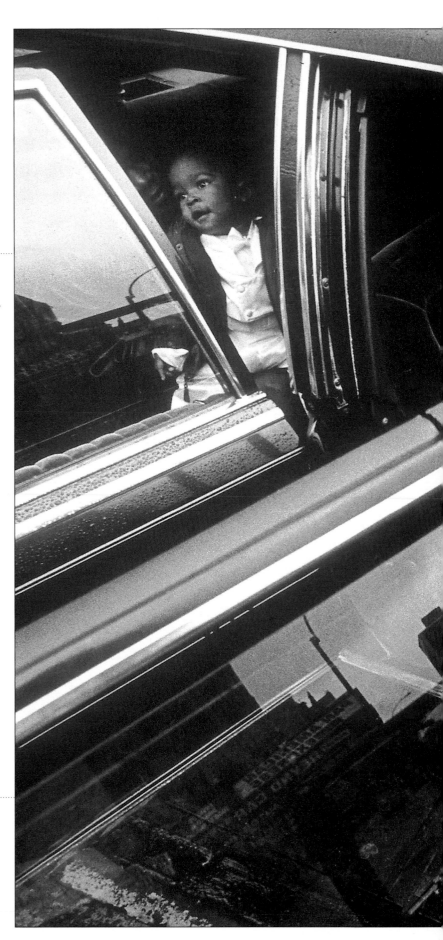

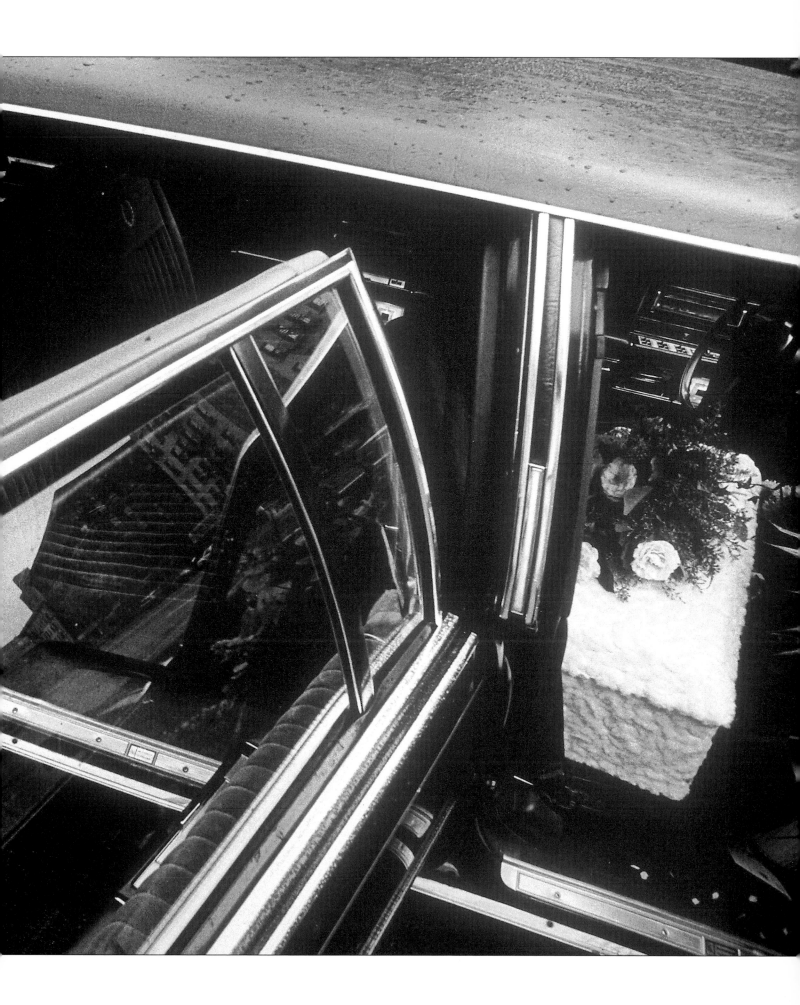

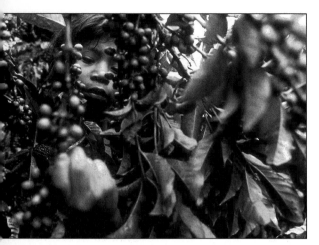

Below ■ Ricardo Vasquez, who farms in the La Sierra Mountains of Honduras, now grows coffee as well as corn and beans. After planting, growing and picking the coffee beans, he and his children de-pulp the fruit for market.

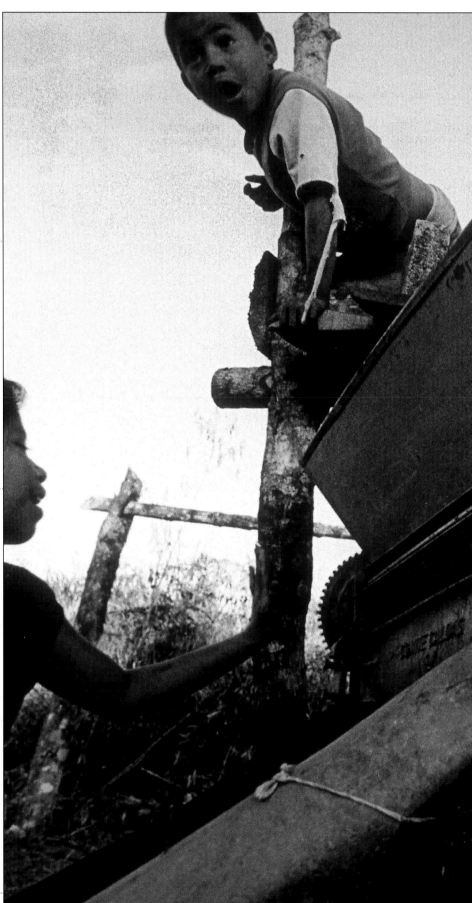

De-pulping coffee beans in Honduras

Above ■ Dilcia Cabrera, age 11, and her 13-year-old brother work in the field, clearing weeds and picking the coffee beans when they're not in school.

Below ■ For peasant farmer Ricardo Cabrera's wife Reina, the day begins at 4am when she nurses her newborn, and begins washing and grinding the corn for their breakfast tortillas. Ricardo rises at 6am to work for two dollars a day.

Next spread ■ Subsistence farmer Benito Lopez lives with his wife and nine children high on a mountain. Not having money for medicine, all are sick with flu and pneumonia.

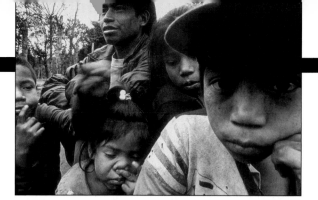

Right ■ Ricardo, 35, wants a better life for his wife and seven children. He tends 3,000 coffee plants on an acre-and-a-half, then works half a week for the wealthy landowners, earning a total of $3,000 a year.

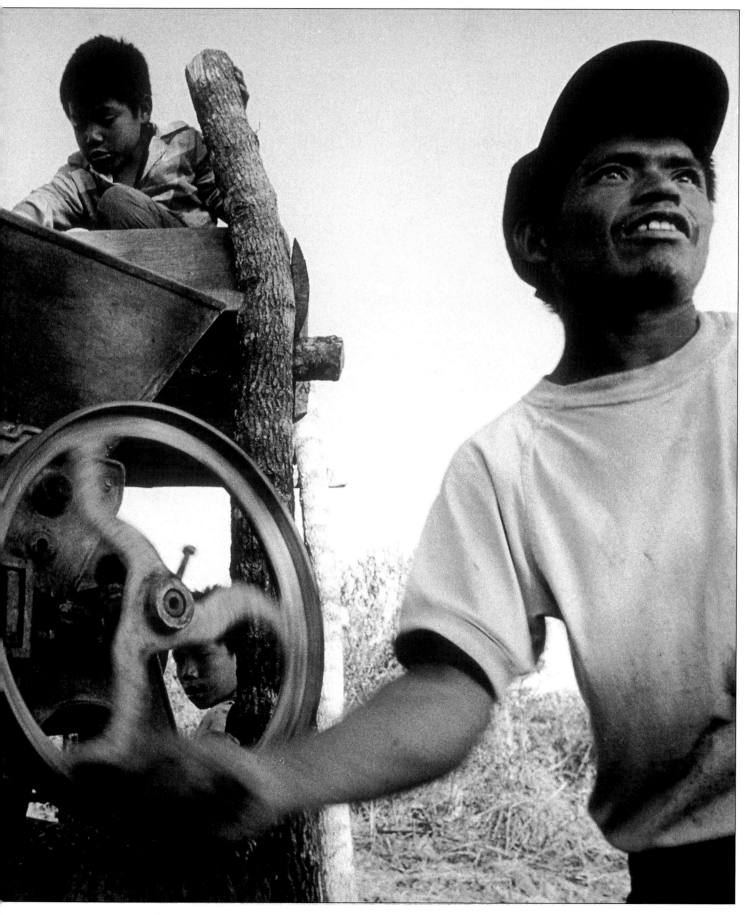

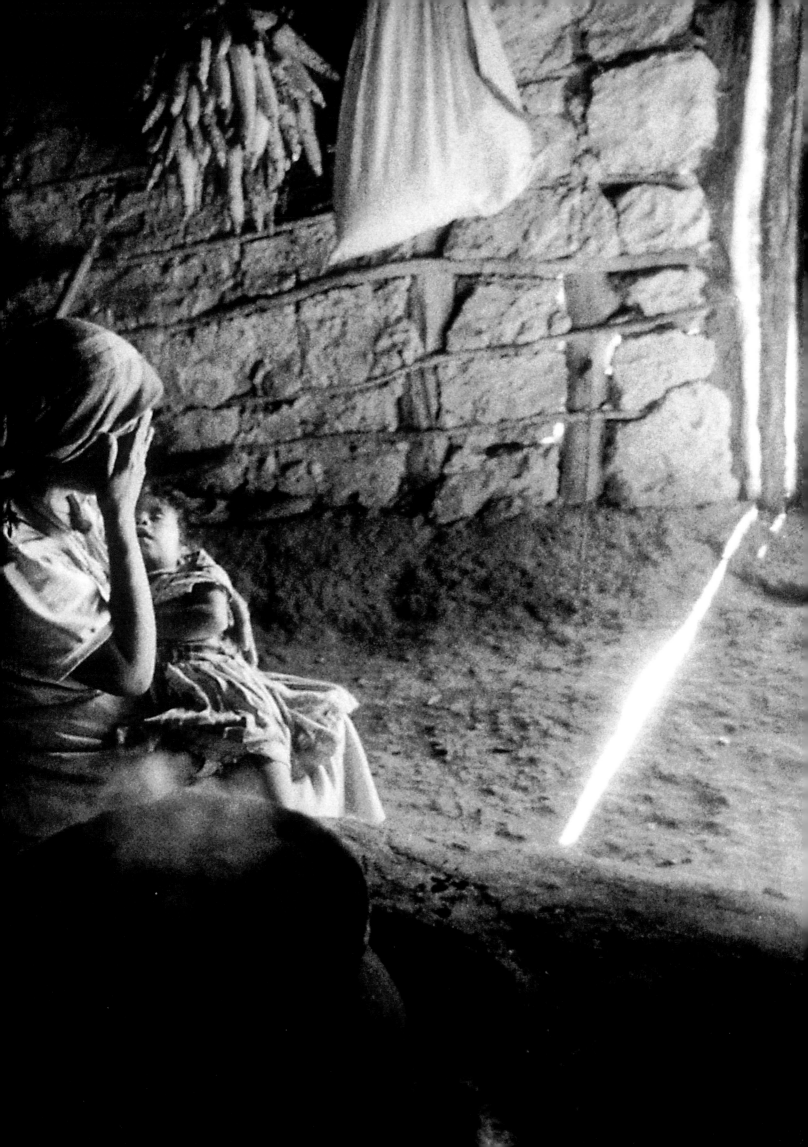

New York's Incarnation Children's Center

The Incarnation Children's Center is New York's only residence exclusively for children with HIV and AIDS. It was founded in a former rectory on a tenement-lined street in the largely Latino-populated Washington Heights. The devoted child care workers at ICC try to make these very different children, from very different backgrounds, into what might be called a surrogate family.

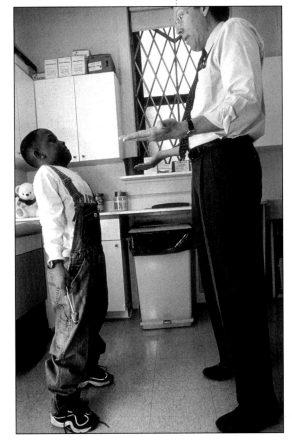

At top ■ Roberta and her father, who lives in a nearby homeless shelter.

Above right ■ Jacquie, who is often in pain, is comforted by her adoptive mom.

Left ■ Dr. Steve Nicholas, director of ICC, urges Tamahl to exercise his legs. Tamahl, whose mother was an intravenous drug user, now lives with his grandmother.

Right ■ Five-month-old Aminata, whose mother is from Africa, is blind, deaf and is now barely hanging onto life.

Left ■
Elena,
a former
physician in
Santo Domingo,
is now one
of the ICC's
extraordinary
child care
workers.

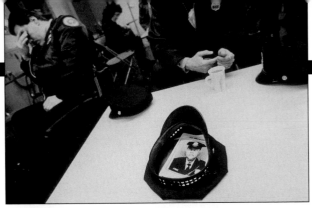

Left ■ At the church, prior to "the showing," officers comfort each other to express their grief before buses carry them to the cemetery. The memorial booklet for Officer Vaird, the first policewoman killed in the city's history, is carried in their caps.

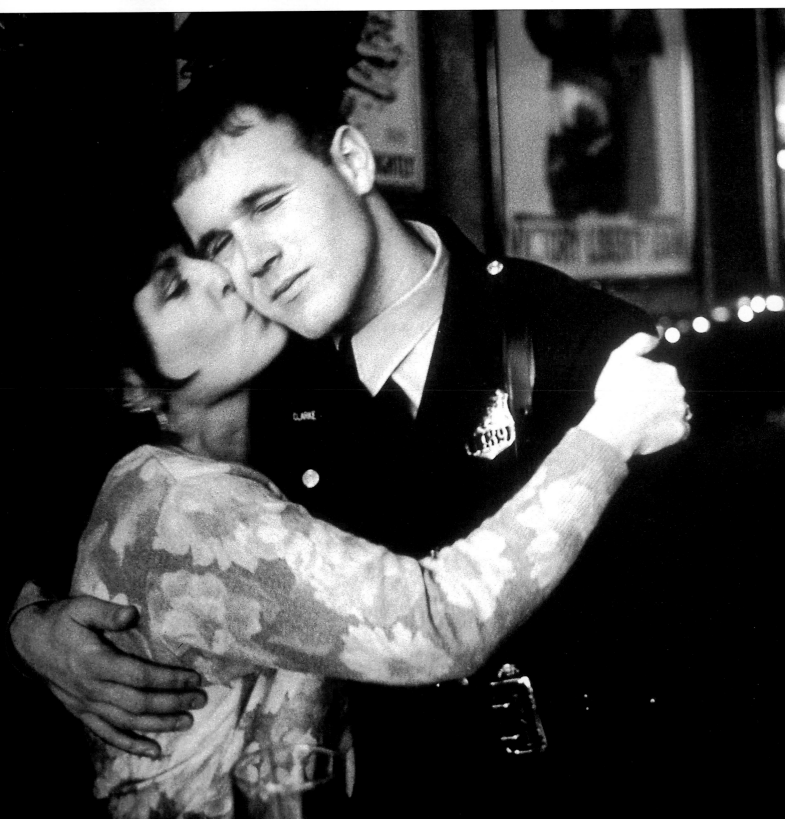

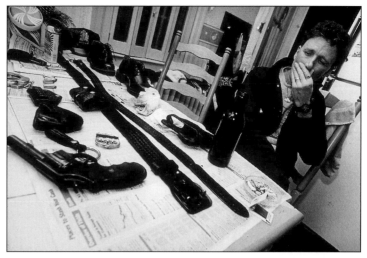

The Twenty-fifth Precinct: Philadelphia

Officer Laretha Vaird was the first policewoman killed in the city's history. The aftermath and effect her death had on the Philadelphia police department varied from private and public grief to a rethinking of their very jobs.

Above ■ 2:30am, the morning before Officer Vaird's funeral, 48-year-old veteran cop Tommy Clarke is unable to sleep and mourns in his own way by polishing his weapon, gunbelt and each silvery round of his weapon.

Left ■ At the very same time, Officer Clarke was considering his resignation from the department, his son, Tommy Clarke Jr., graduates from the Police Academy. His mother, proud yet afraid for him, weeps.

Below ■ After eight hours of duty and two hours of overtime, Officer Clarke does his laundry and babysits his niece while making a call to his son on the portable phone.

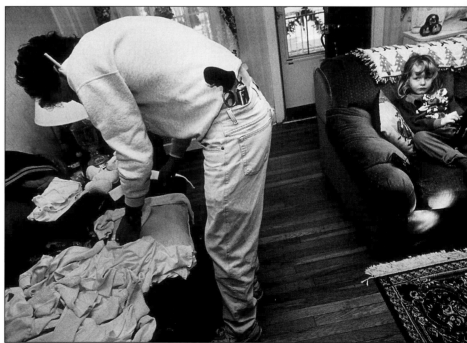

Below ■ The tears of this community activist are the result of fear and frustration as the health concerns of this poor town largely go unnoticed. Louisiana ranks near the bottom in education, health care and overall standard of living while polluting industries flourish.

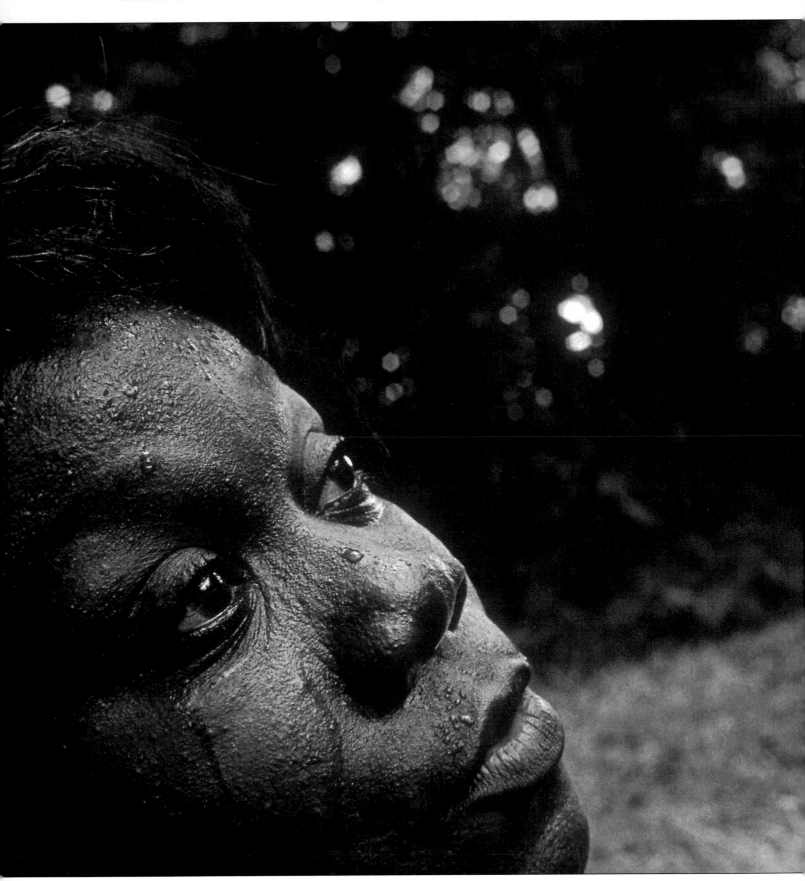

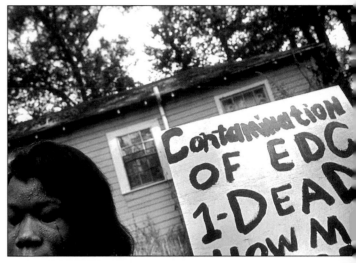

Mossville, Louisiana

A nearly all African-American town, Mossville is polluted, environmentalists and residents say, with dioxin and other waste leakage from the Condea Vista plant and other petrochemical plants. There are 43 chemical plants in Mossville.

Top left ■ The Arco refinery near Mossville.

Above ■ Environmentalists have suggested a link between the release of dioxin from the area's chemical plants with endometriosis and cancer. Ethylene dichloride, used by vinyl plants, is another possible carcinogen. A sign in front of an abandoned house proclaims one of many cancer deaths.

Below ■ In 1994, the Lake Charles, Louisiana, press reported that the Condea Vista plant admitted to 39 industrial accidents. The next year, there were 90 chemical releases from that same plant.

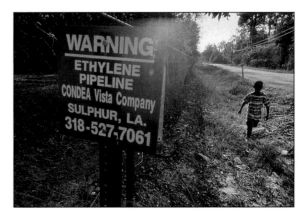

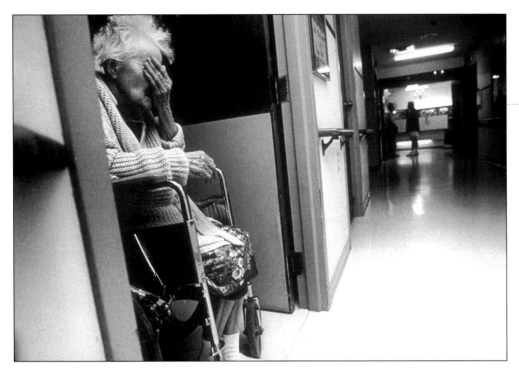

Growing old...

The problems of aging are upon us, failing bodies, Alzheimers disease.

Left ■ Loving memories for those in nursing facilities can also be unkind memories. Seventy-four-year-old Sarah is one minute happy with the care she receives, then bitter that her husband is gone, that her relatives don't visit enough, that the pain in her head won't go away.

Below ■ 92-year-old Clarence Keyser, though a bit reckless, will not give up driving his pickup. He parks close to his house, and sometimes requires assistance to the vehicle, but once the engine's running, the world is his.

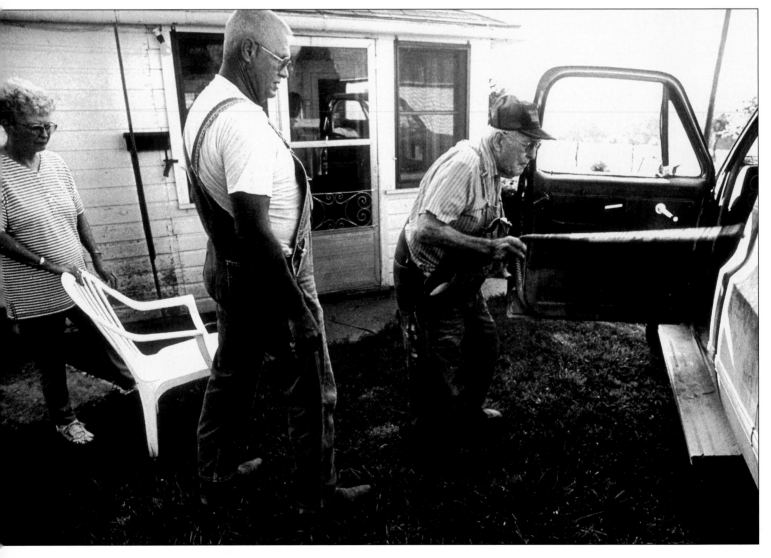

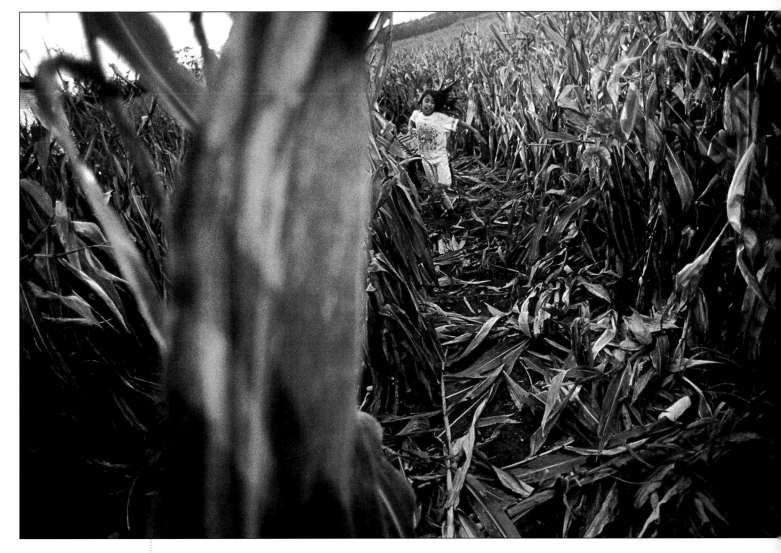

Migrant workers and the cornfields of West Virginia

The United States is a land of opportunity, a chance for an income for hard-working Mexican migrant workers, though often at great personal cost. The migrant workers, mostly men, are up at 4:30am to cook, in the apple orchards at 5:30am, where in autumn, the morning air is wet and cold, and a fire is welcome.

Above ■ Anita and other children of migrant workers play after school in the cornfields of Martinsburg, West Virginia. Their parents labor, picking apples, so these kids will have an education and decent housing, things impossible for them in their impoverished native Mexico.

Left ■ Fermin, a Mexican migrant worker, was allowed to bring his wife – not yet his children – into the U.S. Left in a relative's care, their youngest daughter was murdered, something this woman may never recover from.

Below ■ 80-year-old Rahamou, too old for menial work, cares for children. On her back, she carries her three-year-old great-grandchild, who is dying of the kind of malnutrition that begins from insufficient breast feeding following birth.

THIS PHOTO ALSO WON FIRST PLACE MAGAZINE FEATURE PICTURE. THE OTHER FEATURE WINNERS ARE DISPLAYED BEGINNING ON **PAGE 146.**

Right ■ A young girl draws water from a well. Safo's water is full of giardia and other parasites. Untreated it can cause vomiting, diarrhea and death.

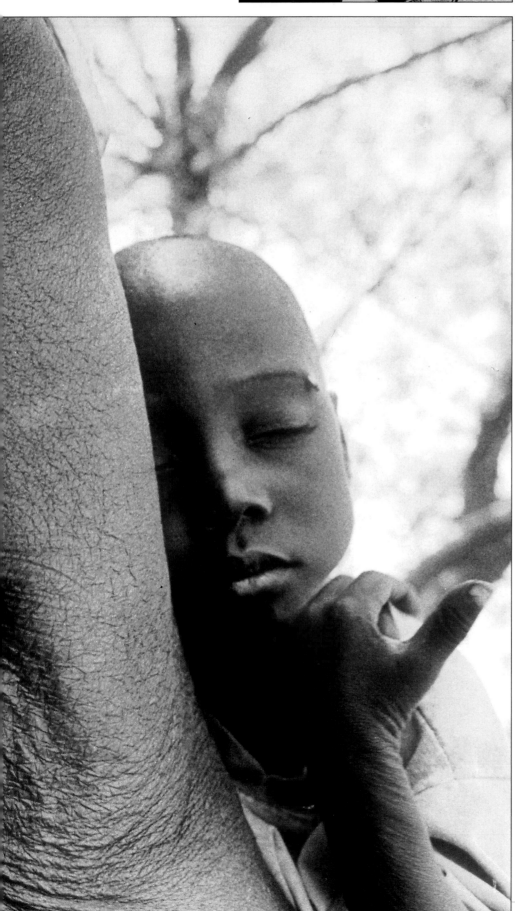

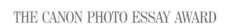
THE CANON PHOTO ESSAY AWARD

Journey to Safo

THIS DESCRIPTION ACCOMPANIED **EUGENE'S** FIRST PLACE PORTFOLIO IN THIS YEAR'S CANON PHOTO ESSAYIST COMPETITION. EUGENE IS A FREELANCE PHOTOGRAPHER BASED IN NEW YORK AND HAS WON THIS AWARD TWICE BEFORE. THIS 14-PAGE CHAPTER DISPLAYS A SELECTION FROM HIS 40-PICTURE CANON PORTFOLIO. HE IS ALSO THIS YEAR'S MAGAZINE PHOTOGRAPHER OF THE YEAR. SELECTIONS FROM THAT PORTFOLIO ARE DISPLAYED BEGINNONG ON **PAGE 30.** EUGENE HAS NOW WON BOTH THESE AWARDS THREE SEPARATE TIMES.

Ten hours drive east of Niamey, Niger's capital, south of crowded, garbage-strewn Maradi, then out across the drought-stricken stretches of flatlands where temperatures exceed 120 degrees F., lies Safo.

In most ways a traditional village, in a nation not now wracked by war, Safo is home to 3,500 people of the Hausa tribe. The village of low-walled compounds and narrow streets is a daily life-and-death struggle with the forces of nature. Broiling heat, drying winds, dropping water tables; with diseases that go untreated. Tuberculosis, polio, AIDS; with the man-made crisis of water pollution; and with hunger.

Those that live in Safo love to work (people with steady work are honored citizens). They freely express their love for children (the infant mortality rate in Niger is among the world's highest). They love food, and have developed myriad ways to flavor the millet they eat three times a day. They are a people struggling to stay in their age-old homes, determined to hang onto tradition and to life itself. ■

Left ■ Measles, malaria, polio, tuberculosis, malnutrition – conditions preventable elsewhere – plague residents. Here, a one-legged beggar makes the rounds of the village compounds.

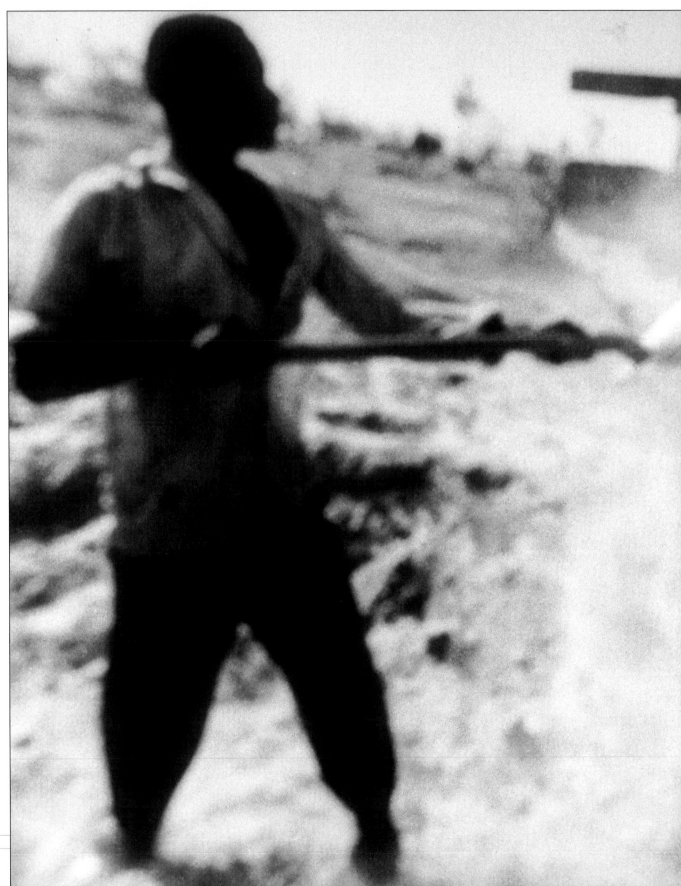

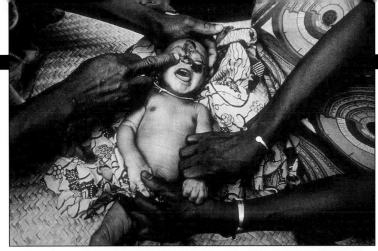

Left ■ At a naming ceremony, a newborn baby girl gets ritual scars on her face. Multiple incisions are made on her arms, legs and torso to get rid of the bad blood her mother gave her during delivery. Ashes are rubbed into the facial wounds to deepen the scars.

Left ■ This hard-working member of the Hausa tribe received his distinctive facial scars not long after birth.

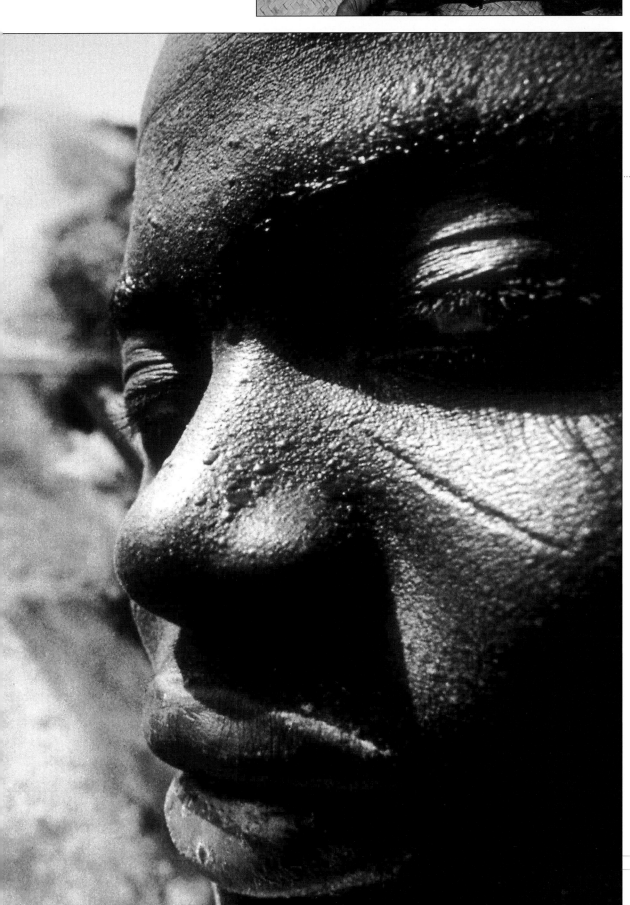

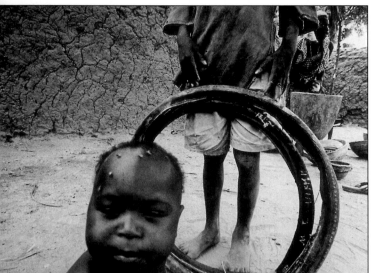

Above ■ As in any impoverished community, toys are makeshift and valued. Cars are fashioned from coat hangers, and abandoned bicycle tires are rolled through the desert.

Right ■ Though the body of this doll has rotted away, its one eye gives it a ghostly appearance. It remains a favorite toy, to be daubed with paint and hung from the bushes when not used as a ball.

Below ■ Children here are generally unaware of their own poverty and play as other children play. A soccer ball, made from bound rags, comes apart during an enthusiastic game.

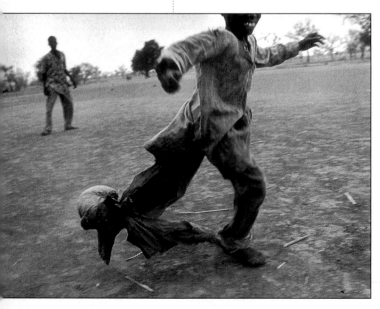

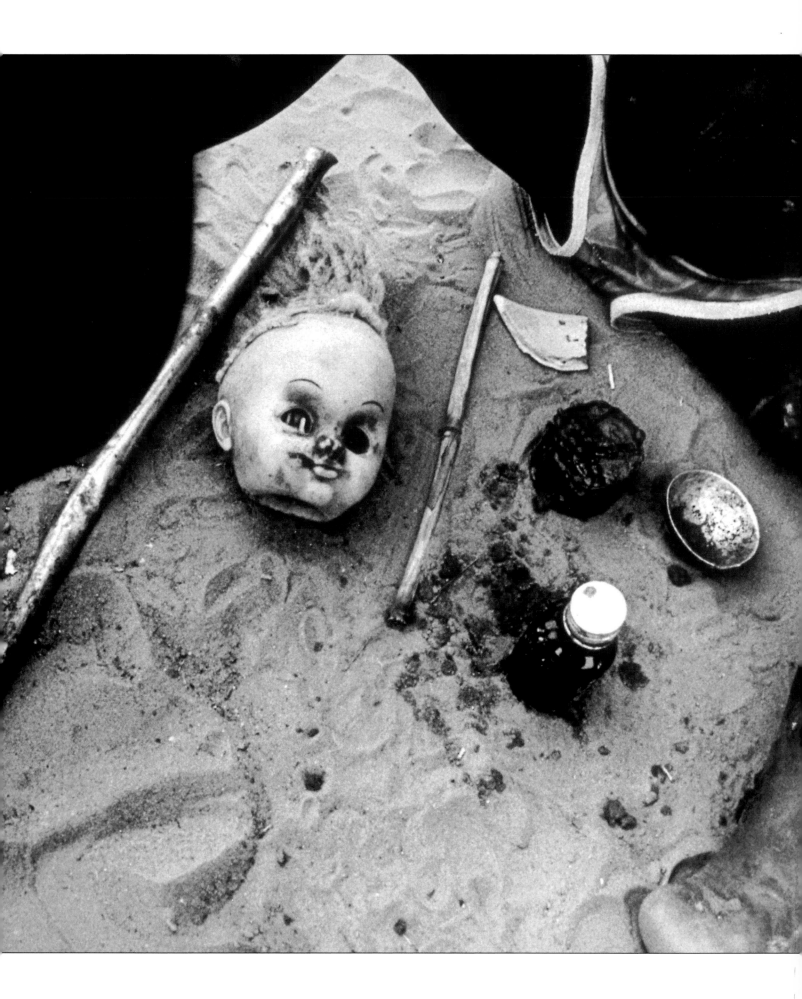

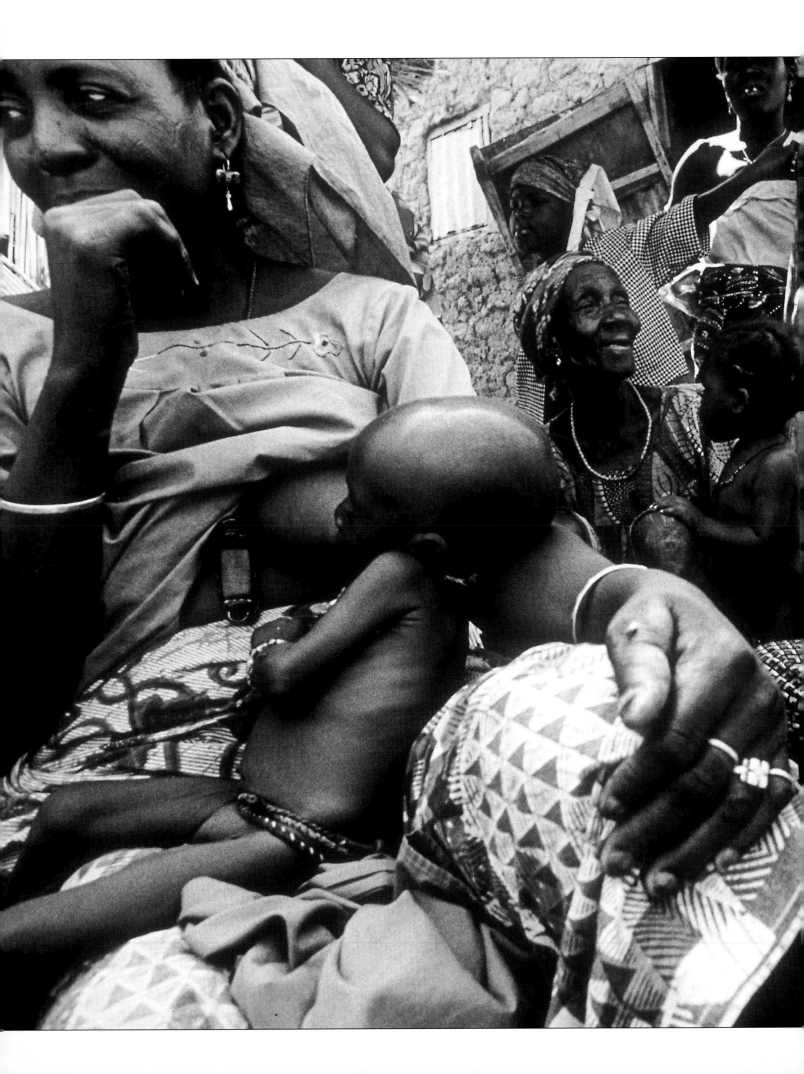

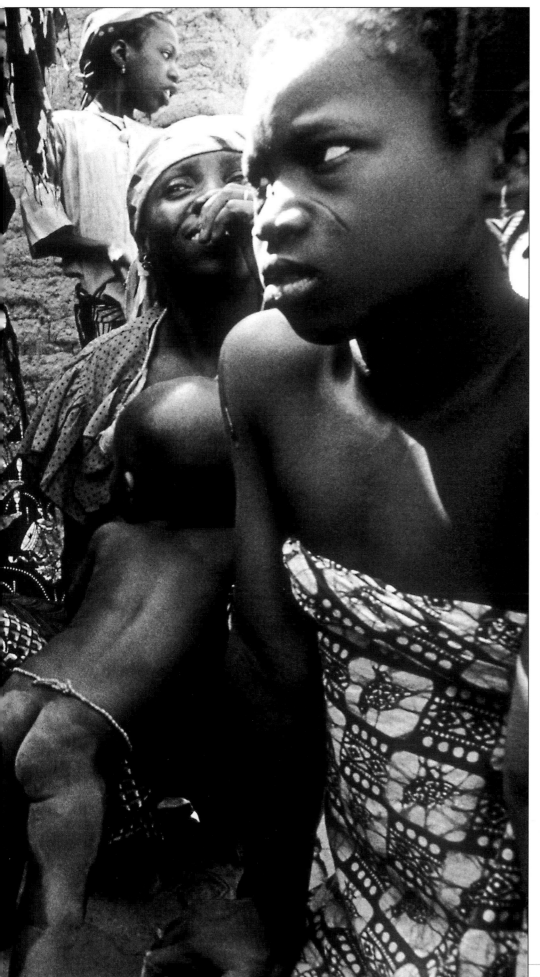

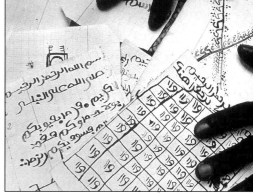

Above ■ The hands and health prescriptions, in Arabic, of a spiritual healer. Some prescriptions are written out on a wooden prayer board, then washed into a cup of water, which the patient drinks.

Left ■ Mornings in the compound become a community gathering for the young and very old to mingle and learn from one another.

Below ■ Villagers gather to watch a medicine man, a malam, make medicine and treat patients.

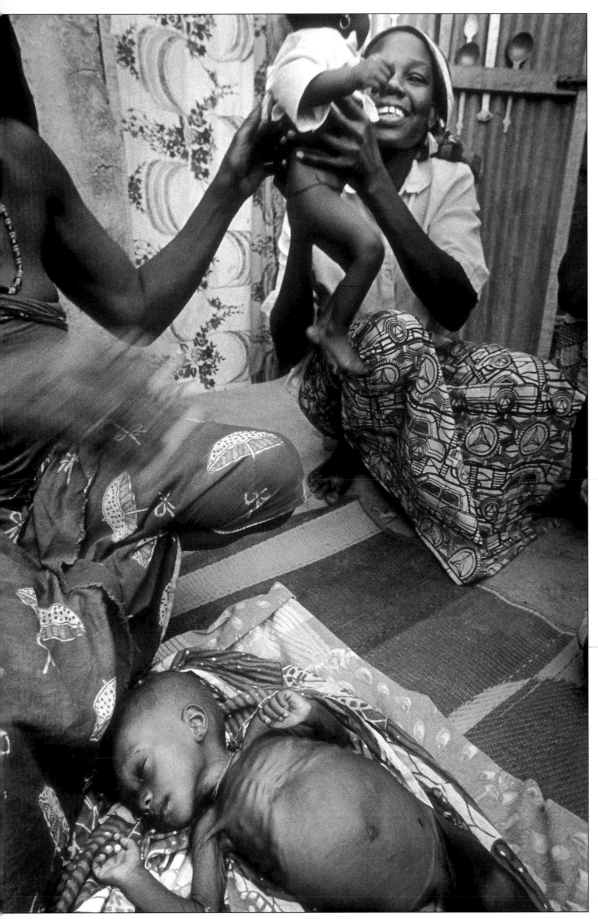

Left ■ In a world where chronic malnutrition and high infant mortality are the norm, a chubby baby is a joy. Here, the mother of a child close to perishing finds solace by playing with a healthy child.

Below ■ Issafou Adamou suffers from tuberculosis. He is in isolation, away from his house and his neighbors.

Right ■ Another village curer, the bone setter, removes a handmade splint from a child's broken leg. The crippling that still often results from such treatment is not nearly as severe as what happens if there is no treatment.

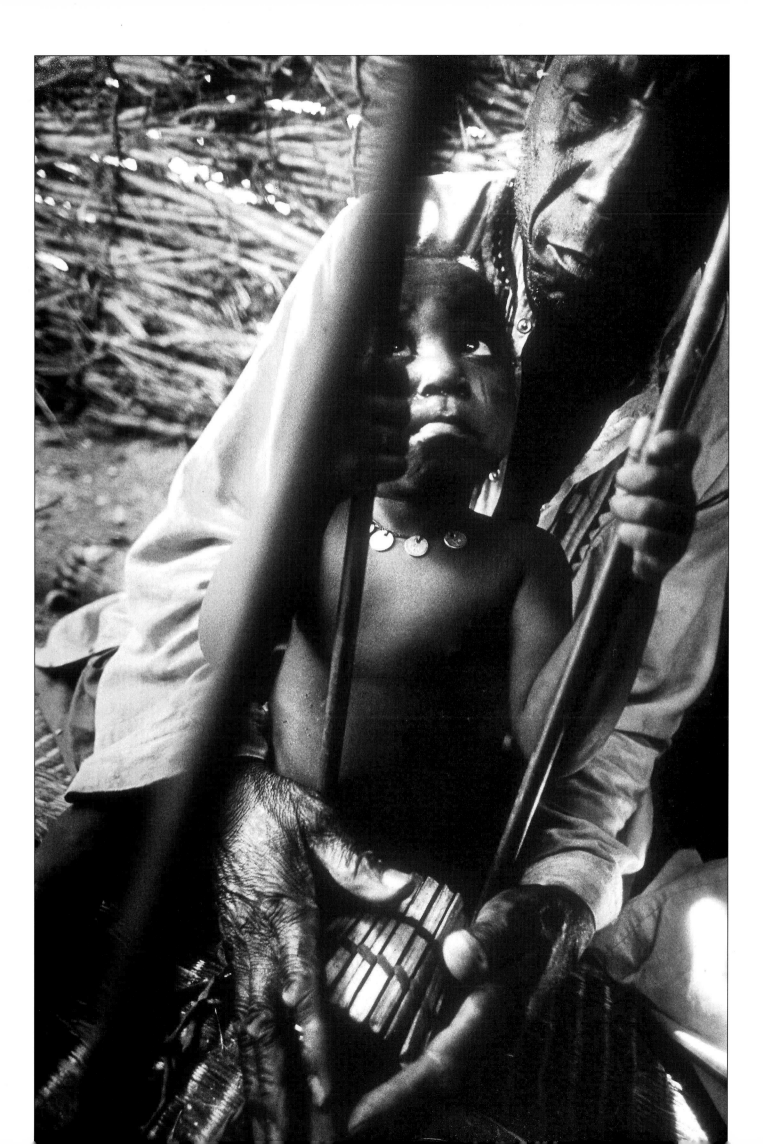

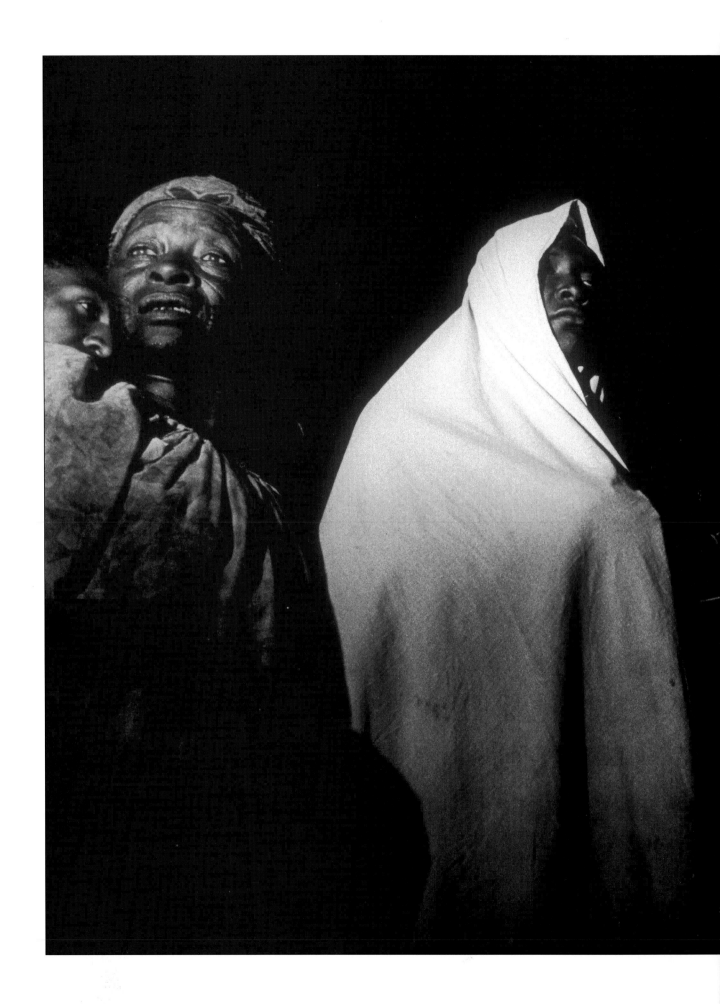

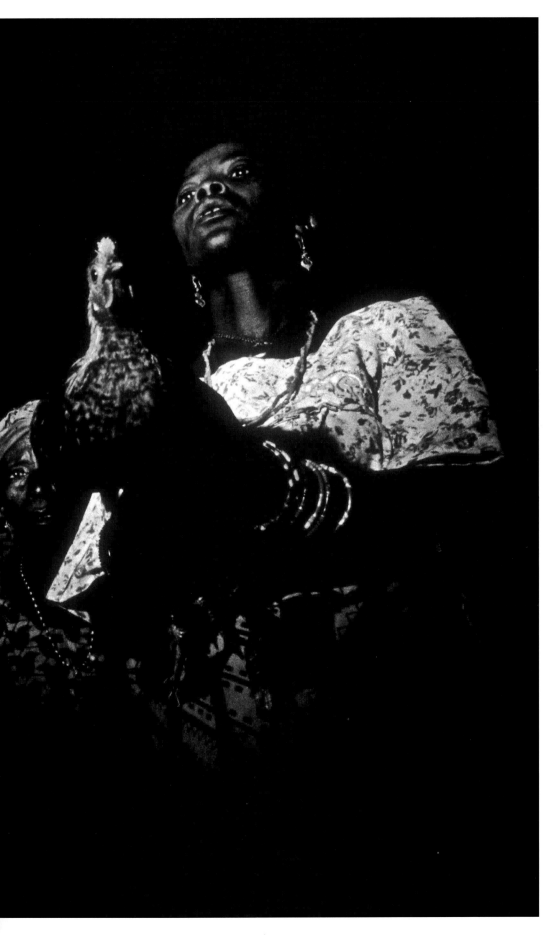

Below ■ Confronting Hassan, a medicine man, the mediums emerge from a trance-like state and make offerings of food. These gatherings of villagers are akin to a Western church service, as they provide refuge and solace at difficult times.

Left ■ Conservative Islam continues to advance in Niger, but indigenous religious practices survive. At a ceremony in darkness, a young man emerges in a trance as a bori, after seven hours of prayer.

Below ■ Begging is some families' way of survival. An aging grandmother leads her blind daughter, age 22, who in turn, leads her four-year-old son. Bratty little girls taunt the boy to come play with them.

Above ■ A young boy passes a poster of Niger's President, Colonel Ibrahim Bare Mainassara, who lead a coup d'etat in January of 1996.

Right ■ Old Hassan has been guardian of an ancient baobab tree for more than 20 years, as his father and grandfather before him. Villagers come to pray to the spirits that dwell in the tree for food and relief from the drought.

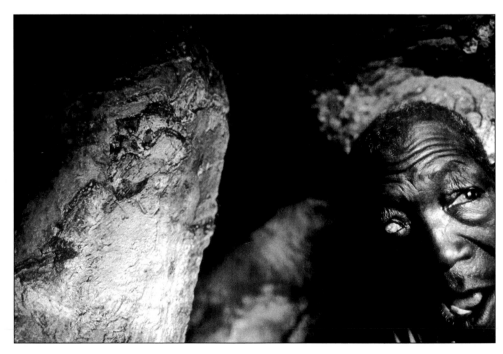

Right ■ Chamsia, a 10-month-old, in the arms of her 15-year-old mother, is now close to death from a disease that has all the appearances of AIDS.

THIS PHOTO ALSO WON AN AWARD OF EXCELLENCE IN THE MAGAZINE GLOBAL NEWS CATEGORY. THE CHAPTER DEVOTED TO NEWS PICTURES BEGINS ON **PAGE 116.**

Below ■ The Hausa are buried in a graveyard, out past the sacred baobab tree, beneath a stone and twigs. Soon the mound of earth will be worn down and blown away by the wind.

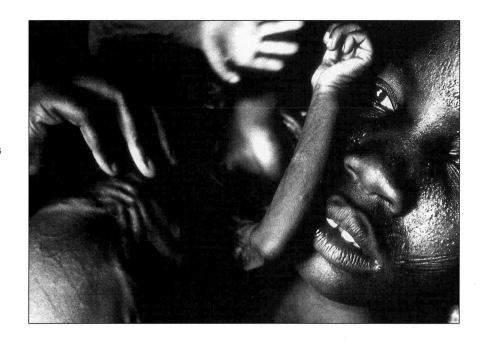

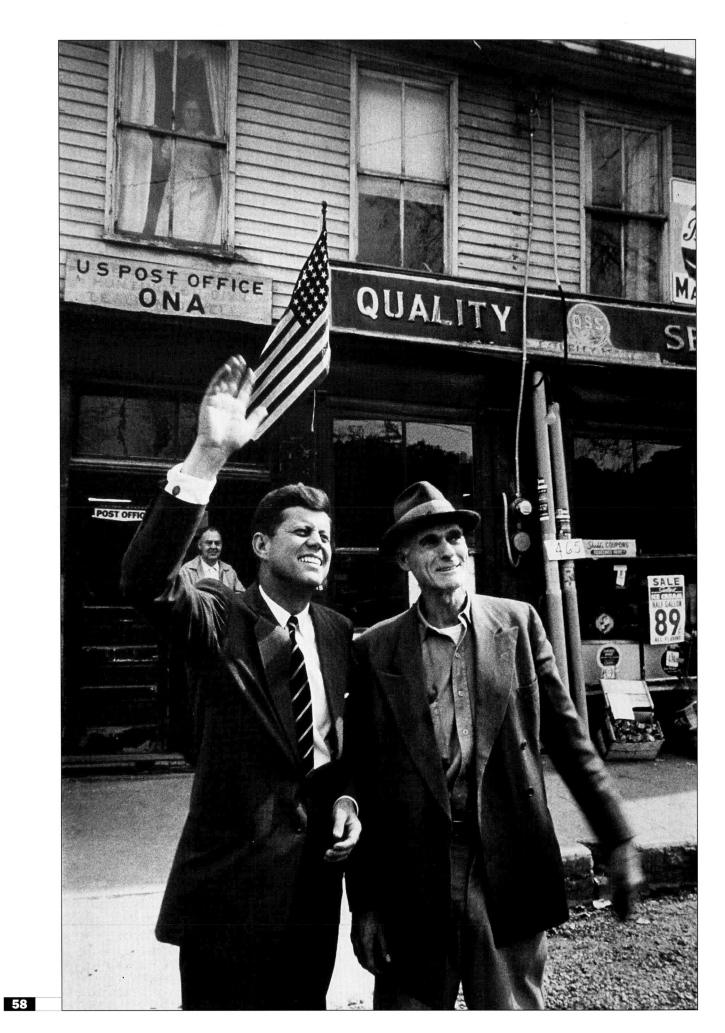

THE KODAK CRYSTAL EAGLE AWARD FOR IMPACT IN PHOTOJOURNALISM

Camelot and the Kennedy mystique

FORMER NPPA PRESIDENT BILL LUSTER, NOW THE PICTURE EDITOR OF THE (LOUISVILLE) COURIER-JOURNAL, SENT THE FOLLOWING LETTER IN NOMINATION OF JACQUES LOWE FOR THE KODAK CRYSTAL EAGLE AWARD FOR IMPACT IN PHOTOJOURNALISM. THIS YEAR'S POY JUDGES SELECTED LOWE'S WORK AS THE WINNER OF THE 1997 AWARD.

I am honored to nominate the work of Jacques Lowe for the Kodak Crystal Eagle Award for Impact in Photojournalism.

In 1957, Mr. Lowe began photographing a family that made an indelible mark on the history of this country. After the devastating Democratic Party defeat in the 1956 presidential election, every magazine in the country became interested in Robert F. Kennedy, a dynamic new chief counsel of the Senate Select Committee on Improper Activity in Labor and Management. Jacques Lowe was a freelance photographer based in New York, and received assignments from a variety of magazines to photograph Mr. Kennedy. Mr. Kennedy became particularly fond of Mr. Lowe's photographs of his entire family for a publication called *"The Sign."* Later, after a dinner invitation to the Kennedy home in McLean, Virginia, he received a midnight call from the patriarch of the family, Joseph Kennedy.

Mr. Kennedy's call to Mr. Lowe resulted in the photographer making pictures of the entire Kennedy family, and led to his friendship with the young Senator from Massachusetts, John F. Kennedy.

Over the next three years, Mr. Lowe spent nearly his entire life with the young dynamic Senator and his wife Jacqueline during the presidential primaries. He spent time at family homes in Hyannis Port; through lonely vigils at Midwestern airports; to the coal field of West Virginia; and in hotel rooms, television studios, and the frenzy of the political conventions. Ultimately, it resulted in trips to the White House, after Kennedy defeated Richard M. Nixon for the presidency.

Mr. Lowe's photographs are unique in American history. These are some

CONTINUED, NEXT PAGE

Left ■ Senator Kennedy on a campaign stop in Ona, West Virginia, a village of five houses, and a population of 12. **Spring, 1960.**

ALL PHOTOGRAPHS, PAGES 58-73
COPYRIGHT © 1998, JACQUES LOWE

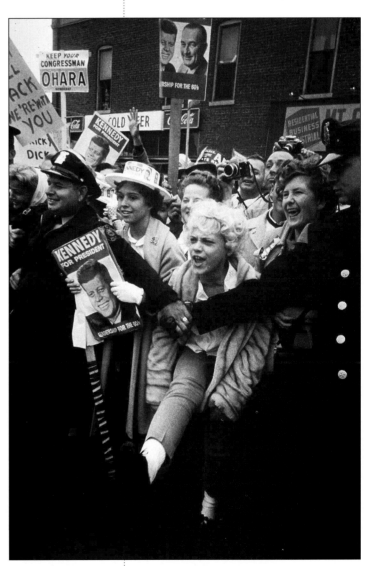

Above ■ The crowds have increased. Here, a boisterous female supporter shouts out her enthusiasm. **Fall, 1960.**

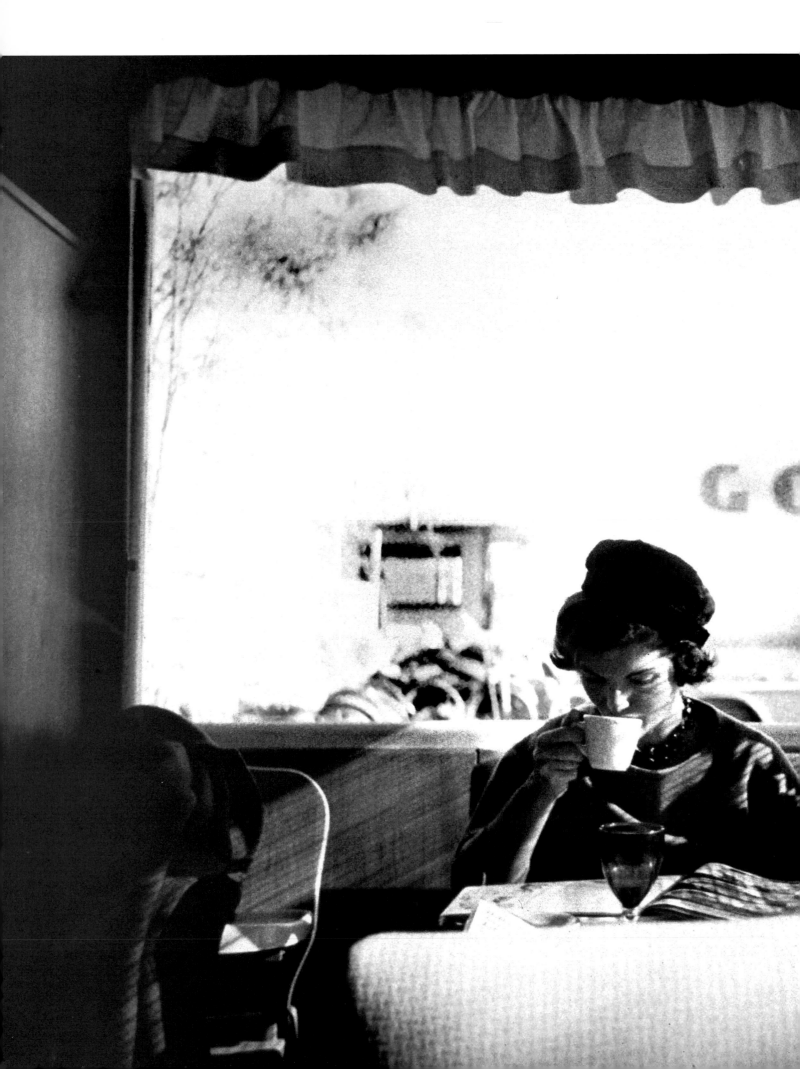

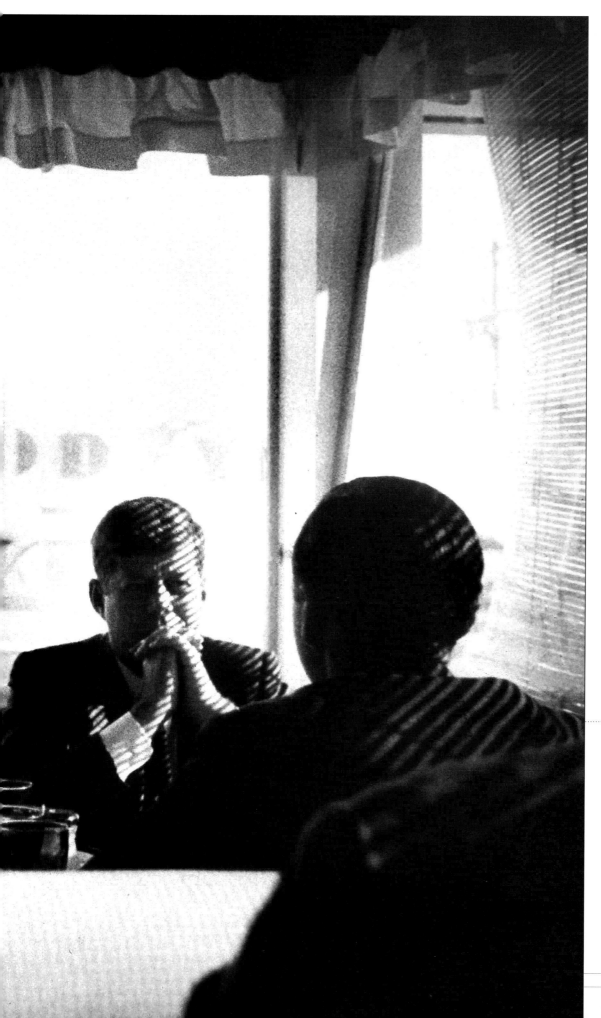

■ CONTINUED FROM PREVIOUS PAGE

of the first photographs of the political land-scape captured in the the modern day style of documentary photo-journalism. Mr. Lowe gained incredible access to the Kennedy family and political machine. His photographs show Kennedy in the begin-ning of his campaign, when only four individ-uals showed up at a Portland, Oregon airport tarmac; Kennedy atop a bulldozer in the coal fields of West Virginia; and only three individ-uals were in the room when Kennedy offered the vice-presidency to Lyndon B. Johnson. One was Mr. Lowe; and Lowe was there in Hyannis Port, photo-graphing the family as the votes were tallied for the presidency.

Washington awoke on Inauguration Day 1961 to a major snowstorm. Mr. Lowe continued his documentation as the New Frontier took on a world torn by the

CONTINUED, NEXT PAGE

Left ■ Early in his cam-paign, it was hard for Kennedy to find anyone willing to listen to his mes-sage "to get the country going again." Here, on a Sunday morning after Mass, at a local coffee shop JFK, Jackie and brother-in-law Steve Smith sit ignored by the locals having breakfast. **Fall, 1960.**

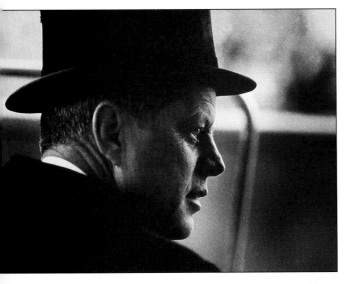

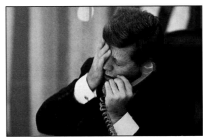

Clockwise, from left ■ Sporting his silk hat throughout the Inaugural Parade; reacting to news of an African assass- ination in February, 1961; rocking in his Senate office in the summer of 1959; the morning paper reports his party's nomina- tion in July of 1960; addressing that same convention in Los Angeles and smoking a favorite stogie on a campaign flight.

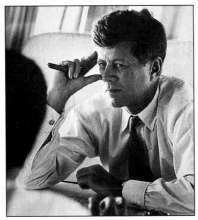

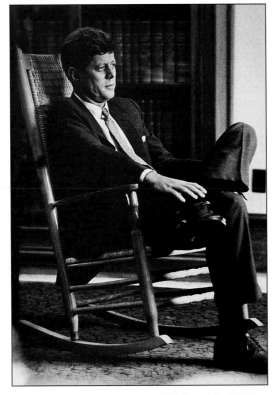

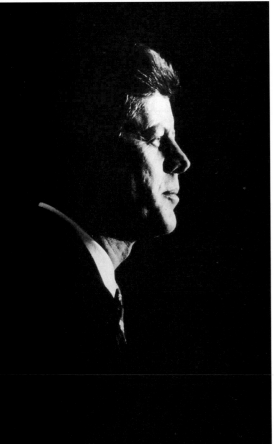

■ CONTINUED FROM PREVIOUS PAGE

continuing Cold War and unrest at home. His work continued until the President went to Dallas in 1963.

Lowe's natural, warm and intimate images helped shape the legacy of Camelot, and his photographs have become visual icons of a very special time in the memory of the nation. Mr. Lowe's work continues to be published in a variety of publications and he has published five books about the Kennedy family. He has contributed to seventeen other books about Kennedy. By his estimates, he shot over 40,000 pictures of Kennedy. His work has also appeared in 250 articles and magazine covers...

On a more personal note, his photographs found their way into the hands of a young photo- grapher growing up in Glasgow, Kentucky. I would spend hours looking at Mr. Lowe's photo- graphs of the Kennedys, studying the composition and the content. The photographs... inspired me at a very young age to seek photographs that possessed those qualities exhibited in the work of Mr. Lowe. Later on, after I joined the staff of The Courier-Journal, I began a process of documenting politicians in my state, hoping that my photographs would one day be historical documents that would be valued. His first book on JFK, entitled *"Portrait: The Emergence of John F. Kennedy"* is a very valued possession in my home.

His work and his commitment to history deserve the Kodak Crystal Eagle Award for Impact in photojournalism and I am proud to nominate him for that award. ■

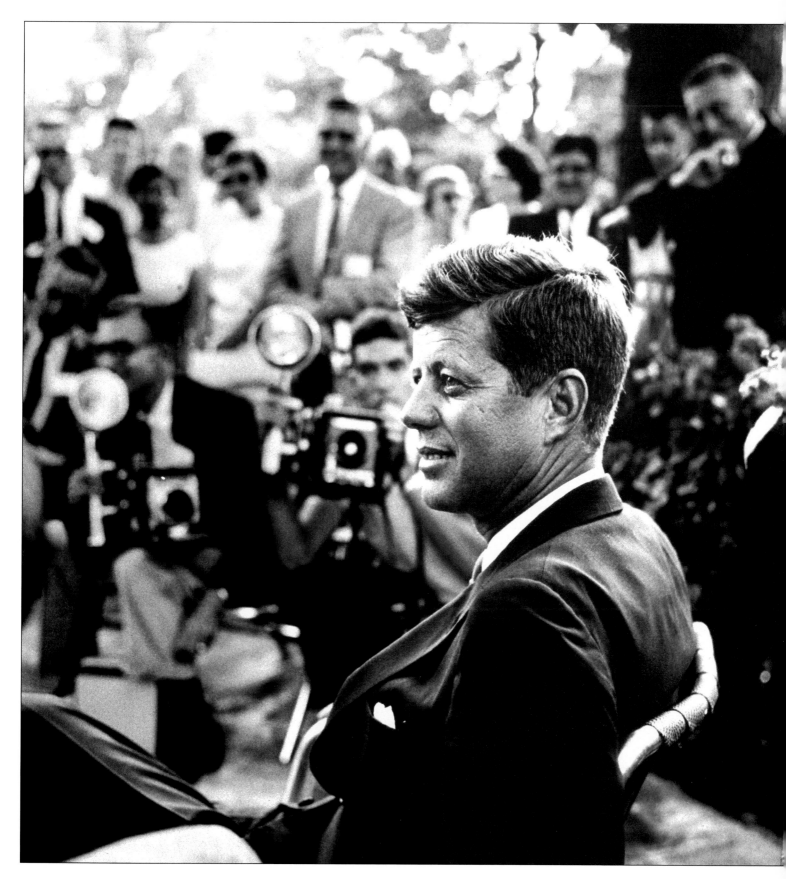

Above ■ Senator Kennedy is interviewed by the press
at a political fundraiser in Omaha, Nebraska. **Fall, 1959.**

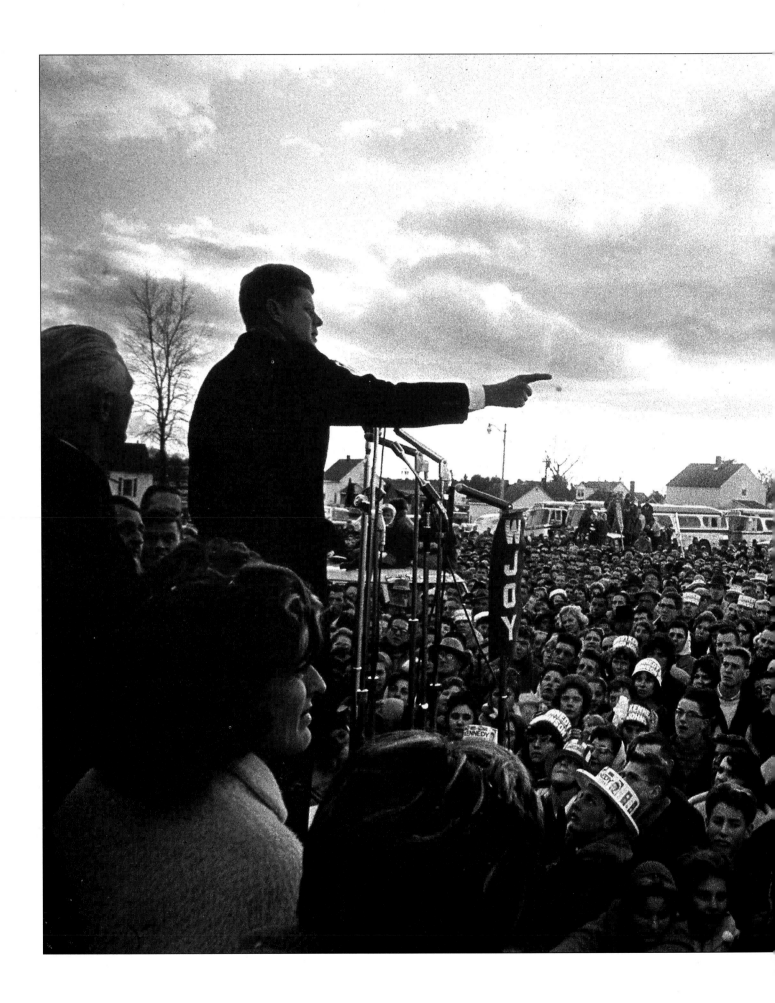

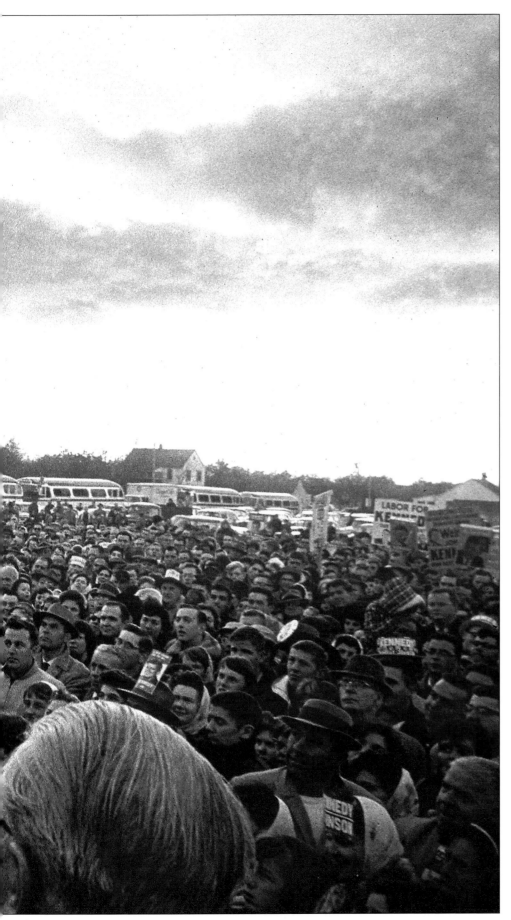

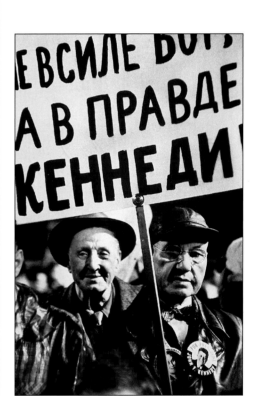

Left ■ A more and more successful candidate points his finger over a huge crowd. **Fall, 1960.**

Above ■ A group of admirers of Russian dissidents hold a placard spelling out "Kennedy" in the Cyrillic language. **Fall, 1960.**

Right ■
A giggling
Jackie in a
rare moment
of total
relaxation at
Nantucket
Sound.
Summer, 1960.

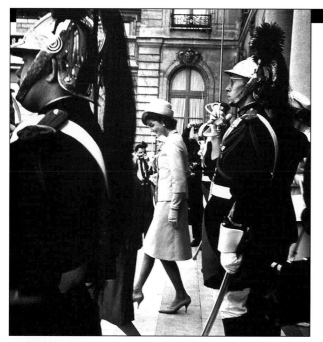

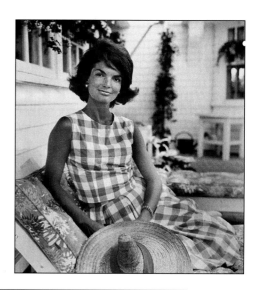

Left ■ The First Lady descends the stairs of the Elysee Palace, home of the French President, General Charles de Gaulle. **July, 1961.**

Right ■ Jacqueline Kennedy in yellow dress with straw hat. Hyannisport. **Summer, 1960.**

Below ■ Caroline Kennedy trying to eat her mother's pearls. Hyannisport. **Summer, 1958.**

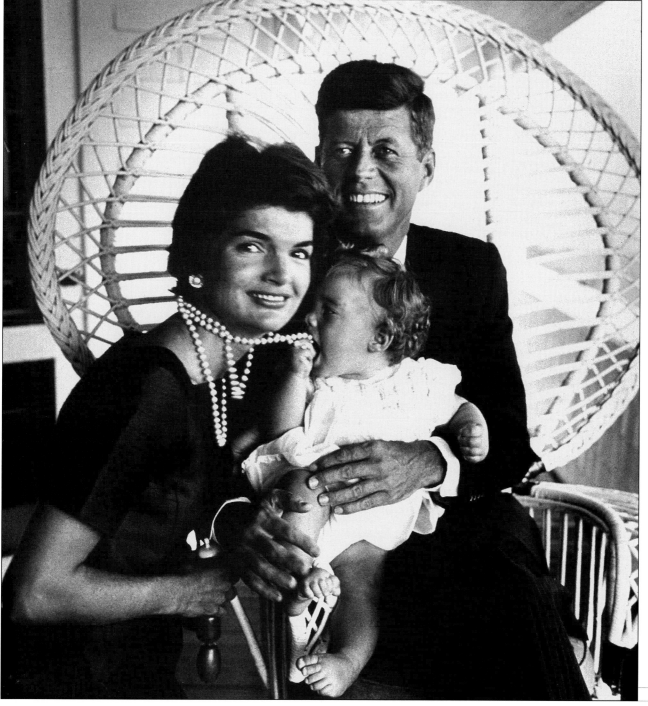

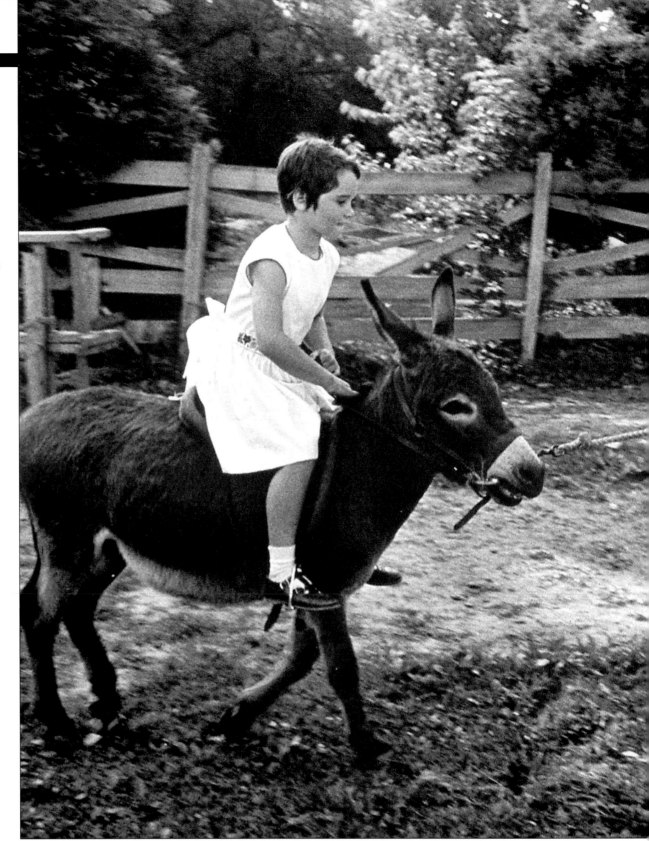

Right ■ Bobby Kennedy pulling his oldest daughter, Kathleen, on a donkey. Hickory Hill, Virginia. **Summer, 1957.**

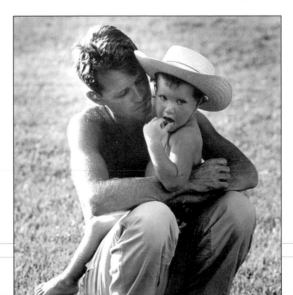

Left ■ Bobby with his favorite son David at Hickory Hill, Virginia. **Summer, 1957.**

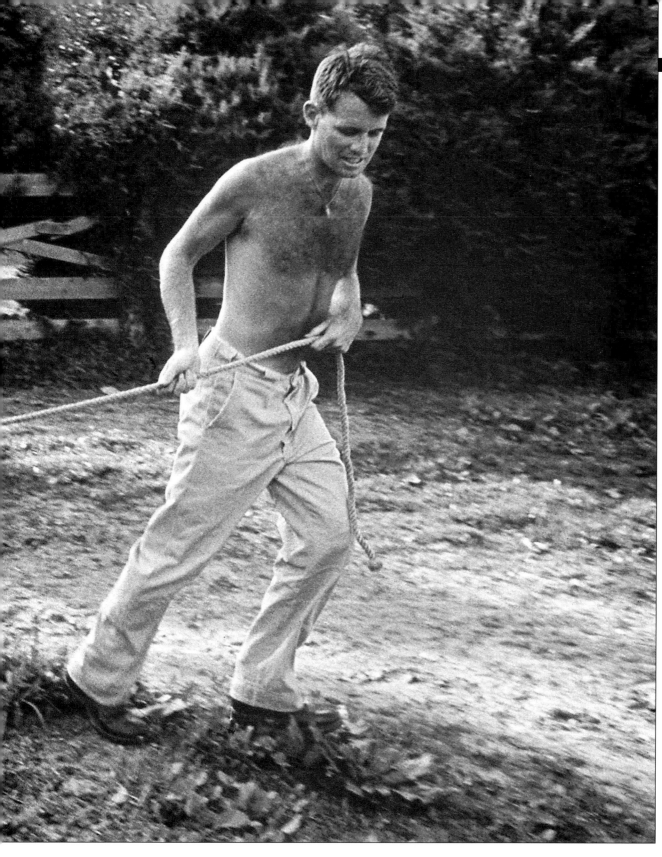

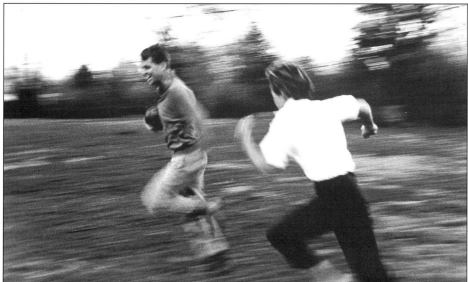

Left ■ Ethel Kennedy chasing Bobby during a football game at Hickory Hill, Virginia. **Fall, 1961.**

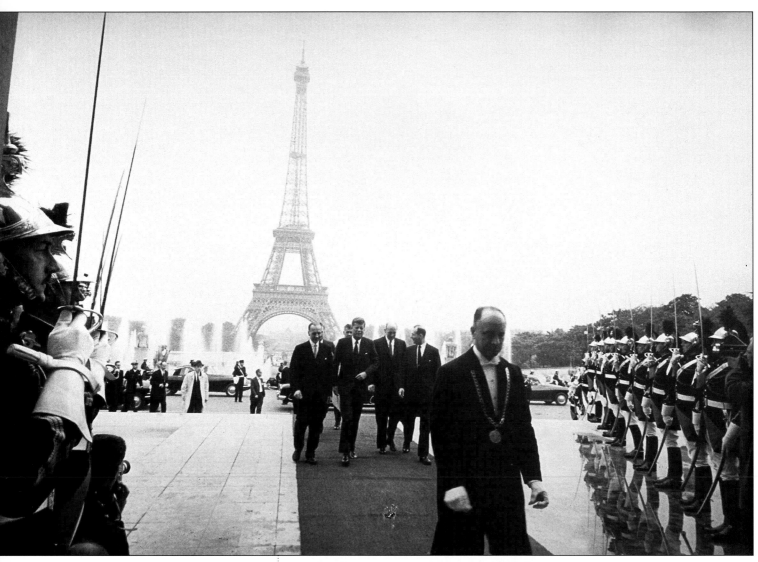

JACQUES LOWE WAS THE PERSONAL PHOTOGRAPHER OF JOHN F. KENNEDY IN HIS QUEST FOR THE PRESIDENCY AND, LATER, DURING THE WHITE HOUSE YEARS. LOWE HAS PUBLISHED 28 PREVIOUS NONFICTION BOOKS RANGING FROM "CELEBRATION AT PERSEPOLIS" TO A DOCUMENTARY ON POPE JOHN PAUL II'S VISIT TO THE DOMINICAN REPUBLIC. AFTER EIGHTEEN YEARS IN EUROPE, LOWE NOW LIVES IN MANHATTAN.

Category definition

THE KODAK CRYSTAL EAGLE AWARD FOR IMPACT IN PHOTOJOURNALISM IS GIVEN TO A PHOTOJOURNALIST WHOSE WORK HAS HAD AN ACKNOWLEDGED IMPACT ON SOCIETY. THE AWARD SHALL RECOGNIZE ONE WHO, BY PHOTOGRAHICALLY EXPLORING AND REPORTING A SUBJECT OF SIGNIFICANT SOCIAL CONCERN, HAS CHANGED THE WAY PEOPLE LIVE OR THE THINGS THEY BELIEVE.

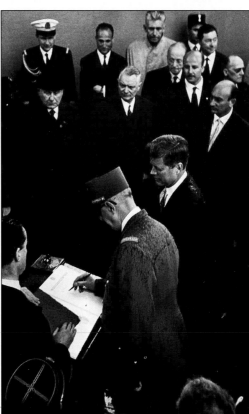

Above ■ President Kennedy on his visit to Paris, entering the North Atlantic Treaty Organization building for his famous NATO address. **July, 1961.**

Left ■ President Kennedy and General Charles DeGaulle sign the Paris city register at the eternal flame of the Arc de Triomphe. **July, 1961.**

Right ■ Senator Kennedy on a tractor during the West Virginia primary addresses a group of school children. Only three adults of voting age were in this crowd. **1960.**

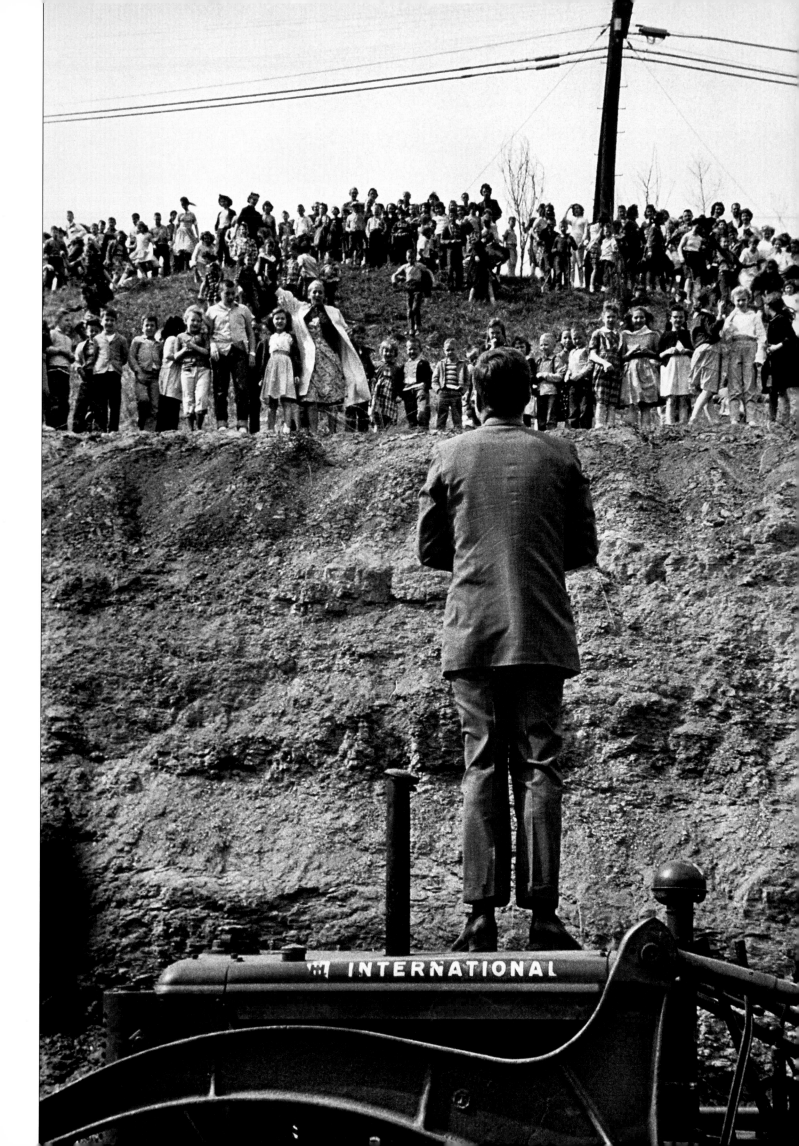

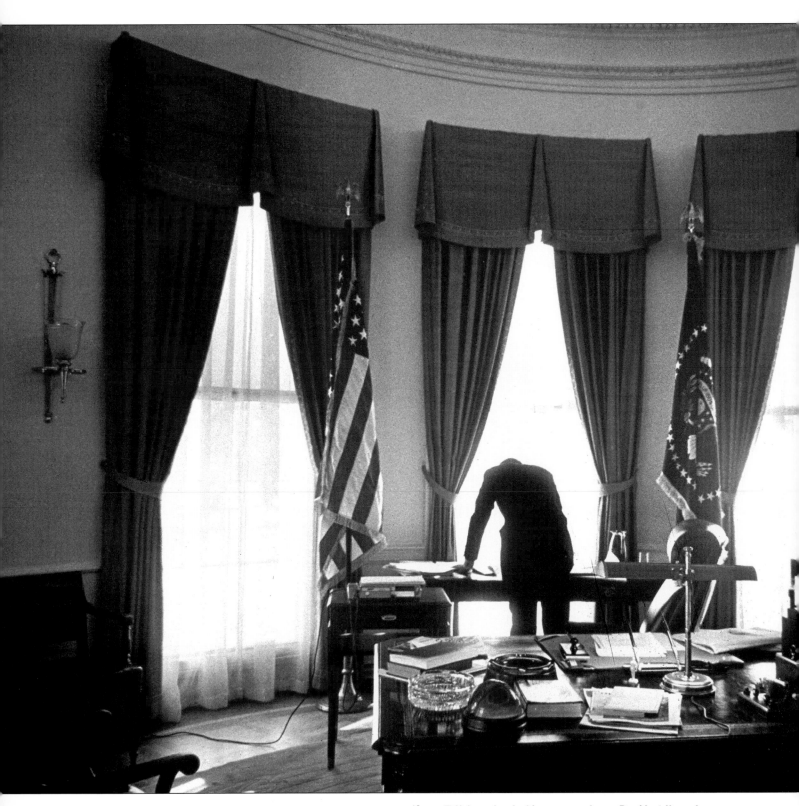

Above ■ Unless absorbed in correspondence, President Kennedy rarely sat at his desk. He would roam, glance at television, scan the newspapers, look in on Evelyn Lincoln, his secretary. Here he leans over the tabletop behind his Oval Office desk where stacks of newspapers, magazines and documents were kept. By leaning on the table this way, he often got relief from his constant back pain.

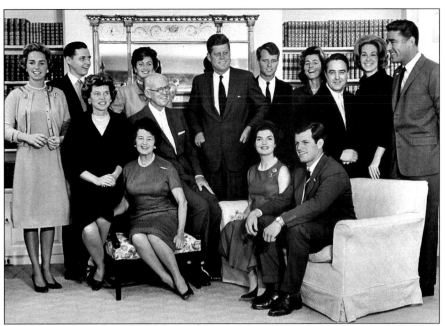

Above ■ Following his presidential victory, the entire Kennedy family sits for the photographer in the library of Joseph P. Kennedy's house in Hyannisport, Massachusetts. **November, 1960.**

Below ■ Presidential nominee JFK offers the vice-presidency to Lyndon Baines Johnson. An angry Bobby Kennedy, who opposed the choice, joined his brother and LBJ at the Biltmore Hotel in Los Angeles. **Fall, 1960.**

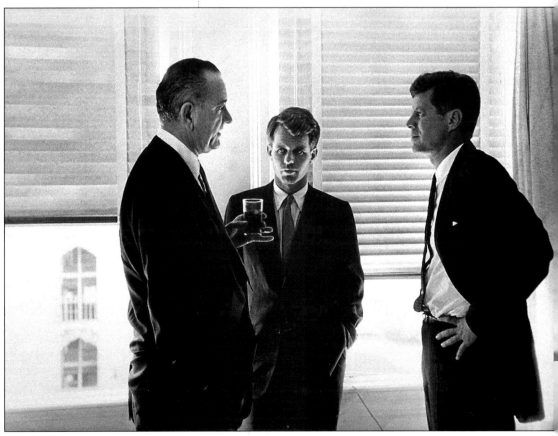

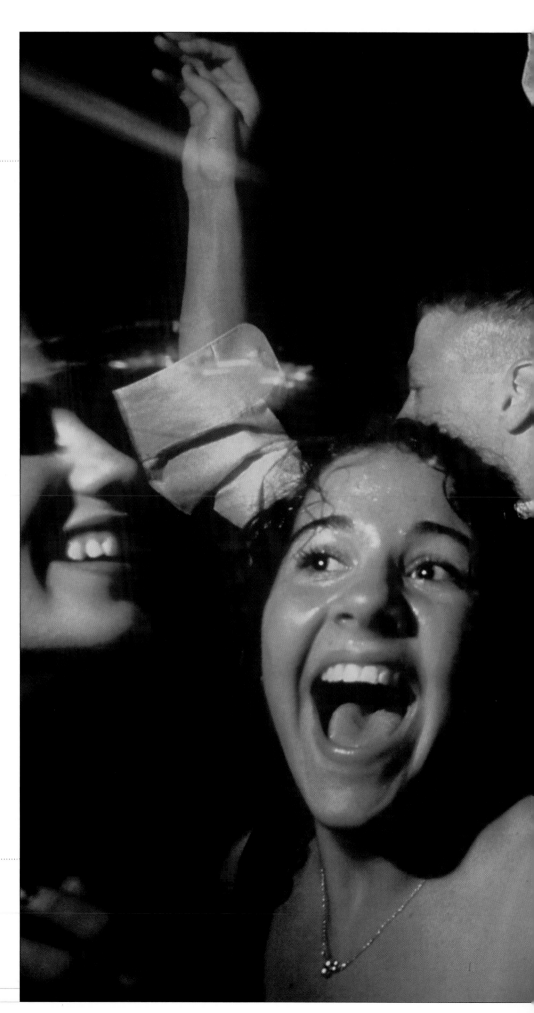

AURORA, ILLINOIS 60504

Kids, Cul-de-sacs and the New American Dream

THIS ESSAY ACCOMPANIED **SCOTT LEWIS'S** FIRST PLACE PORTFOLIO IN THIS YEAR'S COMMUNITY AWARENESS COMPETITION. SCOTT IS THE STAFF PHOTOGRAPHER FOR FOX VALLEY VILLAGES/60504 IN THE CHICAGO SUBURBS.

The far eastern neighborhoods of Aurora, Illinois are a place where children grow up with an abundance of educational, extracurricular and athletic opportunities. Claritas Inc., one of the leading marketing firms in the nation, confirms this area of Aurora – with its 12,000 households – is, indeed, made up of occupants with similar interests and lifestyles. While the other two-thirds of Aurora, the third largest city in the state with a population of 115,000, is 63 percent white, these newer neighborhoods are an overwhelming 85 percent white. With a median household income of $58,928, a median home value of $143,000, and a low crime rate this area has been called one of Chicago's fastest-growing young communities.

CONTINUED, NEXT PAGE

Right ■ For $65 a couple, 425 couples attended Waubonsie Valley High School's yearly ritual at the Radisson Hotel.

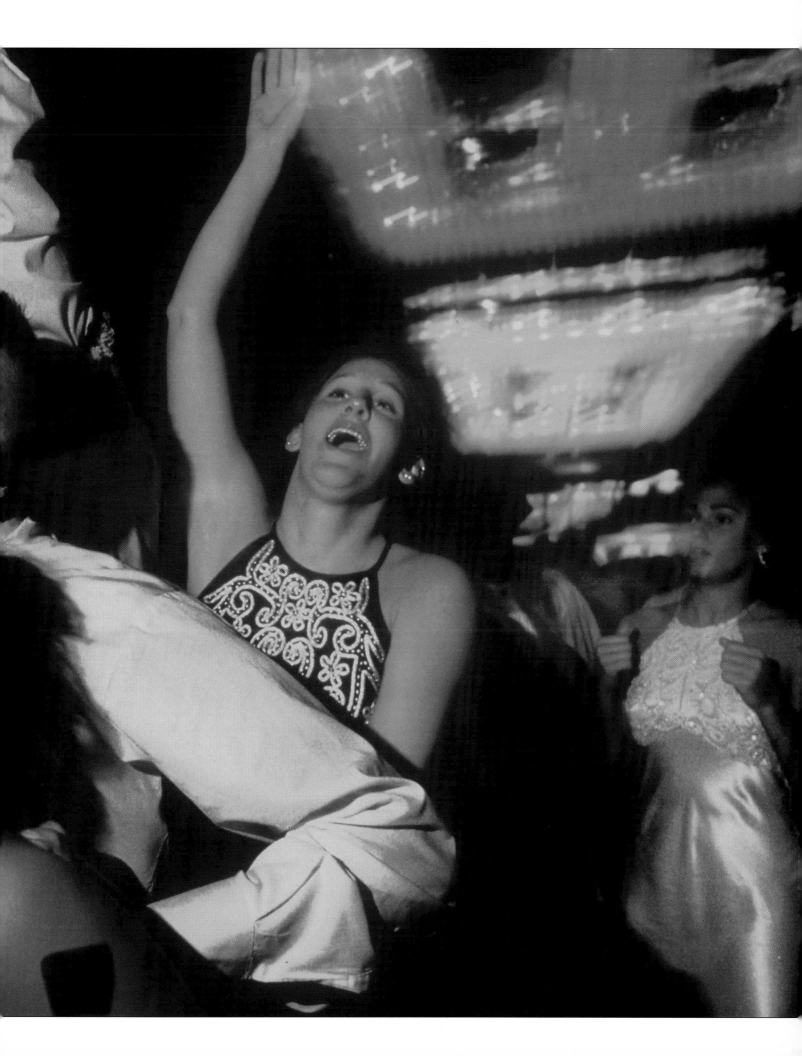

■ CONTINUED FROM PREVIOUS PAGE

The exodus from Chicago to this far west suburb began slowly in the early '70's and has picked up speed in the last few years. Word has spread about the excellent schools and good home values that can be found in the area. What was once miles of soybean, corn and wheat fields is now a community that draws young couples from other parts of metropolitan Chicago as well as from out of state.

Above ■ St. Francis French teacher, Sue Koenitz, uses sophomore Aimee Brouketa in a lesson on phrases. Koenitz is in the majority of lay instructors within the Catholic education system. Schools rarely have more than a few religious figures today.

Right ■ John Nelson warms up before the WVHS orchestra's final concert of the year. The school has three orchestras that perform four evening concerts a year.

This past year was a year of celebrations, aspirations and lamentations. 1997 contained truly the best and worst that life can offer. Babies were born in high numbers. Two thousand commuters rode the train every day into Chicago for work while their families flourished in this '90's version of the American dream. Juniors and seniors at Waubonsie Valley High School completed their last teenage rite of passage as they squeezed into rented tuxes and sequined gowns to attend the prom in high style. With more than 3,000 parishioners, Our Lady of Mercy Catholic Church finally established a permanent home when nine years of planning and praying, and one year of construction closed the chapter of the congregation having to worship at the high school.

What should have been time for a homecoming celebration of a team with several stars instead

CONTINUED, NEXT PAGE

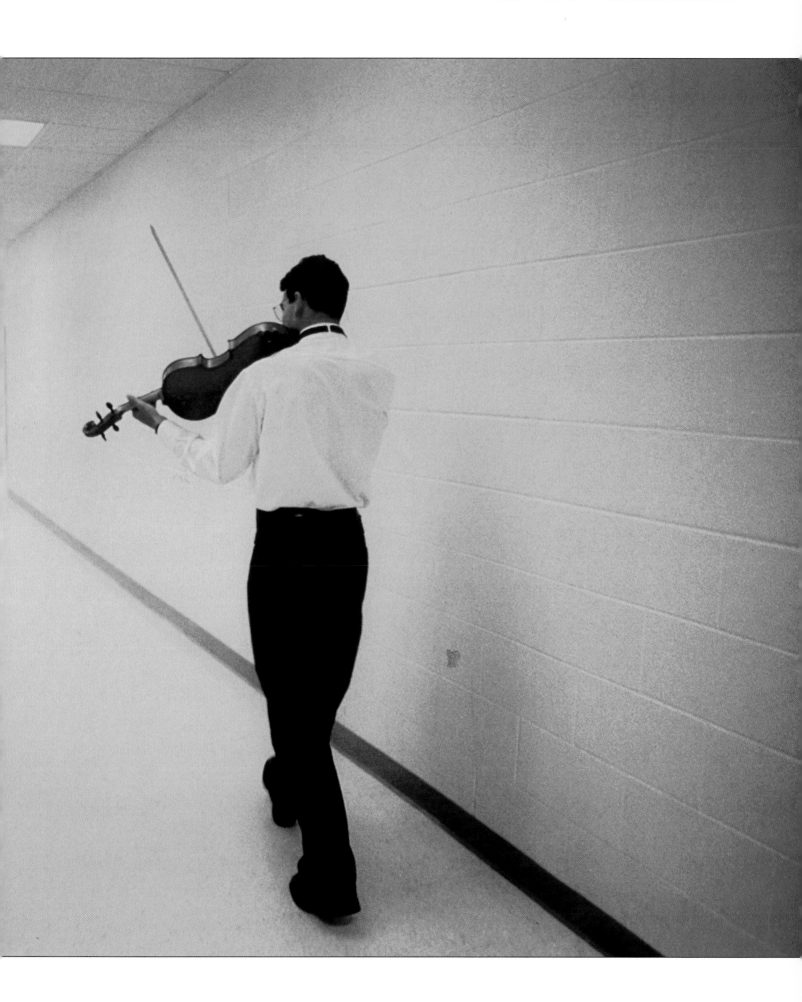

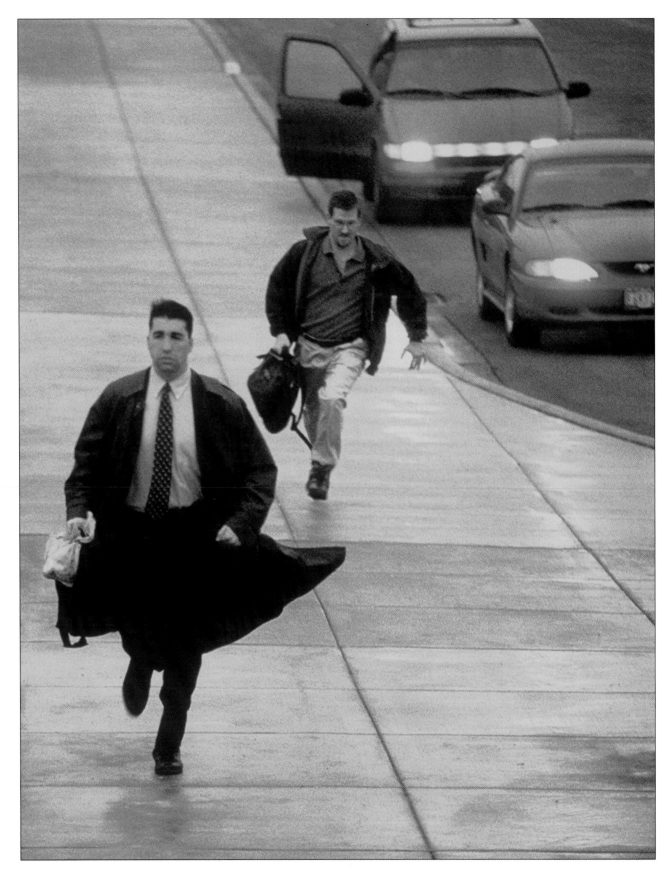

Above ■ Seconds can make the difference between making it to work on time or not.
Once the doors begin to close on the trains there's no giving anyone a break for fear of someone
getting hurt in attempting to get onto the train as it begins to pull away from the station.

■ CONTINUED FROM PREVIOUS PAGE

became a time of mourning. Three friends, juniors at the high school, were out playing pre-homecoming pranks when a drunken driver slammed into their car. The crash killed all three girls as well as a widowed mother of three riding in the other car.

As the community continues to form, their shared celebrations and tragedies combine to become 60504's history. Their focus is on their families, their jobs, their community. "There is a strong sense of values here, of community," said Lorraine Maes, who served for eight years as treasurer of the Lakewood Neighborhood Association. "It is just a wonderful place to live." ■

...

Above right ■ "The nice thing about Chicago is that the commuting is easier," Linda Puccio, a former New Jersey resident says. "The trains are on time and they have a lot of expresses." The express trains that leave the Route 59 station stop only once in Naperville before getting to downtown Chicago in an hour's time.

Middle right ■ "She double commutes," Jamie White says of his friend, neighbor and fellow commuter, Kathy Delehanty. "She telecommutes while commuting." Delehanty works for a management consulting firm in Chicago and talks to business associates as close as Chicago and as far away as London during her commute. "Look at how productive I can be. With all this fellowship and productivity, why would I drive?"

Below right ■ Rich and Pam Heller catch some shut-eye while going home after a full day's work and a few hours of school. Starting their day at 5:30am, the Hellers go to school three nights a week and arrive back in Naperville around 9:30pm.

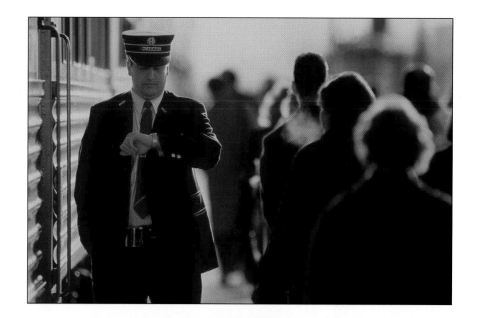

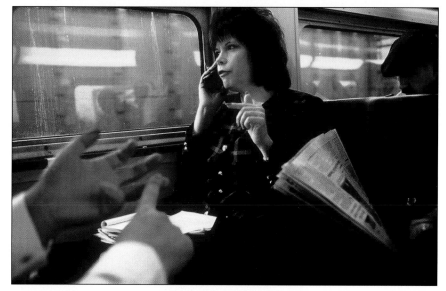

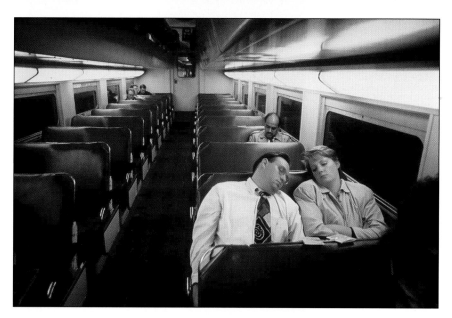

Right ■ While scavenging through free Tupperware items after a Tupperware party, Eva Dumele tries to figure out what the item in her hand is used for. She later learned that it is used for separating egg whites.

Above ■ Nancy Luna sheds tears of joy during the consecration ceremony before parishioners entered the new Our Lady of Mercy church building. Luna has been an active member of the church during its almost decade of temporary living.

SCOTT LEWIS IS A STAFF PHOTOGRAPHER FOR FOX VALLEY VILLAGES/60504. HE WORKS AS THE ONLY STAFF PHOTOGRAPHER FOR THIS WEEKLY TABLOID, ONE OF SEVERAL PUBLISHED BY COPLEY NEWSPAPER IN THE CHICAGO SUBURBS. SCOTT RECEIVED HIS MASTER'S DEGREE IN JOURNALISM FROM THE UNIVERSITY OF MISSOURI IN 1995. HIS UNDERGRADUATE WORK WAS AT THE UNIVERSITY OF TEXAS/AUSTIN. BORN IN NEW YORK CITY AND RAISED IN DALLAS, SCOTT PREVIOUSLY INTERNED AT THE JOLIET HERALD-NEWS, THE ALBUQUERQUE TRIBUNE AND THE GRAND RAPIDS PRESS.

Right ■ After searching through area malls and stores, Waubonsie Valley senior Missy Dugan finally chose a blue-sequined dress for $150 for this year's Waubonsie Valley High School prom.

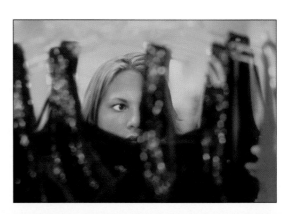

Below ■ A setting sun sparkles off Megan Cannan's dress as her mother, Barb, watches her leave for the dance with her date, Tyler, and their friends. Like many girls, Megan shopped for and purchased her dress with her mother.

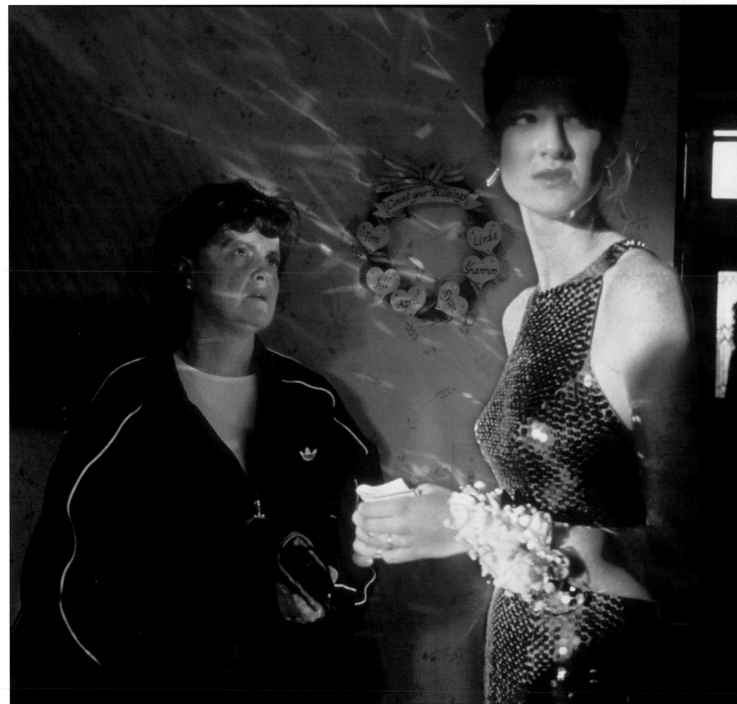

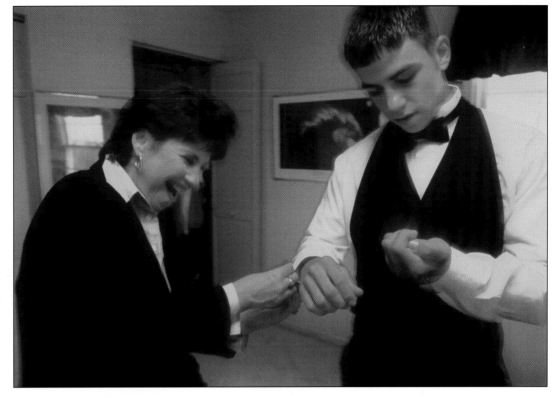

Above ■ Tyler Lineberg gets some help with some cufflinks
from his mom, Mary, as he gets ready to meet his date
and their friends for the dance.

Below ■ "It's sad," Kim Carli says of prom night.
"This is our last dance together." After the dance, many kids
got hotel rooms to spend the early morning hours together.
Missy Dugan, center, and Megan Cannan try to hold a conversation
amidst the chaos of the late night celebration.

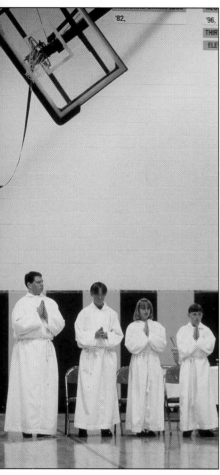

Right ■ Ken Karrels and his wife Audrey cart a new fiberglass statue of Mary and Jesus to the rear of the church. Ken, a church member, poured the concrete for the statue's base and mounted the statue on it.

Below ■ Dan Butler, second from left, bounces his three-month old daughter Kelly while he and other parents keep their babies occupied during the monthly baptism service for parishioners of Our Lady of Mercy Church at St. Anne's Church in Oswego. Our Lady was in the process of building their own church and uses the Oswego facility on Sunday afternoons for their baptism services. This Sunday there were eleven babies baptized.

Above ■ When the Waubonsie Valley High School auditorium was being used for a school function, Our Lady of Mercy Catholic Church was pushed into the gymnasium for their weekend Masses during the nine years of planning for the church's own building.

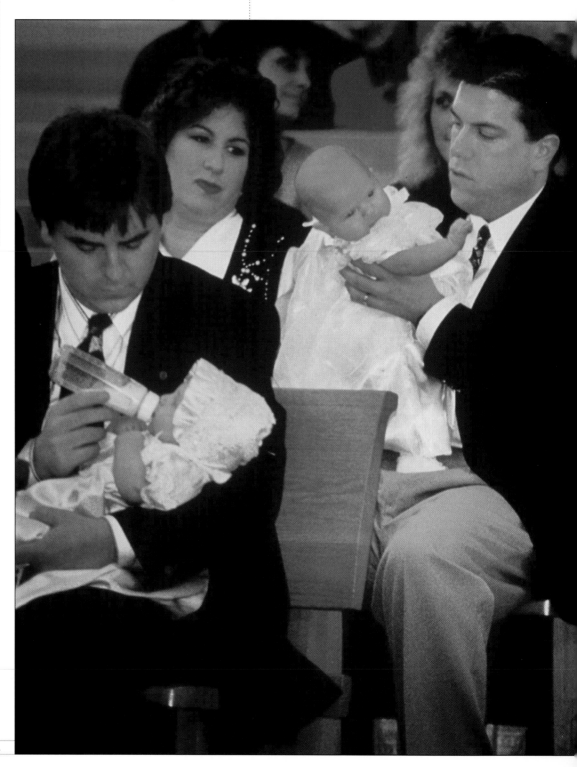

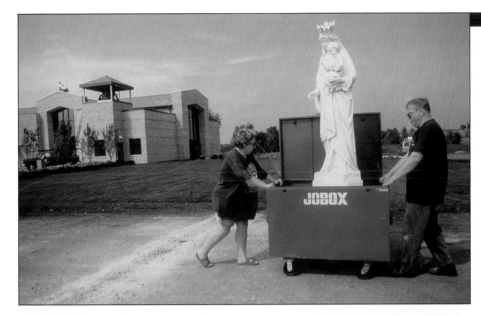

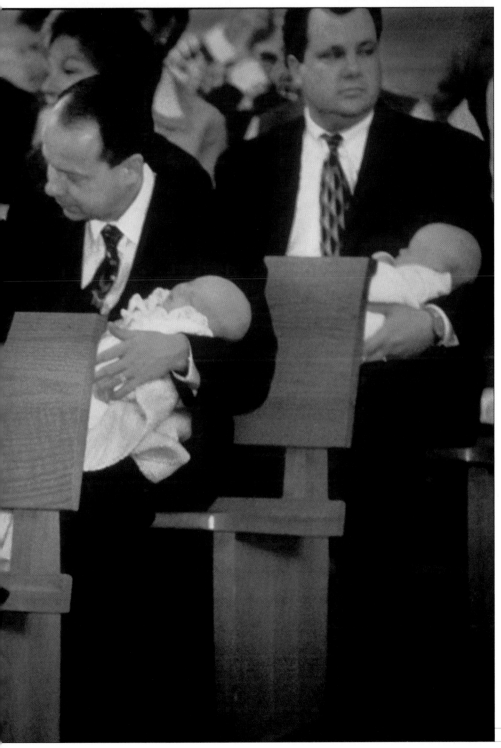

Above ■ Father William DeSalvo, second from right, discusses the future plans for the church's building with Associate Bishop Roger Kaffer while parishioners check out the construction site after the ceremony that blessed the bells that were put into the building.

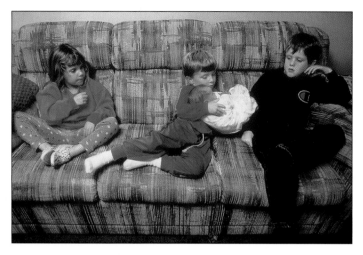

Above ■ Greg Foral, age four, tries to get a friend from the neighborhood to cuddle with Teresa, his new sister. The friend would have no part of the infant, still only a couple of months old.

Right ■ "We've never lost a squirtgun fight since we've lived here," asserts Tiernan McDonald, age nine, after claiming victory over another band of squirtgun-armed assailants.

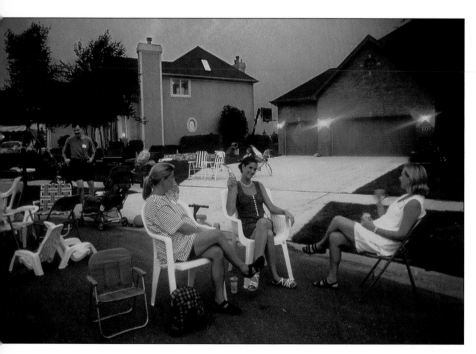

Above ■ Lauren Taylor, Tammy Norton and Marie Pautler relax after a day at the block party in the Lakeridge subdivision. The party is usually scheduled for the July 4th weekend but was a week late this year.

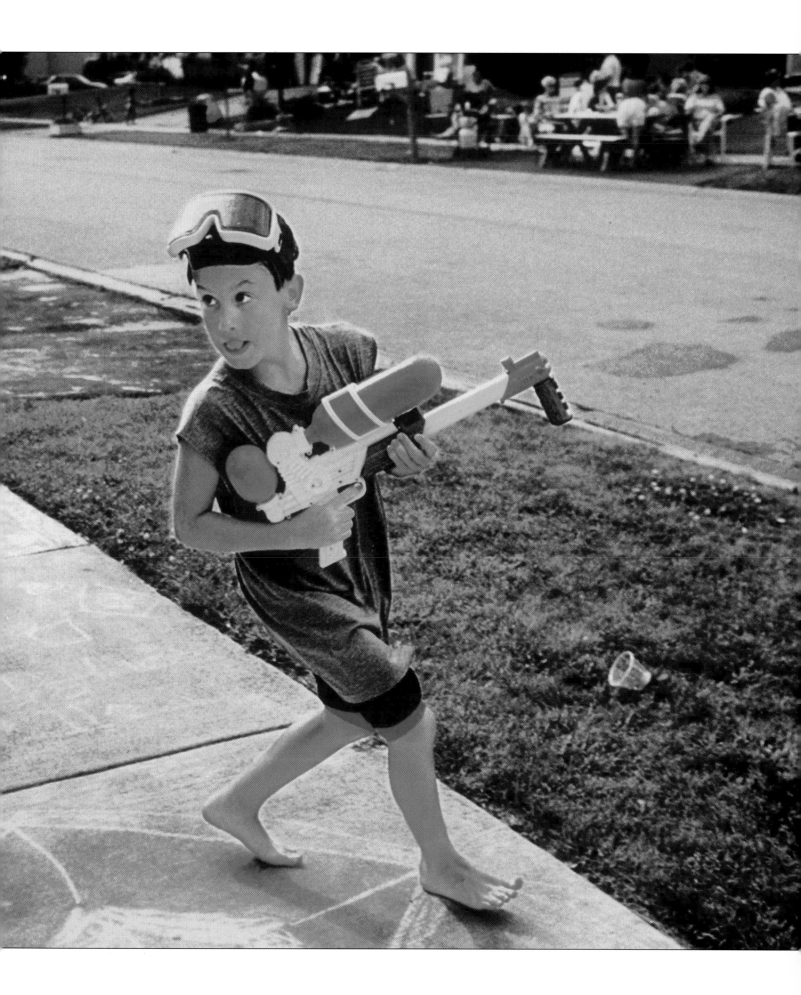

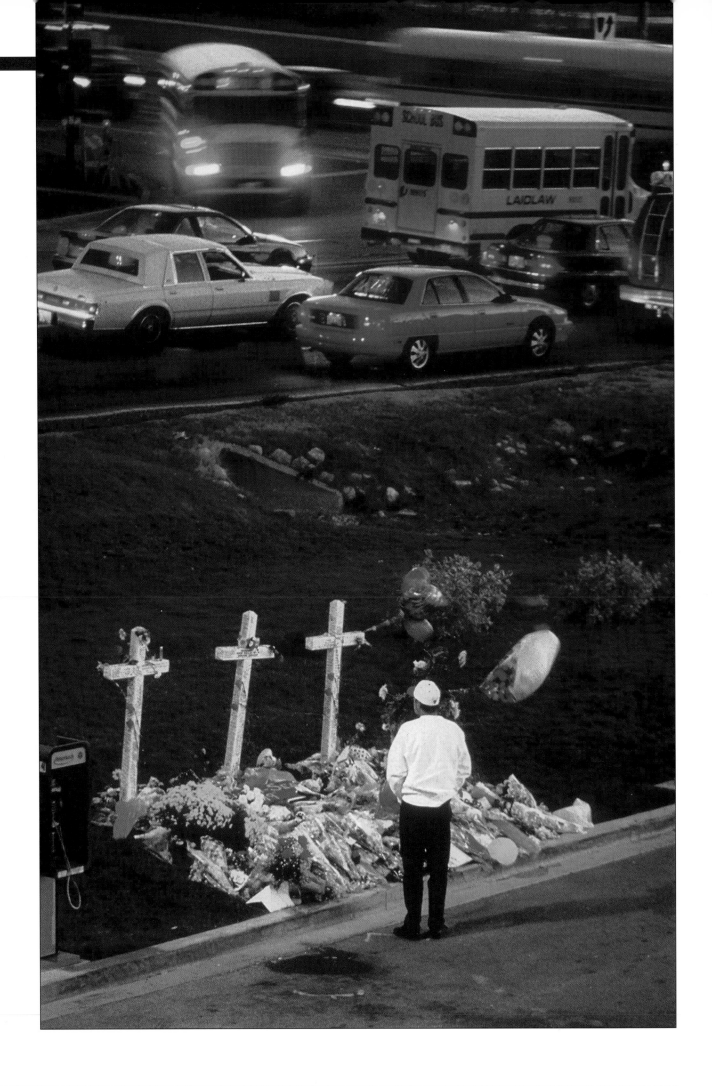

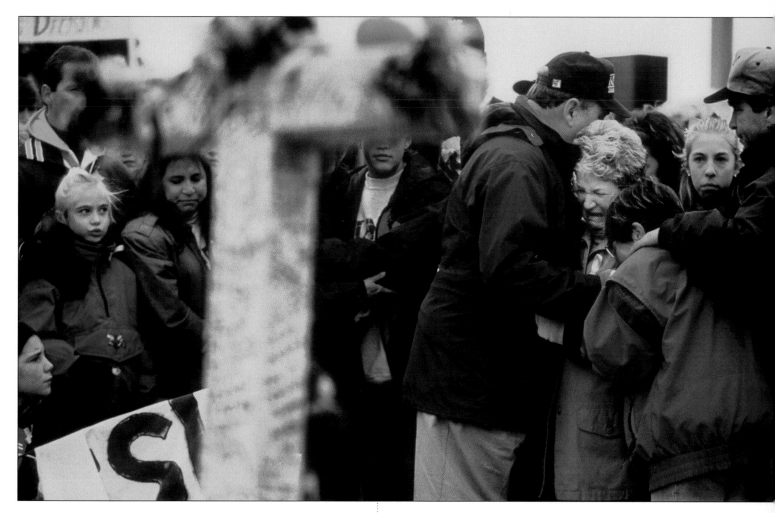

Above ■ Pamela Anderson is consoled by her husband, Sheldon, at the site where their daughter Jenni died in an accident involving a drunken driver. Community members organized a march to remember Jenni and her two friends Allison Matzdorf and Jennifer Roberts, and a mother from Aurora, Illinois who also died in the accident. Speakers at the march discussed ways to battle the problem of drunken driving.

Left ■ A visitor stops at the site where three high school girls and a widowed mother of three were killed in an accident involving a drunken driver on Waubonsie Valley High School's Homecoming Friday.

Right ■ "We were out that night and went home early because it was getting late... It could have been us," Gina Bohm, right, said Friday evening as she and Amber Shadix shared their thoughts and feelings about their friends before the homecoming parade at Waubonsie Valley High School's Dick Kerner Stadium.

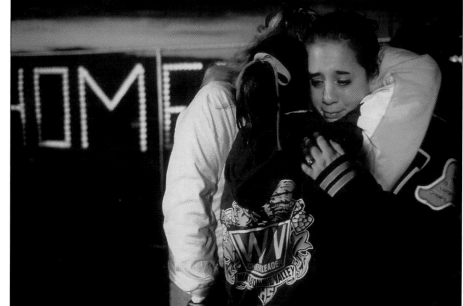

Angus McDougall Overall Excellence in Editing Award

POY judges this year chose The Commercial Appeal, of Memphis, as the one newspaper in this year's competition that consistently demonstrated excellence in photo use in a variety of categories throughout the editing division.

THE COMMERCIAL APPEAL WON SEVEN INDIVIDUAL EDITING AWARDS INCLUDING ONE FIRST PLACE.

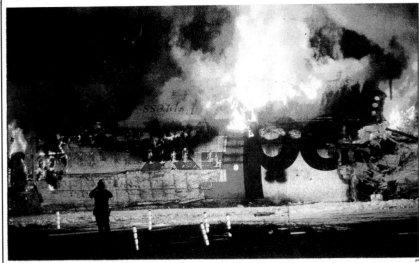

THE COMMERCIAL APPEAL

158th Year, No. 213, 5 Sections Memphis, Tennessee, Friday, August 1, 1997 FINAL 50¢

A FedEx jet burns after bouncing and flipping on its back while landing at the Newark, N.J., airport early Thursday morning. Two pilots and three others aboard survived, scratched and bruised.

FedEx jet flips in hard landing, burns

Five on board escape inferno at Newark airport

By Dave Hirschman
The Commercial Appeal

A FedEx MD11 overturned upon landing and burned Thursday morning at Newark International Airport, but all five of the plane's occupants escaped with minor injuries.

FedEx pilots Robert Freeman, the captain, and Donald Goodin, the first officer, were based in Anchorage. Jumpseat passenger Phyllis Fair worked at FedEx in Memphis And the hometowns of Christine Meeker

and an unidentified worker from an other airline could not be determined Thursday.

"It's a miracle that no one was seriously injured," said Jesse Bunn, a Federal Express Corp. spokesman. "It could have been much worse."

A four-year-old, $120 million aircraft was destroyed in the crash, and virtually all of its cargo appeared to be lost, too. The plane was carrying 145,000 pounds of international shipments to Newark for delivery throughout the eastern United States.

Mike Akin, an MD11 captain and chairman of the FedEx Pilots Association, said the independent union will assist the National Transportation Safety Board (NTSB) and FedEx to determine the cause of the crash.

"We've been in contact with the crew, and we're making arrangements with the company and the NTSB right now," Akin said Thursday morning.

The accident took place about 1:35 a.m. EDT

Witnesses said the plane made an unusually hard touchdown, bounced

skyward, then came down on a wing and skidded on its back. The cavernous fuselage section of the widebody jet came to rest near the center of the airfield, about 200 yards from the passenger terminal. An engine, pieces of wing and debris were scattered over a wide area, and the airport was closed for most of the morning.

All five of the plane's occupants exited through a removable portion of the windshield, which was designed to be pushed out from the inside during emergencies.

Passenger Fair worked as a reporter at The Commercial Appeal and wrote articles about DeSoto

County for the Neighbors section in 1995. Fair and the other occupants of the FedEx plane were treated at a New Jersey hospital and released.

"They were very calm, actually," Port Authority Police Detective Dennis Moriarty said. "I guess they were a little stunned, but they didn't seem to be in a panic."

The NTSB has not determined the cause of the accident.

An examination of NTSB records shows that several MD11s have sus-

Please see CRASH, Page A14

Teamster strike deadline with UPS extended

Sides agree to federal mediator

By Judy Pace
The Associated Press

WASHINGTON — Negotiators for UPS and the Teamsters union continued to meet early today past a midnight deadline as both sides geared up for a strike against the giant delivery service.

Matt Witt, a Teamsters spokesman, said shortly after midnight that other plans were not on hold, but added that could change at any moment.

"There's no limit on how low we'll talk or how long we'll hold off a strike," he said.

As the strike deadline neared, UPS took out a full-page ad in today's editions of The Washington Post telling its customers to expect disruptions in service.

In what it called an "open letter to UPS customers," the company said it has been unable to reach an agreement with the union.

"Under these circumstances, we can no longer provide uninterrupted delivery service," the ad said. "We will, however, make every effort to continue to serve customers."

Nevertheless, the Teamsters convened its bargaining committee at 11:30 p.m. EDT Thursday. Its members were told to stand by as the talks

Please see UPS, Page A13

GOOD MORNING

■ **Today's weather:** Plenty of sunshine and warm today, but not too humid. High of 90. Evening low of 70. Saturday, mostly sunny with a high of 92. Details/A6

■ **One more time:** He might seem a little softer than before, but Mike Ditka, the new coach of the New Orleans Saints, wants to climb the NFL mountain again. **D1**

■ **Cool ice:** Some of the world's most valuable jewels — like this mask for Elizabeth Taylor — are going on display in Tunica. **Playbook**

■ **Payday delay:** The sale of the Truse-McKinney neighborhood to Home Depot hits a $9 million snag. **B5**

IN THE NEWS

Tennessee prisons that Department of Correction Asst. Commissioner Charles Bass wants volunteers. The state cut the department budget $8.9 million, eliminating 317 jobs. Bass wrote department retirees: Please give a few hours a week in "clerical, fiscal, medical, food service or management" in adult prisons, just contact your nearest prison.

INDEX

Ann Landers	C6	Lotteries	A15
Bytes	A15	Metro	B1-8
Business	B6-10	Movies	C4-6
Bygone Days	C5	Neighbors	B5
Classified	D6-16	Scoreboard	D5
Comics	C4-6	Sports	D1-7
Crossword	C5	Stocks	B7
Deaths	B4	Television	C2
Editorials	A8	Viewpoint	A10-11

■ **For home delivery:**
(901) 529-2666
or 1-800-444-NEWS toll free

■ **To fax the newsroom:**
(901) 529-2522

■ **On the World Wide Web:**
http://www.gomemphis.com

■ **EMX:** Jump into the world of bicycle motocross, where racers risk it all in the feeling of being airborne. **B3**

■ **Seasoned sailors:** For a British couple, it's been 58 years at sea for a 35-foot sailboat. **C1**

Police seize explosives, thwart NYC terror plot

Suspects linked to Mideast groups?

By Roberto Suro
and John M. Goshko
The Washington Post

New York City police and federal agents arrested three men and seized five powerful bombs Thursday after a tense shootout in a seedy Brooklyn apartment, and the FBI began trying to determine whether the suspects had ties to Middle East terrorist organizations.

The raid followed a tip from one of the men involved that his colleagues intended to blow up buses and trains in New York City.

One man arrested expressed

Another suspect later admitted that plan to police, according to a complaint filed in Brooklyn federal court later Thursday.

The discovery of the Brooklyn bomb plot marked the third time in the last four years that New York has experienced a terrorist threat with a real or apparent Middle East connection.

Local law-enforcement agencies remained on a state of high alert Thursday evening with extra police patrolling tunnels, bridges and other potential targets.

his support for the suicide bombers who exploded two bombs in a crowded Jerusalem market Wednesday, according to New York Mayor Rudolph Giuliani.

But the mayor cautioned against any anti-Arab backlash.

"This should not be a matter of group blame," Giuliani said. Police burst into a Brooklyn apartment just before dawn Thursday after the tip to police about an impending bomb attack, officials said.

The man who came forward Wednesday night spoke Arabic and attempted to communicate using sign language.

Please see BOMB, Page A14

City builds court fight on sewers-for-annex 'rights'

By Shirley Downing
The Commercial Appeal

About 75 commercial and residential developments in four proposed new towns in Shelby County are covered by an ordinance that makes the properties subject to Memphis annexation in exchange for city sewer service.

The issue is a major argument in the city's court battle against the incorporation of towns under a new state law that makes it easier for communities to incorporate. Memphis and other large cities filed a legal challenge last week in Nashville.

The lawsuit questions the constitutionality of the new state law, saying it has caused

chaos" and caused "irreparable harm" to the orderly growth of municipalities. And some cities— such as Memphis — point to pre-existing contracts that tie sewer service to annexation.

A city ordinance effective in March 1995 extends sewer service to outlying developments in exchange for annexation by Memphis "at the time the city deems appropriate."

Developers who want Memphis sewer service must sign a document requesting future annexation by the city. The document is included as part of the project's final plan, which then is recorded in the Shelby County Register's Office

Countywide, dozens of commercial and residential developments have been approved

SEWER SERVICE

■ Sewer extension generally occurs when the developer signs sewers and signs are adjacent to the property.

■ An ordinance passed in 1995 requires developers to request future annexation if they receive city sewer service.

■ Memphis sewer services involves two fees: sewer extension costs and sewer development fees.

■ The city will extend the sewer and split the cost with the developer 50-50.

■ Developers must pay sewer development fees: $849 for every residential lot in a subdivision and $849 an acre, or $12 a front foot for commercial developments.

by the Land Use Control Board and Memphis City Council since March 1995. Many are outside the Memphis city limits and subject to the annexation

Please see SEWERS, Page A15

METRO

THE COMMERCIAL APPEAL SECTION B

THIS SUNDAY, JANUARY 5, 1997

Three face death chamber Wednesday

Stress of executions felt throughout Ark. system

By Mark Fout
The Associated Press

LITTLE ROCK — Three condemned men in the Mississippi County section of Arkansas await execution next week. Three men are scheduled to die Wednesday.

Nashville police call body hunters into case

NASHVILLE (AP) — Police have asked a group of Oklahoma scientists to review the case of a Nashville actor missing for nearly three years.

The group, calling itself NecroSearch, specializes in the disappearance of Janet Marsh, 33, the wife of a Nashville journalist.

Ants are a growing problem at nature preserve

By Patrick Patterson
The Commercial Appeal

Poet aims to light fire of Americanism at Clinton inaugural

Old-timers square off in 'mind game'

Checkers pieces slam on vinyl

By Charlotte Spencer

INSIDE

■ Briefs, digest

COMING MONDAY

THE COMMERCIAL APPEAL

Lott poised to shape Senate's agenda

Hike in Medicare premium unlikely

'You don't know what you would do' if faced with terminal illness

Aided suicide case fuels push for pain management

Lakeland's new city manager has history of worker conflict

Health care careers offer escape from welfare

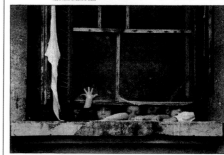

APPEAL *TRAVEL*

MEMPHIS, SUNDAY, NOVEMBER 16, 1997 · THE COMMERCIAL APPEAL · SECTION E

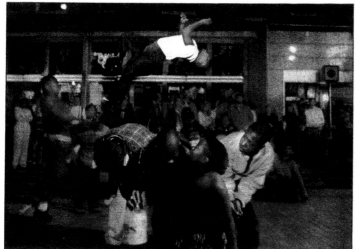

At night on Beale Street youngsters from the nearby housing projects work to entertain the crowds. 16-year-old Rarecas 'Rod' Bonds (left), who has taught most of the boys how to flip, helps his brother Eldridge, 12, clear four companions. "They've got to do what they've got to do to eat," says one of the Beale merchants who looks after them.

On Beale, kids twist, tap, spin seeking change for the better

Some of the boys bike to Beale from Cleaborn and Foote Homes. Their tap shoes get a hard workout.

By Michael Lollar
The Commercial Appeal

DOING FLIPS, EARNING TIPS

Antonio Patterson, 14 (left), Rod and Eldridge count their shares from the tip bucket. In warm weather, they each can earn upwards of $50 a night.

Please see BEALE, Page E4

APPEAL *TRAVEL*

MEMPHIS, SUNDAY, MAY 4, 1997 · THE COMMERCIAL APPEAL · SECTION

MEMPHIS IN MAY 1997

'Some people say they don't have a future'

BRAZIL'S ORPHANS

Pacaembu is a refuge for Brazil's street kids

SÃO PAULO

Story by Vanessa E. Jones

Photographs by Steven G. Smith

Please see KIDS, Page E6

APPEAL

THE COMMERCIAL APPEAL · SECTION

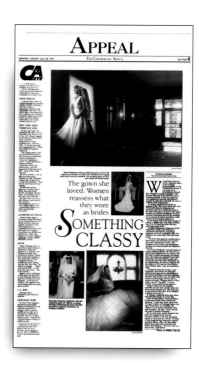

The gown she loved: Women reassess what they wore as brides

SOMETHING CLASSY

Above ■ Part of The Commercial Appeal's second place in team picture-editing.

JEFF MCADORY, LARRY COYNE, LISA WADDELL, DAVE DARNELL
SECOND PLACE, NEWSPAPER PICTURE EDITING/TEAM
AND **LARRY COYNE, LISA WADDELL, LEIGH DAUGHTRIDGE, RICHARD ROBBINS**
AWARD OF EXCELLENCE, MULTIPLE PAGE FEATURE STORY

Above right ■ Brazil: Exotic Land of Extremes.

JEFF MCADORY, LARRY COYNE, STEVEN G. SMITH, LISA WADDELL, DAVE DARNELL, MARK RISELING
THIRD PLACE, NEWSPAPER SERIES

Below right ■ Part of The Commercial Appeal's first place in the best use category.

THE COMMERCIAL APPEAL: FIRST PLACE, BEST USE OF PHOTOGRAPHY
FOR NEWSPAPERS WITH CIRCULATIONS MORE THAN 150,000

MEMPHIS, SUNDAY, JANUARY 5, 1997 THE COMMERCIAL APPEAL E7

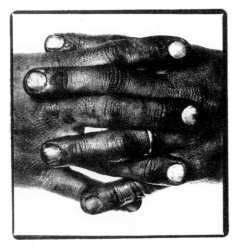

JEFF GRISHAM
CAR MECHANIC

He started on Granddad's trucks. Chevys. Draining oil. Swapping tires. That stuff.
He was 15.
A decade later, Grisham, 25, fidgets when he considers his hands, gritty with grease and sand. Fighting stubborn bolts, measuring tension on belts, sniffing gear oil on the tips of his fingers — Grisham does not want to do this all of his life. The fifth bothers him, after a while.
"But you know," he says one afternoon at his downtown shop, "I want to be associated with cars."
Always has been. Only now the Chevy truck at home is his.

FARRIS HODGES JR.
PURPLE HEART

March 1970: Marine Rifleman Hodges of Memphis steps on a land mine and before his eyes a horrible flash erupts. He is hurtled 30 feet through the heavy air in Vietnam. His arteries are cauterized, sparing his life, but his right arm and both legs are missing.
Today he traps his combat medals between the pincers of his aluminum hook.
Its grip is firm. "I can't think of one thing that you can do that I can't," says Hodges, 46, chief of the prosthetic department at the Memphis Veterans Medical Center. "It just takes me a little longer."

Show of Hands, photographs by Robert Cohen, are on display at The Commercial Appeal gallery, in the first floor lobby, Monday through Saturday, 8 a.m. - 6 p.m., through January 31.

The Commercial Appeal

MEMPHIS, TENNESSEE

Left and below ■ Show of Hands.

LISA WADDELL, ROBERT COHEN, MARC RISELING, JEFF MCADORY
THIRD PLACE, MULTIPLE PAGE FEATURE STORY

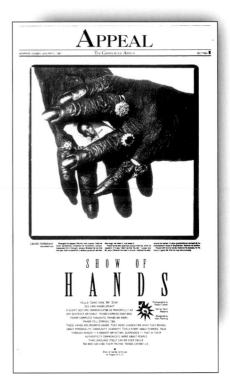

All the Editing winners?

ALTHOUGH WE HAVE SIGNIFICANTLY EXPANDED THE SPACE GIVEN TO EDITING DIVISION WINNERS, UNFORTUNATELY, NOT ALL OF THEM – IN BOTH THE NEWSPAPER AND MAGAZINE CATEGORIES – CAN BE DISPLAYED IN THIS 20-PAGE CHAPTER. THE COMPLETE LIST OF ALL EDITING DIVISION WINNERS IS INCLUDED IN THE OFFICIAL WINNERS LIST WHICH BEGINS ON **PAGE 250.**

APPEAL

MEMPHIS, SUNDAY, APRIL 6, 1997 — THE COMMERCIAL APPEAL — SECTION E

MEMPHIS IN THE BALKANS
Mending Hearts

The heart of Ivana Lovric, 15, is in the hands of Dr. William Novick, a pediatric heart surgeon from Memphis operating at Rebro University Hospital in Zagreb, Croatia.

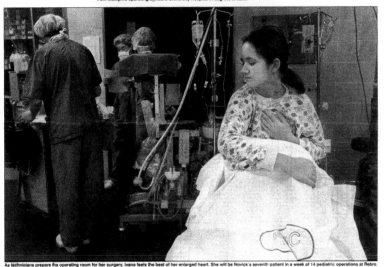

As technicians prepare the operating room for her surgery, Ivana feels the beat of her enlarged heart. She will be Novick's seventh patient in a week of 14 pediatric operations at Rebro.

Surgeon, priest take war's kids in hand

ZAGREB, Croatia — Ivana sat on the operating table glancing around the room as doctors and nurses quietly set out their tools. From time to time, the 15-year-old Croatian girl placed her left hand softly over her chest. She was listening to her defective heart.

Father Joe Kerrigan of Memphis was in the room with Ivana. "I will see your big heart today," he told her. She smiled weakly. Ivana knows she has a big heart. Too big. Her heart has too

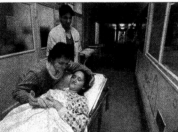

Anica Lovric visits with her daughter for the first time after Ivana's surgery. Ivana was being transferred from intensive care to her hospital room.

much muscle. Her blood can't flow through it.

Down the hall, Dr. William Novick of Memphis tied his blood-spotted tennis shoes. He drew a last drag on a Croatia brand cigarette. Then he walked toward the operating room in Mighty Mouse surgical scrubs that proclaimed: "Here I come to save the day."

Ivana's mother was two floors up, waiting, weeping. Novick told her this surgery would be radical, risky.

Continued on Page E4

Story by David Waters ❖ Photographs by Robert Cohen

Both examples this page ■ Memphis in the Balkans.

LISA WADDELL, LARRY COYNE, ROBERT COHEN, JENI DONLON
SECOND PLACE, NEWSPAPER SERIES

Category descriptions

SINGLE PAGE NEWS STORY – LIMITED TO ONE PAGE, WHICH CANNOT ALSO BE ENTERED AS PART OF A MULTIPLE PAGE ENTRY.

SINGLE PAGE FEATURE STORY – SAME AS ABOVE, BUT MAY INCLUDE SPORTS.

MULTIPLE PAGE NEWS STORY – MUST BE FROM ONE ISSUE OF THE NEWSPAPER OR MAGAZINE. A SERIES IS NOT ELIGIBLE.

MULTIPLE PAGE FEATURE STORY – SAME AS ABOVE, BUT MAY INCLUDE SPORTS.

NEWSPAPER SERIES – ONE TOPIC COVERED IN MULTIPLE ISSUES OF A NEWSPAPER.

NEWSPAPER SPECIAL SECTION – ONE TOPIC COVERED IN ONE ISSUE OF A NEWSPAPER.

PICTURE EDITING AWARD/ INDIVIDUAL PORTFOLIO – ENTRY MUST BE ENTIRELY THE WORK OF **ONE PERSON**. TO QUALIFY ENTRANTS MUST HAVE **PERSONALLY** HANDLED ALL ASPECTS OF EDITING, LAYOUT AND DESIGN.

PICTURE EDITING AWARD/TEAM PORTFOLIO ENTRY MUST INCLUDE THE WORK OF TWO OR MORE PERSONS.

BEST USE OF PHOTOGRAPHY – DAILIES WERE REQUIRED TO SUBMIT FOUR COMPLETE ISSUES, ONLY ONE OF WHICH COULD BE A SUNDAY. THREE OF THE FOUR DATES WERE SUPPLIED. **WEEKLIES** WERE REQUIRED TO SUBMIT THREE CONSECUTIVE ISSUES FROM DATES SUPPLIED AND ONE ADDITIONAL ISSUE OF THEIR CHOICE. **MAGAZINES** WERE REQUIRED TO SUBMIT THREE CONSECUTIVE ISSUES PLUS ONE ISSUE FROM DATES SUPPLIED.

APPEAL

MEMPHIS TUESDAY, APRIL 8, 1997 — THE COMMERCIAL APPEAL — SECTION

MEMPHIS IN THE BALKANS
Soothing Souls

Dr. William Novick takes a break between surgeries just outside the operating room at Rebro University Hospital in Zagreb. "We stop that heart to fix it," Novick says. "It is stopped. If you can't get it started back up, well, that's always in the back of your mind."

Life and death dramas fill week of surgery

ZAGREB, Croatia — The baby's heart was still bleeding. So was the boy's heart in the other operating room.

Story by David Waters ❖ Photographs by Robert Cohen

The Dallas Morning News

THE DALLAS MORNING NEWS WON SIX AWARDS IN THE EDITING DIVISION INCLUDING FOUR FIRST PLACES. PICTURE EDITORS LESLIE A. WHITE AND PAULA NELSON WON BOTH PICTURE EDITING PORTFOLIO CATEGORIES THIS YEAR. (SELECTS FROM THOSE WINS ARE DISPLAYED ON THIS SPREAD.)

Right ■ The Lonely Life: Miguel, Son of an Illegal Immigrant

LESLIE A. WHITE, FIRST PLACE SINGLE PAGE FEATURE STORY

Below ■ A page from the award winning team portfolio.

PAULA NELSON AND LESLIE A. WHITE FIRST PLACE NEWSPAPER PICTURE EDITING/TEAM

HEALING THE HATRED

Sunday, February 9, 1997 The Dallas Morning News **45 A**

THE LONELY LIFE: *Miguel*
SON OF AN ILLEGAL IMMMIGRANT

Miguel, 4, spends much of his day in front of a television as his mother works hard to support the family making piñatas.

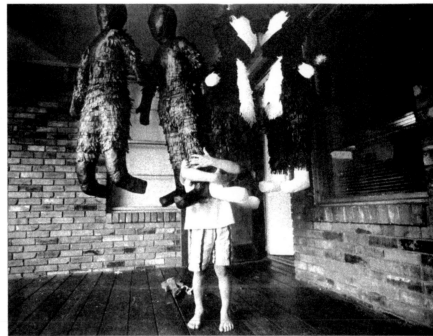

Miguel hangs out with the piñatas his mother makes rather than children his own age in his neighborhood.

Miguel is a 4-year-old criminal. Life was hard for his family in Coahuila, Mexico. They lived and worked in the city dump, surviving on discarded food. His parents crossed the border illegally and have taken up residence in Dallas in hopes of a better life. Now, they have enough food. They have better clothing. They have a roof over their heads. But at a price. Miguel is not free to meet friends, to play outside in his neighborhood, as he did in Mexico. His family members are scared that he will innocently give away that their status and that the Immigration and Naturalization Service will deport them. Miguel is growing up in a gilded prison and his family lives in fear. But hunger is no longer a part of their lives.

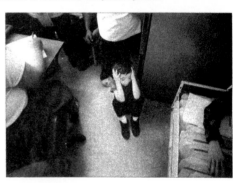

PHOTOGRAPHY BY JUDY WALGREN

Above, Miguel sits on the floor of the offices of Proyecto Adelante while his parents visit with a counselor about becoming legal residents. Left, he rides his bike on the balcony of the apartment complex.

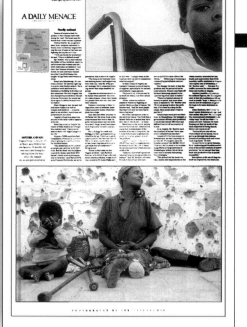

A DAILY MENACE

Left and below ■
A Daily Menace.

PAULA NELSON, FROM THE FIRST PLACE,
MULTIPLE PAGE NEWS STORY

At right, top and bottom
■ From the award-winning individual
editing portfolio.

LESLIE A. WHITE, FROM THE FIRST PLACE,
NEWSPAPER PICTURE EDITING/INDIVIDUAL

The
Stanley Cup
PLAYOFFS

STARS GO
TOE-TO-TOE WITH
EDMONTON OILERS

Sunday, April 27, 1997 The Dallas Morning News

HIDDEN DANGER: LAND MINES' HUMAN TOLL

Sunday, November 23, 1997 The Dallas Morning News 7 J

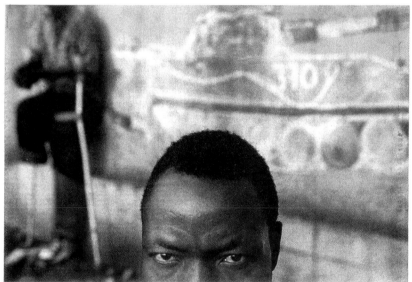

MAIMED SOLDIERS
Two former Angolan government soldiers in Kuito are victims of the war: Damian Bumba (front), 18, who is a double amputee after an injury from an anti-tank mine, and Simpraro Sucombaug, 24, who lost his right leg above the knee to an anti-personnel mine.

A DAILY MENACE

CONTINUED FROM PAGE 1J

Angola often has been cited as an example that demonstrates the need for a worldwide ban of land mines. Leaders of more than 100 countries will meet in Ottawa next month to sign such a treaty. But perhaps even more, Angola demonstrates the complexities of the issue.

Of a population estimated at 10 million, there are about 70,000 amputees, the majority victims of land mines. But with time, Angolans have learned to live with mines — or at the very least to avoid them as much as possible.

Two years after a bloody civil war ended, most mined areas have been identified by mine clearance experts. Angolan soldiers who laid the mines, and by trial and error Angolans sadly know of some mined areas because a loved one or neighbor was killed or maimed there.

The number of unexploded mines remaining in Angola is debated.

Estimates have ranged as high as 10 to 20 million, or one to two mines for every person in the country. Some mine clearance organizations suggest it's lower: perhaps 5-8 million, according to Norwegian People's Aid, or only 500,000, according to HALO (Hazardous Areas Life-Support Organization) Trust.

In terms of deaths, diseases that could be easily treated — if drugs were available — take a much greater toll. Hospital officials and some mine clearance experts say that traffic accidents kill and maim more people than mines. And unexploded artillery shells, grenades and rockets account for many injuries attributed to mines.

Few would deny that mines are a serious problem in Angola, a country that was flooded with weapons of all descriptions as

Cold War superpowers used it for a surrogate battleground. But mines are not necessarily the biggest worry for Angolans.

Many farmers say they worry much more about having enough food for their families and the possibility that fighting may resume. Their perspective is very different from that of those who would ban mines, as though they were looking through opposite ends of a telescope.

Pepino Masoze, the agriculture minister in Kuito province, said mines are a serious problem for farmers in some parts of Angola, "but it would be a lie to say that we can't produce anywhere." Dr. Fernando Chicoa, director

of the only hospital in Huambo, Angola's second-largest city, said that mines are not nearly as deadly as a variety of diseases that could be treated if sufficient drugs were available — including malaria, diarrhea, dysentery and tuberculosis. Other Angolan medical officials say that vehicle accidents, which are not frequent, cause more injuries.

Since 1994, a tentative peace has existed between the government of José Eduardo dos Santos and the main opposition movement, known as UNITA, headed by Jonas Savimbi. But both sides are wary.

Even as mine clearance experts are working to remove the

mines at locations throughout Angola, some minefields have been placed emphatically off-limits by soldiers.

Some "strategic" locations — the banks of rivers that are natural defensive barriers, and the perimeters of military installations — remain mined at the order of military officials.

Near a military barracks in Huambo, the tail of a 250-kilogram bomb juts out of the grass next to a pitted road. The smooth plastic tops of two mines also are visible in the soil, like partially buried Frisbees. Others probably lie unseen, as their designers intended.
Please see A DAILY MENACE on Page 8J.

REGULAR ROUTINE
Two years after the civil war ended, life goes on in Kuito as people walk to and from the market in the town.

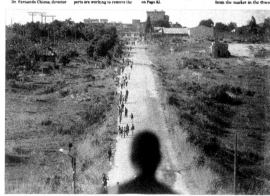

PHOTOGRAPHY BY JOE STEFANCHIK

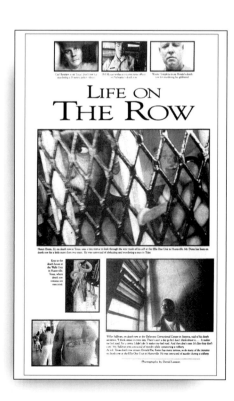

LIFE ON THE ROW

Providence
Journal-Bulletin

THE PROVIDENCE JOURNAL-BULLETIN WON SIX AWARDS IN THE EDITING DIVISION INCLUDING TWO FIRST PLACES.

Right ■ Mother Teresa: 1910-1997.

ANNE PETERS
FIRST PLACE, SINGLE PAGE NEWS STORY

SPECIAL REPORT ■ SECTION 1 ■ THE PROVIDENCE SUNDAY JOURNAL ■ FEBRUARY 16, 1997

Nfed David Bartley prepares for death. Of his life, he says, 'I loved every moment of it.'

A Time
to Die

CONDEMNED TO DEATH BY LOU GEHRIG'S DISEASE,
A MIDDLE-AGED MAN SEIZES THE MOMENT
TO FIGHT FOR THE RIGHT
TO CHOOSE HOW AND WHEN HE WILL DIE

Photographs by John Freidah ■ Story by Felice J. Freyer

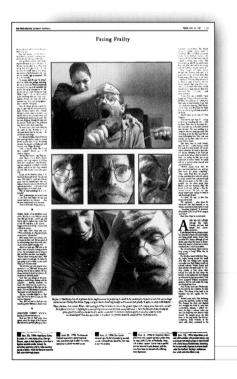

Facing Frailty

MASS. EDITION

Providence Journal·Bulletin

© 1997 PUBLISHED DAILY SINCE 1829 • http://www.projo.com **SATURDAY** SEPTEMBER 6, 1997 /50 CENTS / $2.10 PER WEEK BY CARRIER

NEWS DIGEST

Netanyahu: Bombing nullifies peace accord

In the wake of a fatal bombing in a Jerusalem pedestrian mall, Prime Minister Benjamin Netanyahu declares that Israel is no longer bound by peace accords with the Palestinians and will not hand over large chunks of the West Bank by mid-1998, as once pledged. The bombing Thursday, claimed by the Islamic militant group Hamas, killed seven people and wounded more than 190, including six Americans. **A-2**

United front sought for talks on stadium

Governor Almond dispatches a delegation to City Hall to sound out Mayor Vincent A. Cianci Jr. on the issues of property tax breaks, parking and development rights as he continues his efforts to bring the New England Patriots to Rhode Island. **A-3**

American, Russian begin spacewalk

American astronaut Michael Foale and Russian cosmonaut Anatoly Solovyov float into open space on a rare U.S.-Russian spacewalk aimed at finding punctures from a collision that crippled the aging Mir station. The six-hour expedition is the first hands-on inspection of Mir's damaged hull since June 25. **A-2**

Lawyer vanishes amid allegations

Robert A. Pitassi, a prominent lawyer accused of failing to account for hundreds of thousands of dollars he was managing for his aunt and for his cousin, has not been seen since Aug. 5. The law firm where Pitassi was employed, Adler, Pollock & Sheehan, has fired him in his absence on grounds of client neglect. And his former wife is asking that Pitassi be held in contempt for failing to pay her support money and for violating a restraining order that prohibited him from divesting assets. **A-5**

State moves to clean its waters

Rhode Island applies to become the first state in the country to request that all of its coastal waters — as far as three miles offshore and a three-mile ring around Block Island — be put off limits to all waste discharges from boats. **A-3**

ALSO INSIDE

LIFEBEAT
A coal mine of clichés
Martial arts star and would-be actor Steven Seagal is his usual wooden self in the movie *Fire Down Below*. **C-1**

WEATHER
Today and tomorrow: Carbon copies
Breezy today with mixed clouds and sun, the high 80. Variable clouds tonight and a little milder, the low 59. A repeat performance tomorrow, with a mix of sun and clouds, the high 80. **B-16**

MOTHER TERESA
1910-1997

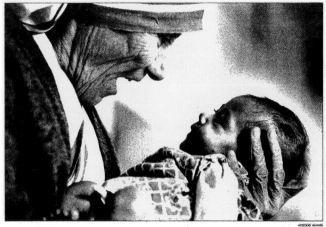

MOTHER TERESA cradles a baby in this 1979 file photo showing what she did best: helping those who had little means to help themselves.
AP/EDDIE ADAMS

India's inspirational 'living saint' dies

■ During a lifetime of tireless service, the recipient of the 1979 Nobel Peace Prize tended to "the poorest of the poor."

Journal-Bulletin Wire Reports

Mother Teresa, the Roman Catholic nun and Nobel laureate who followed a call to serve the dying in the squalor of Calcutta, India, for almost 50 years, and eventually became an inspiration for people of all faiths throughout the world, died of heart failure yesterday. She was 87.

Her health had long been fragile. She was hospitalized several times last year with heart, lung, kidney and other problems, and also suffered ill health in earlier years. Her physician in Rome said her heart had failed during the evening at her convent in Calcutta. She died about 9:30 p.m. (noon EDT).

She collapsed on her bed at her home, Nirmal Hriday, which means tender heart, after saying, "I cannot breathe," according to a close friend.

As her health deteriorated over the past year, she stepped aside and her order, the Missionaries of Charity, chose a new leader, Sister Nirmala, in March.

POPE JOHN PAUL II and Mother Teresa greet a crowd just outside the Home for Dying, in Calcutta, India, in this 1986 file photo.
AP

Turn to TERESA, Page A-7

'I, for one, believe there are lessons to be drawn from her life...'

Trying to soothe mourners, Queen praises Diana

■ In only the second personal address of her 45-year reign, Queen Elizabeth takes pains to convey her sorrow and attempts to forge an allegiance with her subjects in their time of grief.

By WARREN HOGE
The New York Times

LONDON — Speaking in remarkably personal terms for a British monarch, Queen Elizabeth yesterday praised Diana, Princess of Wales, as "an exceptional and gifted human being" and said, "I, for one, believe there are lessons to be drawn from her life and the extraordinary and moving reaction to her death."

In a rare live television broadcast from a room overlooking the crowds of mourners milling about in front of Buckingham Palace on the eve of Diana's funeral, the queen said the princess "never lost her capacity to smile and laugh, nor to inspire others with her warmth and kindness."

She pointedly quashed this by saying "in good times and bad," an allusion to the history of bad blood between the princess and the royal family known to all her listeners.

She also appeared to address the bitterness with the royal family that has been expressed by many in recent days for its failure to appear in public and join in the outpouring of sorrow that has swept Britain since the death of Diana, 36, early Sunday in a car crash in Paris.

QUEEN ELIZABETH and Prince Philip walk among a sea of well-wishers and floral tributes outside Buckingham Palace yesterday, after accusations of not showing public grief over Diana's death.
AP

■ The Spencer family shifts Diana's burial site to the private grounds of its estate.

■ Industry insiders predict big sales for Elton John's new version of "Candle in the Wind," rewritten to eulogize Diana.
Stories on Page A-6.

Turn to DIANA, Page A-6

Taking Charge

1
2
3

These three smaller pages
■ A Time to Die.

LYNN ROGNSVOOG, THEA BREITE, MICHELE MCDONALD, JOHN FREIDAH
FROM THE SECOND PLACE NEWSPAPER SPECIAL SECTION

INDIANS WIN COLDEST WORLD SERIES GAME IN HISTORY 10-3 • SPORTS C1

The Hartford Courant.

America's Oldest Continuously Published Newspaper

WEATHER
Partly sunny,
45-50. Page B12

VOLUME CLIX, NUMBER 296 COPYRIGHT 1997, THE HARTFORD COURANT CO. THURSDAY, OCTOBER 23, 1997 7* SPORTS FINAL NEWSSTAND 50¢

Pope Taps Accused Priest For Assembly

By GERALD RENNER
Courant Religion Writer
and JASON BERRY
Special to The Courant

Pope John Paul II has appointed an influential priest in Rome who has been accused of child sexual abuse as a special delegate to a major church conference next month.

The priest, the Rev. Marcial Maciel Degollado, founder and head of the Legionaries of Christ, is one of 21 people the pope chose to attend the Synod for America to be held in Rome from Nov. 16 to Dec. 12.

The papal appointment dismayed and mystified some Vatican watchers in and out of the church.

"They are completely out of touch with what is going on," said the Rev. Thomas Doyle, a canon lawyer who once worked for the Vatican Embassy in Washington.

The synod will involve a select group of 250 church leaders from North and South America in talks about

Please see POPE, Page A16

A Pledge To Restore Campuses

By ROBERT A. FRAHM
Courant Staff Writer

College officials earlier this year criticized Gov. John G. Rowland's plans to cut their budgets, but they lined up Wednesday to praise the governor's $640 million proposal to rebuild their campuses.

With a $1 billion construction plan already under way at the University of Connecticut, Rowland pledged to restore the crumbling campuses of the state's other two higher education systems.

"Let's do the right thing, as we did for the University of Connecticut," Rowland said as he announced a five-year plan to renovate the Connecticut State University system and the community-technical college system.

"We're thrilled," Bruce H. Leslie, chancellor of the community-technical colleges, said of a plan that would restore libraries and classroom buildings, fix aging utility systems and rewire campuses with state-of-the-art technology.

"This couldn't have been a better thing to happen

Please see S-YEAR, Page A15

INTERVIEW WITH 'THE BUTCHER'

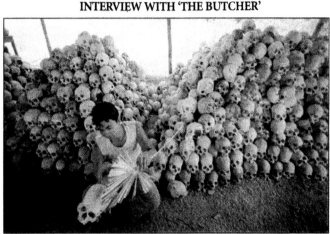

IN THIS 1988 PHOTO, a man cleans a skull near a mass grave at the Chaung Ek torture camp run by the Khmer Rouge during the late 1970s. The bones were being cleaned, numbered and stacked with some specimens destined for museums. More than a million Cambodians died during the group's reign

JEFF WIDENER / ASSOCIATED PRESS

'My Conscience Is Clear'

Ruler Of Cambodia's Killing Fields Is Without Remorse

By KEITH B. RICHBURG
Washington Post

HONG KONG — In his first interview in 18 years, the elusive Pol Pot, who presided over Cambodia's killing fields of the late 1970s, has conceded that his notorious Khmer Rouge movement "made mistakes" but "my conscience is clear."

"I came to carry out the struggle, not to kill people," Pol Pot said, according to excerpts of an interview conducted last week by journalist Nate Thayer. "Even now, and you can look at me. Am I a savage person?"

Pol Pot was unrepentant when questioned repeatedly about accusations that he was responsible for the deaths of more than a million Cambodians, said Thayer, who conducted the interview at the guerrilla group's jungle stronghold at Anlong Veng in northern Cambodia.

"To say that millions died is too much," he is quoted as saying. Independent researchers have estimated the number of deaths as 1 million to 3 million.

For nearly two decades, Pol Pot, 69, whose real name is Saloth Sar, has remained an enigma, moving only in the shadows of Cambodia's tortured politics. Never seen publicly and rarely photographed, his name

alone was enough to elicit terror and loathing.

For years, his elusiveness — his pronouncements were read by others over the guerrilla group's clandestine radio station — only added to his mystique. This gave rise repeatedly to rumors that he was dead or deathly ill, that he was living in luxury in Thailand, that he was retired or actively leading troops in the jungle.

Not until July, when Thayer emerged from the jungles, was there proof that Pol Pot was still alive. Now, for the first time, Pol Pot has spoken to an American reporter about the movement he led for 37 years, the killings that took place under his regime, his regrets (apparently few) and his own view of Cambodia's genocide and why it happened.

Thayer is the American journalist who first photographed Pol Pot July 25, when the Khmer Rouge leader

Please see INTERVIEW, Page A15

FORMER KHMER ROUGE leader Pol Pot, 69, now reportedly under house arrest, was denounced by former colleagues while on trial July 25 in Cambodia.

AP / FILE

Senators Call Funding Tactics Misguided

Lieberman: Fund-Raising Was 'Miles Away' From The Law's Intent

GOP AID
Republicans steered donors' money to sympathetic organizations. See Page A16

By DAVID LIGHTMAN
Washington Bureau Chief

WASHINGTON — When President Clinton told wealthy donors during the 1996 campaign that their dollars had been crucial to his political comeback, he may not have been breaking the law, but his intentions sure seemed misguided and wrong, senators said Wednesday.

The Senate Governmental Affairs

Committee viewed videotapes of Clinton, as well as President Reagan, while he was in office, at different events for big donors. Members of both parties recoiled at what they saw.

"The words spoken are legal," said Sen. Joseph I. Lieberman, D-Conn., after viewing the Clinton and Reagan tapes, "but are part of a process that went way over the line and clearly was wrong."

He said he saw nothing clearly illegal, but the fund-raising was "miles away from the intention of the law."

In one Clinton tape from Dec. 7, 1996, the president, with Sen. Christopher J. Dodd, D-Conn., sitting nearby, explained to donors at a

small hotel dinner how he was able to use soft money, money that can be raised and spent in unlimited amounts.

By being allowed to use such funds, Clinton explained, within earshot of Dodd, how he was not hamstrung by laws that limit how much a presidential campaign can raise and spend.

Dodd, then Democratic Party general chairman, reported Wednesday what he has been saying for months, that he was not aware of any plan to try to get around campaign spending or fund-raising limits.

Lieberman, a senior member of the Senate

Please see SENATORS, Page A16

PERSON IN THE NEWS

State Native Is Choice For Solicitor General

By MICHAEL REMEZ
Courant Staff Writer

WAXMAN

WASHINGTON — To Supreme Court watchers, he is the top attorney for the federal government before the nation's highest court.

To his sisters and old friends, he is a one-time West Hartford kid reaching a peak in his legal career because of smarts, hard work and a well-grounded sense of self.

Seth P. Waxman, 46, has been serving as acting solicitor general since the start of September. Now, he is President Clinton's choice to step into the job in his own right as the nation's top courtroom lawyer.

Waxman is not granting interviews before his nomination goes to the Senate, though family and

Please see CONNECTICUT, Page A14

ON THE Inside

Enter

Who Needs A Cookbook? A Datebook? A Brain? 'Smart Appliances' Do The Thinking For You

CaL

Whether opening for the Rolling Stones, or headlining tours, Blues Traveler keeps things moving

Intrepid Travelers

Our online Web surfer Zoe will take you to the dark side of the Internet this week. Check out her column.

WWW.COURANT.COM

Business	D1	Local news	B1
Classified	E1	Lottery	A2
Comics	F6	Movies	CaL
Connecticut	A3	Nation	A12
Crossword	F2	Obituaries	B10
Editorial	A18	People	CaL
Enter	F1	Sports	C1
Legal notices	E2	Television	F5

The Hartford Courant

THE HARTFORD COURANT WON FOUR AWARDS IN THE EDITING DIVISION.

Left ■
My Conscience is Clear.

THOMAS F. MCGUIRE, SECOND PLACE SINGLE PAGE NEWS STORY

Below ■ A New Holy Trail.

CECILIA PRESTAMO, SECOND PLACE SINGLE PAGE FEATURE STORY

CONNECTICUT LIVING

A new holy trail

Detroit Free Press

THE DETROIT FREE PRESS WON ONE AWARD IN THE EDITING DIVISION OF THIS YEAR'S POY.

...

Below ■ A Final Salute.

**TODD WINGE,
CAROLINE E. COUIG,
ROBERT ST. JOHN,
ROBERT KOZLOFF**
FROM THE SECOND PLACE,
MULTIPLE PAGE NEWS STORY

The Detroit News

THE DETROIT NEWS WON ONE AWARD IN THE EDITING DIVISION OF THIS YEAR'S POY.

...

Above ■ Shine: The Best and the Brightest.
STEVE FECHT, HEATHER STONE, FROM THE THIRD PLACE, NEWSPAPER SPECIAL SECTION

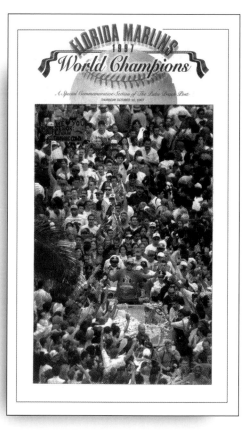

The Palm Beach Post

THE PALM BEACH POST WON FOUR AWARDS IN THE EDITING DIVISION.

Both pages
■ Part of their picture-editing portfolio.

MARK EDELSON
BOTH PAGES ARE PART OF THE SECOND PLACE NEWSPAPER PICTURE EDITING TEAM PORTFOLIO AND, THE PAGE AT RIGHT, ENTITLED "THE LONGEST DAYS," RECEIVED A THIRD PLACE, SINGLE PAGE FEATURE STORY.

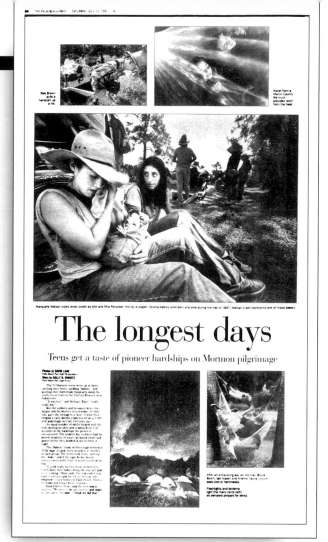

The longest days

Teens get a taste of pioneer hardships on Mormon pilgrimage

Even alcohol's indirect hits can be devastating – and permanent

Twelve years ago, Brian Wrona was driving home when a drunken driver plowed into him. The drunken driver walked away unhurt, but Brian has been in a coma ever since. "The doctors told us in the beginning he would only live a few months," says Janice Wrona. "We're still waiting for my son to die."

We're still waiting for my son to die.

Those left behind

Brian Wrona lives at Sunny Hill nursing home in Plainfield, where his mother still bakes him a birthday cake every year and family celebrate holidays around his bed. His mother believes his eyes sometimes lock onto hers. But the doctors say that's merely a coincidence.

When alcohol affects others

Copley Chicago

COPLEY CHICAGO NEWSPAPERS WON TWO AWARDS IN THE EDITING DIVISION.

Left and right ■
Generations Under the Influence.

BRIAN PLONKA, TOM WALLACE, JOHN KAPLAN, DENISE CROSBY/COPLEY CHICAGO PAPERS
FIRST PLACE, NEWSPAPER SPECIAL SECTION

Below ■ Best Use of Photography.

FOX VALLEY VILLAGES/60504/SUN PUBLICATIONS/ A COPLEY CHICAGO NEWSPAPER
FIRST PLACE, BEST USE OF PHOTOGRAPHY, UNDER 25,000 CIRCULATION

Generations under the influence

Cover Story

Together in tears

Children of the Underground
DAY ONE

Pittsburgh Post-Gazette

THE PITTSBURGH POST-GAZETTE WON TWO AWARDS IN THE EDITING DIVISION OF THIS YEAR'S POY INCLUDING A FIRST PLACE.

Both pages
■ Children of the Underground.

**CURT CHANDLER,
ALLAN DETRICH, BILL PLISKE,**
PART OF THE FIRST PLACE
NEWSPAPER SERIES

Pittsburgh Post-Gazette

SUNDAY

FINAL EDITION

DECEMBER 14, 1997

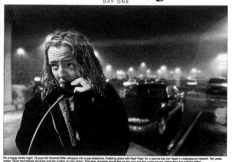

Black juror thwarts acquittal in Gammage death
Another mistrial

Steelers win 24-21 heart stopper

Children of the Underground
DAY ONE

Secret network hides families on the run

Photographs by **Allan Detrich**
Stories by **Mackenzie Carpenter**

The Albuquerque Tribune

THE ALBUQUERQUE TRIBUNE WON A FIRST-PLACE AWARD IN THE EDITING DIVISION OF THIS YEAR'S POY.

Both pages
■ From their "Best Use" entry.

THE ALBUQUERQUE TRIBUNE,
PART OF THE FIRST PLACE AWARD
FOR BEST USE OF PHOTOGRAPHY
IN NEWSPAPERS WITH CIRCULATIONS
BETWEEN 25,000 AND 150,000

THE ALBUQUERQUE TRIBUNE

WEEKEND EDITION
Saturday, November 29, 1997

West Side elementary boundaries are being revised

Baca team says APD needs big reforms

IRENE'S STORY

Since shooting, APD has changed, activists and police officials say

New Mexico's budget dilemma — how to spend extra $130 million

INSIGHTS

Where the **bad boys** are

The New Mexico Boys School in Springer is crowded, dangerous, and for many, just a stop on the way to more crime

between midnight and dawn: china reclaims hong kong

In the early hours of Tuesday, Hong Kong will leave British rule and return to its Chinese roots, melding past with present to write the next chapter in its history. The passage is fraught with risks and opportunities.

San Jose Mercury News

THE SAN JOSE MERCURY-NEWS WON SIX AWARDS IN THE EDITING DIVISION OF THIS YEAR'S POY.

.................................

Left ■ From an individual picture-editing portfolio.

SCOTT DEMUESY,
PART OF THE THIRD PLACE INDIVIDUAL PICTURE EDITING PORTFOLIO

Right ■ Rescued.

SCOTT DEMUESY,
PART OF THE THIRD PLACE MULTIPLE PAGE NEWS STORY

Lawrence Journal-World

THE LAWRENCE (KANSAS) **JOURNAL-WORLD WON ONE AWARD IN THE EDITING DIVISION OF THIS YEAR'S POY COMPETITION.**

.................................

Both pages ■ From their "Best Use" entry.

LAWRENCE JOURNAL-WORLD,
PART OF THEIR SECOND PLACE AWARD FOR BEST USE OF PHOTOGRAPHY IN NEWSPAPERS WITH CIRCULATIONS UNDER 25,000.

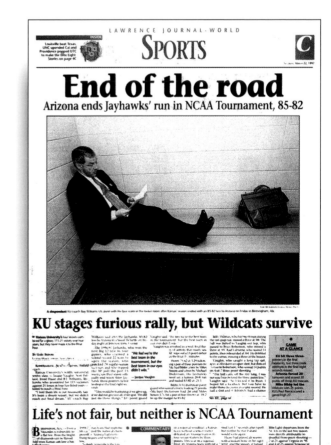

The Spokesman Review

THE SPOKESMAN-REVIEW (SPOKANE, WASHINGTON) **WON ONE AWARD IN THE EDITING DIVISION OF THIS YEAR'S POY COMPETITION.**

Both pages ■ From their "Best Use" entry.

THE SPOKESMAN REVIEW, PART OF THEIR SECOND PLACE AWARD FOR BEST USE OF PHOTOGRAPHY IN NEWSPAPERS WITH CIRCULATIONS BETWEEN 25,000 AND 150,000

The Oregonian

THE OREGONIAN (PORTLAND, OREGON) **WON ONE AWARD IN THE EDITING DIVISION OF THIS YEAR'S POY COMPETITION.**

Both pages ■ Albania: A Country in Need of Adult Supervision

BEN BRINK, RANDY COX, PART OF THE SECOND PLACE, MULTIPLE PAGE FEATURE STORY

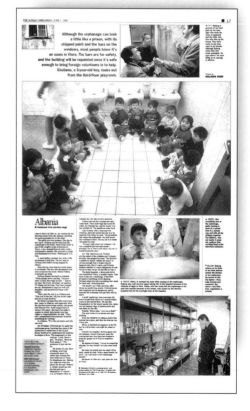

U.S. Champs!

The Boys of Summer

Silent McVeigh handed his fate

Church bells toll as the news reaches Oklahoma

Los Angeles Times

ORANGE COUNTY EDITION

THE ORANGE COUNTY EDITION OF THE LOS ANGELES TIMES WON THREE AWARDS IN THE EDITING DIVISION.

Both pages ■ Their picture-editing portfolio.

COLIN CRAWFORD, GAIL FISHER, DON TORMEY, STEVE STROUD, LARRY ARMSTRONG, CALVIN HORN, BARRY FITZSIMMONS, THIRD PLACE, NEWSPAPER PICTURE EDITING/TEAM (THE PAGE BELOW IS ALSO A PART OF THEIR AWARD OF EXCELLENCE, MULTIPLE PAGE FEATURE STORY.)

The Virginian-Pilot

THE VIRGINIAN-PILOT (NORFOLK, VIRGINIA) WON SIX AWARDS IN THE EDITING DIVISION OF THIS YEAR'S POY COMPETITION.

Above ■ Silent McVeigh Handed his Fate.

NORMAN SHAFER, LISA COWEN, ERIC SEIDMAN, THIRD PLACE, SINGLE PAGE NEWS STORY

THIS PAGE WAS ALSO A PART OF THE AWARD OF EXCELLENCE GIVEN THE VIRGINIAN-PILOT FOR THEIR TEAM PICTURE EDITING PORTFOLIO.

Jacksonville Journal-Courier

THE JACKSONVILLE (ILLINOIS) JOURNAL-COURIER WON ONE AWARD IN THE EDITING DIVISION OF THIS YEAR'S POY COMPETITION.

.....................

Both pages ■ Part of their "Best Use" entry.

JACKSONVILLE JOURNAL-COURIER, THIRD PLACE, BEST USE OF PHOTOGRAPHY FOR NEWSPAPERS WITH CIRCULATIONS UNDER 25,000

The State

COLUMBIA, SOUTH CAROLINA

THE STATE WON TWO AWARDS IN THE EDITING DIVISION OF THIS YEAR'S POY COMPETITION.

.....................

Both pages ■
Part of the "Best Use" entry.

THE STATE, FROM THE THIRD PLACE, BEST USE OF PHOTOGRAPHY AWARD FOR NEWSPAPERS WITH CIRCULATIONS BETWEEN 25,000 AND 150,000

LIFE Magazine

LIFE MAGAZINE WON FIVE AWARDS IN THE EDITING DIVISION OF THIS YEAR'S POY COMPETITION INCLUDING THE FIRST PLACE INDIVIDUAL PICTURE-EDITING PORTFOLIO.

Above and, at left, both spreads
■ Part of their "Best Use" entry.

LIFE MAGAZINE, SECOND PLACE
BEST USE OF PHOTOGRAPHY/MAGAZINES

Below ■ Part of a picture-editing portfolio.

DAVID FRIEND,
FIRST PLACE, MAGAZINE PICTURE
EDITING PORTFOLIO/INDIVIDUAL

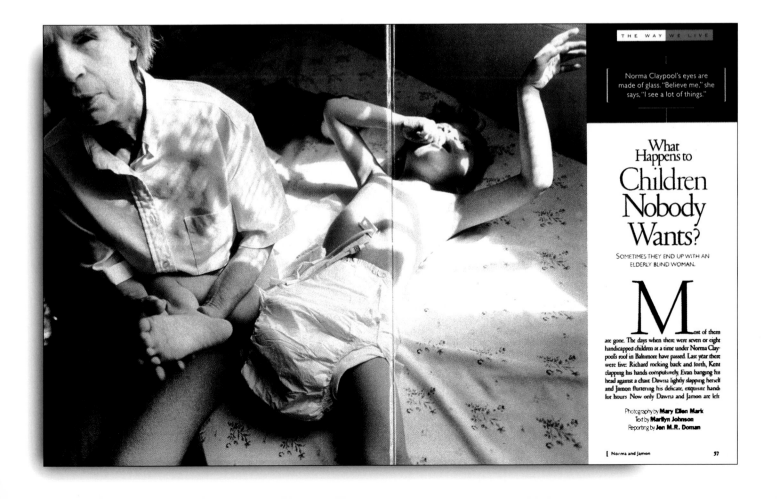

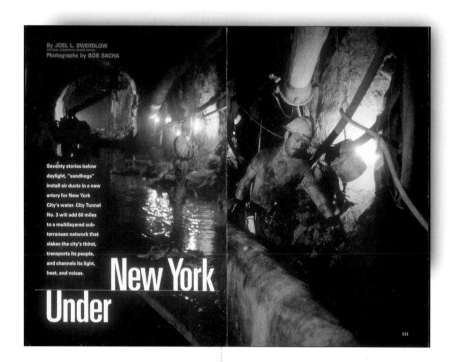

By JOEL L. SWERDLOW
NATIONAL GEOGRAPHIC SENIOR WRITER
Photographs by BOB SACHA

Seventy stories below daylight, "sandhogs" install air ducts in a new artery for New York City's water. City Tunnel No. 3 will add 60 miles to a multilayered sub-terranean network that slakes the city's thirst, transports its people, and channels its light, heat, and voices.

Under New York

Above and below ■
Part of the first-place team picture-editing portfolio.

ELIZABETH CHENG KRIST, DAVID GRIFFIN, BOB SACHA,
FIRST PLACE, MAGAZINE PICTURE EDITING/TEAM

National Geographic

NATIONAL GEOGRAPHIC MAGAZINE WON FIVE AWARDS IN THE EDITING DIVISION OF THIS YEAR'S POY COMPETITION INCLUDING TWO FIRST PLACES.

Above ■ Part of the "Best Use" entry.
NATIONAL GEOGRAPHIC MAGAZINE,
FIRST PLACE, BEST USE OF PHOTOGRAPHY/MAGAZINES

Left ■ Vincent Van Gogh: Lullaby in Color.
JOHN A. ECHAVE, LYNN JOHNSON, DAVID GRIFFIN,
THIRD PLACE, MULTIPLE PAGE FEATURE STORY

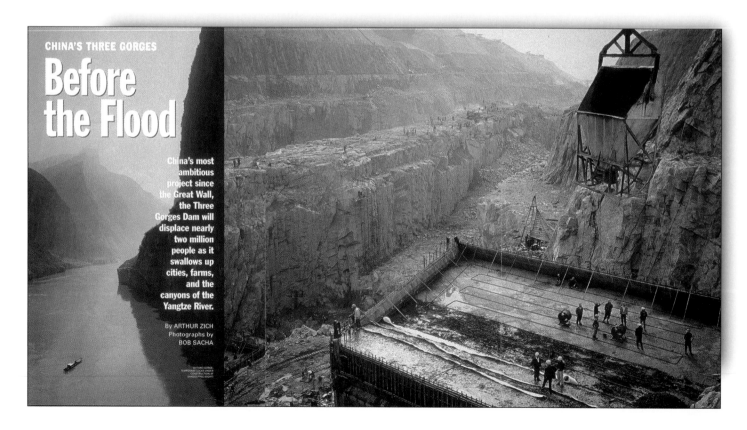

CHINA'S THREE GORGES

Before the Flood

China's most ambitious project since the Great Wall, the Three Gorges Dam will displace nearly two million people as it swallows up cities, farms, and the canyons of the Yangtze River.

By ARTHUR ZICH
Photographs by BOB SACHA

TIME
Magazine

TIME MAGAZINE WON A FIRST PLACE IN THE EDITING DIVISION OF THIS YEAR'S POY COMPETITION.

Above and left ■
Steve's Job: Restart Apple.

BRONWEN LATIMER,
FIRST PLACE, MULTIPLE PAGE NEWS STORY

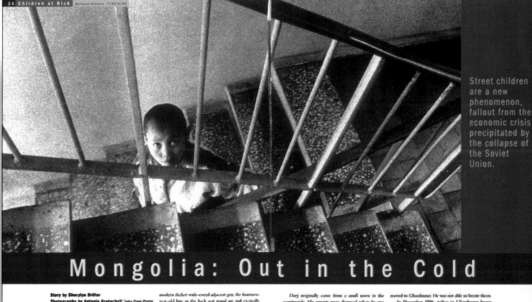

Street children are a new phenomenon, fallout from the economic crisis precipitated by the collapse of the Soviet Union.

Natural
History
Magazine

NATURAL HISTORY MAGAZINE WON TWO AWARDS IN THE EDITING DIVISION OF THIS YEAR'S POY.

Both pages ■ Part of their award-winning team portfolio.

KAY ZAKARIASEN, BRUCE STUTZ, TOM PAGE
THIRD PLACE, MAGAZINE PICTURE EDITING/TEAM

Newsweek

NEWSWEEK MAGAZINE WON TWO AWARDS IN THE EDITING DIVISION OF THIS YEAR'S POY.

Right ■ Follow Me: Inside the Heaven's Gate Mass Suicide.

GUY COOPER, PART OF THE THIRD PLACE, MULTIPLE PAGE NEWS STORY

Below ■ Farewell, Diana.

GUY COOPER, PART OF THE SECOND PLACE, MULTIPLE PAGE NEWS STORY

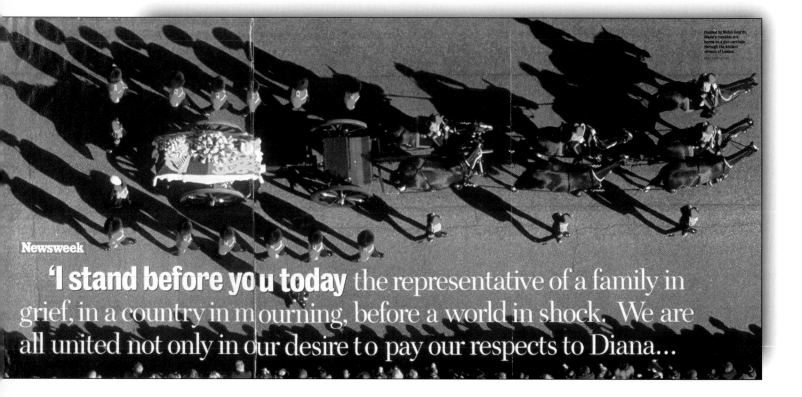

'I stand before you today the representative of a family in grief, in a country in mourning, before a world in shock. We are all united not only in our desire to pay our respects to Diana...

The New York Times Magazine

THE NEW YORK TIMES MAGAZINE WON FOUR AWARDS IN THE EDITING DIVISION INCLUDING A FIRST PLACE.

Right ■ Times Square.

KATHY RYAN, PART OF THE FIRST PLACE, MULTIPLE PAGE FEATURE STORY

U.S. News & World Report

U.S. NEWS WON TWO AWARDS IN THE EDITING DIVISION OF THIS YEAR'S POY.

All three pages ■ Part of their picture-editing portfolio.

MARYANNE GOLON, SECOND PLACE, MAGAZINE PICTURE EDITING/TEAM

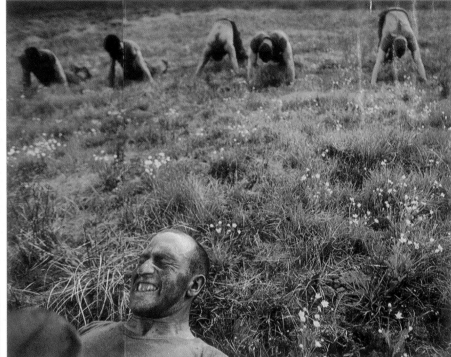

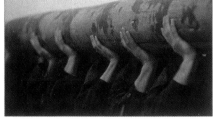

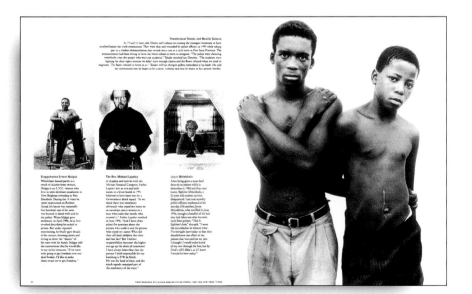

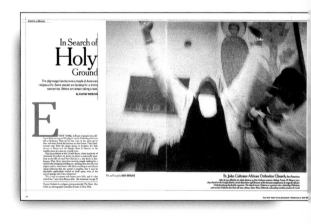

Left, above ■ Part of the Times team portfolio.

**KATHY RYAN, SARAH HARBUTT,
JODY QUON, EVAN KRISS, COURTENAY CLINTON**
SECOND PLACE, MAGAZINE PICTURE EDITING/TEAM

The Last Human Horses

■ time.com/rickshaw2

JAY COLTON, TIME.COM
FIRST PLACE, BEST USE OF PHOTOGRAPHY, INTERNET WEBSITES

Calcutta is the last place in India where people are transportation. But the City of Joy's 50,000 rickshawallahs may soon be out of business. The Communist government is determined to ban the pullers from streets. Party officials say the rickshaws are "degrading," slow traffic to five mph and discourage much-needed foreign investment.

Calcutta's 50,000 pullers disagree.

(This is photographer Colin Finlay's story of the rick-shawallahs' lives and their struggle to keep their jobs.)

Two new categories this year

Changes in this year's POY have added two new categories. Entitled "Best Use of Photos in a CD-ROM" and "Best Use of Photos in an Internet Website," they were created – says POY director Bill Kuykendall *"to extend the POY discussion of standards and excellence to embrace the new media."* This six-page chapter displays selects from the five website winners and the single CD-ROM winner in this year's POY judging. Unfortunately, this book is only able to display a small, representative portion of these winners. To see more, visit the website or seek out the CD-ROM. *(Those URLs and the CD publisher are noted in red.)*

Category definitions

INTERNET WEBSITES: AN INTERACTIVE, MULTIMEDIA EDITORIAL REPORT PUBLISHED ON THE WORLD WIDE WEB. SINGLE STORIES AND ESSAYS ARE ELIGIBLE, AS ARE COMPLEX PACKAGES THAT DEAL WITH A SINGLE TOPIC OR THEME. CONTENT – IMAGES, SOUND, WRITING, NEWS VALUE – OVERALL ORGANIZATION, CLARITY OF FOCUS AND EASE OF USE WILL BE THE GUIDING CRITERIA.

CD-ROMS: AN INTERACTIVE, MULTIMEDIA EDITORIAL REPORT PUBLISHED ON CD-ROM. SINGLE STORIES AND ESSAYS ARE ELIGIBLE, AS ARE COMPLEX PACKAGES THAT DEAL WITH A SINGLE TOPIC OR THEME. CONTENT – IMAGES, SOUND, WRITING, NEWS VALUE – OVERALL ORGANIZATION, CLARITY OF FOCUS AND EASE OF USE WILL BE THE GUIDING CRITERIA.

Netscape: Welcome to Hell 3

NONSTOP SWEAT ◄ INDEX ►

LISTEN TO THE AUDIO CLIP

Squad leader Todd Fowler (right) stares down Brendan McAndrews

"The first day, we were all fairly sure that he was certifiably insane."
- Brendan McAndrews, Kilo Company Plebe

story list | thumbnails | comments Photos ©1997 Pete Souza

Nonstop Sweat

■ www.journale.com/navel

ALAN D. DOROW, JOURNAL E
SECOND PLACE, BEST USE OF PHOTOGRAPHY, INTERNET WEBSITES

During the summer of 1996, Pete Souza photographed one of the companies of the incoming class at the U.S. Naval Academy in Annapolis. The photos were made during more than 30 visits to the Academy. In April of 1997, Souza returned with Journal E to record the comments of that company's experience.

Netscape: Endless Exhaustion 2

NONSTOP SWEAT ◄ INDEX ►

LISTEN TO THE AUDIO CLIP

Struggling through PEP

"PEP was a little too early in the morning and I didn't think it was that fun at all..."
- Tajsha Walker, Kilo Company Plebe

story list | thumbnails | comments Photos ©1997 Pete Souza

MERCURY CENTER | SAN JOSE MERCURY NEWS

STREET SMARTS
Poco Way comes back to life

Macromedia
Shockwave and Java
version

shockwave

Unshocked version

Street Smarts

■ www.mercurycenter.com/
clips/pocoway

JIM GENSHEIMER,
SAN JOSE MERCURY NEWS
THIRD PLACE, BEST USE
OF PHOTOGRAPHY, INTERNET WEBSITES

For nearly three decades two simple
words, "Poco Way," were the very definition
of a block-long slice of hell.
The infamous East Side neighborhood was
long considered the most violent, drug-
drenched enclave in San Jose, California.
It was heavily populated with criminals,

ASSIGNMENT:
Times Square

TS HOME | DISCUSSION
PREVIOUS | IMAGE INDEX | NEXT

The New York Times | click here
Business

Richard
Burbridge

Assignment:
Times Square

■ www.nytimes.com/
specials/ts/home

THE NEW YORK TIMES ELECTRONIC MEDIA CO.
AWARD OF EXCELLENCE,
BEST USE OF PHOTOGRAPHY, INTERNET WEBSITES

The most famous photograph of Times Square is surely Alfred Eisenstaedt's
chestnut of the kissing couple, which summed up the national mood in 1945
because it combined all the right elements: the returning soldier, the woman
who welcomed him back and Times Square, the crossroads that symbolized
home. Some people were upset to learn later that Eisenstaedt may have staged
the kiss, as if this somehow invalidated the image. The picture had first been
published in LIFE Magazine, which meant that it was assumed to document
what happened serendipitously at the instant the shutter clicked. Of course,
all photographs are contrived to the degree that the photographer chooses the

gang bangers, junkies and dope pushers. Even cops wouldn't walk down that street alone. Now, after nearly four years of hard work by the weary residents, volunteers, city officials, housing authority members, social workers and the police, the neighborhood has been revitalized into a clean, safe street full of hope. On this special site, with the visual assistance of over 60 photos by San Jose Mercury News staff photographer Jim Gensheimer and text by staff writer David E. Early, the uplifting story of how Poco Way went from a "Mean Street to a Clean Street" comes to life.

image, framing what is to be in and out of it, and Eisenstaedt, to insure he'd get the effect he wanted, simply recreated for the camera what was taking place around him anyway. But, if so, he still broke the pact between photojournalist and viewer, creating something that tended toward fiction or theater. In a strange way it was true at least to the spirit of Times Square, the epicenter of Broadway.
(Excerpted from the New York Times website.)

Child Labor

■ time.com/reports/
childlabor

CHRISTINA HOLOVACH, TIME.COM
AWARD OF EXCELLENCE,
BEST USE OF PHOTOGRAPHY, INTERNET
WEBSITES

Resolved: Childhood is endowed with certain inherent and inalienable rights, among which are freedom from toil for daily bread; the right to play and to dream; the right to the normal sleep of the night season; the right to an education, that we may have equality of opportunity for developing all that there is in us of mind and heart.

Eight decades after this "Declaration of Dependence," many children are still denied the rights of childhood. The International Labor Organization estimates that more than 250 million children between the ages of five and 14 work under life-threatening conditions. In Egypt, there are 1.4 million child laborers.

Children from Cairo's "City of the Dead," named for its location on an old graveyard, toil in tile, glass, shoe and carpet factories 10 hours a day, six days a week. Photographer Colin Finlay won first place in the 1996 POY Magazine Issue Reporting Picture Story for this portrait of their lives.

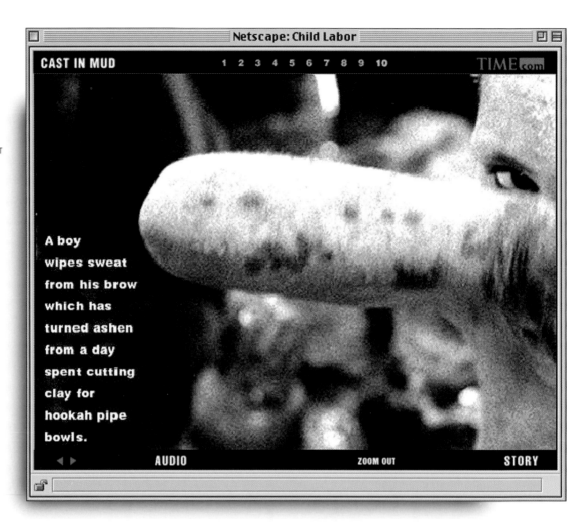

JUNE 1991

I'M NOT GOING TO LAST.

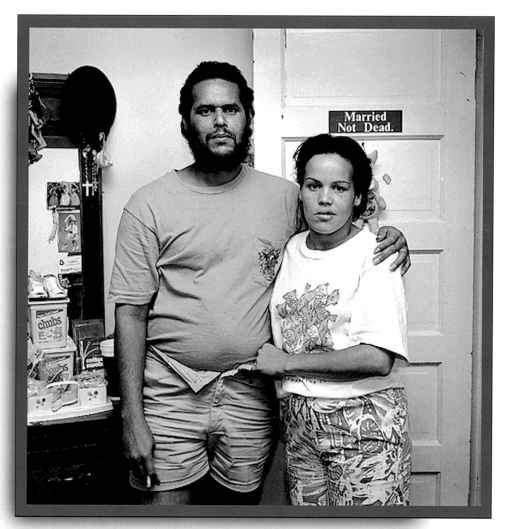

Married Not Dead.

A Bronx Family Album

■ CD-ROM, published by Scalo

STEVE HART, FREELANCE, (BROOKLYN, NEW YORK)
FIRST PLACE, BEST USE OF PHOTOGRAPHY, CD-ROMS

(THIS ESSAY, "A BRONX FAMILY ALBUM," ALSO RECEIVED A JUDGE'S SPECIAL RECOGNITION IN THE COMMUNITY AWARENESS CATEGORY OF THIS YEAR'S POY.)

In 1990, Steve Hart began documenting the lives of Richard and Sensa, a Puerto Rican couple living on welfare with four children between the ages of two and 13. Both parents are HIV positive and Sensa is addicted to crack. She turns to prostitution to support her habit and eventually becomes pregnant again. She dies as a result of complications with her pregnancy exacerbated by AIDS. Shortly thereafter the fourteen year-old daughter leaves home and becomes pregnant.

This CD project, "A Bronx Family Album" spans seven years and includes all the pain, joy and humor that fill a growing, if threatened, family. Using powerful photographic reportage, video and voice recordings, Steve Hart gives a unique insider's view of this family's struggle and determination, its love and disillusion. Hart explains, "It's a family album. Family albums are about love, about relationships, about interaction."

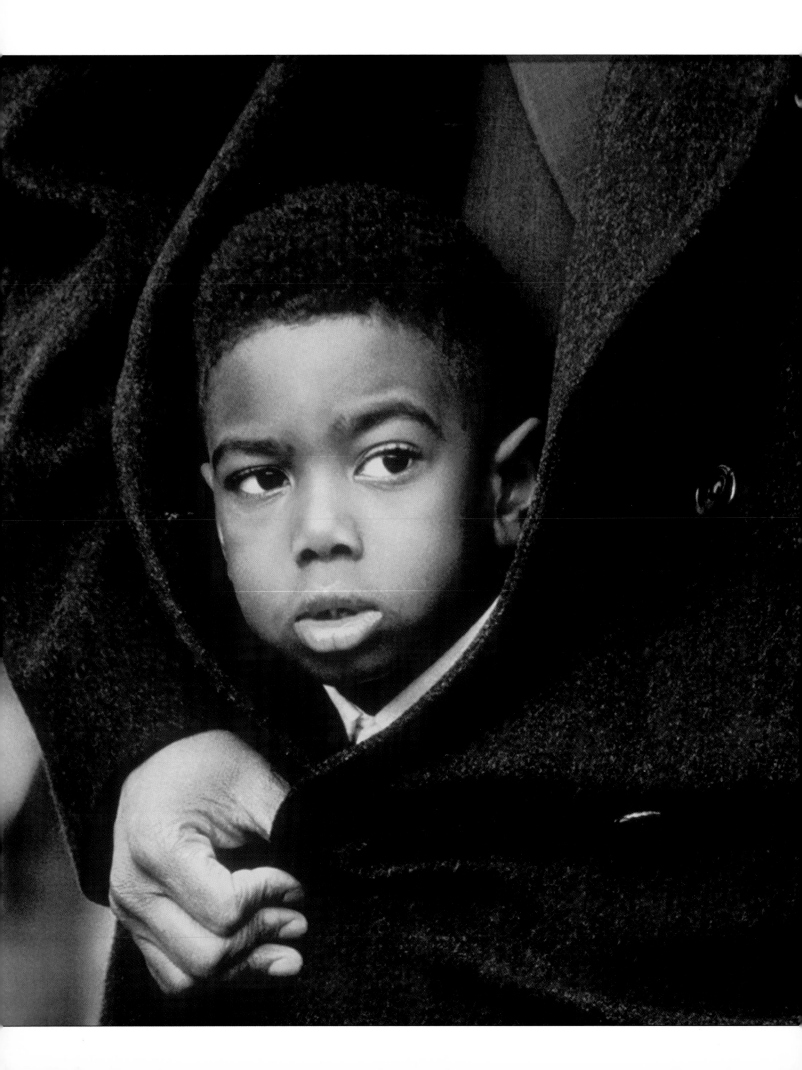

NEWS PICTURES

The events, the tragedies and the happenings we call news

This 18-page chapter includes 26 of the 31 award winners from the spot, general and global news categories in both the newspaper and magazine divisions of this year's 55th Pictures of the Year competition.

NOT INCLUDED HERE IS NANCY ANDREWS' AWARD OF EXCELLENCE GENERAL NEWS PHOTO. IT CAN BE FOUND WITH HER NEWSPAPER PHOTOGRAPHER OF THE YEAR PORTFOLIO **ON PAGE 25.** NANCY'S AWARD OF EXCELLENCE GLOBAL NEWS PICTURE IS DISPLAYED WITH HER FIRST PLACE GLOBAL NEWS PICTURE STORY **ON PAGE 202.** ALSO NOT INCLUDED IS EUGENE RICHARDS' AWARD OF EXCELLENCE GLOBAL NEWS PICTURE. IT CAN BE FOUND WITH HIS CANON PHOTO ESSAY **ON PAGE 57.** FINALLY, ROGER LEMOYNE'S THIRD PLACE AND AWARD OF EXCELLENCE IN THE GLOBAL NEWS CATEGORY ARE DISPLAYED WITH HIS FIRST PLACE MAGAZINE GLOBAL NEWS PICTURE STORY **ON PAGE 205.**

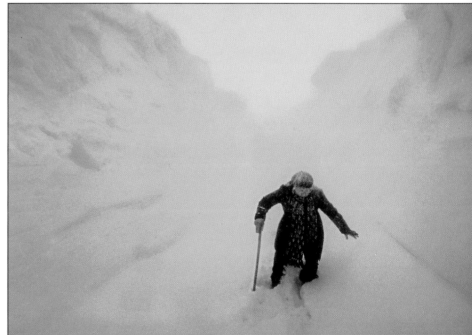

Above ■ An old woman struggles through 20-foot high snow drifts left by a blizzard.

BILL ALKOFER, ST. PAUL PIONEER PRESS
AWARD OF EXCELLENCE, SPOT NEWS

Left ■ Muammar Ramadan peers from his dad's coat at a rally for the "Day of Absence" in Philadelphia on the second anniversary of the "Million Man March."

DAVID MAIALETTI, PHILADELPHIA DAILY NEWS
AWARD OF EXCELLENCE, GENERAL NEWS

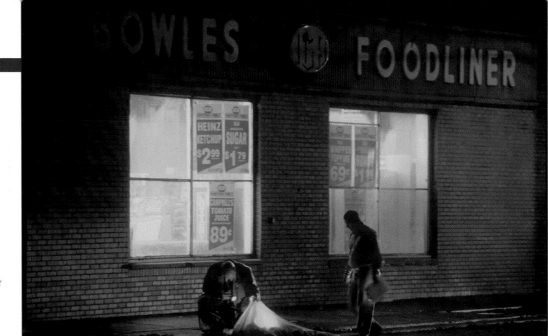

Right ■ Columbus police detectives inspect the body of a man who was deliberately run over after a dispute.

DORAL CHENOWETH III, COLUMBUS DISPATCH

SECOND PLACE, SPOT NEWS

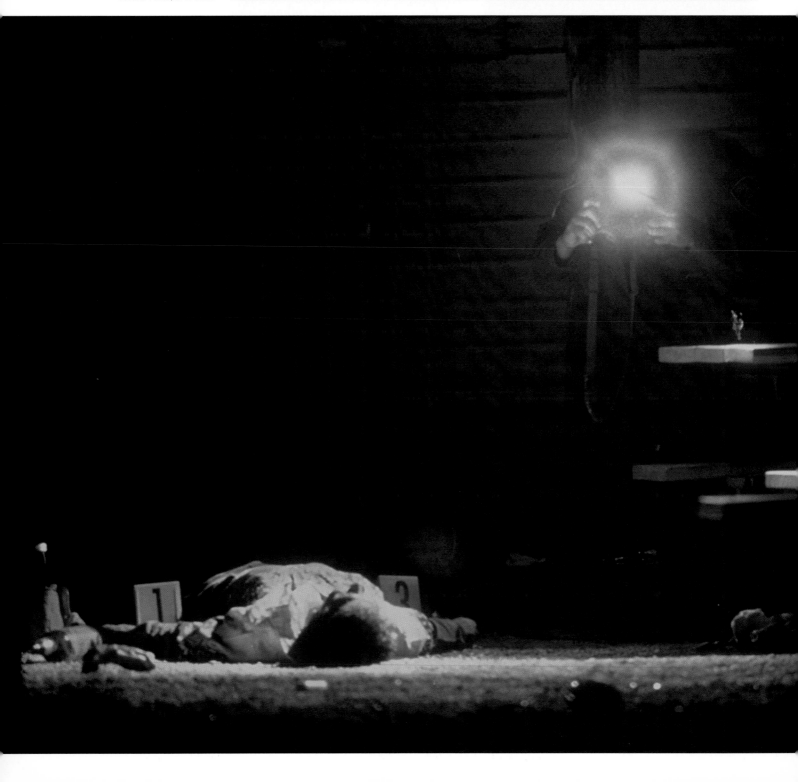

Below ■ A San Antonio police officer photographs a man that was killed in a bar fight.

**EDWARD D. ORNELAS III,
SAN ANTONIO EXPRESS-NEWS**

AWARD OF EXCELLENCE, SPOT NEWS

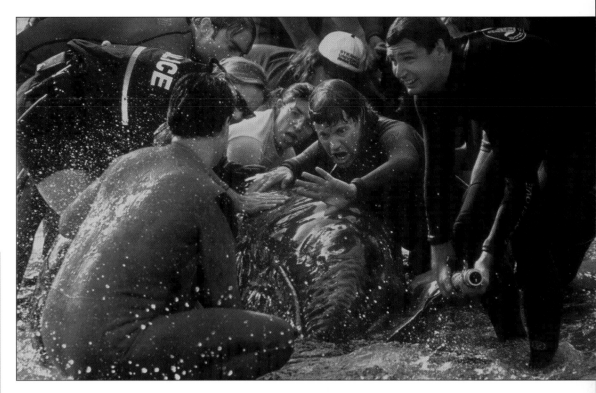

Above ■ Rescuers load an abandoned newborn gray whale
on a stretcher at Venice State Beach before hoisting her onto a truck.

BERNARDO ALPS, THE NEWS-PILOT, SANTA MONICA
AWARD OF EXCELLENCE, SPOT NEWS

Below ■ With his mother Jacqueline at his side, Gereco Buckner,
age 3, talks to a fire department battalion chief after using a lighter
to ignite a mattress that destroyed his family's apartment.

ROBERT COHEN, COMMERCIAL APPEAL
AWARD OF EXCELLENCE, SPOT NEWS

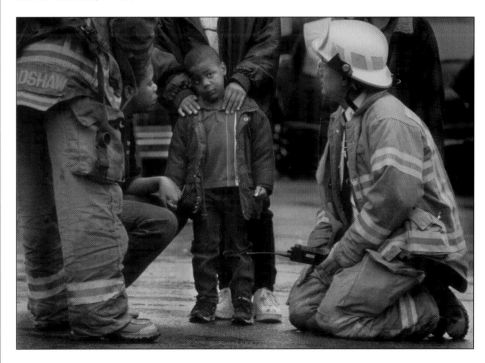

Above ■ A member of the People's Armed Police Honor Guard stands at attention as the flag commemorating the death of Deng Xiao Peng hangs at half mast.

STEVE LEHMAN, U.S. NEWS & WORLD REPORT
FIRST PLACE, GENERAL NEWS

Right ■ Pam Barber comforts her young daughter at Pearl Harbor as her husband leaves for the Persian Gulf on the USS Reuben James.

JEFF WIDENER, HONOLULU ADVERTISER
SECOND PLACE, GENERAL NEWS

Below ■ Washington D.C. fireman Jonathan Sneed is both restrained and comforted after he attempted to re-enter a burning building where his friend and fellow firefighter perished.

DAYNA SMITH, THE WASHINGTON POST
FIRST PLACE, SPOT NEWS

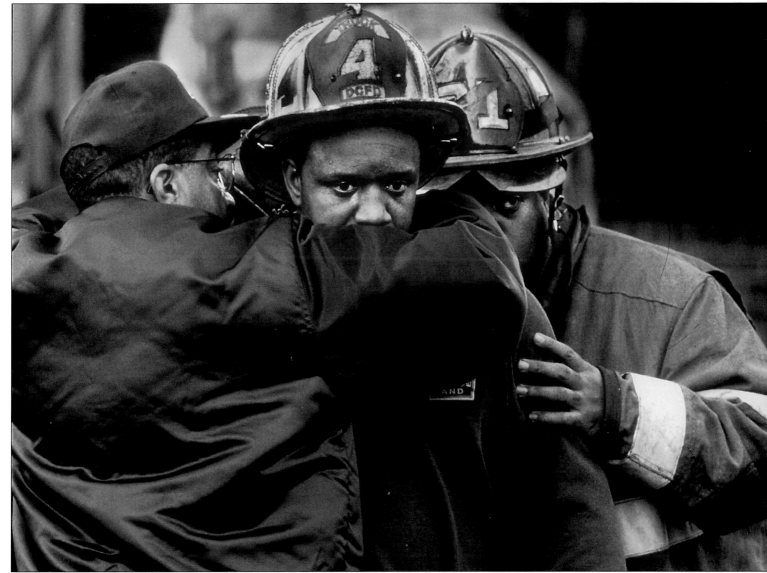

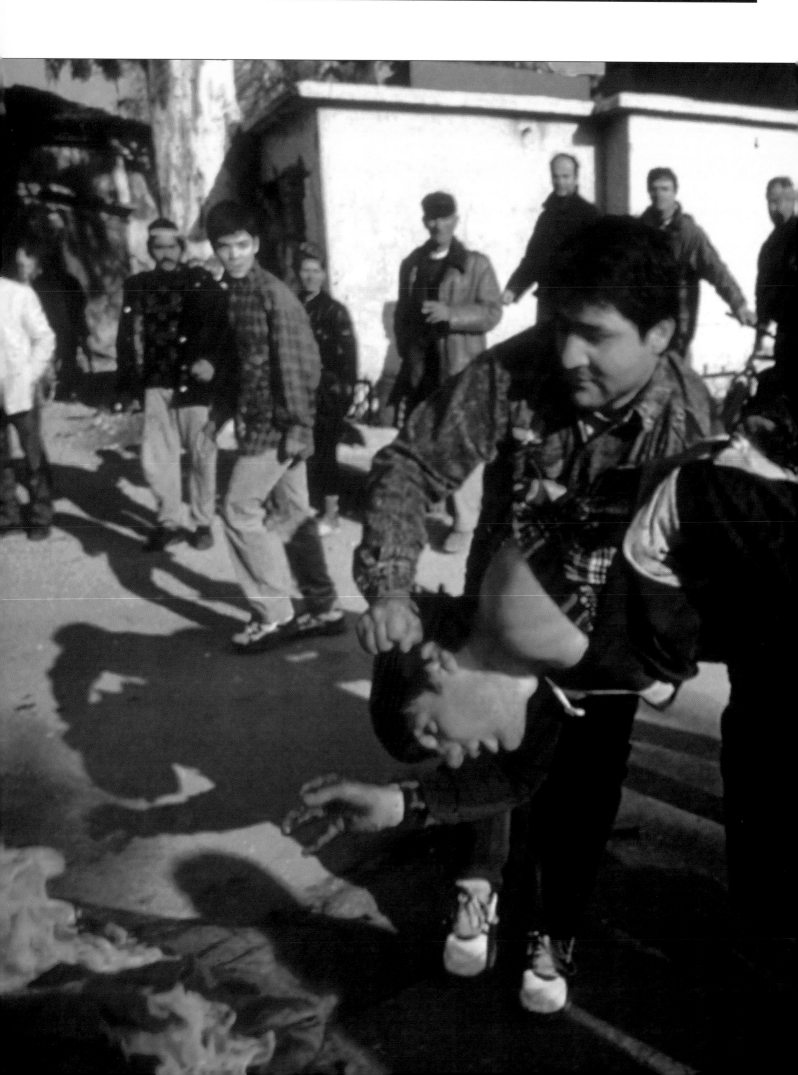

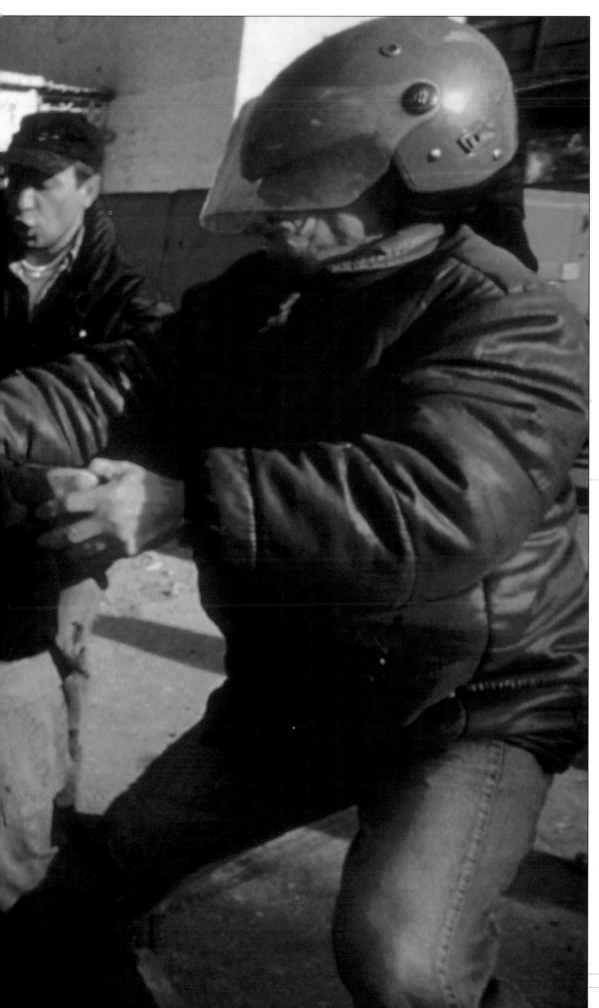

Left ■ Albanian citizens, one wearing a stolen police helmet, attempt to throw a plain-clothed policeman into street fire during clashes in Vlora, Albania.

**SANTIAGO LYON,
THE ASSOCIATED PRESS**

FIRST PLACE,
NEWSPAPER GLOBAL NEWS

THIS PHOTOGRAPH WAS ALSO
PART OF AN AWARD OF EXCELLENCE
GLOBAL NEWS PICTURE STORY.
SEE PAGE 204.

Category definitions

SPOT NEWS – A PICTURE OF AN
UNSCHEDULED EVENT FOR WHICH
NO ADVANCE PLANNING WAS
POSSIBLE TAKEN IN THE COURSE
OF DAILY COVERAGE. EXAMPLES:
FIRES, ACCIDENTS AND LOCALIZED
NATURAL DISASTERS.

GENERAL NEWS – A PICTURE OF
A SCHEDULED POLITICAL, SOCIAL
OR CULTURAL EVENT FOR WHICH
ADVANCE PLANNING WAS POSSIBLE.
EXAMPLES: DEMONSTRATIONS,
STAGED ENTERTAINMENT AND
PROMOTIONAL EVENTS.

GLOBAL NEWS – COVERAGE OF
MAN-MADE AND NATURAL DISASTERS
THAT PRODUCE MASSIVE SOCIAL
UPHEAVAL SUCH AS WAR OR FAMINE.

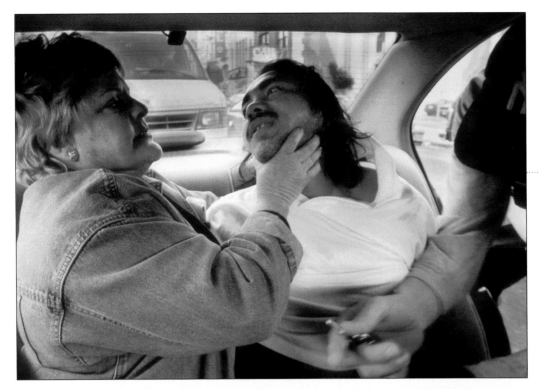

Left ■ Bounty hunter Mackenzie Green puts a chokehold on Julio Rojas who pulled free from handcuffs while trying to escape.

**BOB LARSON,
CONTRA COSTA TIMES**
AWARD OF EXCELLENCE,
SPOT NEWS

Below ■ Staring into the barrel of an officer's gun, Robert Caperelli faces possible life in prison under the three strikes law after trying to steal several worthless medals he thought were gold.

**RICK LOOMIS,
LOS ANGELES TIMES/ORANGE COUNTY EDITION**
THIRD PLACE, SPOT NEWS

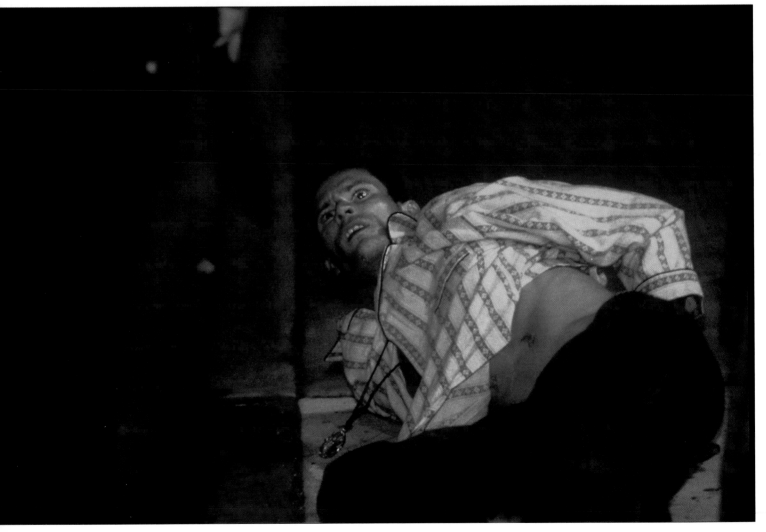

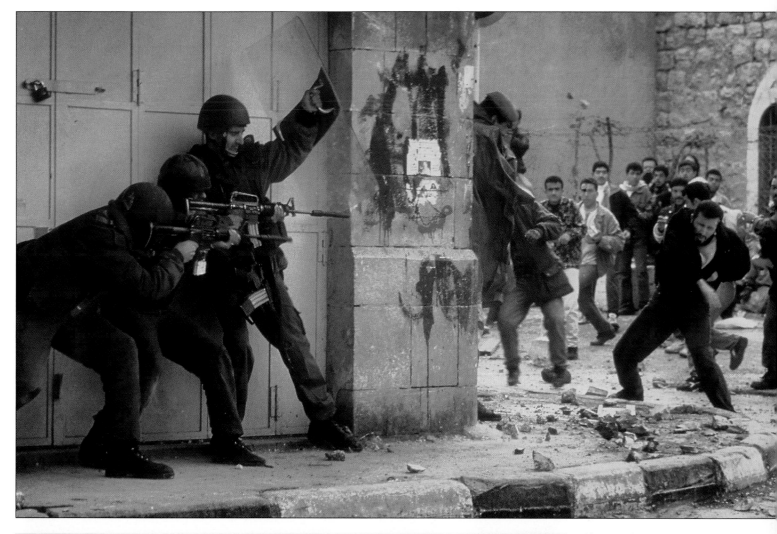

Above ■ A stone-throwing Palestinian demonstrator recoils the instant he is shot by Israeli soldiers firing rubber-sheathed metal bullets during clashes in the West Bank town of Hebron.

WENDY LAMM,
FREELANCE, AGENCE FRANCE-PRESS
AWARD OF EXCELLENCE,
NEWSPAPER GLOBAL NEWS

Left ■ A man, suspected of belonging to the defeated presidential guard of President Mobutu, tumbles forward after being executed in a Kinshasa alley by victorious Zairean rebels.

JEAN-MARC BOUJU,
THE ASSOCIATED PRESS
AWARD OF EXCELLENCE,
NEWSPAPER GLOBAL NEWS

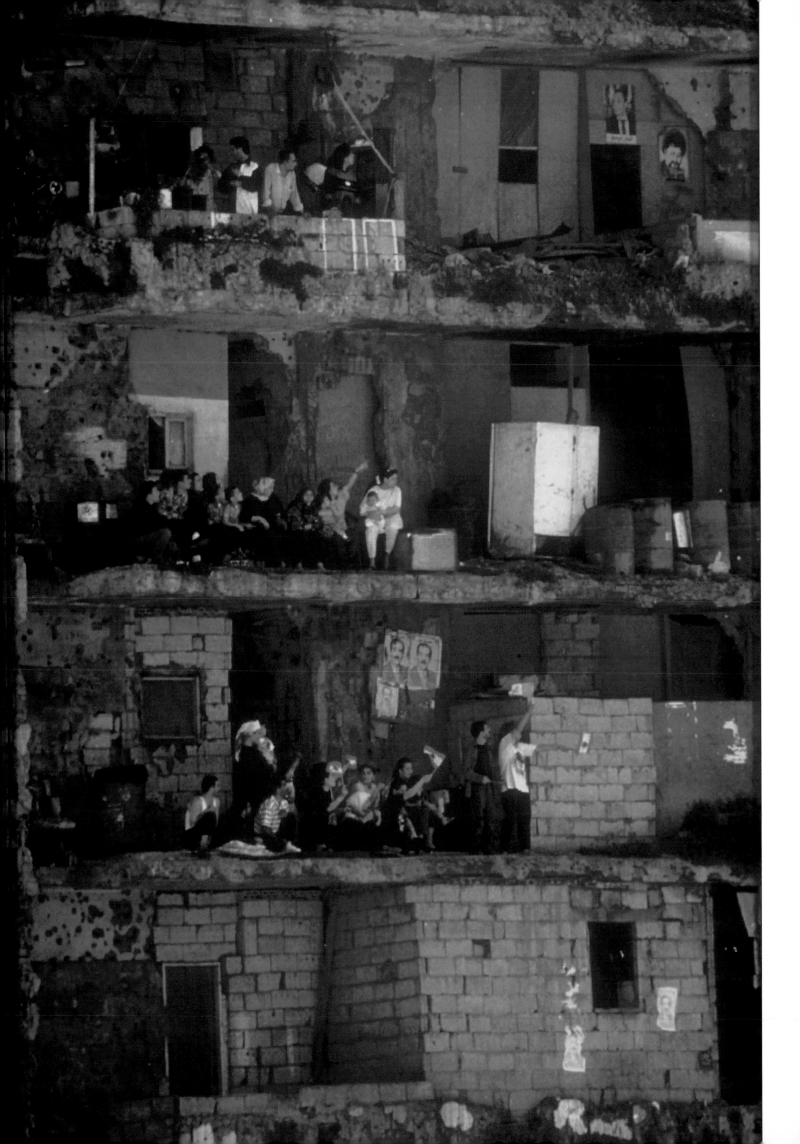

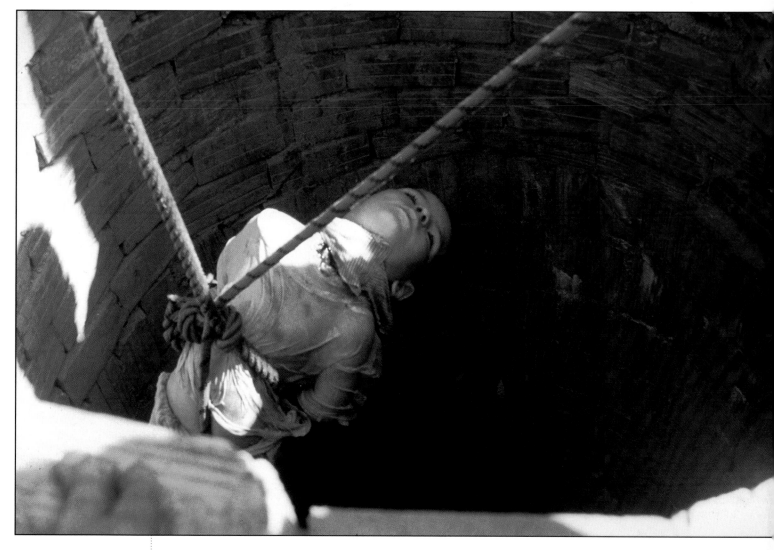

Facing Page ■
Beirut residents living
in a war-torn building
on the old Green Line
wave as Pope John Paul
II makes his way
from the airport.

**JEROME DELAY,
THE ASSOCIATED PRESS**

AWARD OF EXCELLENCE,
GENERAL NEWS

Above ■ A boy slashed by Algerian extremists.

ANONYMOUS, SIPA PRESS, AWARD OF EXCELLENCE, SPOT NEWS

Below ■ A gravely ill Hutu refugee clutches for help near a makeshift clinic
in the Biaro refugee camp in Zaire.

JOHN MOORE, THE ASSOCIATED PRESS, SECOND PLACE, NEWSPAPER GLOBAL NEWS

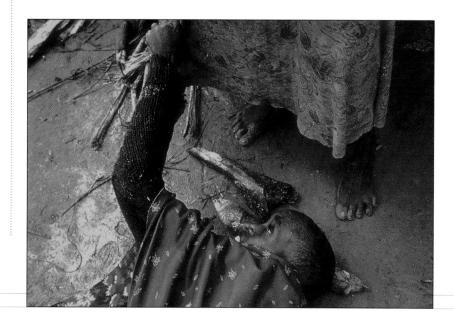

Right ■ Ninety-one Hutu refugees died of asphyxiation when they crowded onto a train leaving their jungle camps.

ROGER LEMOYNE, GAMMA-LIAISON
FIRST PLACE, MAGAZINE GLOBAL NEWS

THIS PHOTOGRAPH WAS ALSO PART OF THE FIRST PLACE GLOBAL NEWS PICTURE STORY. **SEE PAGE 205.**

Above ■ Rwandan Hutu refugees await food, medicine and repatriation in the forest east of Kisangani in April. Tens of thousands had fled Goma six months earlier.

RADHIKA CHALASANI, SIPA PRESS
AWARD OF EXCELLENCE,
MAGAZINE GLOBAL NEWS

THIS PHOTO WAS ALSO PART OF THE SECOND PLACE GLOBAL NEWS PICTURE STORY. **SEE PAGE 206.**

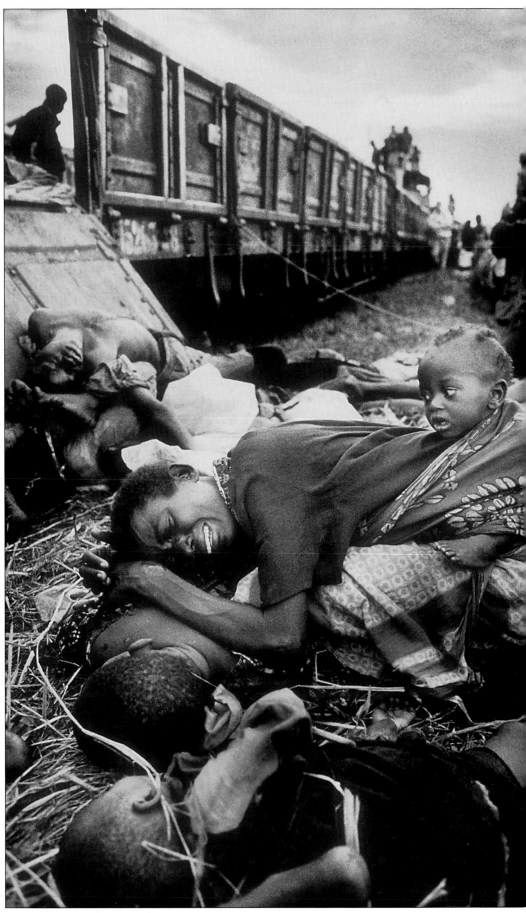

Above ■ "This is our home. I want to live here for the rest of my life," said the child after turning cartwheels in the street. He and his family lived here all through the war and he is happy to be able to go outside to play in the sniper-free streets of Sarajevo.

NANCY ANDREWS, THE WASHINGTON POST
AWARD OF EXCELLENCE,
NEWSPAPER GLOBAL NEWS

THIS PHOTO WAS ALSO PART OF THE FIRST PLACE GLOBAL NEWS PICTURE STORY AND THE FIRST PLACE NEWSPAPER PHOTOGRAPHER OF THE YEAR PORTFOLIO. **SEE THE STORY ON PAGE 202, THE PORTFOLIO ON PAGES 14-29.**

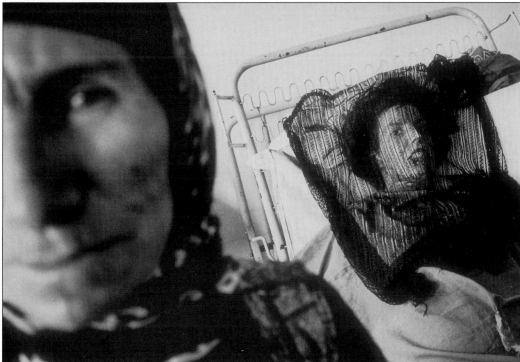

Left ■ At a hospital in Sulaymaniyah, the chief surgeon estimates that 70 percent of his patients are brought in with injuries caused by land mines.

FRANCESCO ZIZOLA, MATRIX/LIFE MAGAZINE
SECOND PLACE, MAGAZINE GLOBAL NEWS

Below ■ Christopher Coffman, age 5, hangs on
to his mother during his family's visit to the Moving
Vietnam Veterans Wall. He was there to see
the name of the cousin he never knew.

ARISTIDE ECONOMOPOULOS, THE HERALD (JASPER, INDIANA)
THIRD PLACE, GENERAL NEWS

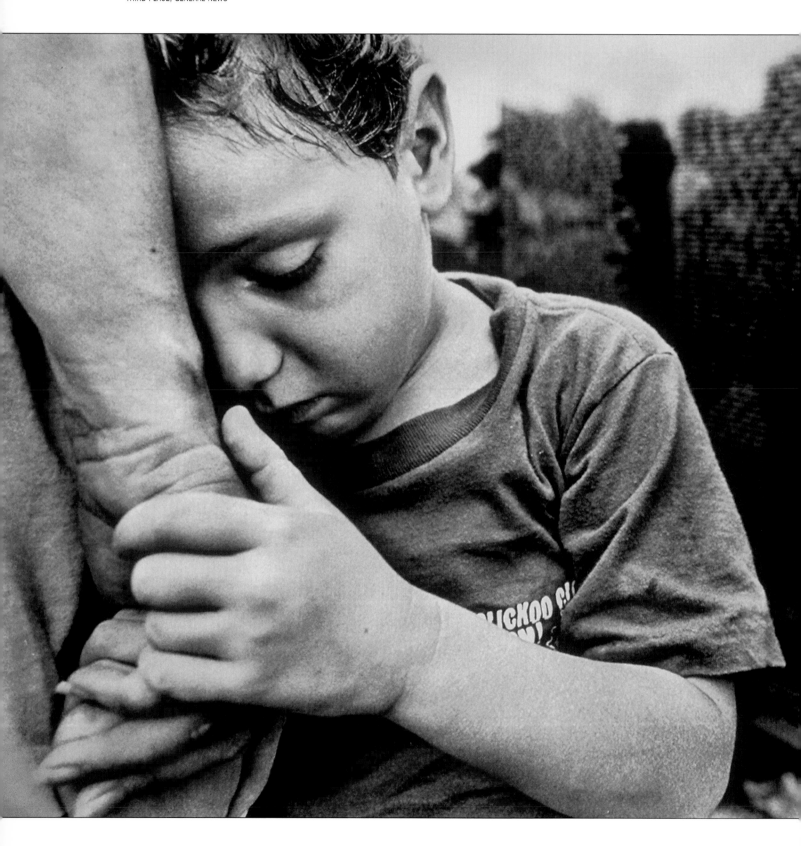

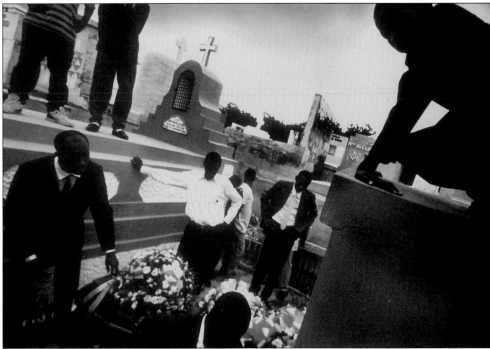

Above ■ Death is a serious part of daily life for Haiti's poor. A little boy perched on a tomb watches over a burial in the Port-au-Prince cemetery after the funeral.

DEBBIE MORELLO, FREELANCE, KNIGHT-RIDDER/TRIBUNE
THIRD PLACE, NEWSPAPER GLOBAL NEWS

THIS PHOTO IS ALSO PART OF THE THIRD PLACE GLOBAL NEWS PICTURE STORY, **PAGE 204.**

Below ■ During the signing ceremony for the Adoption and Safe Families Act of 1997, seven-year-old Aaron Badeau sits next to President Clinton. Aaron is from a Philadelphia family of 21 children, most of whom are adopted.

SUSAN BIDDLE, THE WASHINGTON POST, AWARD OF EXCELLENCE, GENERAL NEWS

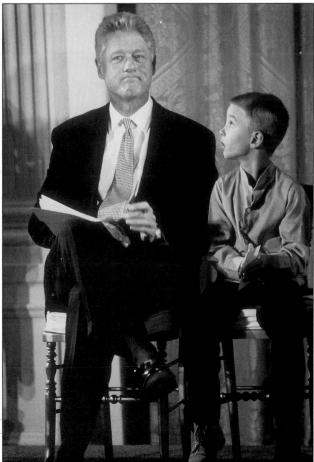

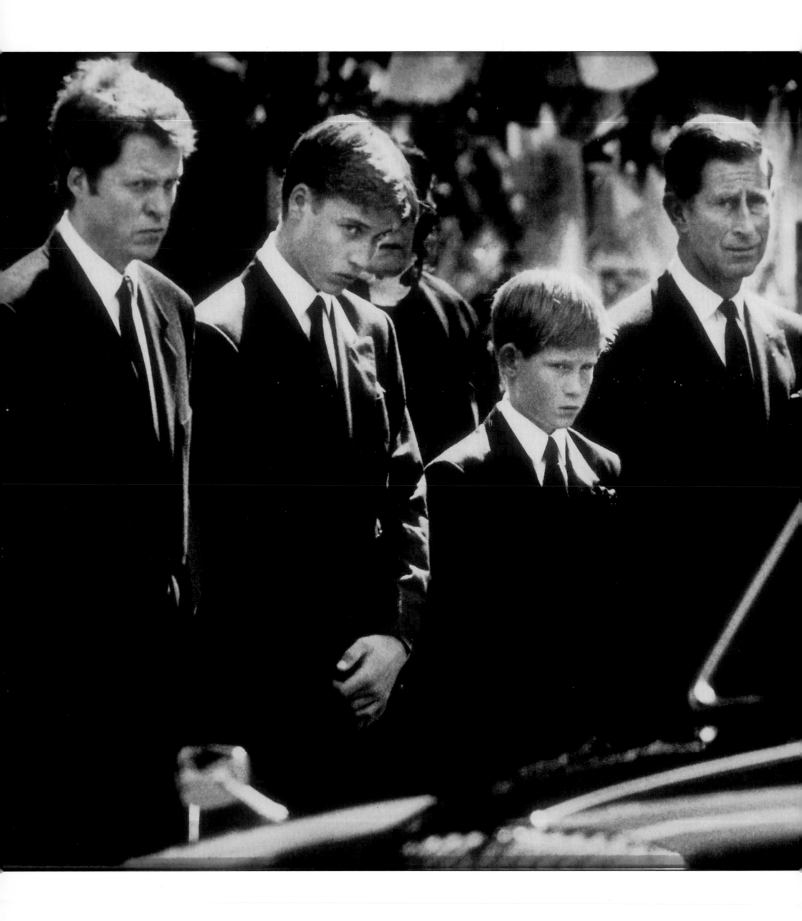

Below ■ "Cobra" rebels loyal to General Denis Sassou-Nguesso sit on a sofa set up near a roadblock in Brazzaville, Republic of Congo.

DAVID GUTTENFELDER, THE ASSOCIATED PRESS
AWARD OF EXCELLENCE, NEWSPAPER GLOBAL NEWS

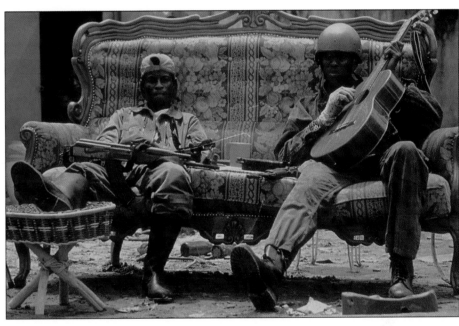

Left ■ Princess Diana's brother, The Earl Spencer, her sons Princes William and Harry and her ex-husband, Prince Charles, watch the hearse carrying her casket leave Westminster Abbey.

BRIAN WALSKI, BOSTON HERALD
JUDGES' SPECIAL RECOGNITION, NEWSPAPER GLOBAL NEWS

..

THIS YEAR'S POY JUDGING PANEL VOTED TO RECOGNIZE THIS PHOTO WITH A SPECIAL AWARD. ENTERED IN THE GLOBAL NEWS CATEGORY, THE JUDGES THOUGHT THIS SUCH AN OUTSTANDING PHOTO IT SHOULD BE RECOGNIZED DESPITE ITS MIS-CATEGORIZATION. THEY DIDN'T WANT TO CONFUSE PHOTOGRAPHERS ABOUT WHAT WAS APPROPRIATE FOR THE CATEGORY BY GIVING IT AN AWARD OF EXCELLENCE.

JUDGE TOM KENNEDY SUMMED UP THEIR FEELING THIS WAY: " [IT'S] PROBABLY THE FINEST PICTURE THAT I SAW COME OUT OF THE FUNERAL COVERAGE AND I DON'T WANT IT TO BE LOST TO POSTERITY BECAUSE I THINK IT'S AN EXAMPLE OF REALLY INCREDIBLY GOOD SEEING... AND, YOU KNOW, THE DEFINING MOMENT OF AN EVENT WHERE THE WHOLE WORLD LITERALLY IS WATCHING AND YET THIS PICTURE RISES TO THE FORTH SO ALL I'M SAYING IS WE SHOULDN'T LOSE THIS... THIS IS AN EXAMPLE THAT SHOULD BE EMULATED FOR THE FUTURE..."

Issue reporting

This category is defined as: *"A photograph that explores an important social, economic or political issue. Examples: the homeless and those that help them, decline and growth in urban communities, environmental decay or preservation.* This eight-page chapter includes 15 of the 16 award winners from the newspaper and magazine divisions.

NOT INCLUDED HERE IS PAULA LERNER'S FIRST PLACE MAGAZINE ISSUE REPORTING PHOTOGRAPH. IT CAN BE FOUND WITH HER FIRST PLACE ISSUE REPORTING PICTURE STORY. SEE **PAGE 211**.

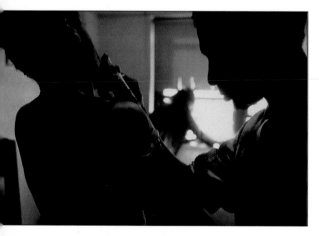

Above ■ Two brothers inject each other with heroine as their mother, also an addict, looks out the window.

ANDRE LAMBERTSON, SABA

AWARD OF EXCELLENCE, MAGAZINE ISSUE REPORTING

Right ■ At the Mayo Hospital in Lahore, a victim of "wife burning" receives treatment after her estranged husband threw acid on her face.

ED KASHI, FREELANCE, SAN FRANCISCO

THIRD PLACE, MAGAZINE ISSUE REPORTING

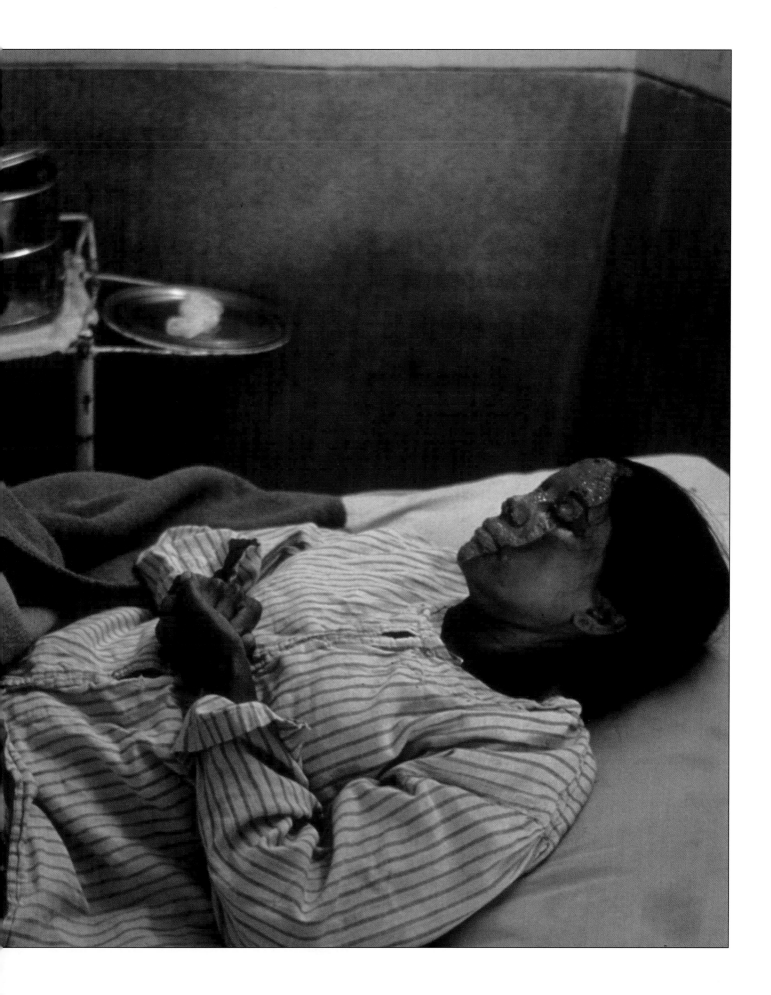

Right ■ Tisha, 22, was removed from the custody of her mother when she was eight. The reason Tisha doesn't smoke crack is because her mother was addicted to crack cocaine. Yet, she doesn't want her 4-year-old daughter Zurie to see her smoking marijuana.

BRENDA ANN KENNEALLY, FREELANCE, NEW YORK CITY

AWARD OF EXCELLENCE, MAGAZINE ISSUE REPORTING

THIS PHOTO IS ALSO PART OF A COMMUNITY AWARENESS PORTFOLIO THAT RECEIVED A JUDGES' SPECIAL RECOGNITION. **SEE PAGE 242.**

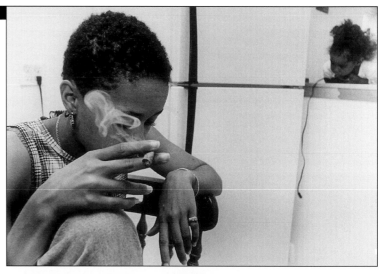

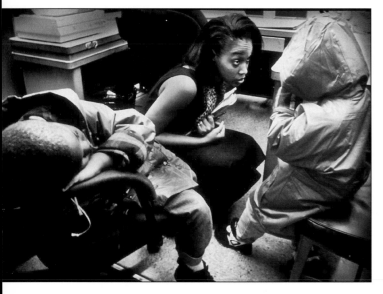

Above ■ Welfare caseworker Angela Perkins talks to Harry Harris as his brother David sleeps while waiting for their mom Cynthia Harris.

JUANA ARIAS, THE WASHINGTON POST

AWARD OF EXCELLENCE, NEWSPAPER ISSUE REPORTING

Right ■ Cameron Gonzales, 3, watches television on his uncle's porch. The television is his babysitter while his parents visit his uncle.

DON SEABROOK, THE WENATCHEE WORLD

AWARD OF EXCELLENCE, NEWSPAPER ISSUE REPORTING

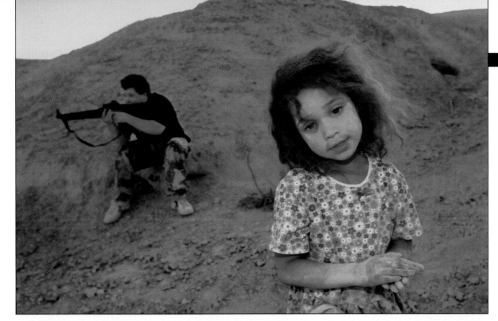

Left ■ Four-year-old Renee Lalonde, of Las Vegas, asks a stranger "Did you kill my mommy?" as her brother Matt empties multiple rounds into the Nevada desert.

CAROLYN COLE, LOS ANGELES TIMES

THIRD PLACE, NEWSPAPER ISSUE REPORTING

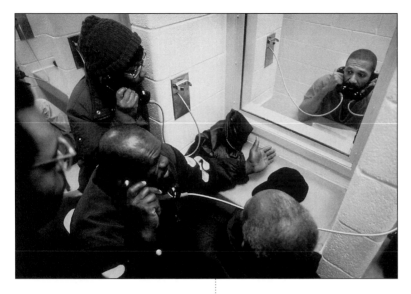

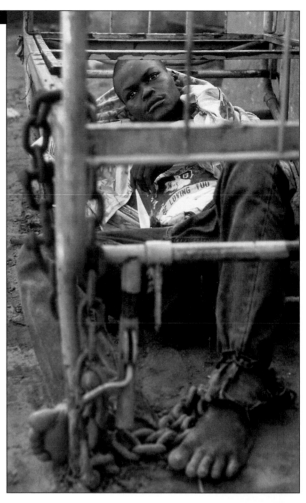

Above ■ Patrick Elie, a Haitian political prisoner being held in a Warsaw, Virginia. jail, has little contact with outsiders but is visited once a week by members of a Brooklyn support group who drive down to spend time with him.

SUSAN BIDDLE, THE WASHINGTON POST
AWARD OF EXCELLENCE,
NEWSPAPER ISSUE REPORTING

Below ■ Pear blossoms are pollinated by hand near Ikaruga, Japan, due to the overuse of pesticides by farmers destroying many of the insects which pollinate naturally.

GIDEON MENDEL, NETWORK PHOTOGRAPHERS
AWARD OF EXCELLENCE,
MAGAZINE ISSUE REPORTING

Left ■ An 8-year-old boy carries clay pots to a nearby kiln where burning tires harden the clay wares. He works an eight-hour day earning $1.50 a day in Cairo, Egypt.

MATTHEW MOYER,
EGYPT TODAY MAGAZINE

AWARD OF EXCELLENCE,
MAGAZINE ISSUE REPORTING

Left ■ Patients at Pap Kitoco's mental asylum in Luanda, Angola, are chained to their beds and other large heavy objects, to prevent escape.

JOE STEFANCHIK,
THE DALLAS MORNING NEWS

AWARD OF EXCELLENCE,
NEWSPAPER ISSUE REPORTING

Below ■ Children in kindergarten and victims of famine in North Korea.

JUSTIN KILCULLEN,
SYGMA/NEWSWEEK

AWARD OF EXCELLENCE,
MAGAZINE ISSUE REPORTING

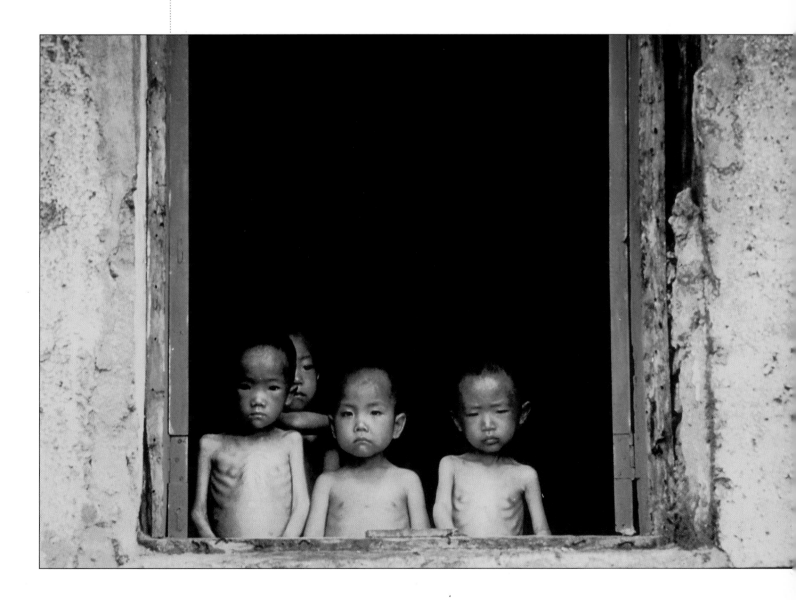

Left ■ Outside her home in Stillwater, Oklahoma, anorexic Jayme Porter shows off how skinny she is. "I have power," she says, "I am thinnest."

**NINA BERMAN,
SIPA PRESS/LIFE MAGAZINE**

SECOND PLACE,
MAGAZINE ISSUE REPORTING

Below ■ A mother with six children and no home of her own feeds her famished kids with leftovers brought back by her mother-in-law from a party.

**MARICE COHN BAND,
MIAMI HERALD**

FIRST PLACE,
NEWSPAPER ISSUE REPORTING

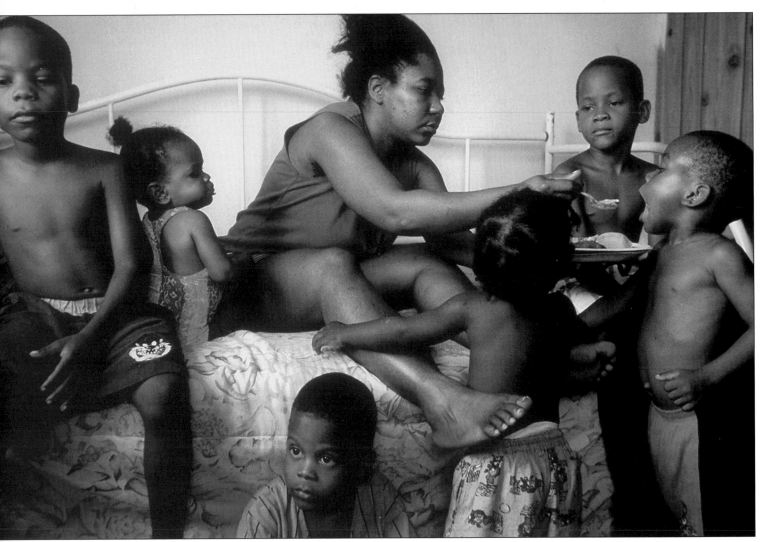

Above ■ Ashley Windle, 7, autistic and mentally retarded, watches her favorite channel, Nickelodeon. She is back home after a four-month stay in a children's home because her roommate beat her.

**VICKI CRONIS,
THE VIRGINIAN - PILOT**

SECOND PLACE,
NEWSPAPER ISSUE REPORTING

Right ■ Noel Earley, a proponent of physician-assisted suicide, has a custom-made coffin delivered to his home in preparation for his suicide.

**JOHN FREIDAH,
THE PROVIDENCE JOURNAL - BULLETIN**

AWARD OF EXCELLENCE,
NEWSPAPER ISSUE REPORTING

Illustrations and other realities

The Product Illustration category of the 55th POY competition is displayed on the following four pages. The category is defined as: *"A photograph illustrating a consumable product such as clothing and accessories, food, appliances, or automobiles.* (This year, the Issue Illustration category was eliminated.)

Above ■ **The Taste of the Town.**
An illustration for a story on the top ten restaurants in the Norfolk area.

MARTIN SMITH-RODDEN, THE VIRGINIAN-PILOT, (NORFOLK, VIRGINIA)
SECOND PLACE, PRODUCT ILLUSTRATION

Below ■ **Once is not enough.**
A Pittsburgh body piercing specialist
who says he has 16 piercings is
interested in adding more.

ANNIE O'NEILL, THE PITTSBURG POST-GAZETTE
THIRD PLACE, PRODUCT ILLUSTRATION

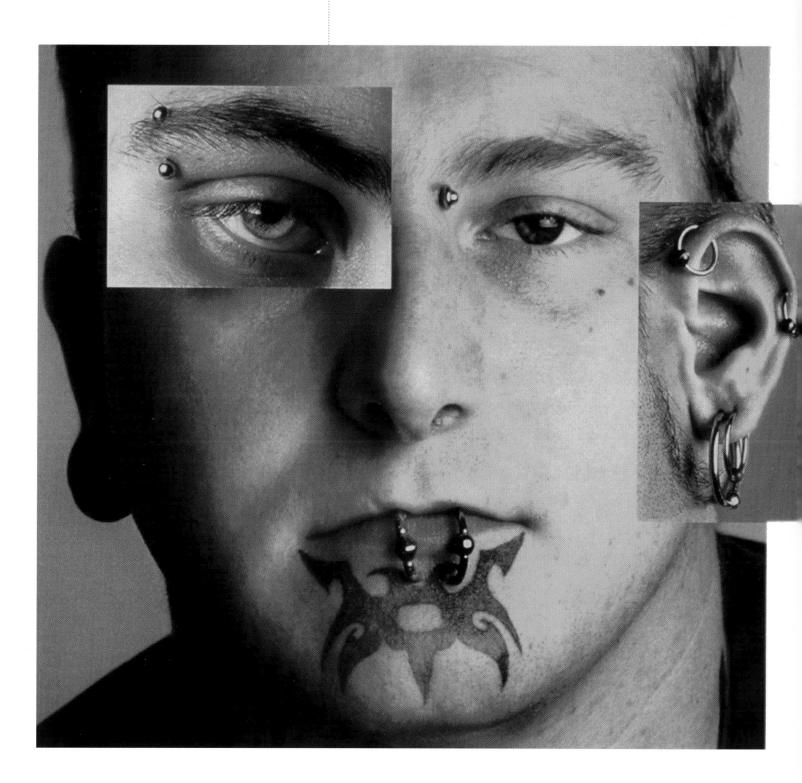

Above ■ **Fruit.**
Pears and apples are
popular in holiday recipes.

**NITA LUSK, FREELANCE,
MONTEREY COUNTY, CALIFORNIA**

FIRST PLACE,
PRODUCT ILLUSTRATION

Right ■ **Biscotti.**
Biscotti with Cappuccino
is a trendy dessert.

JIM WITMER, DAYTON DAILY NEWS

AWARD OF EXCELLENCE,
PRODUCT ILLUSTRATION

Right ■ With energy plentiful and cheap, few corporations or consumers put conservation on their priority lists.

KEVIN HORAN, U.S. NEWS & WORLD REPORT
AWARD OF EXCELLENCE, SCIENCE/NATURAL HISTORY

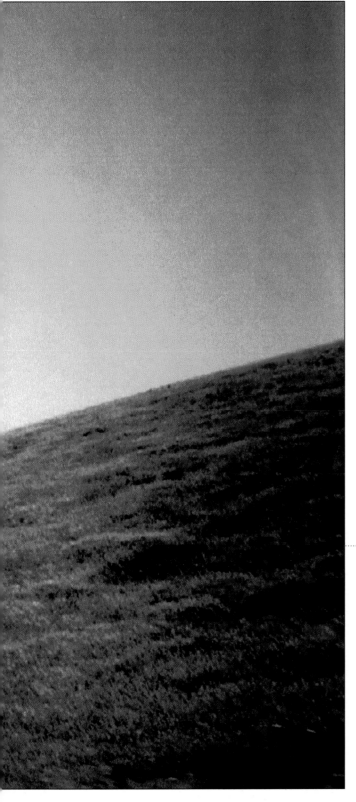

Natural history, science & pictorials

T his chapter displays 14 of the 15 winners in the Pictorial and Science/Natural History categories of this year's 55th POY competition. And, this year for the first time a new category was added for Science/Natural History picture stories. Selections from three of the four winning stories are displayed here too.

NOT INCLUDED HERE IS RANDY OLSON'S THIRD PLACE MAGAZINE PICTORIAL. IT CAN BE FOUND ALONG WITH A SELECTION FROM HIS FIRST PLACE MAGAZINE FEATURE PICTURE STORY ON **PAGE 224**. ALSO NOT INCLUDED IS JIM BRANDENBERG'S SECOND PLACE SCIENCE/NATURAL HISTORY WINNER. IT IS DISPLAYED ALONG WITH SELECTIONS FROM HIS JUDGES' SPECIAL RECOGNITION PORTFOLIO IN THE COMMUNITY AWARENESS CATEGORY. **SEE PAGE 246.**

Below ■ The fire of dawn lights a path across Africa's Zambezi River where villagers in Zambezi travel as they always have – in a dugout canoe.

CHRISTOPHER JOHNS, NATIONAL GEOGRAPHIC, AWARD OF EXCELLENCE, MAGAZINE PICTORIAL

Category definitions

PICTORIAL: A GRAPHIC IMAGE THAT EXPRESSES BEAUTY, TENSION AND OTHER ABSTRACT CONCEPTS THROUGH COMPOSITION AND TONAL AND COLOR RELATIONSHIPS MORE THAN THROUGH HUMAN INTERACTION.

SCIENCE/NATURAL HISTORY: A PHOTOGRAPH, STORY OR ESSAY THAT INCREASES UNDERSTANDING AND APPRECIATION FOR SCIENCE AND THE NATURAL WORLD.

Left ■ A British soldier seen through his protective plastic shield in Northern Ireland.

ANDREW HOLBROOK, FREELANCE, NEW YORK CITY
AWARD OF EXCELLENCE, MAGAZINE PICTORIAL

Below ■ A fisherman pulls his fishing line around his hands.

ERIC MENCHER, PHILADELPHIA INQUIRER
FIRST PLACE, NEWSPAPER PICTORIAL

THIS PHOTO IS ALSO PART OF A NEWSPAPER FEATURE PICTURE STORY THAT WON AN AWARD OF EXCELLENCE. **SEE PAGE 223.**

Above ■ A grim reminder with ghostly silhouettes from countless accused felons manacled to a bench at the Port Authority Police detention cell in New York.

LARRY TOWELL, MAGNUM/ NEW YORK TIMES MAGAZINE
FIRST PLACE,
MAGAZINE PICTORIAL

Right ■ Dr. Ian Wilmut, a genetic pioneer, in a field across from his Roslin Institute. (A digitally assembled photo illustrating a flock of Dollys.)

REMI BENALI, GAMMA LIAISON/LIFE MAGAZINE
THIRD PLACE,
SCIENCE/NATURAL HISTORY

Next page ■ Portrait of Michael, "Misha" Scott, a premature baby in his father's hand. Misha was born 13 weeks premature, a surviving twin.

NADIA BOROWSKI SCOTT, THE ORANGE COUNTY REGISTER
AWARD OF EXCELLENCE,
SCIENCE/NATURAL HISTORY

Below ■ **Bride2.**
Illustration for a story
on the latest in bridal fashions.

MICHAEL McMULLAN, THE COMMERCIAL APPEAL

AWARD OF EXCELLENCE, PRODUCT ILLUSTRATION

Below ■ **Bride2.**
Illustration for a story
on the latest in bridal fashions.

Feature pictures, the moments of life

A feature picture is defined as: *"An unposed photo that celebrates life. Respect for the dignity of the subject is important."* This six-page chapter includes nine of the ten award winners from the newspaper and magazine categories.

EUGENE RICHARDS'S FIRST PLACE MAGAZINE FEATURE PICTURE IS DISPLAYED WITH HIS CANON PHOTO ESSAY ON **PAGES 44-45.**

Right ■ It's recreation hour at the Little Sisters of the Poor. Sister Gertrude Mary keeps telling jokes that really make Sister Marguerite laugh.

MARY BETH MEEHAN, PROVIDENCE JOURNAL-BULLETIN

SECOND PLACE, NEWSPAPER FEATURE PICTURE

MARY BETH MEEHAN, CHIEN-CHI CHANG

Left ■ After a full day of wedding activities a newlywed couple falls asleep on their way home oblivious to their nephew and niece.

CHIEN-CHI CHANG, MAGNUM PICTURES
AWARD OF EXCELLENCE, MAGAZINE FEATURE PICTURE

THIS PHOTO IS ALSO PART OF AN AWARD OF EXCELLENCE MAGAZINE FEATURE PICTURE STORY. FOR MORE, **SEE PAGE 227.**

Above ■ Strong, obliging Tahitians usher ashore French vacationers after a lagoon cruise
on an outrigger canoe. Oppressive French rule has turned hospitality to hostility among many islanders.

JODI COBB, NATIONAL GEOGRAPHIC, SECOND PLACE, MAGAZINE FEATURE PICTURE

Right ■ Family and
friends photograph
Ms. Senior America
Pageant contestants
in Biloxi, Mississippi.

**DANIEL ROSENBAUM,
THE WASHINGTON TIMES**

AWARD OF EXCELLENCE,
NEWSPAPER FEATURE PICTURE

Facing Page ■ Two
dancers with the School
of the Hartford Ballet
perform "Tiger Rag"
in the Morgan Great Hall
at the Wadsworth
Atheneum.

**CLOE POISSON,
THE HARTFORD COURANT**

AWARD OF EXCELLENCE,
NEWSPAPER FEATURE PICTURE

Right ■ Children on the streets of West Belfast.

ANDREW HOLBROOKE, FREELANCE, NEW YORK CITY
THIRD PLACE, MAGAZINE FEATURE PICTURE

Above ■ Adrift in thought, Beauty Nalumeno Muslyualike nurses her baby before church.

CHRISTOPHER JOHNS, NATIONAL GEOGRAPHIC SOCIETY
AWARD OF EXCELLENCE, MAGAZINE FEATURE PICTURE

Right ■ Glenna Moore, relaxes in her family's one bedroom house while her great-grandson Michael Henderson Jr. watches his father rebuild a salvaged home for his six-member rural family.

CARL D. WALSH, FREELANCE, DAYTON, MAINE
FIRST PLACE, NEWSPAPER FEATURE PICTURE

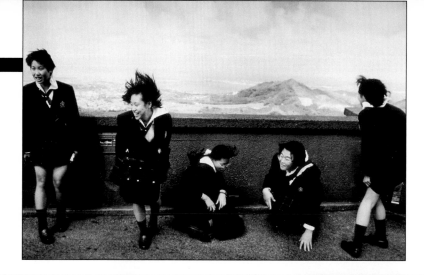

Right ■ A group of Japanese school girls giggle
as they try to weather windy Pali Lookout in Honolulu.

JEFF WIDENER, HONOLULU ADVERTISER

THIRD PLACE, NEWSPAPER FEATURE PICTURE

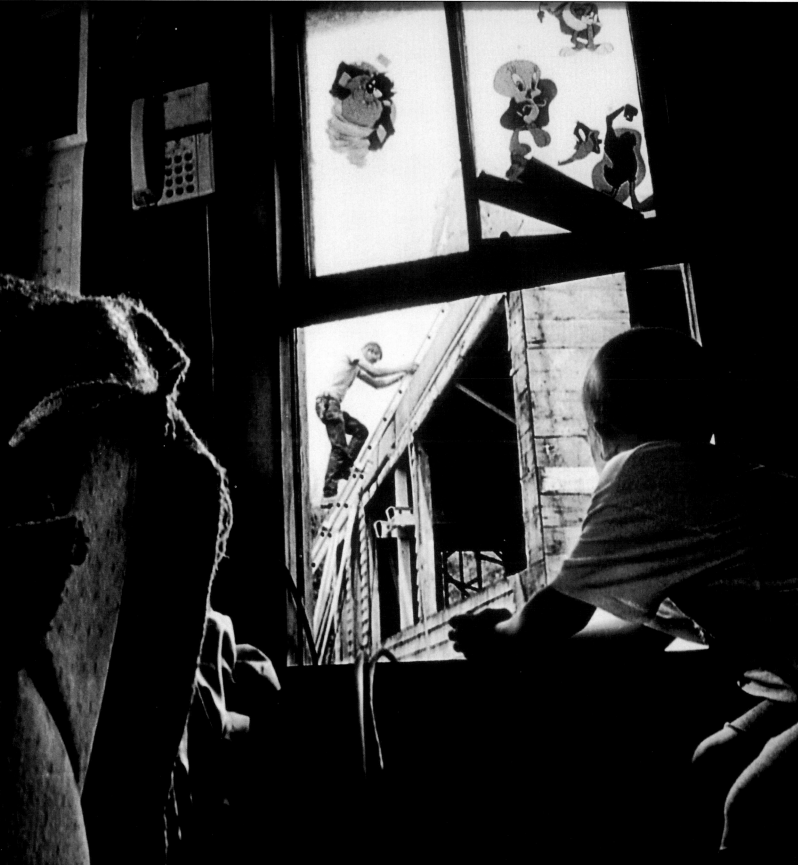

Right ■ Built of moon glow and water spray, a bridge of colored light arches over the chasm at Victoria Falls.

CHRISTOPHER JOHNS, NATIONAL GEOGRAPHIC,
SECOND PLACE, MAGAZINE PICTORIAL

Below ■ A hillside in fall.

STEPHANIE SECREST, FREMONT ARGUS (FREMONT, CALIFORINIA)
THIRD PLACE, NEWSPAPER PICTORIAL

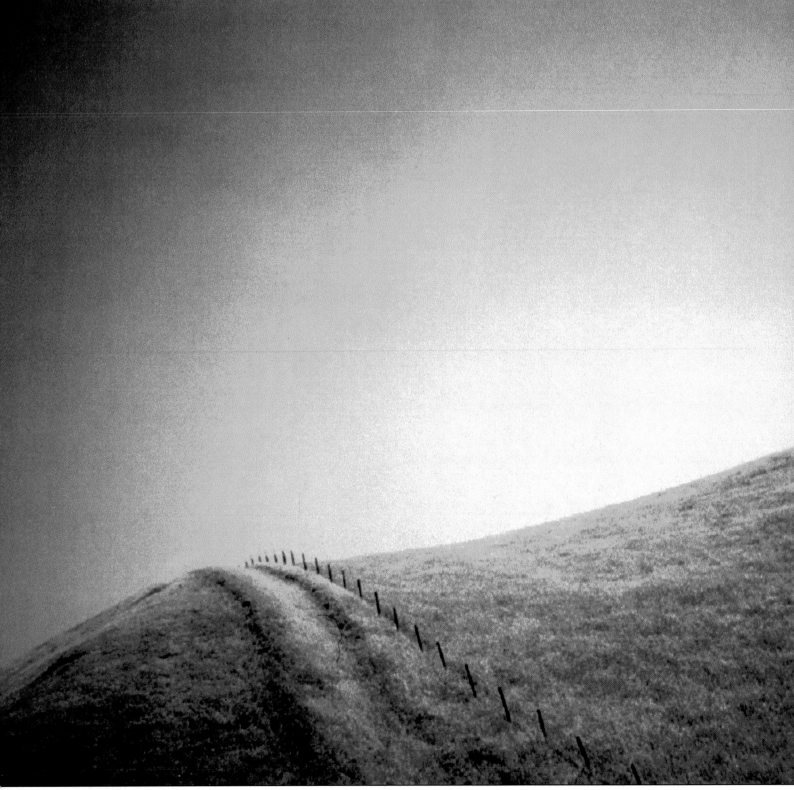

Left ■ At the break of day, the city of Oaxaca, begins to wake.

PAUL E. RODRIGUEZ, ORANGE COUNTY REGISTER,
AWARD OF EXCELLENCE, NEWSPAPER PICTORIAL

Below ■ An old female elephant is set loose to wander
as far as her chain will allow after daily treatment
at an animal hospital in northern Thailand.

CHIEN-CHI CHANG, MAGNUM,
AWARD OF EXCELLENCE, SCIENCE/NATURAL HISTORY

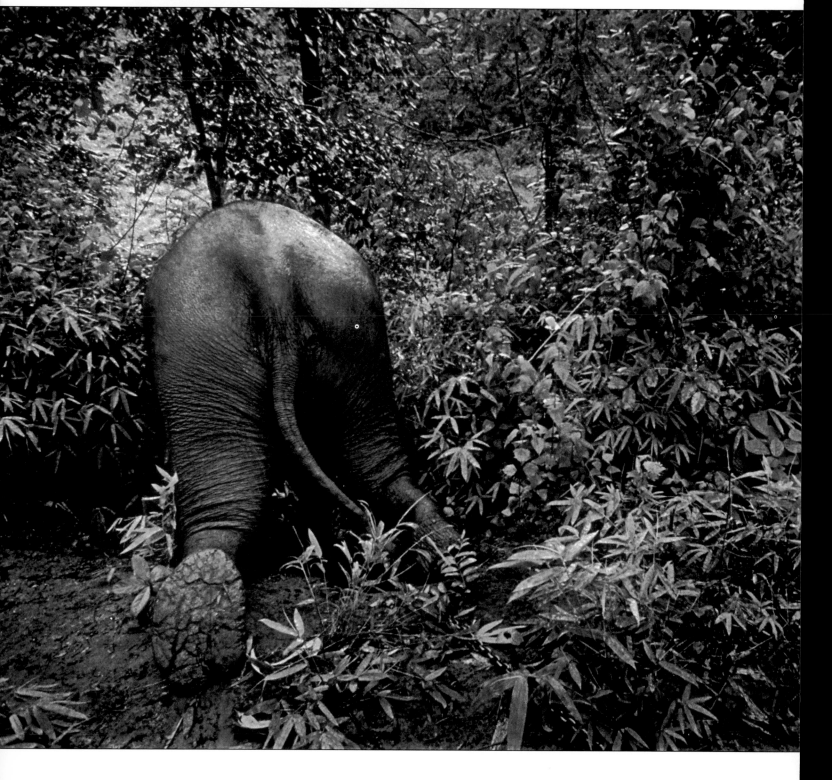

Above ■ A young tourist battles a gust of wind as she descends from the top of a Long Island lighthouse.

**SUSANNA FROHMAN,
PROVIDENCE JOURNAL**

SECOND PLACE, NEWSPAPER PICTORIAL

Below ■ More than 200 hundred feet above ground, ecologist Joel Clement reaches the summit of a Douglas Fir. Scientists are increasing their study of treetops, where many species are normally hidden from view.

DR. MARK W. MOFFETT, NATIONAL GEOGRAPHIC,

SECOND PLACE, SCIENCE/NATURAL HISTORY

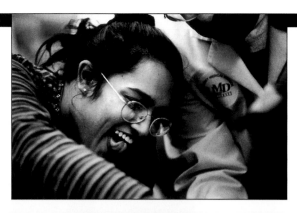

Right ■ During a gall bladder removal, student Sreedevi Chittineni receives assistance from her instructor, Dr. Anthony Boccabella.

Below ■ A student reviews X-rays and MRI images on light panels in the gross anatomy lab.

Body of Knowledge

To develop "Body of Knowledge," a photographer and reporter chronicled first-year medical students as they study gross anatomy at the University of Medicine and Dentistry of New Jersey-Newark. The class is a make or break proposition. Students who master its intricacies usually go on to become doctors; those who fail turn to other professions. In gross anatomy, respect for the cadaver is paramount. As their instructors often tell them, the cadaver is their first patient.

NOAH K. MURRAY, **ASBURY PARK PRESS**, FIRST PLACE, SCIENCE/NATURAL HISTORY PICTURE STORY

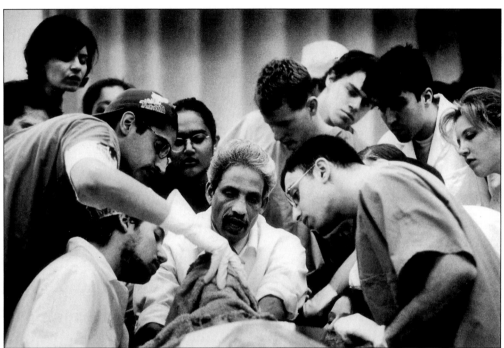

Above ■ Surrounded by his students, Instructor Nagaswami Vasan explains which arteries to look for in a brain.

Left ■ In the bone storage room, a clinical detachment is evident.

Right ■ David Gutierrez wipes perspiration from his face after an exhausting day of dissection.

Beneath the Tasman Sea

DAVID DOUBILET, NATIONAL GEOGRAPHIC
AWARD OF EXCELLENCE, SCIENCE/NATURAL HISTORY PICTURE STORY

Above ■ Evening light coats the stark thousand-foot cliffs of Tasmar Island.

Left ■ Nose architecture reaches its pinnacle in the Southern Saw Shark. Long tentacles above its eye-like nostrils sense prey which will be slashed by the shark's saw teeth.

Below ■ Cold, deep and remote waters are filled with fanciful creatures such as this foot-long, weedyseadragon.

THIS PHOTO ALSO RECEIVED FIRST PLACE IN THE SCIENCE/ NATURAL HISTORY CATEGORY.

Elephants of Way Kambas

**STEVEN SIEWERT,
SYDNEY MORNING HERALD**

THIRD PLACE,
SCIENCE/NATURAL HISTORY
PICTURE STORY

Right ■ The elephants of the Way Kambas elephant school in southern Sumatra, Indonesia.

Below ■ A trainer takes a rest on the back of his elephant. Some of the trainers become quite attached to their animals.

Above ■ The elephants are captured after they have trampled crops in local villages. During the show, crowd members lie on the ground while the elephant walks delicately between them.

The games we play

This chapter displays 27 of the 28 single-category sports winners in both the newspaper and magazine divisions. All four of the award-winning newspaper sports portfolios are also represented. POY judges gave no magazine portfolio awards this year. Sports picture stories are displayed in the chapter which begins on page 214.

NOT INCLUDED HERE IS NANCY ANDREW'S FIRST PLACE NEWSPAPER SPORTS FEATURE. IT CAN BE FOUND ON **PAGE 17** ALONG WITH SELECTIONS FROM HER NEWSPAPER PHOTOGRAPHER OF THE YEAR PORTFOLIO.

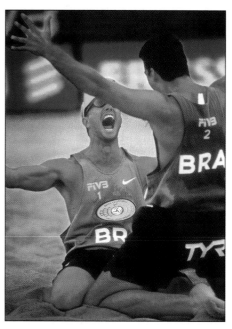

Left ■ Brazil's Rogero "Para" Ferreira de Souza lets out a scream as he and partner Guilherme Luiz Marques celebrate their win in the FIVB Men's Beach Volleyball World Championship at UCLA.

RICHARD HARTOG, THE OUTLOOK (SANTA MONICA, CALIFORNIA)
FIRST PLACE
NEWSPAPER SPORTS PORTFOLIO

Right ■ Twelve-year-old Trylene Overlin tries on Jack Lambert's old helmet as Lambert looks on from a poster.

**BRADLEY E. CLIFT
THE HARTFORD COURANT**
THIRD PLACE
NEWSPAPER SPORTS PORTFOLIO

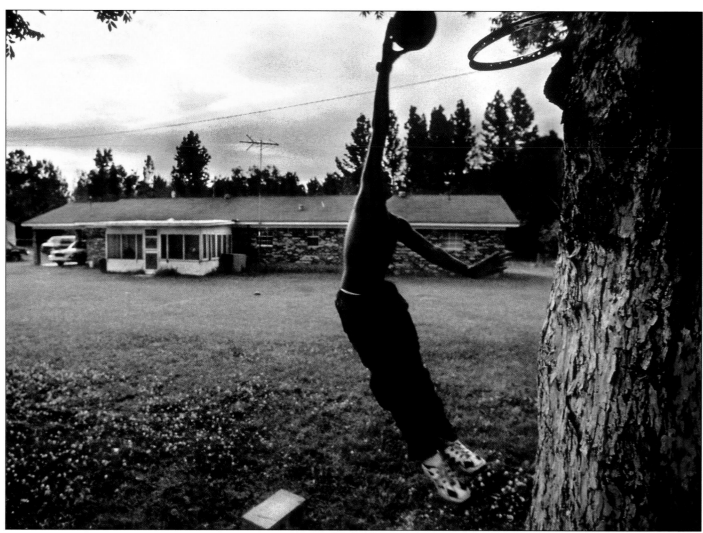

Above ■ Frederick Bladwin, 12, lifts off from a cement block in back of his grandparents' house. Frederick's cousin, Olympic basketball star Ruthie Bolton, practiced on this same bicycle rim as a child in rural Mississippi.

BRYAN PATRICK, THE SACRAMENTO BEE, PART OF THE SECOND PLACE, NEWSPAPER SPORTS PORTFOLIO AND AWARD OF EXCELLENCE, NEWSPAPER SPORTS FEATURE

Right ■ Elementary school children battle during a pickup basketball game at a Chicago playground.

DAVID BUTOW, SABA/U.S. NEWS & WORLD REPORT
SECOND PLACE, MAGAZINE SPORTS FEATURE

(THIS PHOTO IS ALSO A PART OF THE SECOND PLACE MAGAZINE SPORTS PICTURE STORY. SEE **PAGE 218.**)

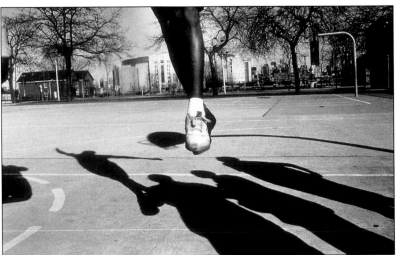

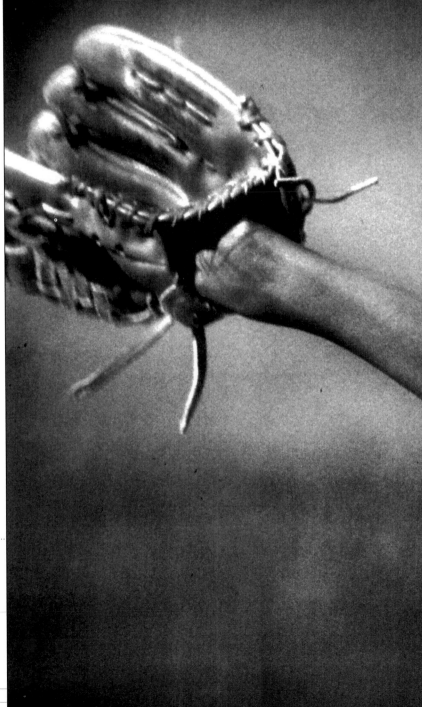

Above ■ Andy Vasquez dreams of a basketball scholarship so he can go to college. In the Bushwick section of Brooklyn where Andy lives, most kids drop out of school by the age of 14.

BRENDA KENNEALLY, FREELANCE (BROOKLYN, NEW YORK)
THIRD PLACE, MAGAZINE SPORTS FEATURE

(THIS PHOTO IS ALSO A PART OF A JUDGES' SPECIAL RECOGNITION IN THE COMMUNITY AWARENESS CATEGORY. ADDITIONAL SELECTS FROM THAT PORTFOLIO CAN BE SEEN ON **PAGE 242.**

Right ■ Sammie Pearson delivers a pitch.

KHUE BUI, THE WASHINGTON POST
FIRST PLACE, NEWSPAPER SPORTS ACTION

(THIS PHOTO IS ALSO A PART OF THE THIRD PLACE NEWSPAPER SPORTS PICTURE STORY. SEE **PAGE 216.**)

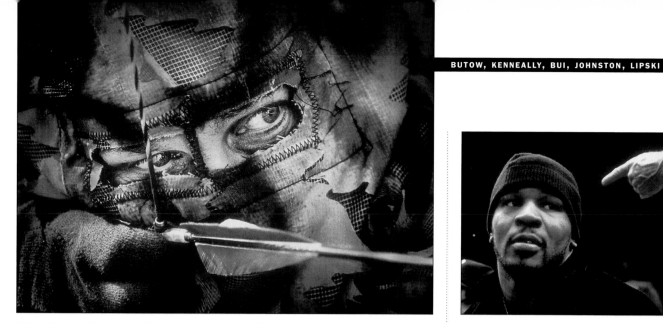

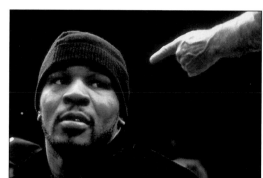

Above ■ Long Bow hunter Tim Forster draws back his trusty arrow to release it for the kill of a Sika deer in a swamp on the Eastern shore of Maryland. He makes his own bows.

FRANK B. JOHNSTON, THE WASHINGTON POST, THIRD PLACE, NEWSPAPER SPORTS FEATURE

Above ■ Since biting off part of Evander Holyfield's ear, Mike Tyson has been the object of much finger pointing.

RICHARD LIPSKI, THE WASHINGTON POST
AWARD OF EXCELLENCE, NEWSPAPER SPORTS FEATURE

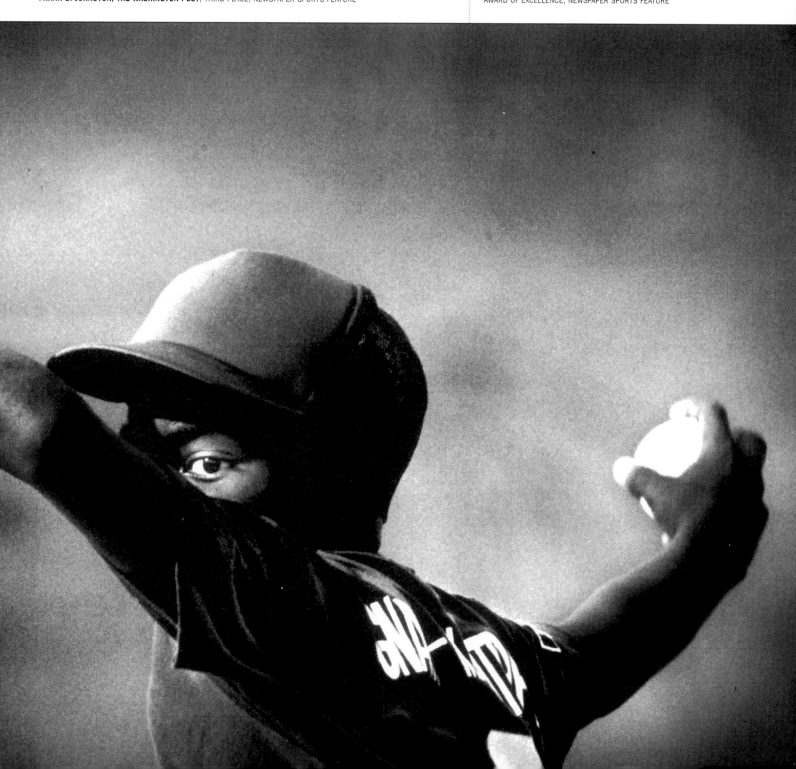

Right ■ Simply one of the best young swimmers in the state, Shawn Dugal sometimes refuses to come up for air. The 11-year-old spends most summer days in the pool preparing for upcoming meets.

BRADLEY E. CLIFT, THE HARTFORD COURANT
THIRD PLACE, NEWSPAPER SPORTS PORTFOLIO

Above ■ Tyler Painter swims through a wall of water during the U.S. National Swim championships in Nashville, Tennessee.

AL BELLO, ALLSPORT USA
THIRD PLACE, MAGAZINE SPORTS ACTION

Below ■ A halo of light surrounds a swimmer as he relaxes in the cool-down pool at the U.S. Swimming and Diving Championships.

STEVE HEALEY, THE INDIANAPOLIS STAR & NEWS
AWARD OF EXCELLENCE, NEWSPAPER SPORTS PORTFOLIO

Right ■ Russia's Yulia Pakhalina hits the springboard during her last dive at the Women's 3-Meter springboard finals. Pakhalina entered the final round in first place, needing 68 points to win the championship. However, with this failed dive, she received no points and dropped to seventh place.

PRESTON C. MACK, FT. LAUDERDALE SUN SENTINEL
THIRD PLACE, NEWSPAPER SPORTS ACTION

Below ■ Girls trying out for the U.S. national water polo team share a laugh together as they make their way into position during one of their three daily workouts at the United States Olympic Training Center in Colorado Springs.

RICHARD HARTOG, THE OUTLOOK (SANTA MONICA, CALIFORNIA)
FIRST PLACE, NEWSPAPER SPORTS PORTFOLIO

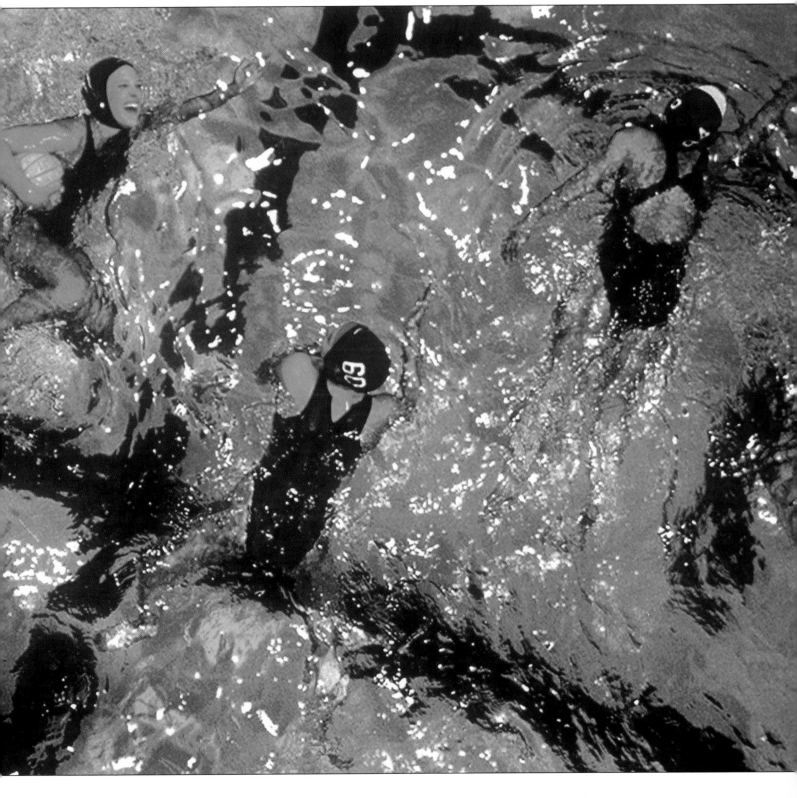

Below ■ At the Monticello raceway in upstate New York a harness driver barely stays ahead of the second place horse.

**BILL FRAKES,
SPORTS ILLUSTRATED**
FIRST PLACE
MAGAZINE SPORTS ACTION

Left ■ Running of the bulls in Pamplona, Spain.

**JOHN KIMMICH,
FREELANCE/UNIVERSITY OF IOWA**
AWARD OF EXCELLENCE
MAGAZINE SPORTS ACTION

Above ■ With the sword stuck in its back the bull has just moments to live.

**JOHN KIMMICH,
FREELANCE/UNIVERSITY OF IOWA**
FIRST PLACE, MAGAZINE SPORTS FEATURE

Below ■ Cowboy Justin Seaton is stunned and wet after being thrown by his bull at the All-Florida Rodeo Championships.

**CHRISTIAN FUCHS,
SUN COAST MEDIA GROUP
(PUNTA GORDA, FLORIDA)**
AWARD OF EXCELLENCE
NEWSPAPER SPORTS ACTION

Left ■ The only event Amish teenagers are allowed to attend is harness racing at a rural Ohio fair.

**RANDY OLSON,
NATIONAL GEOGRAPHIC MAGAZINE**
AWARD OF EXCELLENCE
MAGAZINE SPORTS FEATURE

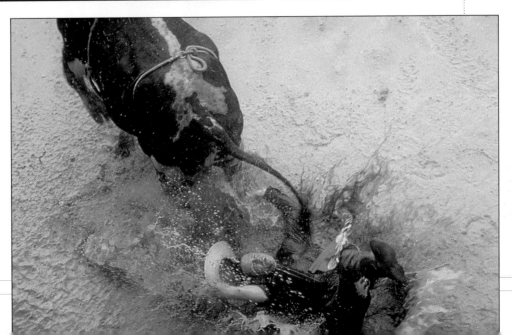

Below ■ The Anderson Monarch baseball team playing with their equipment. The team "barnstormed" across the country in honor of the old Negro League teams.

GEORGE MILLER, PHILADELPHIA DAILY NEWS
SECOND PLACE, NEWSPAPER SPORTS FEATURE

Above ■ Top area high school pitcher Teresa Tolson prays during her game, hopeful for a hit that will break the 0-0 tie in the last inning of the game. Her prayers were answered and Teresa got her 1-0 shutout.

BRYAN PATRICK, THE SACRAMENTO BEE
SECOND PLACE, NEWSPAPER SPORTS PORTFOLIO

Below ■ The Harbor College bench erupts in celebration as Los Angeles City College's last hope, William Reed, is spun around after he strikes out in the top of the ninth inning to end the junior college baseball game at Harbor College in Wilmington, California.

RICHARD HARTOG, THE OUTLOOK (SANTA MONICA, CALIFORNIA)
FIRST PLACE, NEWSPAPER SPORTS PORTFOLIO

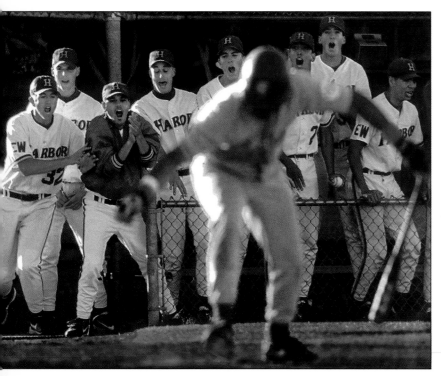

BRYAN PATRICK, RICHARD HARTOG, GEORGE MILLER, STEPHEN D. CANNERELLI

Left ■ 11-year-old Chris Springer watches a Syracuse-Norfolk minor league baseball game from a hilltop behind the right field wall.

STEPHEN D. CANNERELLI, SYRACUSE NEWSPAPERS
AWARD OF EXCELLENCE, NEWSPAPER SPORTS FEATURE

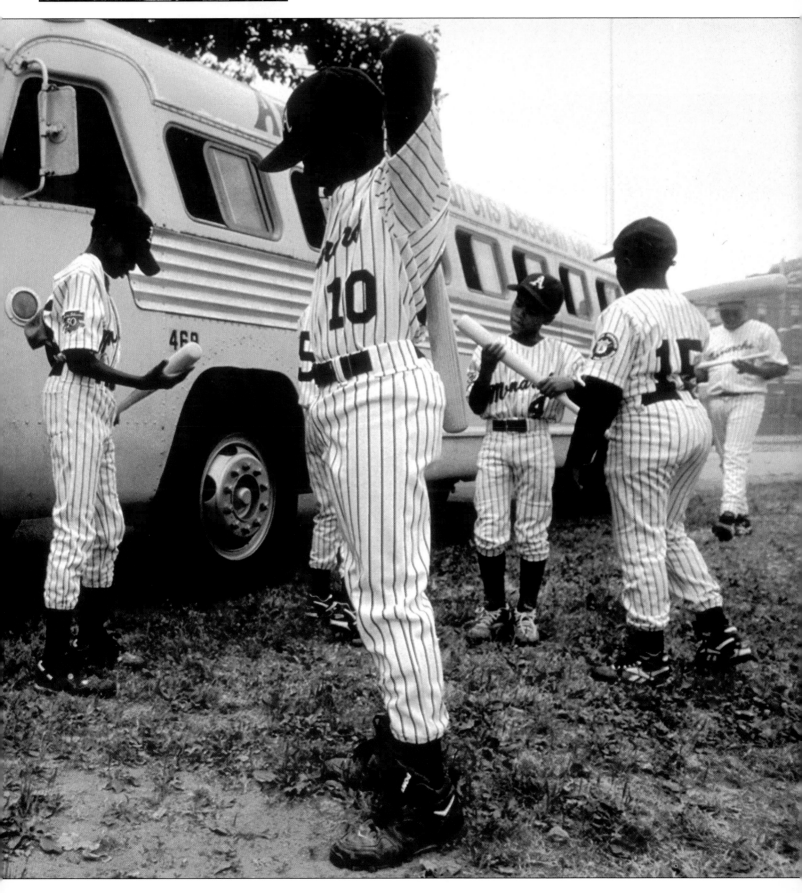

Left ■ Eddie Robinson, the winningest coach in college football history, cries before the start of his final home game as Grambling coach.

RUSTY COSTANZA, THE TIMES-PICAYUNE
AWARD OF EXCELLENCE, NEWSPAPER SPORTS FEATURE

Above ■ Iowa City West High senior Laura Schlapkohl, left, cries tears of joy as she hugs freshman Veronica Bordewick after West won the cross country state title.

DANNY WILCOX FRAZIER, IOWA CITY PRESS-CITIZEN
AWARD OF EXCELLENCE, NEWSPAPER SPORTS ACTION

Left ■ Permanently paralyzed from a motocross race accident, Brian Tisdale, once the star athlete in his high school, dances with his girlfriend during the last homecoming dance.

BRYAN PATRICK, THE SACRAMENTO BEE
SECOND PLACE, NEWSPAPER SPORTS PORTFOLIO

Below ■ Doubles partners celebrate the win that propelled their team to the Indiana State Championship.

STEVE HEALEY, THE INDIANAPOLIS STAR & NEWS
AWARD OF EXCELLENCE, NEWSPAPER SPORTS PORTFOLIO

Right ■ Barrington's Kim Doetzel reacts as she scores her third goal to win the high school soccer game.

BILL ZARS, DAILY HERALD (ARLINGTON HEIGHTS, ILLINOIS)
AWARD OF EXCELLENCE
NEWSPAPER SPORTS ACTION

Above ■ Santa Monica High's Tom Lewis, bottom, finds himself on the wrong end of pinning at the hands of Culver City High's Dan Stephens during the CIF Bay League wrestling finals at Santa Monica High School.

RICHARD HARTOG, THE OUTLOOK (SANTA MONICA, CALIFORNIA)
FIRST PLACE, NEWSPAPER SPORTS PORTFOLIO

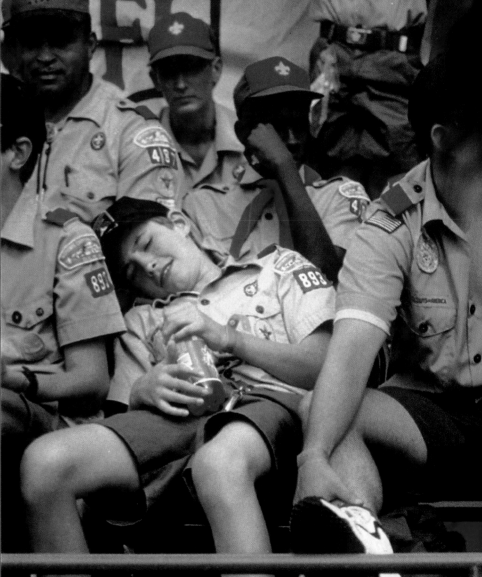

Left ■ Dante Rodgers, age 13, stands and dodges a speedbag during a workout at the Sacramento Police Athletic League. He's hopeful that one day his workouts will make him a professional.

BRYAN PATRICK, THE SACRAMENTO BEE
AWARD OF EXCELLENCE, NEWSPAPER SPORTS FEATURE

Above ■ Female boxing championship in Biloxi, Mississippi.

CO RENTMEESTER, FREELANCE/LIFE MAGAZINE
AWARD OF EXCELLENCE, MAGAZINE SPORTS ACTION

Left ■ Justin Vitallis of Troop 893 from Centerville, Virginia, checks out the cheerleaders during opening day festivities at the new Jack Kent Cooke Stadium where the Washington Redskins play.

KAREN BALLARD, THE WASHINGTON TIMES
AWARD OF EXCELLENCE, NEWSPAPER SPORTS FEATURE

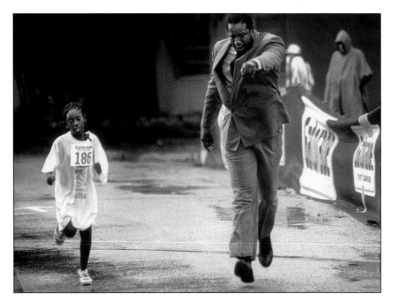

Above ■ Offering moral support, a father points to the finish line as he runs alongside his daughter at the end of the kids' triathlon.

LANNIS WATERS, THE PALM BEACH POST
AWARD OF EXCELLENCE, NEWSPAPER SPORTS FEATURE

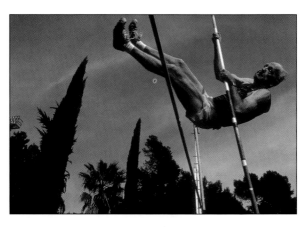

Above ■ Defying gravity, 85-year-old Carol Johnson pole vaults. He holds the world record for his age, seven-feet, six-inches.

KAREN KASMAUSKI, NATIONAL GEOGRAPHIC MAGAZINE
AWARD OF EXCELLENCE, MAGAZINE SPORTS FEATURE

Below ■ Two brothers compete in Birmingham, Alabama.

KARIM SHAMSI-BASHA, FREELANCE/SPORTS ILLUSTRATED
SECOND PLACE, MAGAZINE SPORTS ACTION

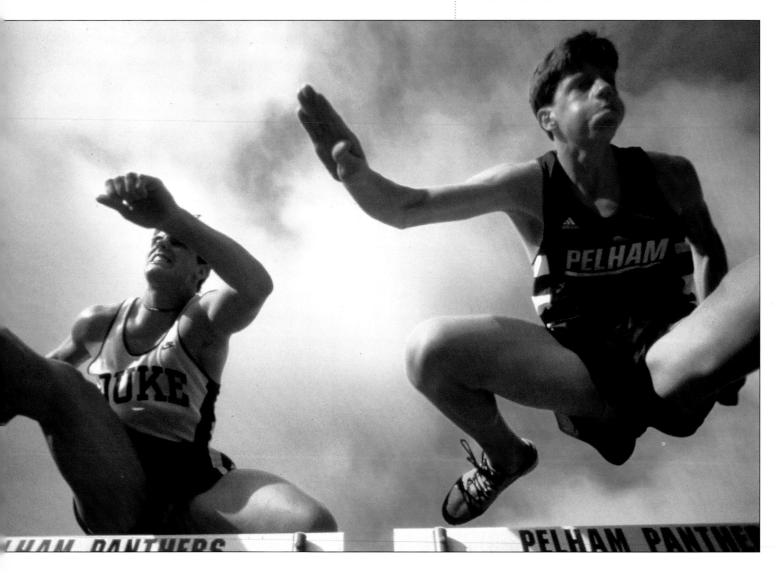

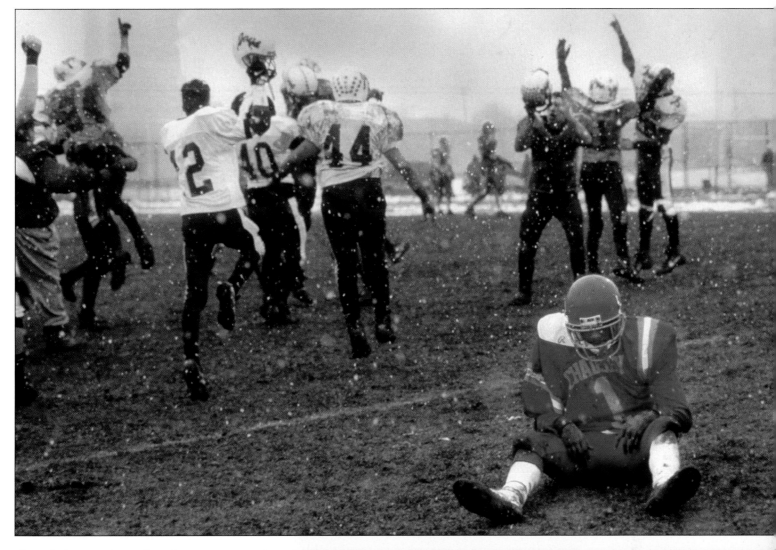

Above ■ Quarterback John Taylor is sacked at the end of the game as Allen Park players celebrate their victory.

CLARENCE TABB, JR., THE DETROIT NEWS
SECOND PLACE, NEWSPAPER SPORTS ACTION

Right ■ Hasbrouck Heights and St. Mary's slip-slided their way up and down the field until the game was postponed due to heavy rain.

DANIELLE P. RICHARD, THE RECORD (TEANECK, NEW JERSEY)
AWARD OF EXCELLENCE, NEWSPAPER SPORTS ACTION

Below ■ Carolina return specialist Dwight Stone keeps the ball from crossing the goal line, pinning the Oakland Raiders on their one yard line.

PATRICK SCHNEIDER, THE CHARLOTTE OBSERVER
AWARD OF EXCELLENCE, NEWSPAPER SPORTS ACTION

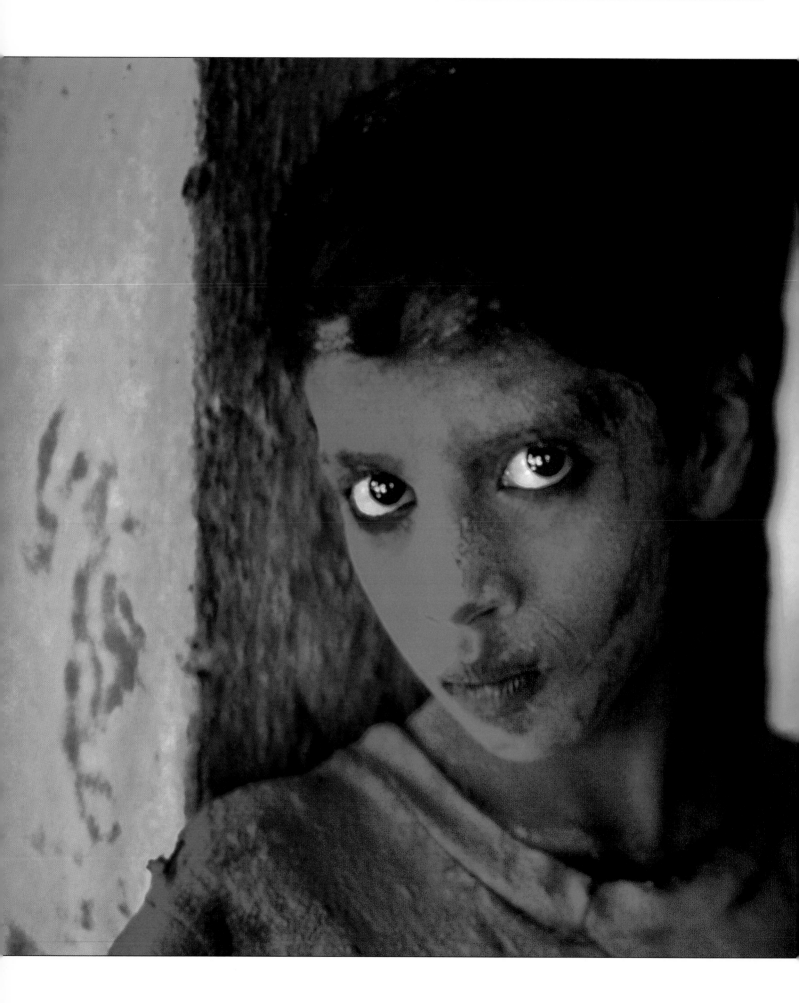

PORTRAITURE

The essence of character

This eight-page chapter includes 14 of the 16 award-winning portraits from both the newspaper and magazine divisions of this year's Pictures of the Year competition. The category is defined as: *"A picture of a person that reveals the essence of the subject's character."*

NOT INCLUDED HERE IS BRENDA ANN KENNEALLY'S THIRD PLACE MAGAZINE PORTRAIT. IT CAN BE FOUND ALONG WITH A SELECTION FROM HER PORTFOLIO THAT WON A JUDGES' SPECIAL RECOGNITION IN THE COMMUNITY AWARENESS CATEGORY **ON PAGE 256.** ALSO NOT INCLUDED IS CAROL GUZY'S AWARD OF EXCELLENCE NEWSPAPER PORTRAIT. IT CAN BE FOUND ALONG WITH A SELECTION FROM HER FIRST RUNNER-UP NEWSPAPER PHOTOGRAPHER OF THE YEAR PORTFOLIO **ON PAGE 228-229.**

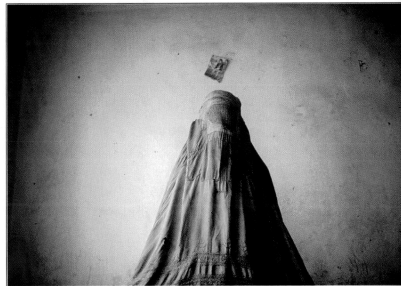

Above ■ An Afghan woman puts on her burka before leaving her house in Kabul, Afghanistan. The Taliban Islamic Movement requires all women to wear head-to-toe covering when in public.

MICHAEL WIRTZ, THE PHILADELPHIA INQUIRER
SECOND PLACE, NEWSPAPER PORTRAIT/PERSONALITY

Left ■ Celebrants powder their faces for the Ganesh Chaturthi festival in Mumba, formerly known as Bombay, India.

STEVE McCURRY, NATIONAL GEOGRAPHIC MAGAZINE
AWARD OF EXCELLENCE, MAGAZINE PORTRAIT/PERSONALITY

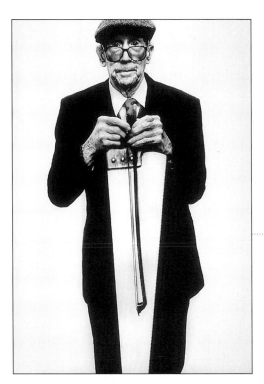

Left ■ Saw player Walter McLaughlin, age 87, with his musical instrument.

STEVEN SIEWERT, SYDNEY MORNING HERALD

AWARD OF EXCELLENCE,
NEWSPAPER PORTRAIT/PERSONALITY

Below ■ Thomas Sykes, 12, was misdiagnosed by doctors during his infancy and consequently his complications lead him to become mentally retarded.

ERIC GRIGORIAN, JACKSONVILLE JOURNAL COURIER

AWARD OF EXCELLENCE,
NEWSPAPER PORTRAIT/PERSONALITY

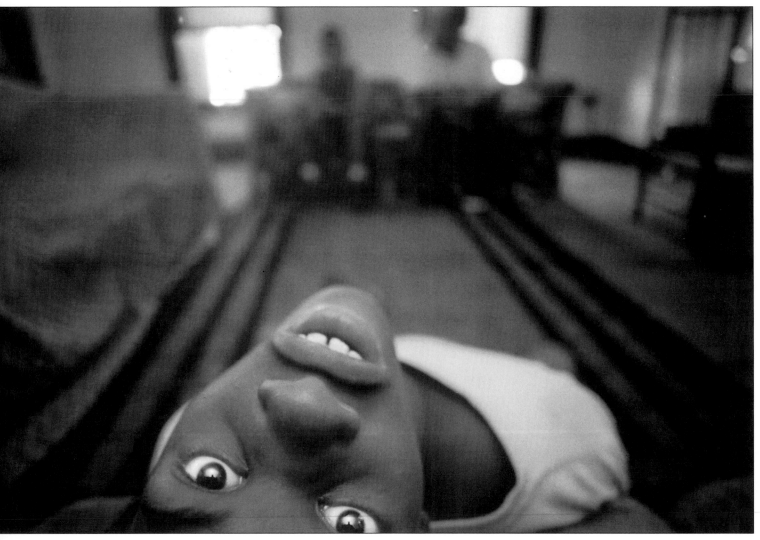

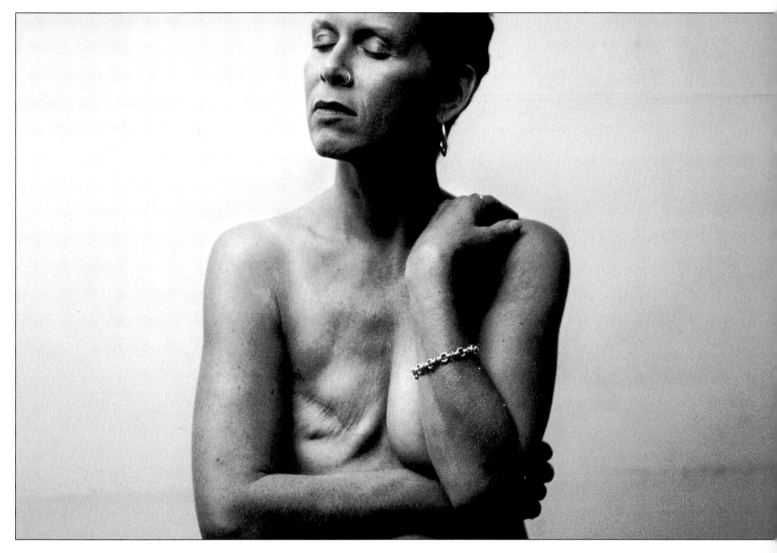

Above ■ Ned Asta found a lump in her breast in 1993 and was diagnosed with Invasive Carcinoma. "When I was first diagnosed I looked for women with one breast," says Asta. Urged to undergo surgery without delay she unsuccessfully sought out photographs of the results of the surgical procedure.

**MARGUERITE NICOSIA TORRES,
THE ITHACA JOURNAL**

FIRST PLACE, NEWSPAPER PORTRAIT/PERSONALITY

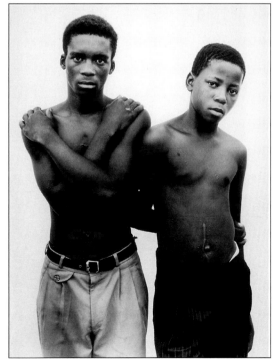

Left ■ At 19- and 15-years-old, they are among the youngest witnesses to testify before the commission about being shot and wounded by police officers in 1993. The two were taking part in a student demonstration which turned into a riot.

**JILLIAN EDELSTEIN,
NETWORK PHOTOGRAPHERS**

AWARD OF EXCELLENCE,
MAGAZINE PORTRAIT/PERSONALITY

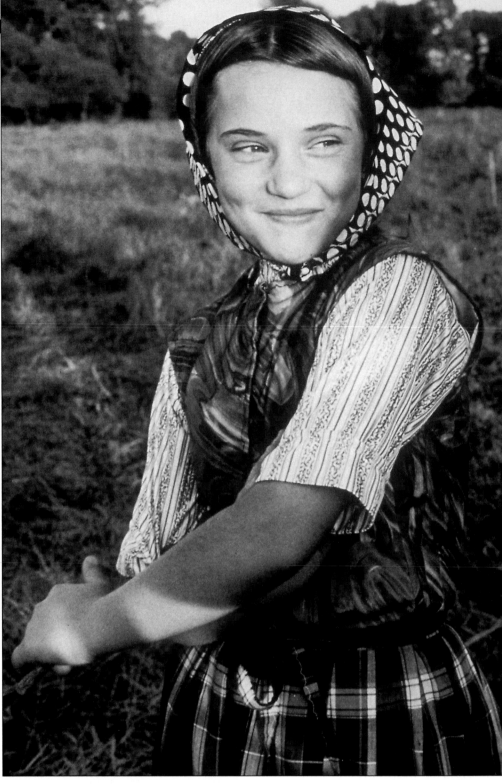

Right ■ Two Hutterite teenagers enjoy each others company after finishing their chores.

FIRST PLACE

ALL FOUR PHOTOS ON THIS SPREAD ARE AWARD-WINNING MAGAZINE PORTRAITS BY:

ANDREW HOLBROOKE, FREELANCE, NEW YORK CITY

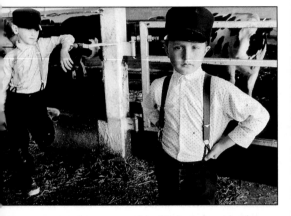

Above ■ Two Hutterite boys take a break from their chores in the cow barn.

AWARD OF EXCELLENCE

Right ■ Children play an important role in the daily work on Hutterite farms. Starting at six-years-old they perform chores such as picking vegetables and as they get older.

AWARD OF EXCELLENCE

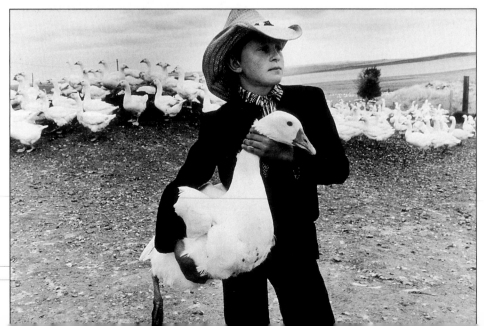

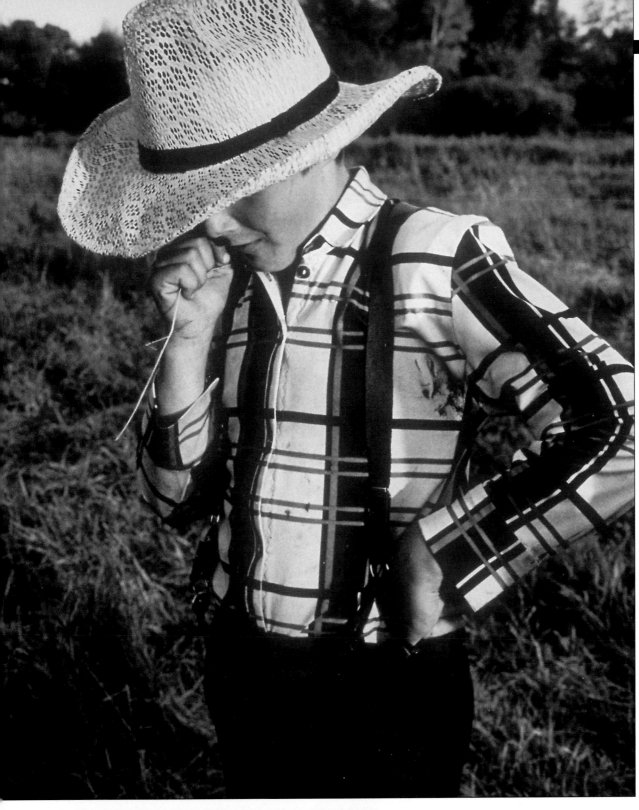

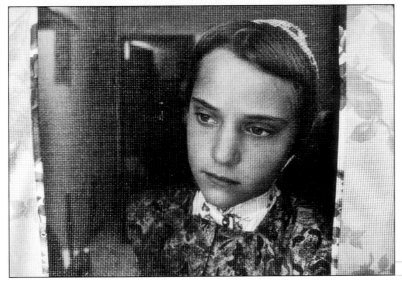

Left ■ **A Hutterite girl gazes outside while baby-sitting for a neighbor.**

AWARD OF EXCELLENCE

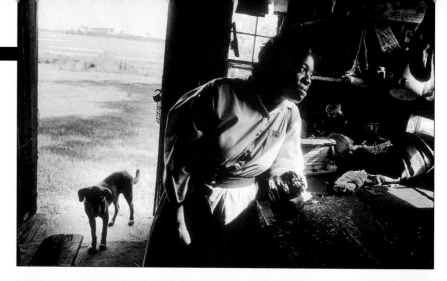

Right ■ Jesse Mae Hunter peers through a window in the cabin in which her father was born. The cabin was built on the plantation where her grandparents once worked and now serves as a storage shed.

PEGGY PEATTIE,
FREELANCE, OHIO UNIVERSITY
AWARD OF EXCELLENCE,
NEWSPAPER PORTRAIT/PERSONALITY

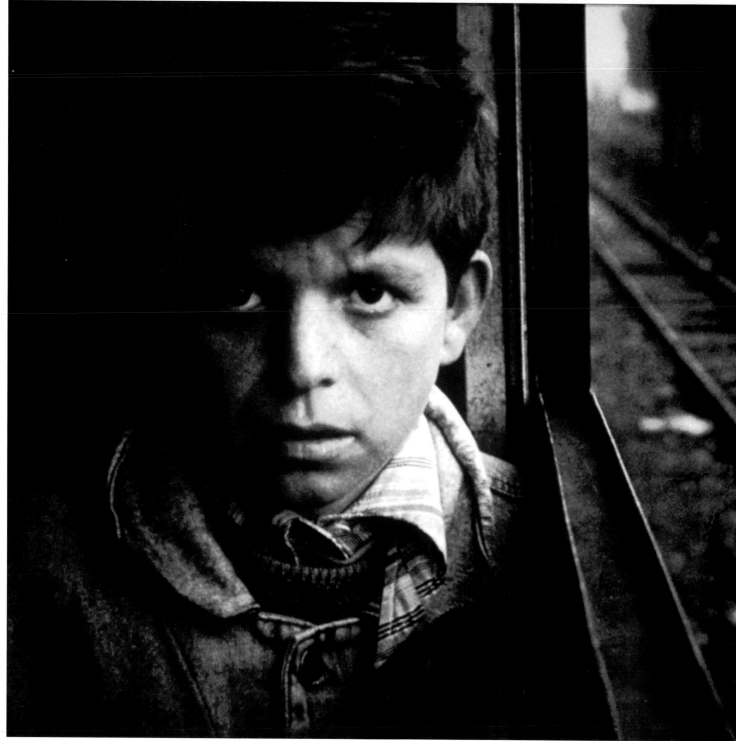

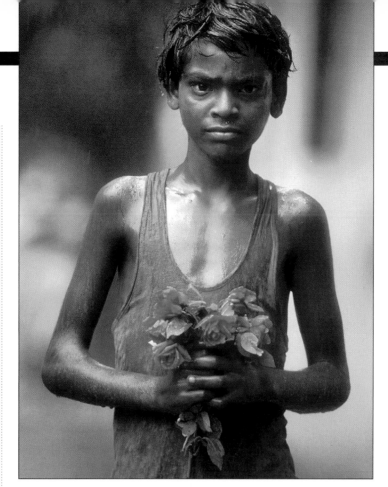

Below ■ An Albanian boy waits for the train to restart outside the coastal city of Dorresy, Albania.

SPENCER PLATT,
STAR GAZETTE (ELMIRA, NEW YORK)
THIRD PLACE,
NEWSPAPER PORTRAIT/PERSONALITY

Above ■ A street urchin waits outside St. Thomas' church in Calcutta with a bouquet of flowers to pay his respects to Mother Theresa.

DAVID LONGSTREATH, THE ASSOCIATED PRESS
AWARD OF EXCELLENCE, NEWSPAPER PORTRAIT/PERSONALITY

Below ■ Near Kisangani, Zaire, a young Rwandan refugee waits in line outside a medical tent in Biaro Camp for treatment. Many refugees were killed when the camp was attacked by rebel soldiers.

RADHIKA CHALASANI, SIPA PRESS
AWARD OF EXCELLENCE, MAGAZINE PORTRAIT/PERSONALITY

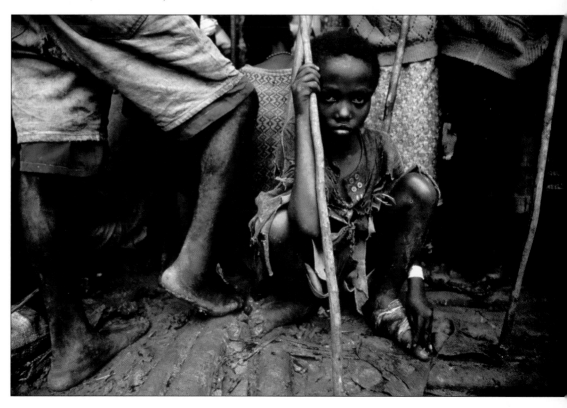

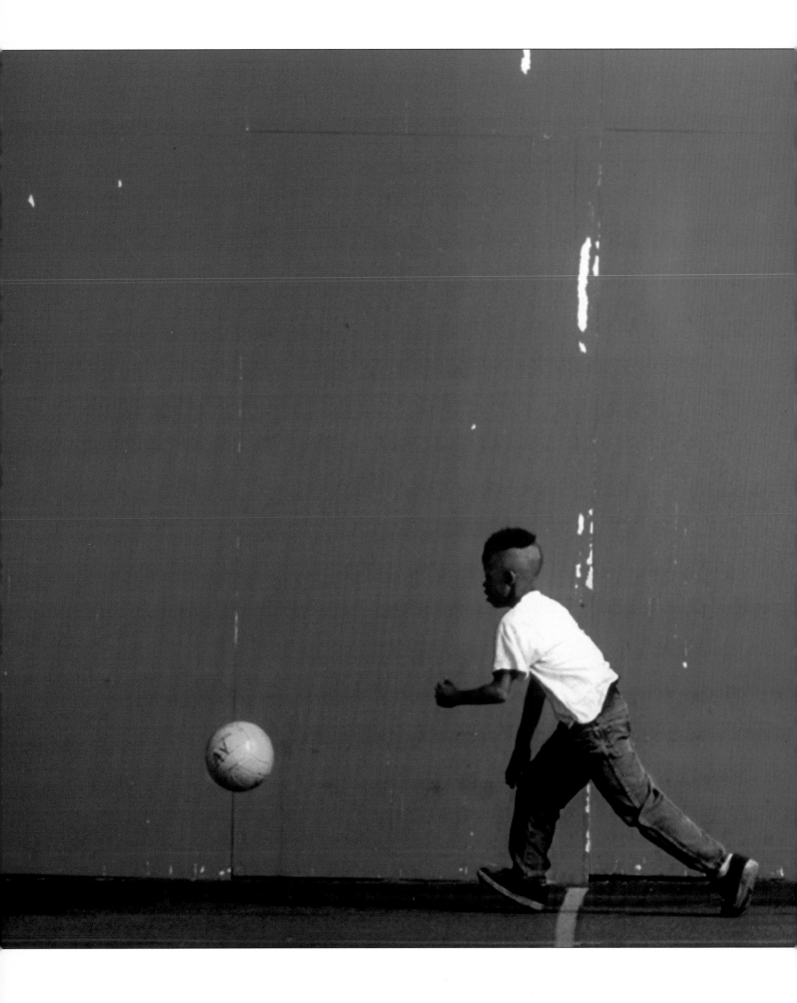

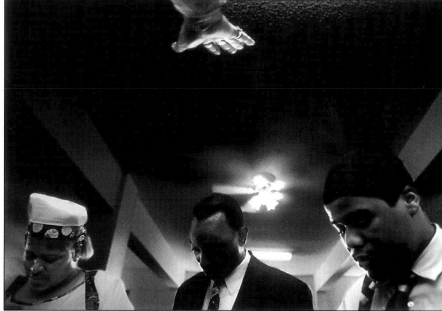

One Week's Work

T he One Week's Work category of the 55th POY competition is displayed on the following twelve pages. The category is defined as: *"Demonstrate versatility in general assignments. Submit up to ten pictures. All must be taken, but not necessarily published within seven consecutive days."*

Left ■ First grader Reggie Black chases down a ball during a game of handball at Alta Vista School in Redondo Beach, California.

Above ■ Former drug addicts Debbie Jenkins, left, and Ricky Turner, center, bow their heads in prayer during a wedding ceremony in which Debbie's son Martel serves as the best man. Jenkins and Turner met during the outreach program.

Below ■ A Minnesota player exults in victory as UCLA players realize their NCAA Tournament bid has ended.

ALL PHOTOS ON THIS SPREAD:
WALLY SKALIJ, DAILY BREEZE (TORRANCE, CALIFORNIA),
FIRST PLACE, ONE WEEK'S WORK

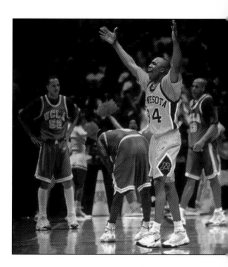

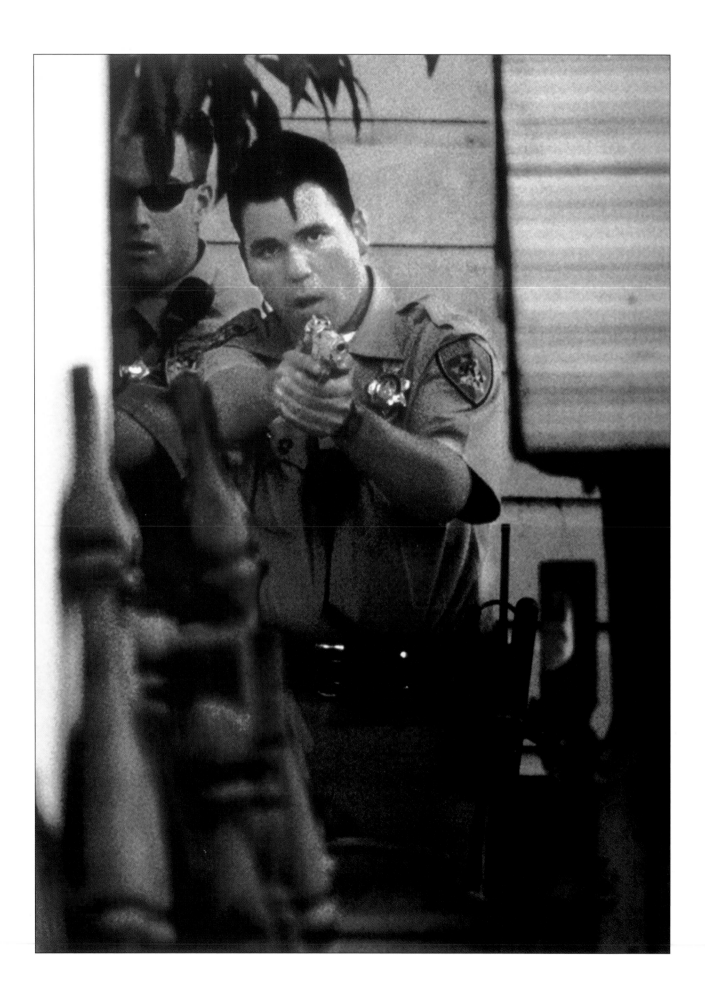

Left ■ With his gun drawn, highway patrol officer Ed Ayabarreno searches for a suspect who crashed a stolen vehicle and ran across a freeway into a neighborhood.

Right ■ This suspect is arrested after eluding police for forty minutes.

ALL PHOTOS ON THIS SPREAD:
WALLY SKALIJ, DAILY BREEZE (TORRANCE, CALIFORNIA),

FIRST PLACE,
ONE WEEK'S WORK

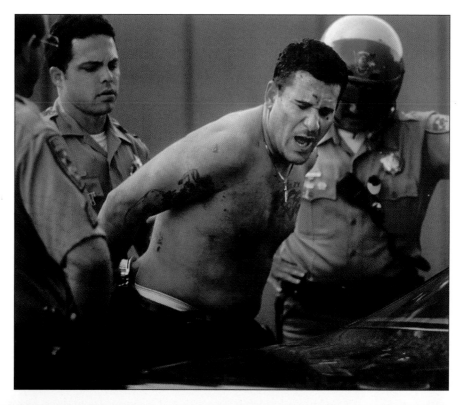

Below ■ Shanelle Jackson, age 5, watches while residents in the Three R's Outreach Program pray during a church service.

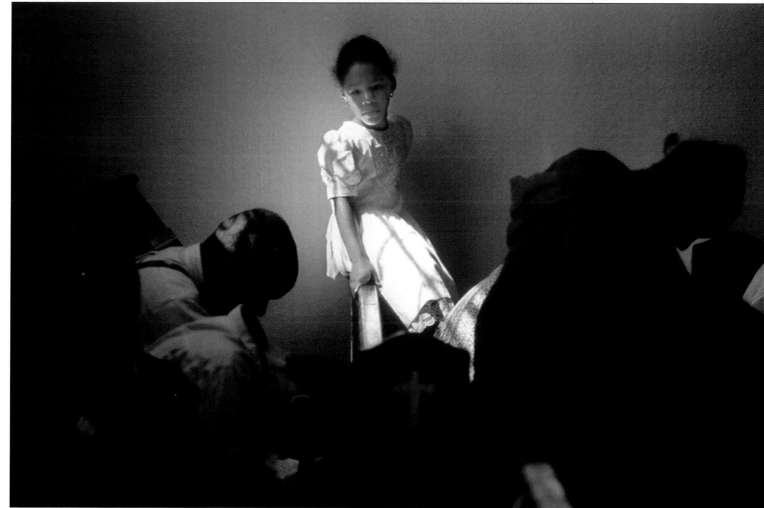

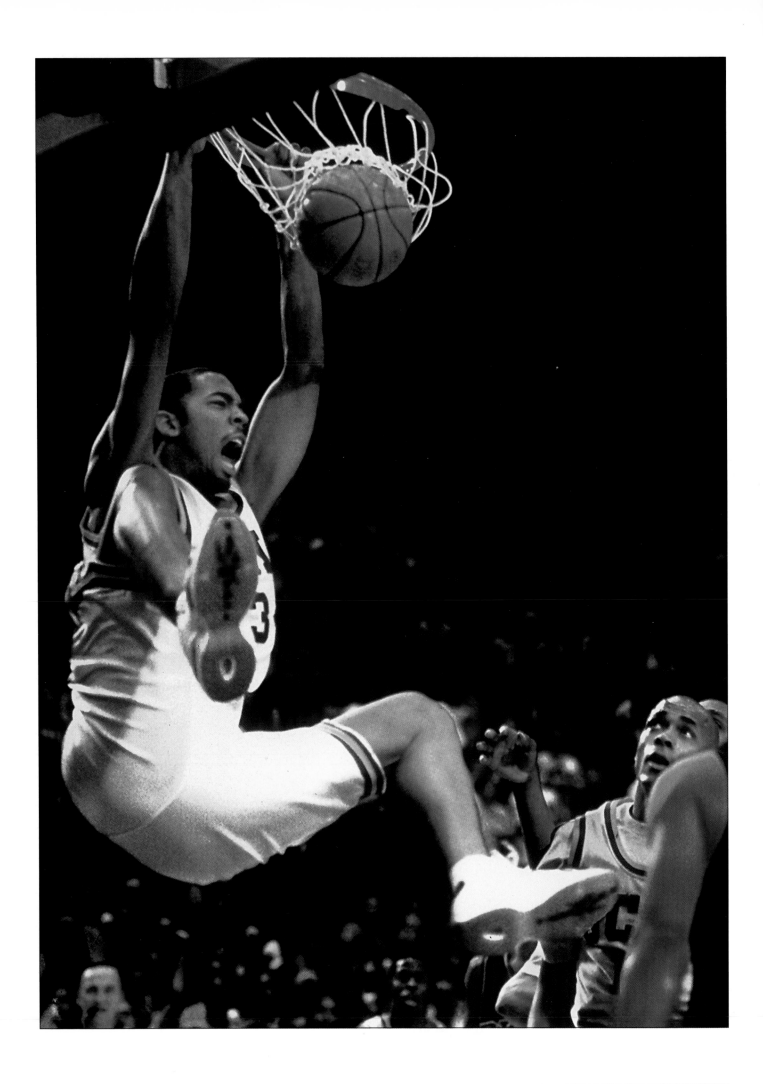

Left ■ UCLA's Jelani McCoy finishes off
a slam dunk with a roar during first-half action
of a big win over Duke.

Below ■ Hamilton High girls' soccer coach
Angel Mendez, at right, goes airborne as he
and his team celebrate their overtime shoot-out
win over Westchester in the Los Angeles
City 3-A playoffs.

ALL PHOTOS ON THIS SPREAD:
RICHARD HARTOG, THE OUTLOOK (SANTA MONICA, CALIFORNIA),
SECOND PLACE, ONE WEEK'S WORK

Left ■ Marymount
High's Teri Thomason,
at right, beats out
Brentwood School's
Shakira Gagnier with
a header during second-
half prep girls' soccer
playoff action in
Brentwood, California.

Right ■ A dejected Westchester High's Kristen Hill sits with her father Jim after the Comets loss to Hamilton High in an overtime shoot-out during the Los Angeles City 3-A girls soccer playoffs.

(THIS PHOTOGRAPH WAS ALSO PART OF THE FIRST PLACE NEWSPAPER SPORTS PORTFOLIO.)

Below ■ Four-year-old Garret LaRue and older brother Aaron are a little shy as they meet the press on leaving the UCLA Medical Center in Westwood. After an umbilical cord blood transfusion, both boys happily left on their big wheels.

ALL PHOTOS ON THIS SPREAD:
**RICHARD HARTOG, THE OUTLOOK
(SANTA MONICA, CALIFORNIA),**

SECOND PLACE, ONE WEEK'S WORK

Above ■ Artist Cruz Lopez finishes a wooden carving of Nuestra Señora de Guadalupe in the courtyard of the Fowler Museum on the UCLA campus in Westwood, California. He says that it will be a gift for his fiancee.

Left ■ Nathan Berlin, takes advantage of the warm weather and catches up on some reading while soaking up sun at Coldwater Canyon Park in Beverly Hills, California.

Left ■ Nalgia Myers, 18, looks through a bullet-riddled window in the living room where her mother, Juanita, was fatally wounded in Los Angeles.

ALL PHOTOS
ON THIS SPREAD:
**WALLY SKALIJ,
LOS ANGELES TIMES,**

THIRD PLACE,
ONE WEEK'S WORK

Above ■ During a tryout in Pasadena, California, Claude Hodge holds a picture and the ashes of his deceased wife Lil whose dream was to be honored as the queen of the Doo Dah Parade.

Below ■ Sgt. Jeff Sloat of the 7th Special Forces pay his respects to fellow veterans as he walks through the Los Angeles Cemetery.

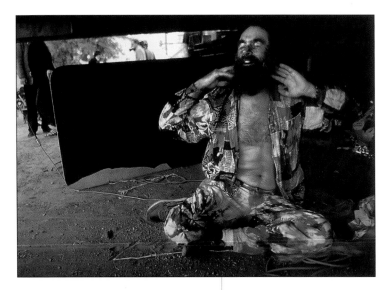

Above ■ A man takes a break after competing for the queen of the Doo Dah Parade in Pasadena.

Below ■ Outside the Berendo School, a well-wisher kisses the hand of Bartholamew – the spiritual leader of the world's 250 million Orthodox Christians – before a six-block march along Pico Blvd. in Los Angeles.

ALL PHOTOS ON THIS SPREAD:
WALLY SKALIJ, LOS ANGELES TIMES,
THIRD PLACE, ONE WEEK'S WORK

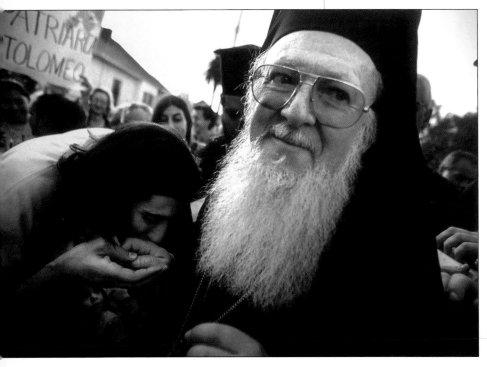

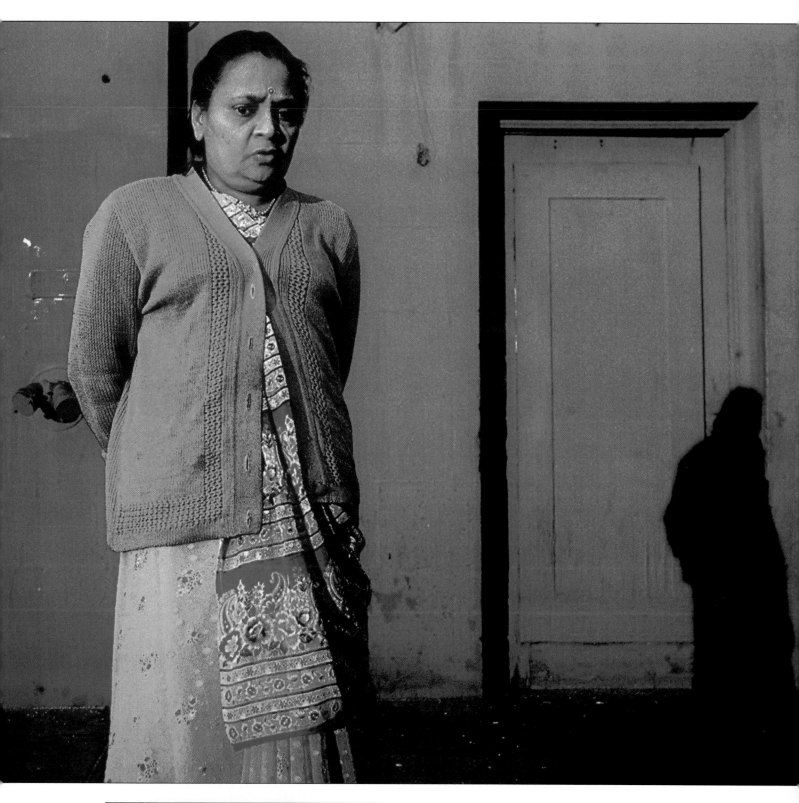

Above ■ A woman stands outside her apartment building during a late afternoon walk in Los Angeles.

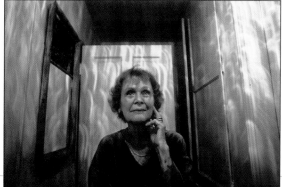

Left ■ Actress Gloria Stuart plays the role of a living survivor in the sinking of the Titanic in the blockbuster movie.

Graveyard Shift

MICHAEL WILLIAMSON, THE WASHINGTON POST, FIRST PLACE, NEWS PICTURE STORY

Above ■ The waiting room at D.C. General Hospital at 4:15am. Because major traumas get priority, these folks with less than critical injuries often wait as long as ten hours. Most have no insurance or access to regular medical care.

Left ■ Medical student Charles Rukus performs C.P.R. on a man who was shot several times. He tried to keep the man alive as a surgery team prepped, but after thirty minutes, the 21-year-old man was declared dead.

Below ■ Although dead, the haunting stare of a shooting victim seems to have life, just moments after he was declared dead in the emergency room. He was tagged "John Doe # 165" as his identity was not known.

Picture stories

Five of the six picture story categories in this year's 55th POY competition are displayed on the following 28 pages. This year, a Science & Natural History picture story category was added to the competition. Selects from the winners in this new category are displayed on pages 160-163.

NEWS PICTURE STORY:
MAY BE SPOT OR GENERAL
NEWS STORIES.

**GLOBAL NEWS PICTURE
STORY:** COVERAGE OF MAN-
MADE OR NATURAL DISASTERS
THAT PRODUCE MASSIVE
UPHEAVAL SUCH AS WAR
OR FAMINE.

**ISSUE REPORTING PICTURE
STORY:** A STORY OR ESSAY
THAT EXPLORES IMPORTANT
SOCIAL, ECONOMIC OR
POLITICAL ISSUES.

FEATURE PICTURE STORY:
A CANDID STORY OR ESSAY
THAT CELEBRATES LIFE.
RESPECT FOR THE DIGNITY OF
THE SUBJECT IS IMPORTANT.

SPORTS PICTURE STORY:
A STORY OR ESSAY THAT
INCREASES UNDER-STANDING
AND APPRECIATION FOR
INDIVIDUAL AND TEAM
SPORTS AND/OR THE ROLE
THAT ATHLETICS PLAYS
IN THE LIVES OF AMATEUR
AND/OR PROFESSIONAL
ATHLETES AND FANS.

PLEASE NOTE: NOT ALL
PICTURE STORY WINNERS ARE
DISPLAYED IN THIS SECTION AS
THEY MAY BE A PART OF A
PORTFOLIO AWARD DISPLAYED
ELSEWHERE IN THIS BOOK.

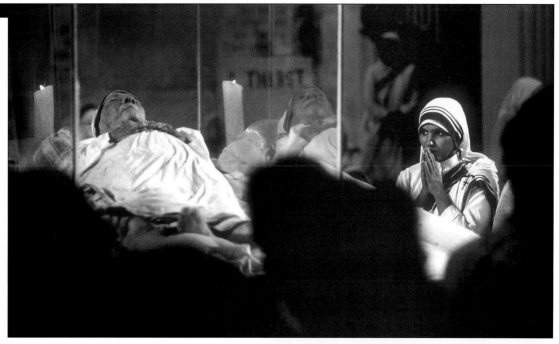

Legacy of Love

CAROL GUZY, THE WASHINGTON POST, THIRD PLACE,
NEWS PICTURE STORY (THIS STORY WAS ALSO PART OF THE FIRST
RUNNER-UP NEWSPAPER PHOTOGRAPHER OF THE YEAR PORTFOLIO.)

Above ■ A sister from Mother Teresa's Missionaries
of Charity says her goodbyes in an intimate moment
amid the crowds viewing the body.

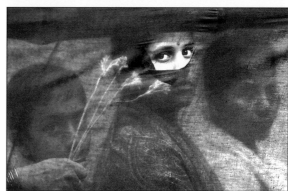

Right ■ A woman peers through a gauze netting
covering the barricades as masses of people file into
a Calcutta church to say farewell to Mother Teresa.

Drug Hole Warriors

NURI VALBONA, THE MIAMI HERALD
AWARD OF EXCELLENCE, NEWS PICTURE STORY

Right ■ A police officer, part of a special squad
targeting the drug trade, searches an abandoned
apartment where suspected dealers like to hide.

Below ■ Officer Kelvin Harris searches a juvenile
who was acting as "lookout" for drug dealers.

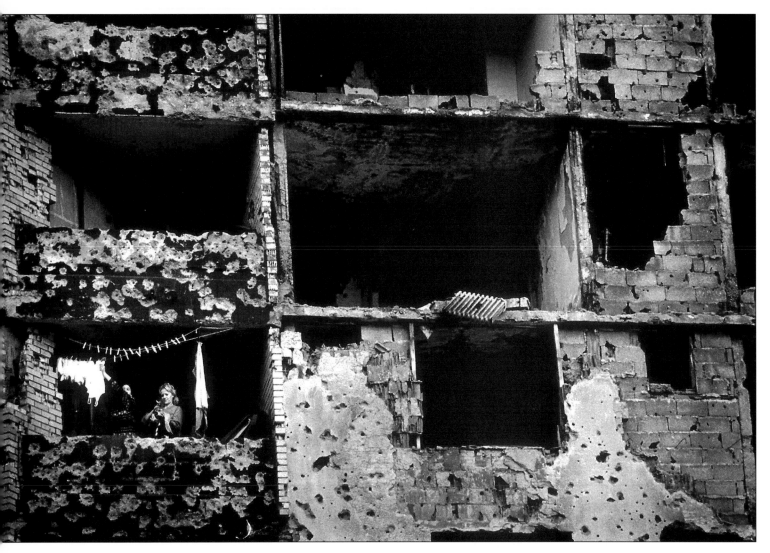

Bosnia:
A Hopeful Peace

NANCY ANDREWS, THE WASHINGTON POST
FIRST PLACE, NEWSPAPER GLOBAL NEWS

(THIS STORY WAS ALSO PART OF THE FIRST PLACE NEWSPAPER PHOTOGRAPHER
OF THE YEAR PORTFOLIO. A PICTURE FROM THIS STORY ALSO WON AN AWARD
OF EXCELLENCE IN NEWSPAPER GLOBAL NEWS. SEE IT ON **PAGE 129.**)

Above ■ "We didn't spend much time on the balcony,"
jests Aovija Mangafic. Peace is tenuous in Bosnia; President
Clinton has repeatedly extended the stay for U.S. troops
Most believe fighting will resume if U.S. and NATO troops
leave. For Mangafic, "I have my trust in the Americans.
I believe they will not allow a new war. As long as the
U.S. is here, there will not be a war..."

THIS PHOTO RECEIVED AN AWARD OF EXCELLENCE IN NEWSPAPER GLOBAL NEWS.

Right ■ With such cruelty from both sides in the Bosnian
war it is often said that only the children were innocent. Now,
during peace, these Muslim refugee children say they don't
like their new houses but want to return to "their" original
homes in Brcko, now held by the Serbs.

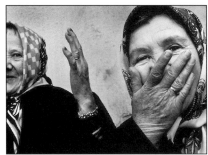

Left ■ Widows laugh and talk
with friends after visiting an aid
station. They have little means
of income, and their children
have fled the country for better
jobs in Germany.

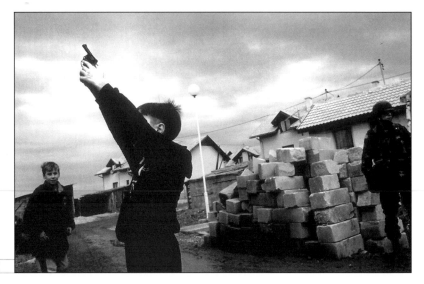

Northern Ireland: On the Brink of Peace?

BRIAN WALSKI, BOSTON HERALD
SECOND PLACE,
NEWSPAPER GLOBAL PICTURE STORY

Left ■ Members of the Royal Ulster Constabulary surround Catholic protesters in the pre-dawn hours on the Garvaghy Road in Portadown. Their attempt to block a Protestant Orange Order parade through their neighborhood was in vain.

Below ■ A teenager celebrates at a bonfire in Belfast to usher in the Protestant July 12 holiday.

Right ■ A Catholic youth vents his anger by throwing a brick at an armored RUC cruiser on the Springfield Road in West Belfast.

Albanian Unrest

SANTIAGO LYON, THE ASSOCIATED PRESS
AWARD OF EXCELLENCE, NEWSPAPER GLOBAL NEWS PICTURE STORY

(A PICTURE FROM THIS STORY, NOT SHOWN, ALSO WON AN AWARD
OF EXCELLENCE IN NEWSPAPER GLOBAL NEWS. SEE IT ON **PAGES 122-123.**)

Above ■ A masked Albanian anti-government rebel points
a rifle at the head of Adem Hasa, the chief of the Albanian's
president's bodyguards.

Below ■ An Albanian anti-government protester prepares
to bite into the leek, the symbol of a poor man's diet,
during a demonstration in Fier, Albania.

Haiti's Sorrow: Still the Same

DEBBIE MORELLO, FREELANCE/KNIGHT-RIDDER TRIBUNE
THIRD PLACE, NEWSPAPER GLOBAL NEWS PICTURE STORY

(A PICTURE FROM THIS STORY ALSO WON A THIRD PLACE
IN NEWSPAPER GLOBAL NEWS. SEE IT ON **PAGE 131.**)

Above ■ Six-year-old Veronique cries for her father as she walks
through the National Cemetery in Port-au-Prince to her father's
gravesite with a relative. Her 35-year-old father died after months
of a respiratory illness and fevers that persisted. Undiagnosed
and unable to receive proper medical care.

Below ■ At the Sunday Mass in the Cathedral in downtown
Port-au-Prince, a little boy looks up to his mother as she
gently touches him. For the poverty-stricken people of Haiti
solace is found in religion. For these people, praying for divine
intervention seems to be the only hope they have.

Above ■ An old train was used to move Rwandan refugees lost in a jungle in Zaire to an airfield in Kisangani.

(THIS PHOTOGRAPH ALSO RECEIVED AN AWARD OF EXCELLENCE IN MAGAZINE GLOBAL NEWS.)

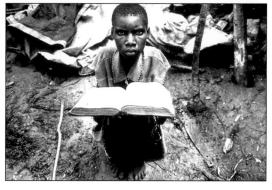

Lost in Zaire: Hutu Refugees

ROGER LEMOYNE, GAMMA-LIAISON
FIRST PLACE, MAGAZINE GLOBAL NEWS PICTURE STORY

Middle left ■ A 12-year-old girl, traumatized by mass killings at Kasese and Biaro camps, reads from her Bible.

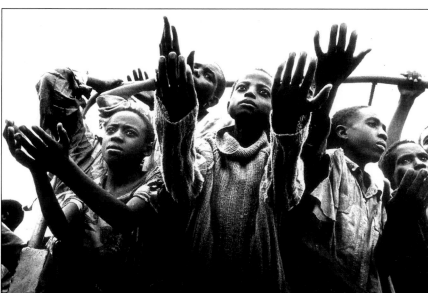

Below left ■ After two-and-a-half years of exile and a journey of more than 700 kilometers on foot, refugees begin the trip back to Rwanda.

(THIS PHOTOGRAPH ALSO RECEIVED THIRD PLACE IN MAGAZINE GLOBAL NEWS.)

(ANOTHER PICTURE FROM THIS STORY ALSO WON FIRST PLACE IN MAGAZINE GLOBAL NEWS. SEE IT ON **PAGE 128.**)

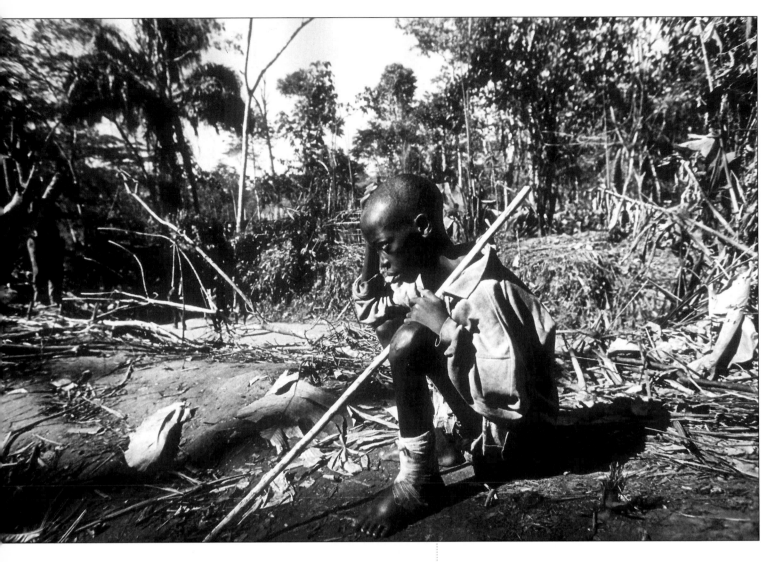

Waiting in the Jungle

RADHIKA CHALASANI, SIPA PRESS
SECOND PLACE,
MAGAZINE GLOBAL NEWS PICTURE STORY

(A PICTURE FROM THIS STORY ALSO WON
AN AWARD OF EXCELLENCE IN MAGAZINE
GLOBAL NEWS. SEE IT ON **PAGES 128.**)

Above ■ A young Rwandan refugee
with sore, swollen feet sits alone
east of Kisangani after walking
for months.

Right ■ A father holds his
newborn baby in a refugee camp
near Kisangani. The three-week-old
child was born after its mother
trekked for six months.

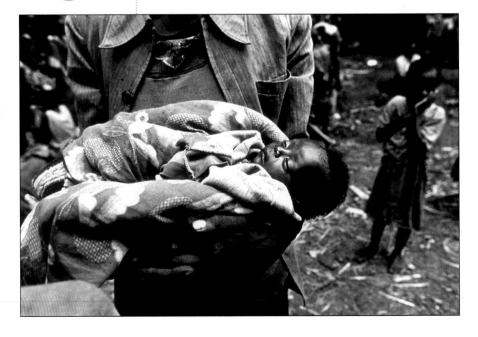

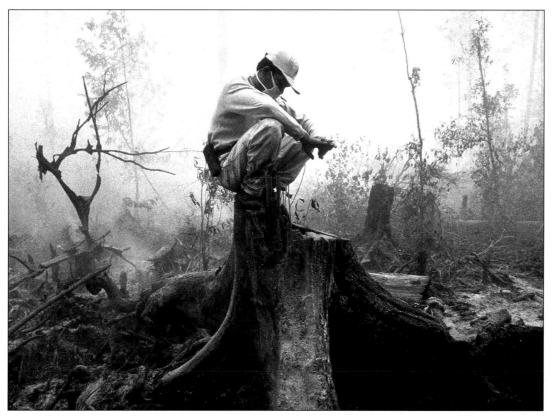

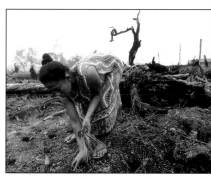

Indonesian Forest Fires

DAVID PORTNOY
U.S. NEWS & WORLD REPORT/
BLACK STAR
THIRD PLACE,
GLOBAL NEWS PICTURE STORY

Above ■ A farmer plants rice seedlings in a recently burned field.

Left ■ A firefighter rests on top of a stump in the burned-out forest.

The Nursing Home Dilemma

STEVE HEALEY, THE INDIANAPOLIS STAR & NEWS
THIRD PLACE, ISSURE REPORTING PICTURE STORY

Below ■ Evelyn says goodbye to long-time neighbor Tom Wheatley. She is moving into a nursing home. She had hoped to live the rest of her life at home with her husband. Multiple strokes, however, changed all that.

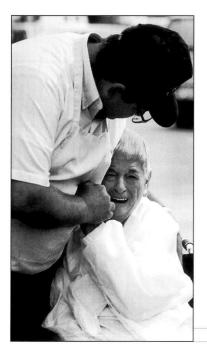

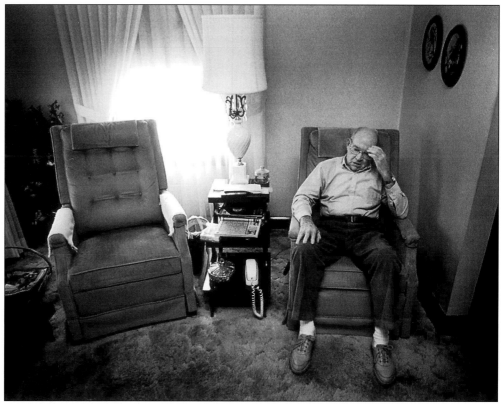

Above ■ Feeling guilty and frustrated for not being able to care for Evelyn, Ray sits alone in the living room he once shared with her daily. "This is a bunch of crap," he says, responding to a question posed by a reporter about how it makes him feel to put his wife of 60 years in a nursing home.

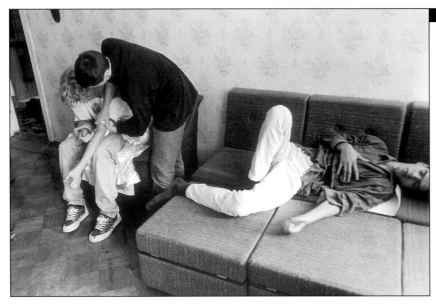

Inside a High Risk Community: HIV in the Former Soviet Union

Above ■ While parents are away, Moscow students try ketamine, an anesthetic that causes hallucinations. Each bought fresh syringes but share a bottle filled with many doses.

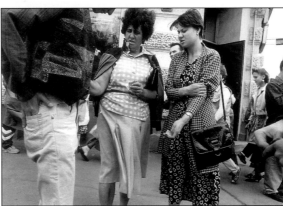

JOHN RANARD, FREELANCE, NEW YORK CITY
FIRST PLACE, NEWSPAPER ISSUE REPORTING PICTURE STORY

Left ■ Two middle-class house wives deal in paraphernalia and chemicals for making homemade drugs with a young customer across the way from the old KGB headquarters.

Below ■ Odessa's bright lights lure Oksana from the depressed Ukrainian countryside into the life of prostitution. Many of the girls on the street turn to drugs.

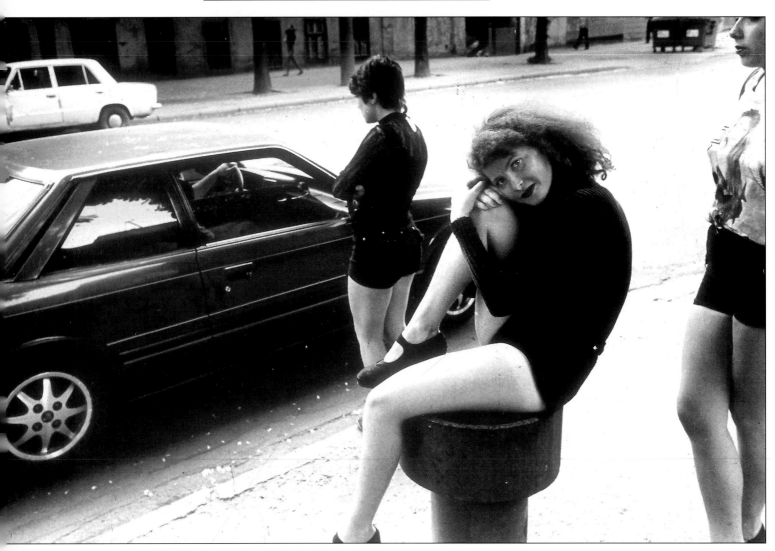

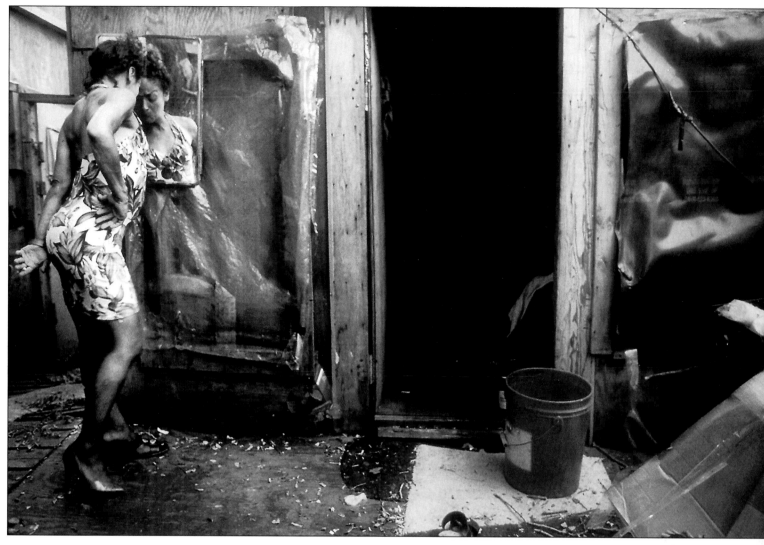

Gloria: Life on the streets

SUSAN WATTS, NEW YORK DAILY NEWS, SECOND PLACE, NEWSPAPER ISSUE REPORTING PICTURE STORY

Above ■ Gloria takes a last look and practices her strut in the mirror before going out to work the streets in search of a john in the Hunt's Point section of the Bronx, New York. "Truckers are much easier. They're less likely to hurt you with the logos on their trucks," she says.

Right ■ To avoid tearing her pantyhose, Gloria squeezes the scabs on her legs. Once beautiful, her body is virtually covered with open sores and lesions from drug use and malnutrition.

Below ■ Again, drug sick and desperate, Gloria reaches for the smallest human touch. Her friend "White Boy John," a homeless man from the streets, provides a temporary comfort.

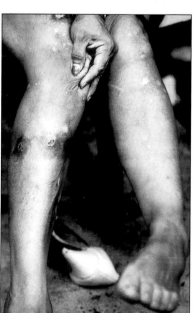

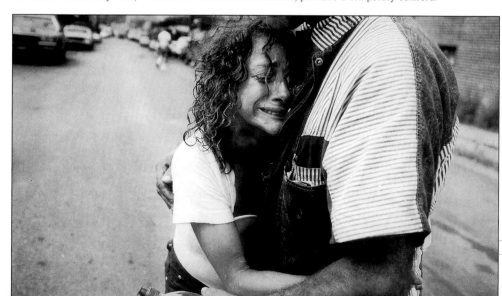

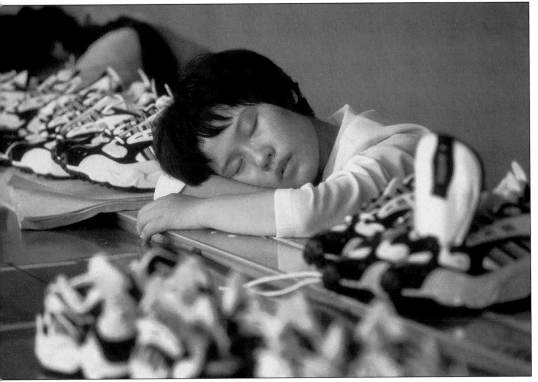

Nike and Asia's Shoe Industrial Revolution

PAUL KITAGAKI, JR., THE OREGONIAN
AWARD OF EXCELLENCE,
NEWSPAPER ISSUE REPORTING PICTURE STORY

Above ■ Some of the 8,000 workers in one portion of the Pou Chen plant in Dougguan, China, stream toward the canteen for factory provided lunch. Workers eat in two shifts during the 1.5 hour lunch break.

Left ■ Workers relax during a post-lunch nap typical in many of the Asian shoe factories. The lights are dimmed and workers snooze on the assembly line, their desks and on floors. Some work seven days a week.

Life in Prison

ANDREW LICHTENSTEIN
SYGMA/
U.S. NEWS & WORLD REPORT
AWARD OF EXCELLENCE,
MAGAZINE ISSUE REPORTING
PICTURE STORY

Right ■ A violent prisoner is placed in a restraining chair after trying to fight with his jailers.

Below right ■ Members of the Aryan Brotherhood in a recreation yard separated from other prisoners.

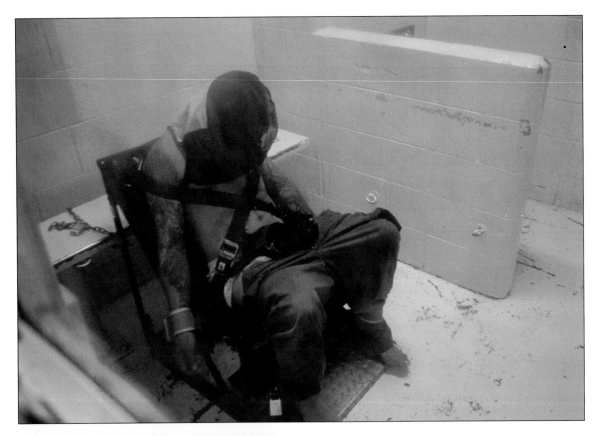

A Widow on Welfare: An Untold Story

PAULA LERNER, WOODFIN CAMP
FIRST PLACE, MAGAZINE FEATURE PICTURE STORY

Above ■ Although Darla's sparring with her son Ricky is meant to be playful, the strains of being a single parent show through. When her husband Richard Danilowicz died suddenly at age 35 she found herself a widow with three children, the youngest of which was only eight-months-old. With no means of supporting the family she reluctantly went on welfare. As current welfare reforms take effect, her family's struggle to make ends meet will become that much harder.

Below left ■ A part-time student at Bunker Hill Community College, Darla is thrilled when she gets a right answer to a tough question on a quiz.

Below right ■ Darla is overcome with tears when she recalls her family's life before the sudden death of her husband.

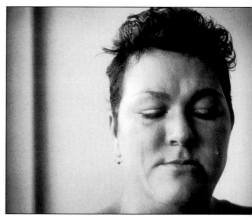

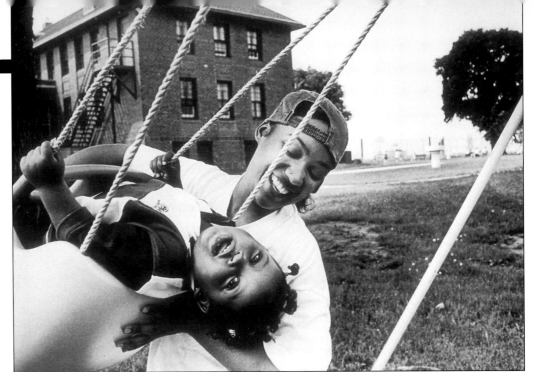

Women Behind Bars

**JANE EVELYN ATWOOD,
LIFE MAGAZINE**
SECOND PLACE,
MAGAZINE ISSUE REPORTING
PICTURE STORY

Above right ■ At the
Nebraska Correctional Center for Women,
18-month-old Zheronte visits
his mother, Azuree Lynch, age 19,
doing time for armed robbery.

Middle right ■ A women's prison
in Marseilles, France, is home to inmates and
their children from infancy
to 18 months of age.

Below ■ In the United States,
women in labor are handcuffed and
shackled when taken off prison grounds.
Doctors often insist that restraints
be removed.

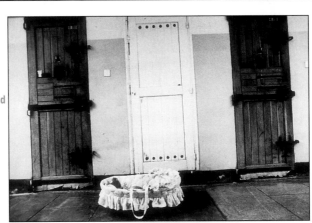

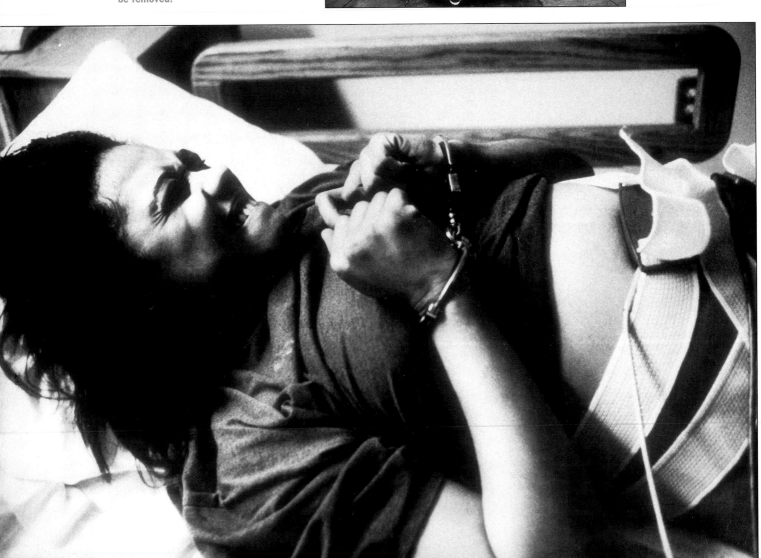

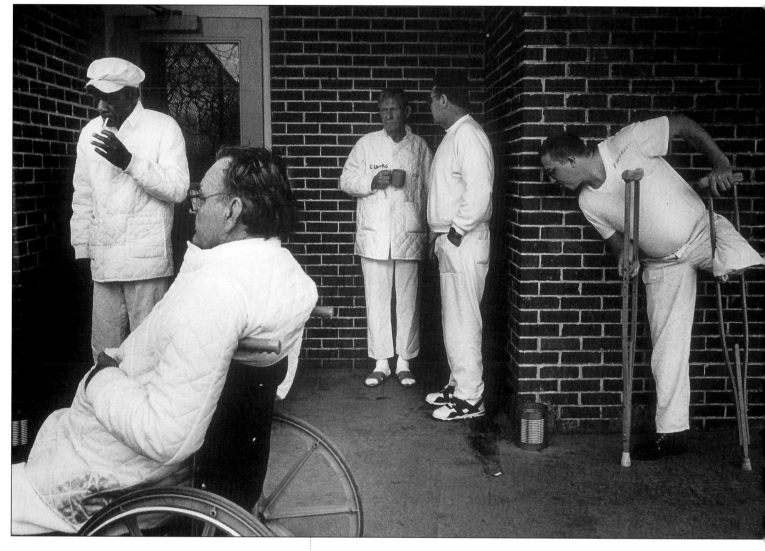

America's Aging Inmates

ED KASHI, FREELANCE, SAN FRANCISCO, THIRD PLACE, MAGAZINE ISSUE REPORTING PICTURE STORY

Above ■ Both elderly and young inmates have a smoke in the only area designated for smoking in this prison.

Left ■ An elderly inmate struggles with weights at the Hamilton Correctional facility for the Aged and Infirmed in Alabama.

Below ■ This blind prisoner listens to books on tape while sitting in his cubicle. This new living arrangement represents how prisons are dealing with the needs of elderly prisoners.

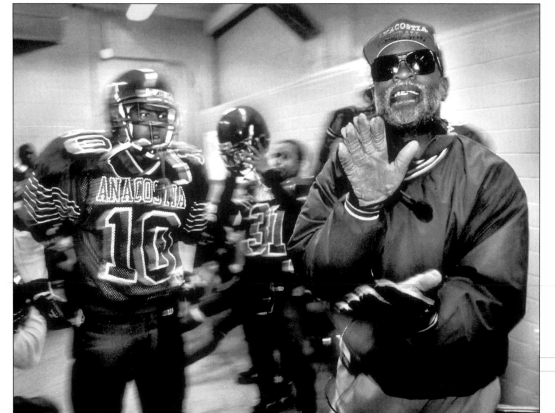

Game of Life

DUDLEY M. BROOKS
THE WASHINGTON POST
SECOND PLACE,
NEWSPAPER SPORTS PICTURE STORY

(THIS STORY WAS ALSO PART OF THE THIRD
RUNNER-UP NEWSPAPER PHOTOGRAPHER
OF THE YEAR PORTFOLIO.)

Left ■ After a rousing halftime
pep talk, Anacostia High School
Head Football Coach Willie
Stewart claps his hands as he
sends his players back to the
field for the second half of their
semi-final game. The team went
on to win the game which
qualified them to play in the
finals, called the Turkey Bowl.

The Anderson Monarchs

**ERIC MENCHER,
THE PHILADELPHIA INQUIRER**
FIRST PLACE, NEWSPAPER SPORTS PICTURE STORY

Above right ■ As his team falls behind, the mood on the bench becomes somber.

Left ■ Outfielders for the Monarchs, an inner city Little League baseball team from Philadelphia warm up before a game.

Below ■ It's sleep time on the bus as the Monarchs endure a long stretch of driving on the last day of their ten-day, old-fashioned "barnstorming" tour through the Eastern U.S. Traveling in a 1940s bus, the youngsters recreated the spirit of the Negro League.

Right ■ Outside the locker room, Anacostia lineman Raymond Ballard is comforted by team manager Takesha Weston after the team lost the Turkey Bowl championship.

Below ■ Star player Cato June (#1) rejoices after scoring the team's first touchdown in the Washington, D.C. city championship game. Although June scored early, his team lost the game by a narrow margin.

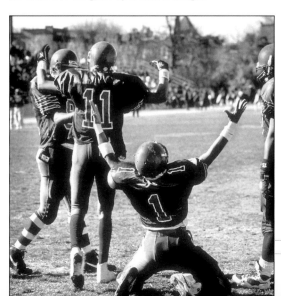

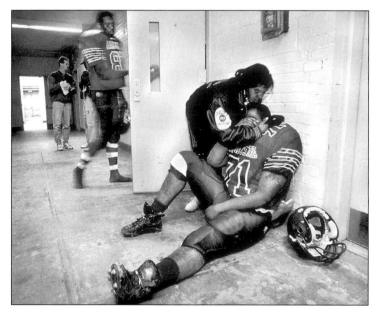

Field of Dreams

KHUE BUI, THE WASHINGTON POST
THIRD PLACE, NEWSPAPER SPORTS PICTURE STORY

(A PICTURE FROM THIS STORY ALSO WON FIRST PLACE
IN THE NEWSPAPER SPORTS ACTION CATEGORY.
SEE IT ON **PAGE 166.**)

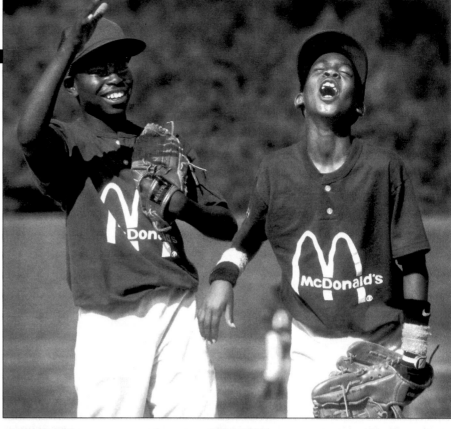

Above ■ Sammie Pearson, left, and Dominic Lane,
joke around between innings. Kenilworth-Parkside went
on to win the game.

Left ■ Parents show their support under a crumbling scoreboard.

The Grand Sumo

TOURNAMENT IN AUSTRALIA

**CRAIG GOLDING,
SYDNEY MORNING HERALD**
AWARD OF EXCELLENCE,
NEWSPAPER SPORTS
PICTURE STORY

Right ■ The pomp
and ceremonial
rituals associated
with the ancient
Sumo wrestling form
are many and varied.
Here, before the
matches begin,
a Sumo and boy.

Right ■ In this
pre-match ceremony,
the grace of the
wrestler's years of practice
and study contrasts sharply with the
gigantic size of his body and the ornamentation
of his ceremonial garb.

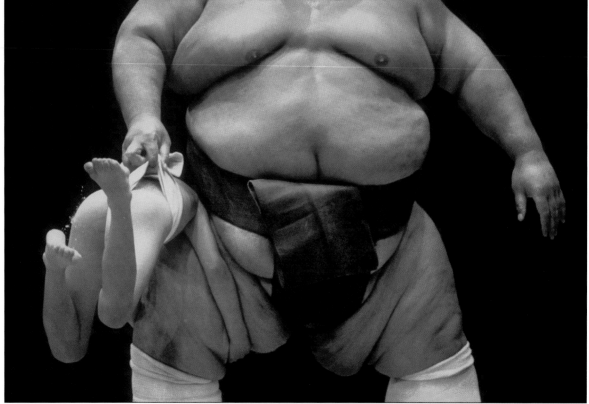

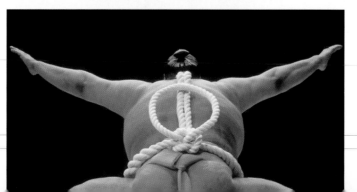

Wrestling in Gambia

STEPHEN DUPONT, CONTACT PRESS IMAGES
FIRST PLACE, MAGAZINE SPORTS PICTURE STORY

(THIS STORY WAS ALSO PART OF THE SECOND RUNNER-UP
MAGAZINE PHOTOGRAPHER OF THE YEAR PORTFOLIO.)

Left ■ "A ticket seller" at Serekunda Stadium. Unfortunately, many locals cannot afford the ticket price to attend the wrestling matches.

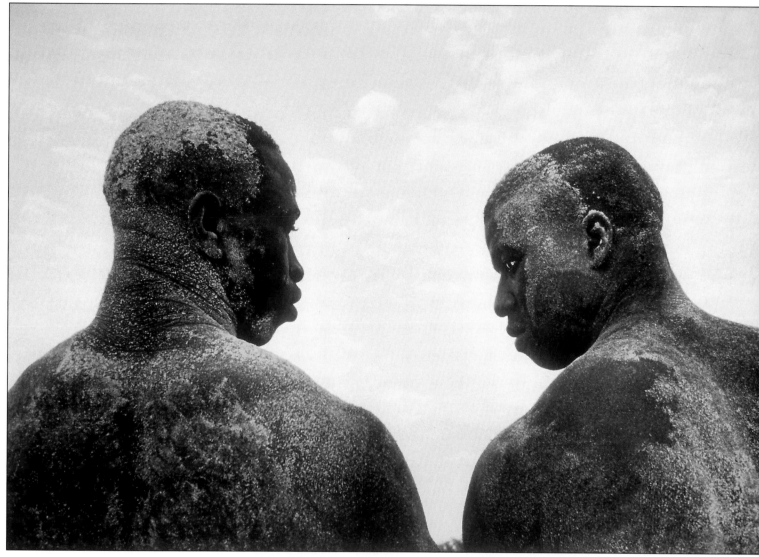

Above ■ The wrestlers often parade their strength before the matches begin. Here, "Apollo," right, and "Manpower," at a practice wrestling session in Brikama Stadium.

Right ■ In a blur of strength and agility, two opponents wrestle each other at Serekunda Stadium.

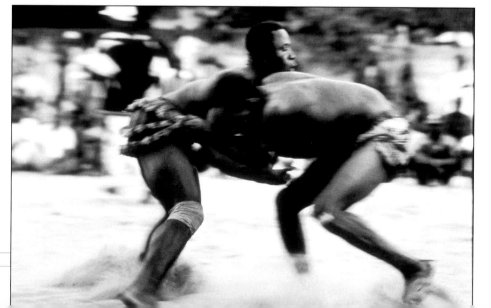

Inner City Sports

DAVID BUTOW, U.S. NEWS & WORLD REPORT
SECOND PLACE, MAGAZINE SPORTS PICTURE STORY

(A PICTURE FROM THIS STORY ALSO WON SECOND PLACE IN
THE MAGAZINE SPORTS FEATURE CATEGORY. SEE IT ON **PAGE 166.**)

Above ■ A football player for sports-fixated
Farragut Academy on Chicago's South Side
works out in the weight room during the off
season. As in most schools, the really social
champions at this nearly all-black public academy
are the athletes. The notion that children need
to excel in sports to be socially acceptable
raises questions about the state of education
in low-income black communities.

Above right ■ A group of neighborhood
kids play a pickup game with a makeshift hoop
on Chicago's downtrodden South Side. The odds
that any high school athlete will play a sport
on the professional level are remote, about 10,000-
to-1. Yet sixty-six percent of all African-American
males between age 13 and 18 believe they can
earn a living playing professional sports.

Below right ■ Larry Hawkins is both a teacher
and a coach to these top academic students
who are not as athletically inclined.

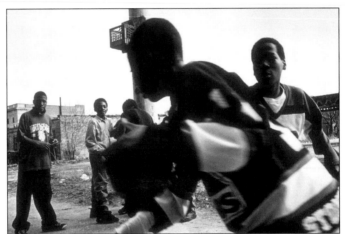

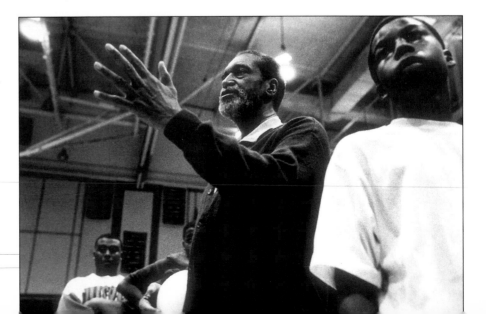

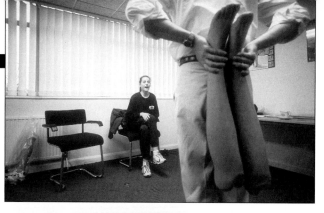

DAVID BUTOW, LYNN JOHNSON, PAUL CARTER

Triumph of the Human Spirit

LYNN JOHNSON, SPORTS ILLUSTRATED/AURORA AGENCY
THIRD PLACE, MAGAZINE SPORTS PICTURE STORY

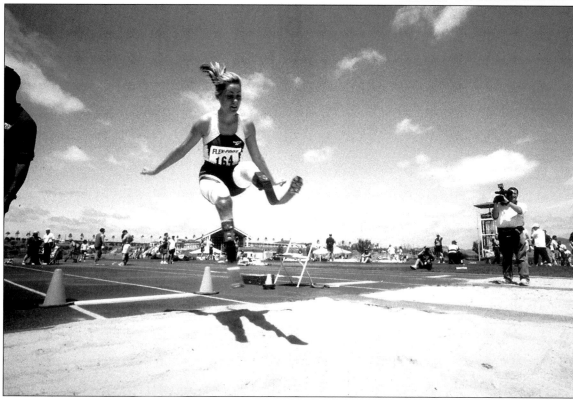

Above ■ Dr. Watts showing Aimee her new legs for the first time. The silicon legs are almost lifelike.

Left ■ Among the many activities Aimee continues to participate in is this long-jumping at at track meet in San Diego.

Death Be Not Proud

PAUL CARTER, THE REGISTER-GUARD
THIRD PLACE, NEWSPAPER FEATURE PICTURE STORY

Right ■ Larisa was diagnosed the previous April with cancer, an inoperable tumor in her liver. Here, she smiles gamely as she poses for a snapshot with her closest friend Katie Phipps. Heavily medicated, she still manages to throw a party to say goodbye to her circle of high school friends.

Below ■ Glenda Brooks and a small group of friends prepare her daughter Larisa's body for cremation. At a mortuary, they adorn her body with flowers and tokens of love before placing the body in the cremation chamber. Larisa died two days after Christmas.

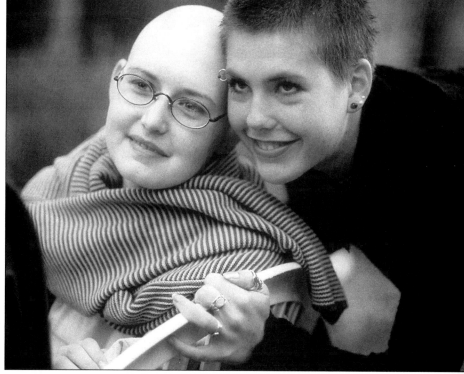

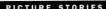

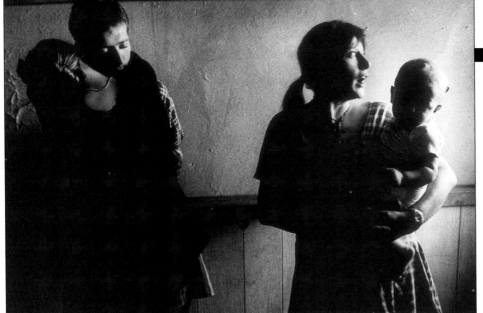

The Circle Remains Unbroken

PEGGY PEATTIE, OHIO UNIVERSITY
FIRST PLACE,
NEWSPAPER FEATURE PICTURE STORY

Above left ■ Lyne hands her baby to Chris, her mom, when boyfriend Ben comes over for a visit.

Below ■ There are times when Ben and Lyne escape to the local lake, baby Jerry in tow of course, to do what teenagers do. Lyne is almost 15. Her son Jerry, the product of a date rape, is almost one-year-old. Lyne has convinced Ben to be Jerry's father figure, a role he accepts so long as he can share the togetherness of Lyne's poor but loving family.

Right ■ Lyne still sucks her thumb sometimes when she's nervous, a habit she masks with suckers and cigarettes. She talks openly about her and Ben's plans to marry in two years when she's 17. She stops at the end of Main Street several times a week, while bumming cigarettes, to look at the local bakery's cakes.

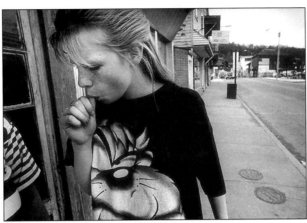

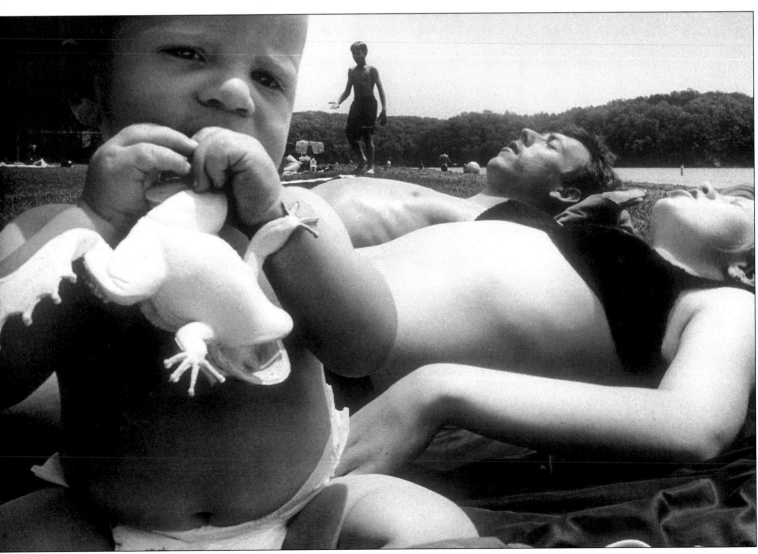

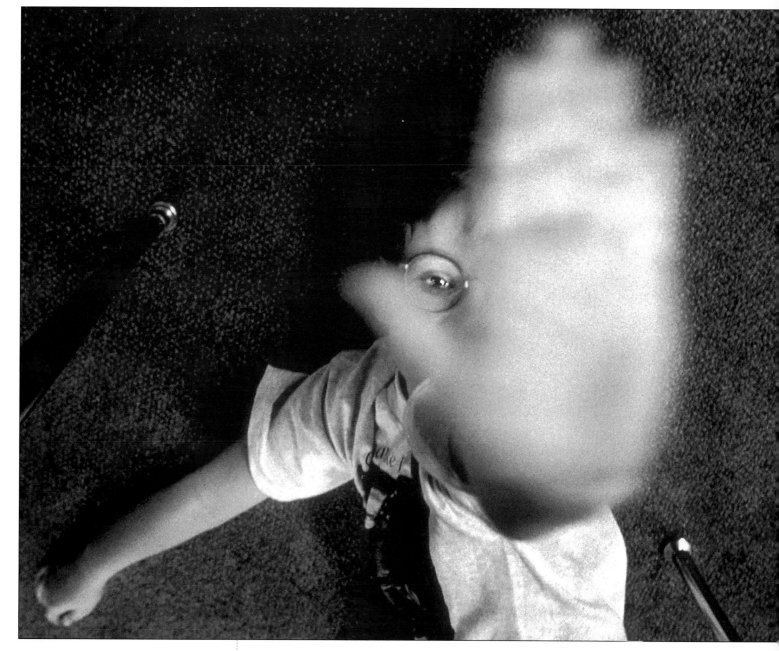

A World
of His Own

CAROL GUZY, THE WASHINGTON POST
SECOND PLACE, NEWSPAPER FEATURE PICTURE STORY

(THIS STORY WAS ALSO PART OF THE FIRST RUNNER-UP
NEWSPAPER PHOTOGRAPHER OF THE YEAR PORTFOLIO.)

Above ■ Alex Mont, age 9, is a child with autism. He is also considered
a math genius. He is in a world of his own at times. As other children study
in class at Candlewood Elementary in Rockville, Alex lays under a table.

Below right ■ Alex on a neighbor's swing.
There are moments of pure joy along with the anxieties of his life.

Below left ■ Alex works with his beloved numbers at home.

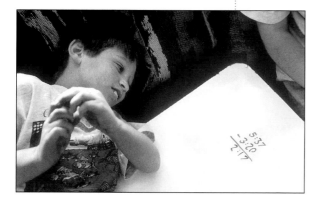

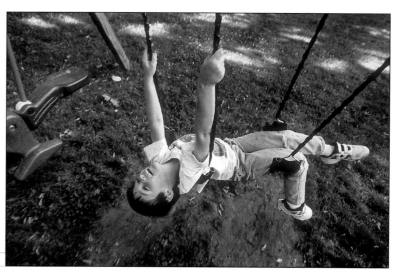

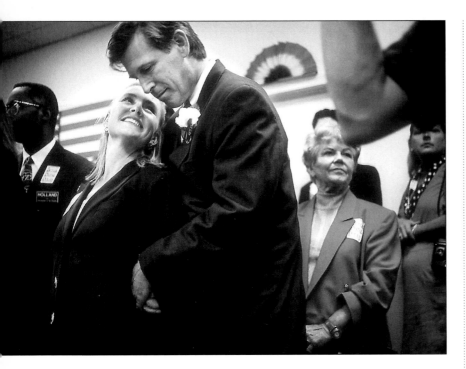

On Beyer's Trail

VICKI CRONIS, THE VIRGINIAN-PILOT
AWARD OF EXCELLENCE, NEWSPAPER FEATURE PICTURE STORY

Above ■ Megan Beyer leans against her husband, Donald, Democratic candidate for Virginia governor, during a rare meeting on the campaign trail at a campaign office opening. She and her husband are touring the state separately and this is their only chance to be together for the weekend.

Below ■ Bill Keenan, wearing a mixture of Republican stickers, one supporting Donald S. Beyer's opponent, laughs after Beyer asked him for his support. Beyer lost the bid for the governor's office after serving eight years as Lieutenant Governor

Mobile Clinic

BARBARA DAVIDSON
THE WASHINGTON TIMES
AWARD OF EXCELLENCE,
NEWSPAPER FEATURE PICTURE STORY

Above ■ Caregivers of all ages, along with their toddlers, crowd into the tiny waiting area inside the front end of the mobile clinic at the Fort Dupont site in southeast Washington D.C.

Below ■ Linda D. Lee agonizes over the pain of her 2-year-old son, Brandon, as he receives a tetanus shot.

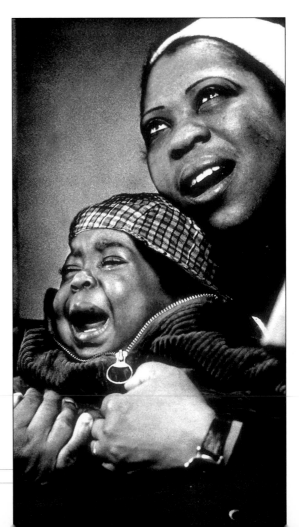

Cuba: On the Edge

ERIC MENCHER, THE PHILADELPHIA INQUIRER
AWARD OF EXCELLENCE, NEWSPAPER FEATURE PICTURE STORY

Right ■ A father and his daughter on the balcony of their Havana home. By mixing nationalism with patriotism, by implementing authoritarian rule and by masterfully manipulating his only enemy left in the world, Fidel Castro has now been in power for almost four decades. But the collapse of the Soviet Union led to the collapse of the Cuban economy. Fuel is doled out in eyedroppers and food is measured in ounces and teaspoons. The dollar is legal and the ills of capitalism have set upon the scourge of communism. Economically, Cuba has already entered the post-Castro area.

But there remains with the people an energy, a joy of life, a lyricism in the land. There is a decrepit beauty and a constant song as Cubans struggle with their day-to-day existence. It is a land on the edge. ºWhat is over the edge, no one can be sure.

At right ■ Women in a Havana beauty salon.

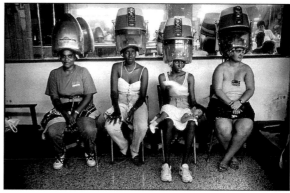

Coming of Age

SUZANNE PLUNKETT, THE JERSEY JOURNAL
AWARD OF EXCELLENCE, NEWSPAPER FEATURE PICTURE STORY

Below ■ Randi, age 15, flirts with her friend Devin at Burger King. This self-proclaimed "nerd" has always been shy and desperately wants to overcome it. Her plan is to become more active at school and in the community. And it's working. Since the beginning of the school year, she's been voted vice-president of the Future Homemakers of America, joined the BYKOTA (Be Ye Kind, One to Another), gone steady with a few boys and started wearing makeup.

Right ■ After school in Carthage, Missouri, Randi receives secret information from a classmate about a boy who likes.

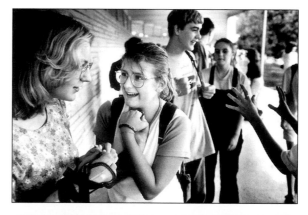

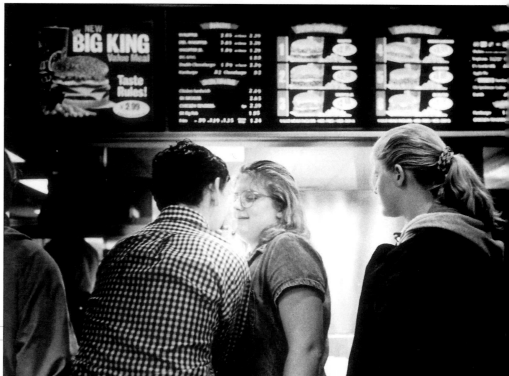

The World From My Front Porch

LARRY TOWELL LIFE MAGAZINE/MAGNUM
SECOND PLACE,
MAGAZINE FEATURE PICTURE STORY

(LARRY ALSO WON FIRST PLACE IN THE
MAGAZINE PICTORIAL CATEGORY. THAT PHOTO
CAN BE SEEN ON **PAGE 155.**)

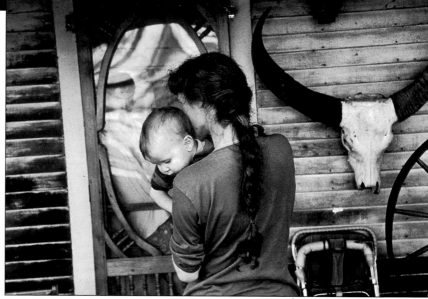

The work from this story has been shot during the past ten years and within 100 yards of the house.

Above ■ Naomi and a cat in a tree.

Above right ■ Ann holds Isaac on the front porch.

Below ■ Caught on one of the photographer's first rolls of film in 1974, his two sisters in an abandoned farmhouse.

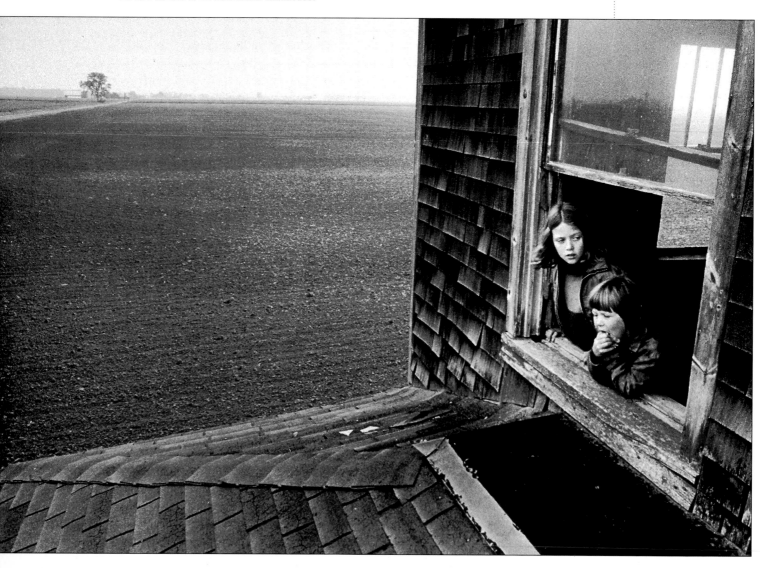

County Fairs: Rural America's Last Hurrah

RANDY OLSON,
FREELANCE/NATIONAL GEOGRAPHIC MAGAZINE,
FIRST PLACE, MAGAZINE FEATURE PICTURE STORY

(ANOTHER PHOTO FROM THIS STORY WON AN AWARD
OF EXCELLENCE MAGAZINE SPORTS FEATURE.
IT CAN BE SEEN ON **PAGE 170.**)

Above left ■ An unwilling participant in the Texas heat at the Brazoria County Fair.

Above right ■ During the turn-of-the-century-inspired pig and ford race, dairy farmers carry pigs around the track in their Model-T Fords in Tillamook, Oregon.

Below ■ Talent show at the Del Norte County Fair, California.

(THIS PHOTO ALSO WON FIRST PLACE IN MAGAZINE PICTORIAL. IT CAN BE SEEN ON THIS PAGE.)

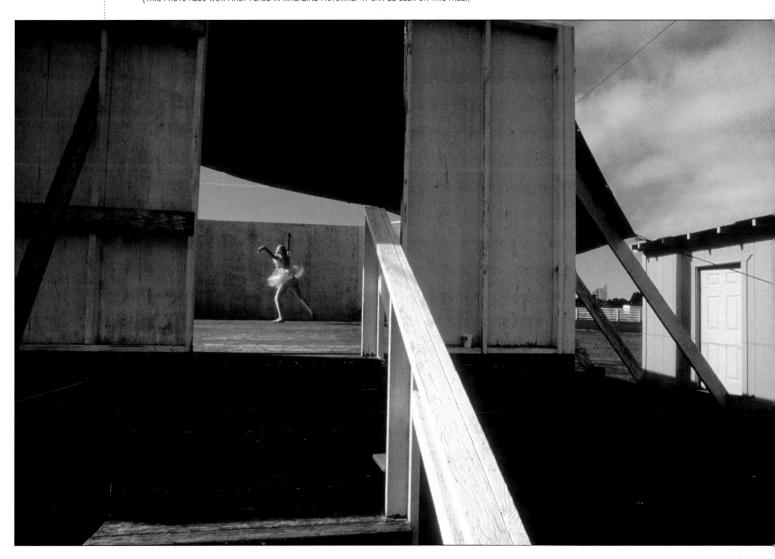

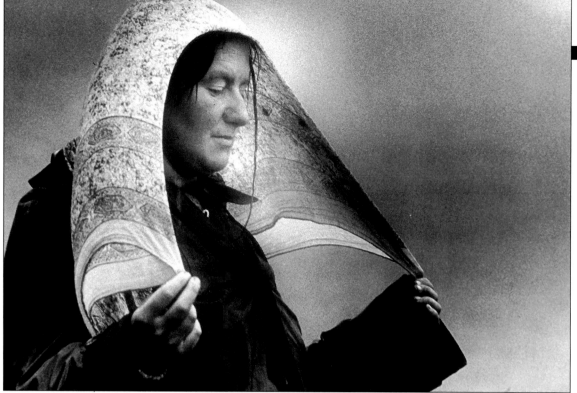

Stones to Heaven

**MICHELE MCDONALD,
FREELANCE,
ARLINGTON, MASSACHUSETTS**
AWARD OF EXCELLENCE,
MAGAZINE FEATURE
PICTURE STORY

Above left ■ It is a rare year when pilgrims see a view from the Croagh Patrick. The sun shines at the bottom, but rain, cold mist and fog cover the mountain as one climbs the holy mountain in Ireland.

Left ■ Millions of stones make up a steep moonscape of loose, sharp-edged quartzite. Without a stick, it's almost impossible to climb the mountain.

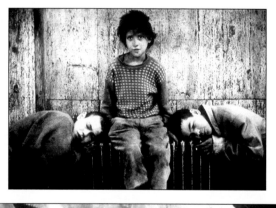

Bucharest: The Children of North Station

ETTORE MALANCA, SIPA PRESS
THIRD PLACE, MAGAZINE FEATURE PICTURE STORY

Above ■ The children warm themselves around a radiator in the train station when it becomes cold.

Left ■ Two travelers, a mother and her young son, pass a teen lying on the platform. The son nudges the teen who has lost consciousness.

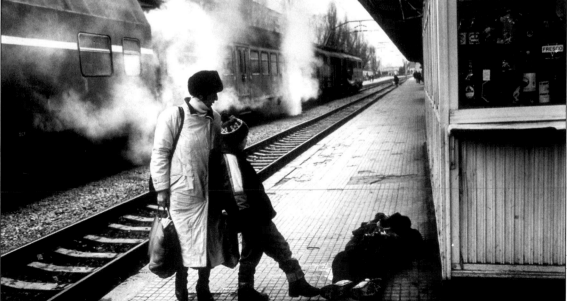

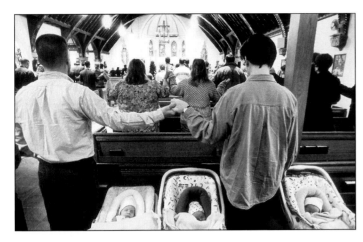

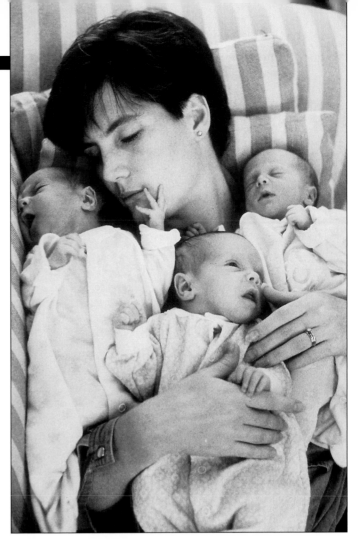

Joy Times Three

VIVIANE MOOS, FREELANCE, PARENTS MAGAZINE
AWARD OF EXCELLENCE, MAGAZINE FEATURE PICTURE STORY

Above ■ The Whalens take their first family outing to Most Holy Trinity Chapel. After ten years of fertility problems and one attempt at in-vitro fertilization, Tim and Cathy are now proud parents of triplets.

Right ■ After just 24 hours of experimenting with separate cribs, Tim and Cathy realize that these babies, bedfellows in the womb, sleep better together – sometimes in Mom's arms.

Yes, I Do.

CHIEN-CHI CHANG, MAGNUM PHOTOS
AWARD OF EXCELLENCE, MAGAZINE FEATURE PICTURE STORY

(THIS STORY WAS ALSO PART OF THE SECOND RUNNER-UP MAGAZINE PHOTO-GRAPHER OF THE YEAR PORTFOLIO. AND, ANOTHER PHOTO FROM THIS STORY WON AN AWARD OF EXCELLENCE MAGAZINE FEATURE PICTURE. IT CAN BE SEEN ON **PAGE 147.**)

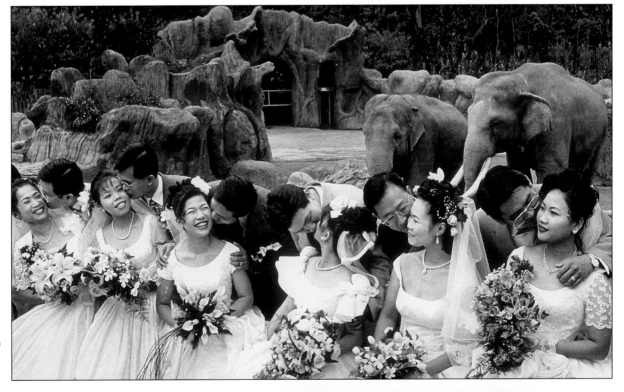

Right ■
Newlyweds line up for a photo after a group wedding at the Taipei Zoo. The wedding was timed to coincide with an elephant's 80th birthday.

Far right ■ Under the direction of a photographer, a bride has her wedding pictures taken two months before her big day.

Carol Guzy

NEWSPAPER PHOTOGRAPHER OF THE YEAR: FIRST RUNNER-UP

CAROL GUZY IS A STAFF PHOTOGRAPHER AT THE WASHINGTON POST. SHE WAS PREVIOUSLY NAMED NEWSPAPER PHOTOGRAPHER OF THE YEAR IN 1990, 1993 AND 1997.

Above ■ Pallbearers carry Holala's special, Mercedes-inspired coffin through the streets to his final resting place in a barren field.

Right ■ In the barn of the his farm in Berrien Springs, MIchigan – where he trained for fights in the past – Muhammad Ali reminisces. It is now full of memorabilia, posters and nostalgia. Though stricken with Parkinson's disease, Ali maintains a positive outlook and a gracious demeanor.

Below ■ A couple embraces the romance and sensuality of Florence, Italy.

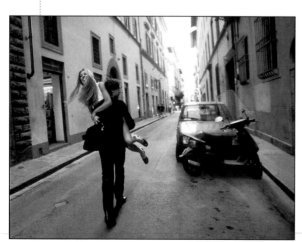

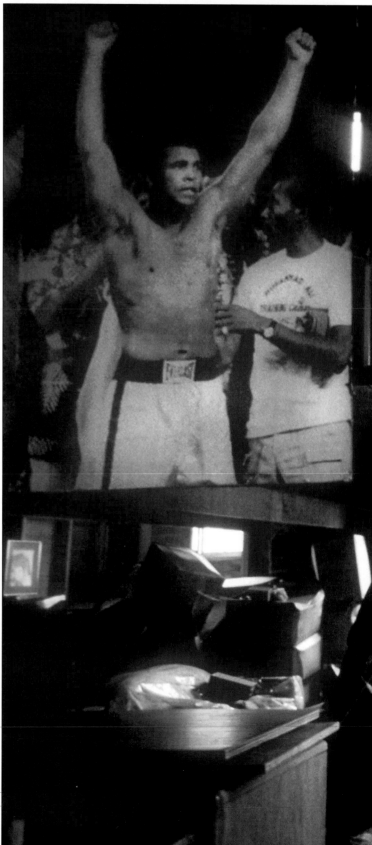

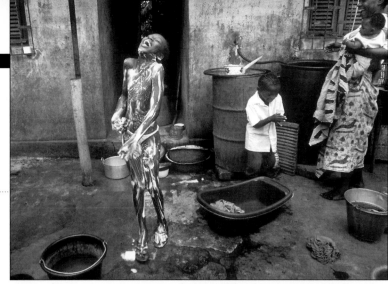

Left ■ Tamunie Hegisso, a traditional birth attendant in Ethiopia, sings praises to God following a successful birth.

Right ■ Adele Ouattara, a ten-year-old girl, lathers up for her bath in the courtyard of her apartment building in Abidjan on the Ivory Coast of Africa. (For a story on working class families.)

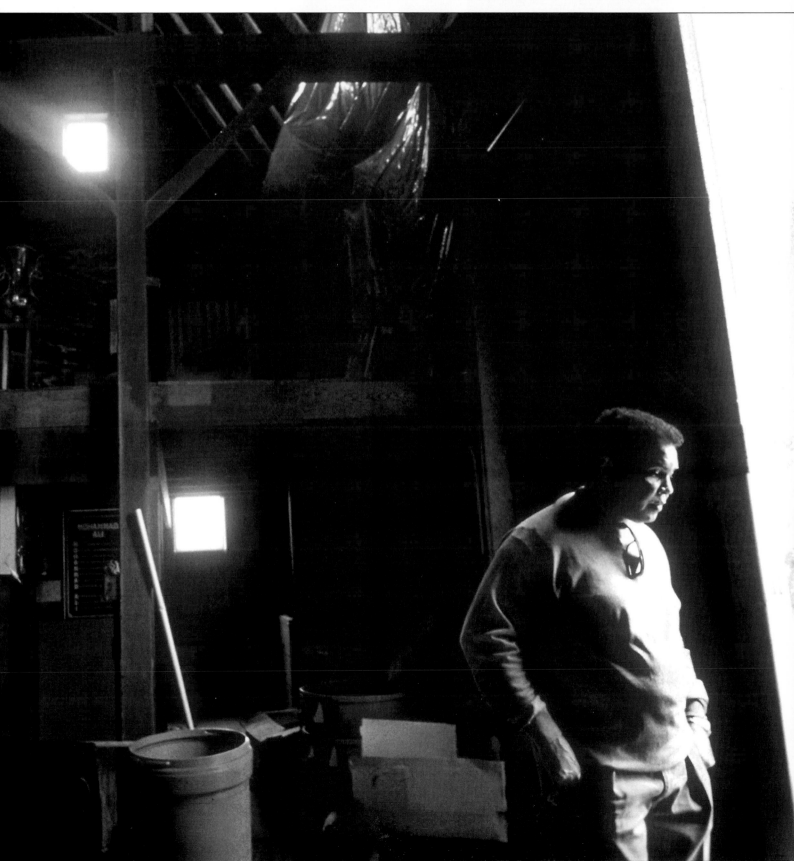

Left ■ A man waiting to cross into the U.S. from Mexico peeks through a hole in the border fence at San Ysidro, California.

Michael Williamson

NEWSPAPER PHOTOGRAPHER OF THE YEAR: SECOND RUNNER-UP

MICHAEL WILLIAMSON IS A STAFF PHOTOGRAPHER AT THE WASHINGTON POST. HE WAS NAMED NEWSPAPER PHOTOGRAPHER OF THE YEAR IN 1995 AND, IN 1994, WAS THE KODAK CRYSTAL EAGLE AWARD WINNER.

Right ■ During Elvis Week, Cindy Ammer, of Olive Branch, Mississippi, enthusiastically enjoys the antics of an Elvis performer at the Four Points Hotel in Memphis.

Below ■ Trying to deal with the ruin torrential rains had brought to Kentucky in early 1997, Stephen Child is physically tired and mentally worn out as he takes a break. He was working on cleaning up the muddy mess at his home in Falmouth, Kentucky, where he's lived all his life.

Left ■ Ernie Manfredo of Pepperell, Massachusetts, walks through National Airport's new terminal holding the dummy head of "Bob," the mascot of his scuba diving club. The group takes the mascot with them to all dives as a kind of reminder of what can happen when proper safety measures aren't taken.

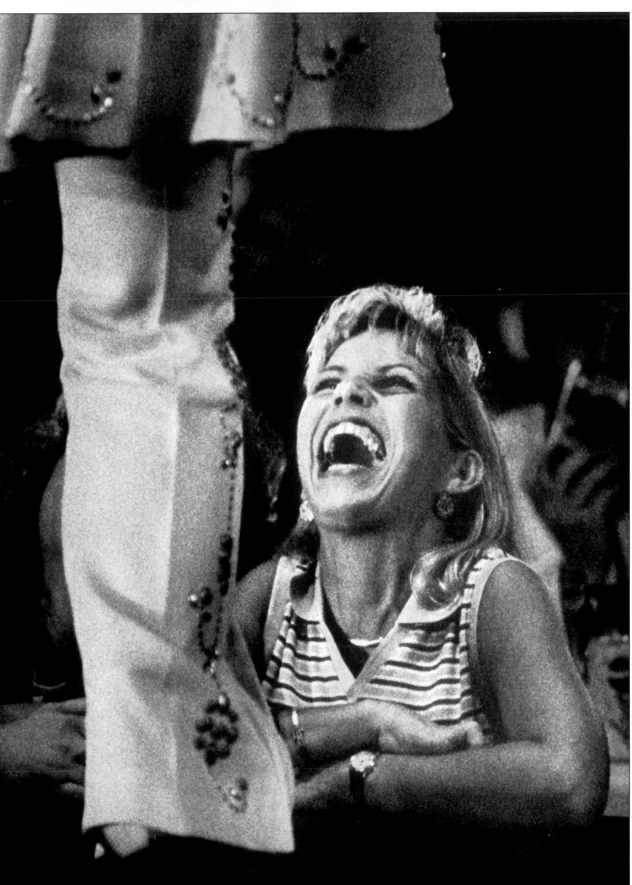

Above ■ Fifteen-month-old Sln Tlk Kei is congratulated by his dad, Sln Yuk Hong, and mom, Lammei Sze. As the winner of the baby crawling contest, the family received a one-year supply of diapers.

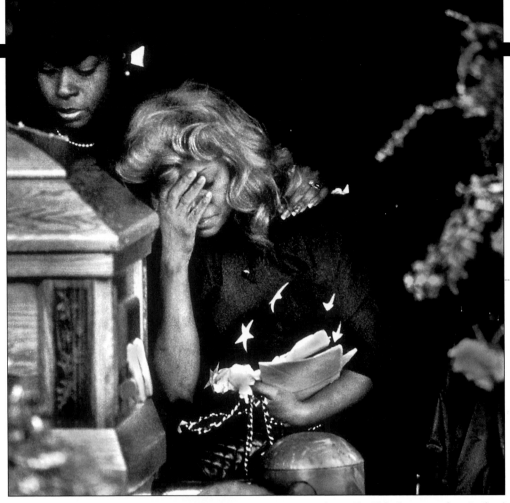

Dudley M. Brooks

NEWSPAPER
PHOTOGRAPHER
OF THE YEAR:
THIRD RUNNER-UP

DUDLEY M. BROOKS IS A STAFF
PHOTOGRAPHER AT THE WASHINGTON
POST. HE ALSO RECEIVED A SECOND
PLACE IN THE SPORTS PICTURE
STORY CATEGORY.

Above left ■ The mother
of Washington D.C. police
officer Brian Gibson weeps
quietly at his burial.

Opposite page ■
A retired Araber takes
a drag. "Arab" is the name given to the dwindling group of Baltimore,
Maryland, men who carry on the tradition of selling produce through
the streets from a horse-drawn cart.

Left ■ Before the bench press competition, a coach, right, gets his
powerlifter focused on the moment during a Powerlifting competition
for Special Olympians.

Below left ■ Players from the Anacostia High School football team.

Below ■ 12-year-old Deion Robinson, with a record of 38 wins
and only three losses, met his match at the Silver Gloves competition
in Lenexa, Kansas, where he lost in the semi-final round.

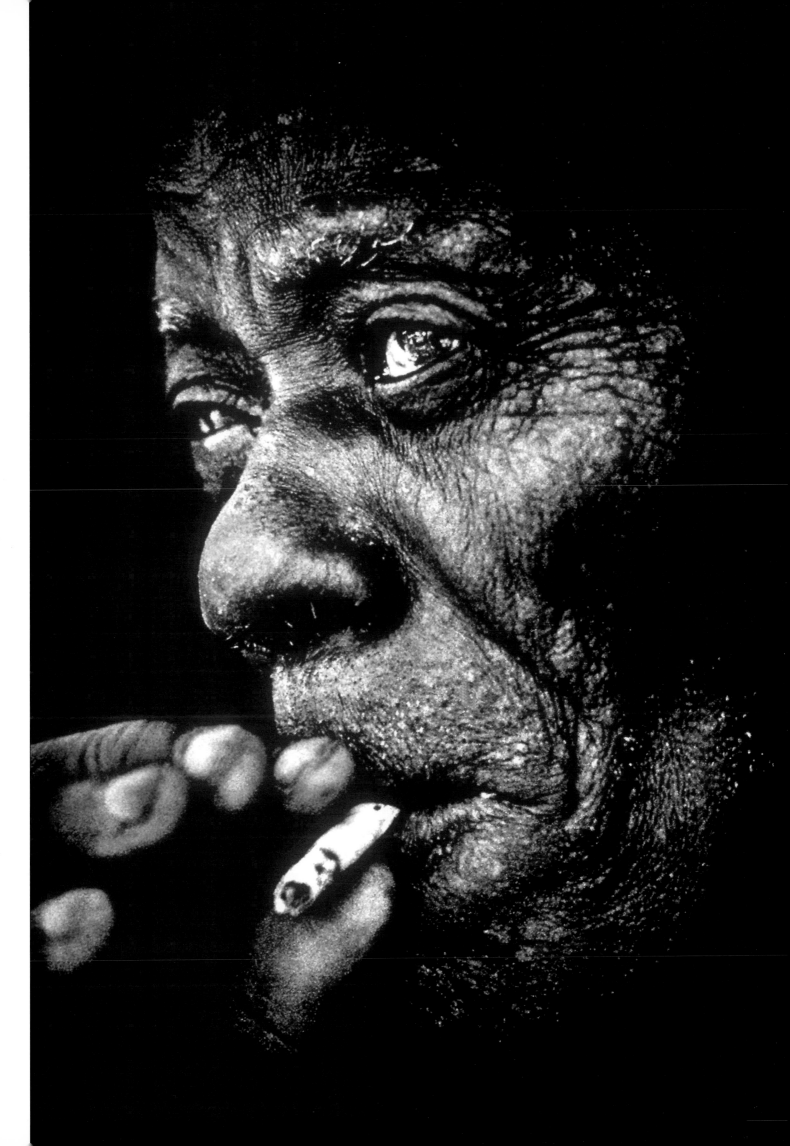

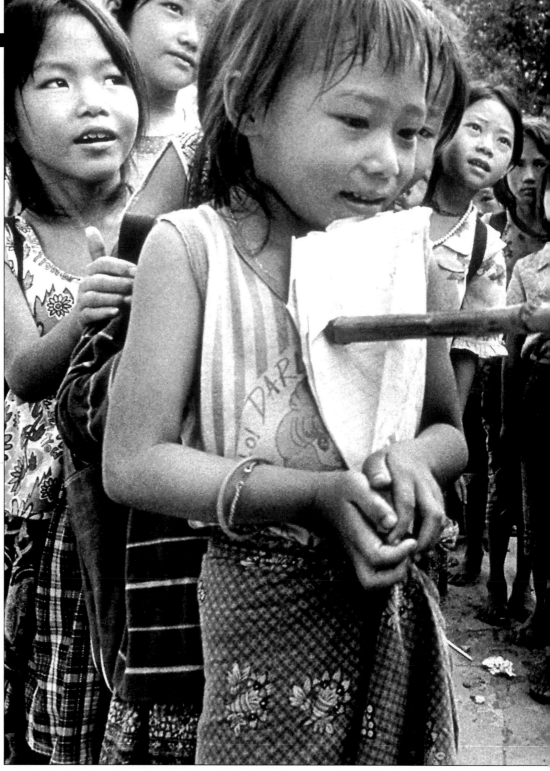

Chien-Chi Chang

MAGAZINE
PHOTOGRAPHER
OF THE YEAR:
FIRST RUNNER-UP

CHIEN-CHI CHANG IS AFFILIATED WITH MAGNUM.
IN THIS YEAR'S POY COMPETITION, HE ALSO
RECEIVED THREE AWARDS OF EXCELLENCE IN THE
SCIENCE/NATURAL HISTORY, FEATURE PICTURE
AND FEATURE PICTURE STORY CATEGORIES.

Above ■ Each spring, Taiwanese
followers of Saint Matsu make
a pilgrimage to honor her. Here,
a marching band plays, oblivious
to the rain along the route.

Below right ■ Far from the streets
of Bangkok, the Buddhist Phra Baat
Nam Phru temple in rural northern
Thailand has become a final refuge
for patients with AIDS. Experts
predict that will be the leading
cause of death in Thailand by the
year 2000. Never-theless, Thai
society has ostracized its citizens
with AIDS. The temple monks,
many of whom are HIV-positive
themselves, comfort the suffering
bodies and spirits of their patients,
easing their transition into the next
life. Here, a patient who just died
is ritually cleansed prior to cremation.

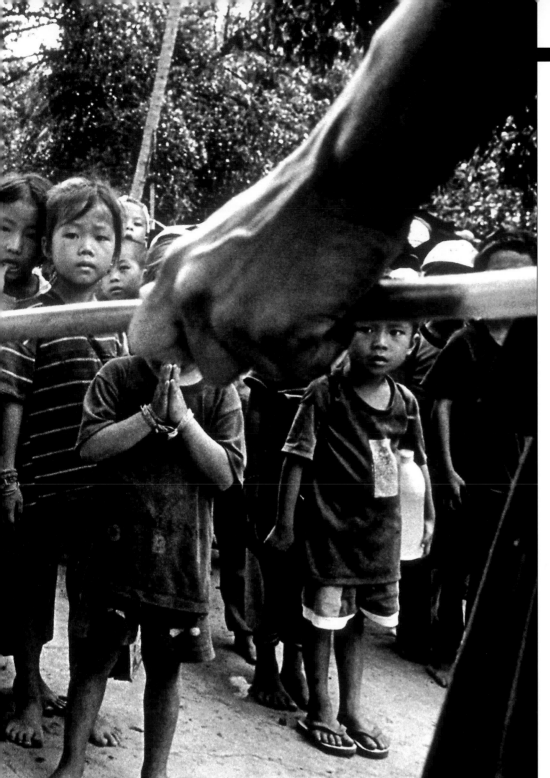

Above ■ In a ceremony at Fakuang Shan Temple in Taiwan, head monk Hsin-yun symbolically closes the Buddhist facility to the public.

Left ■ Driven from their homes in the mountains of Laos, refugees from the ancient Hmong tribe have been living in the camps on the Thai-Laotian border for decades. As refugees, they have a meager existence and few opportunities. Here, a teacher reinforces the proper manner of greeting to a Hmong girl.

Left ■ Since 1971, the Lungfa Tang Temple in southern Taiwan has taken in the mentally disabled patients rejected by the medical establishment as insane and incurable. Here, female patients receive comfort and care from the nuns despite an otherwise harsh existence.

Stephen Dupont

MAGAZINE
PHOTOGRAPHER
OF THE YEAR:
SECOND
RUNNER-UP

STEPHEN DUPONT IS
AFFILIATED WITH CONTACT
PRESS IMAGES. HE ALSO
WON FIRST PLACE FOR A
SPORTS PICTURE STORY.

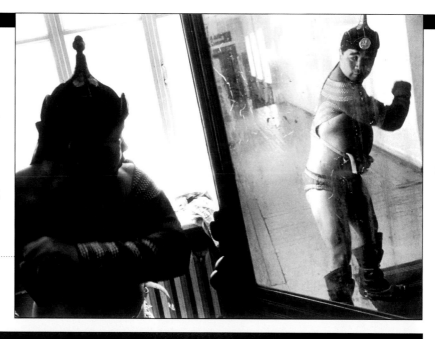

Above left ■ A wrestler
inspects himself in a
mirror in Mongolia.

Above ■ A little girl
with a Chinese flag at
the time of the Hong
Kong takeover by China.

Below left ■ Abdul
Rahman. Sere Tribe
champion wrestler.

Below ■ A Scots-guard
mourns with the crowd
at Princess Diana's
funeral.

Opposite page ■
The Jeremy Scott fashion
show. Paris, France.

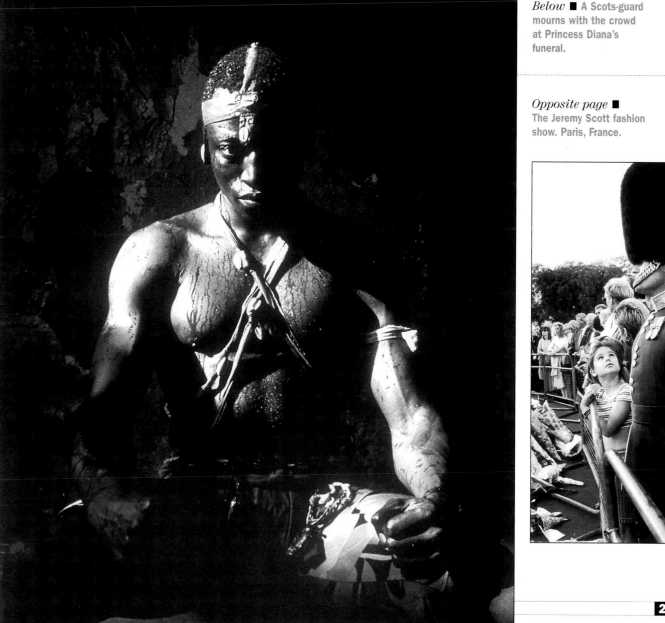

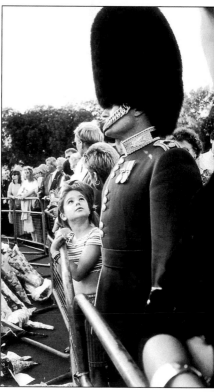

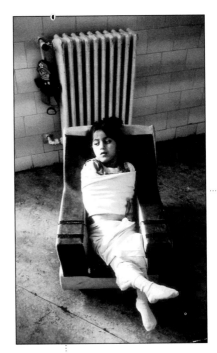

Colin Finlay

MAGAZINE PHOTOGRAPHER OF THE YEAR: THIRD RUNNER-UP

COLIN FINLAY IS AFFILIATED WITH THE SABA PICTURE AGENCY.

Left ■ Tied up, a young Romanian girl watches other children eat. (From a story entitled "Romania's Lost Children.")

Right ■ Sniffing glue and smoking help suppress the appetites of children in Romania. (From the same story, "Romania's Lost Children.")

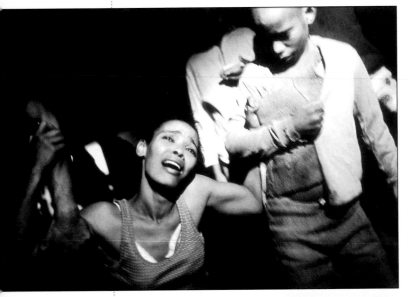

Above ■ A woman's family helps her on her journey to the church. Some sacrifice their own pain in an effort to heal loved ones.

Right ■ Breaking out of the pen, a grimacing rider holds on at a rodeo in South Central Los Angeles.

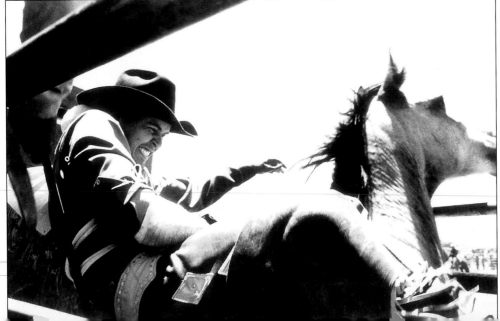

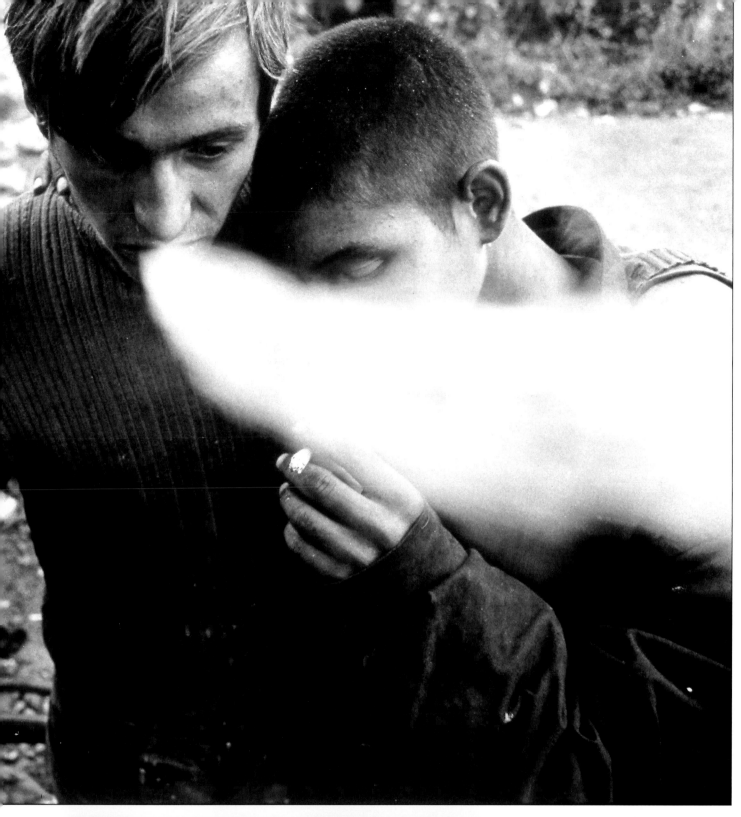

Left ■ As a form of penance, a Cuban man attaches bricks and chains to his ankles and crawls to the Church of St. Lazarus in homage to the saint.

Gideon Mendel

CANON PHOTO ESSAY AWARD: JUDGES' SPECIAL RECOGNITION

A Broken Landscape: HIV and AIDS in Africa

Above ■ Children chase a vehicle used by an HIV and AIDS homecare team based at the pioneering Chikenkata hospital in Zambia as they leave the village.

Below ■ A nurse working with an AIDS homecare team monitors the fever of Faustina Nyauga. She is in the terminal stages of the disease.

THE FOLLOWING ESSAY ACCOMPANIED GIDEON MENDEL'S ENTRY IN THIS YEAR'S CANON PHOTO ESSAYIST COMPETITION. GIDEON IS A FREELANCE PHOTOGRAPHER ASSOCIATED WITH NETWORK PHOTOGRAPHERS IN LONDON, ENGLAND.

AIDS in Africa is an invisible, slow-burning tragedy on a monumental scale. According to the World Health Organization there are nearly 30 million people infected with HIV in the world today. Of these, more than 20 million are in Sub-Saharan Africa, whose 500 million people comprise only ten percent of the world's population. These countries are already some of the poorest of earth – all have acute political, social and economic problems. Now they also face the loss of a high proportion of the ablest and most active women who are testing HIV-positive. The disease has a huge effect on children in Sub-Saharan societies. Many become orphans and end up stretching the meagre resources of aunts and uncles or aged grandparents. Around 30% of children born to HIV-positive mothers catch the disease from them... These photos show the human dimensions of the epidemic – how it is affecting the lives of ordinary people in four countries: Zambia, Zimbabwe, Tanzania and South Africa. They also show the work being done by many dedicated and brave individuals, many of whom have the disease themselves, to combat the problem with education and care. At the same time they show the social context in which the disease exists... AIDS and HIV in Africa cannot be separated from fundamental human rights... While the disease causes immense pain and suffering, it is important to challenge the stereotypes of people with AIDS... as pathetic victims. In Africa, people with AIDS are starting to mobilize and challenge the prejudices they face and to help their own communities fight against the virus. ∎

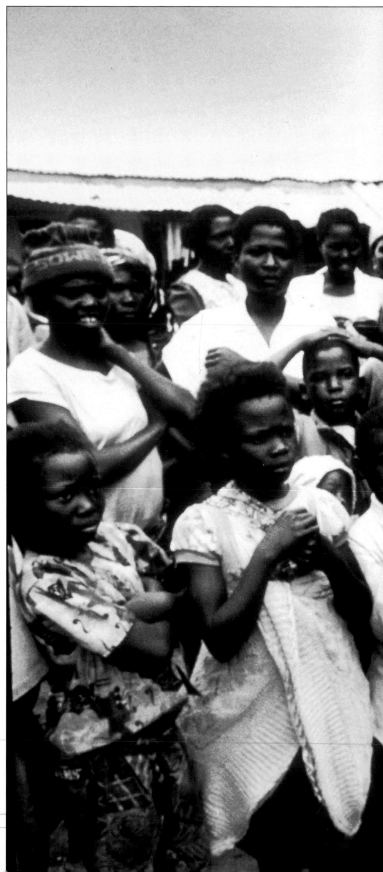

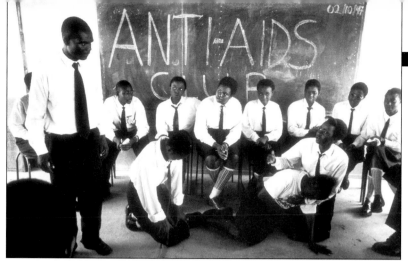

Left ■ An anti-AIDS club in Lusaka, Zambia performs a play about a schoolgirl infected with HIV. Twelve percent of schoolgirls aged 15 to 16 living in Lusaka are testing positive.

Below ■ Hilda Mwewa, whose husband and two children died of AIDS is HIV-positive herself. She has launched a personal crusade to educate people about AIDS.

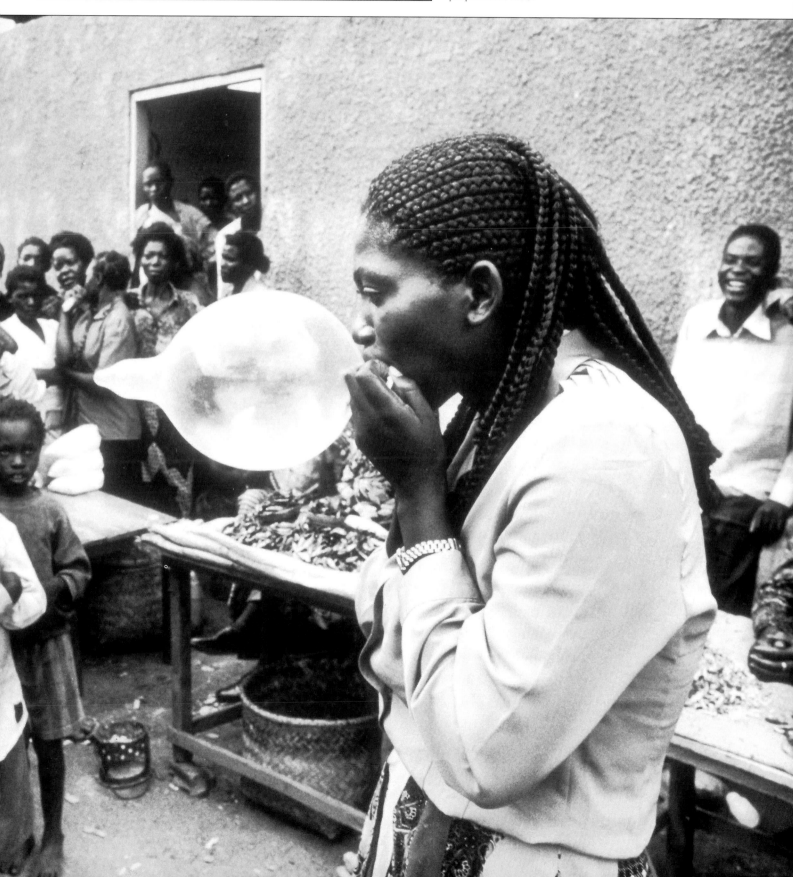

Brenda Ann Kenneally

COMMUNITY AWARENESS AWARD:
JUDGES' SPECIAL RECOGNITION

Off Broadway

THE FOLLOWING ESSAY ACCOMPANIED BRENDA ANN KENNEALLY'S ENTRY IN THIS
YEAR'S CANON PHOTO ESSAYIST COMPETITION. BRENDA IS A FREELANCER BASED
IN NEW YORK CITY. SHE ALSO RECEIVED A THIRD PLACE SPORTS FEATURE,
A THIRD PLACE PORTRAIT AND AN AWARD OF EXCELLENCE FOR ISSUE REPORTING.

Left ■ Zurie, Tisha's four-year-old daughter, watches for her mother's reaction as she scales the partition between the kitchen and living room to get to the ashtray. The baggies are from different neighborhood "weed" sellers.

Broadway in Brooklyn connects three of the toughest neighborhoods in all of New York's five boroughs. Buswick, Bedford-Styvesant and East New York are part of North Brooklyn, an area bound together by high incidences of domestic violence, a large percentage of high school dropouts, poverty, drug addiction, broken families, teen pregnancy, and chronic illness. Broadway is also the street that for the past year and some months has been my home. I was amazed at how yesterday's headlines were daily existence for most of the people I could see just outside my bedroom window. As a photo-journalist, these were great stories; as a woman these were my neighbors. Loud whispers of FIVE-O and DT *(street talk for police and detective)* began a tenuous relationship between me and the drug dealers on the corner. What did the white lady with the camera care about their wives, girlfriends and children? Slowly, my relationships with the women and their families in my neighborhood have grown. They realize that I am here to stay. Our sometimes daily visits have ended in both tears and laughter and usually with the feeling that we are more alike than different. At times, I am a sounding board, like when Tisha saw the photograph of her daughter reaching for bags of marijuana in an ashtray and she told me that she looked like an addict – a determination that she will ultimately need to make for herself. I have found bonds here so strong that passion quickly turns to anger. "Family Values," [a] most mis-understood phrase... are more than an ideal here, they are often a person's only tangible assets... ■

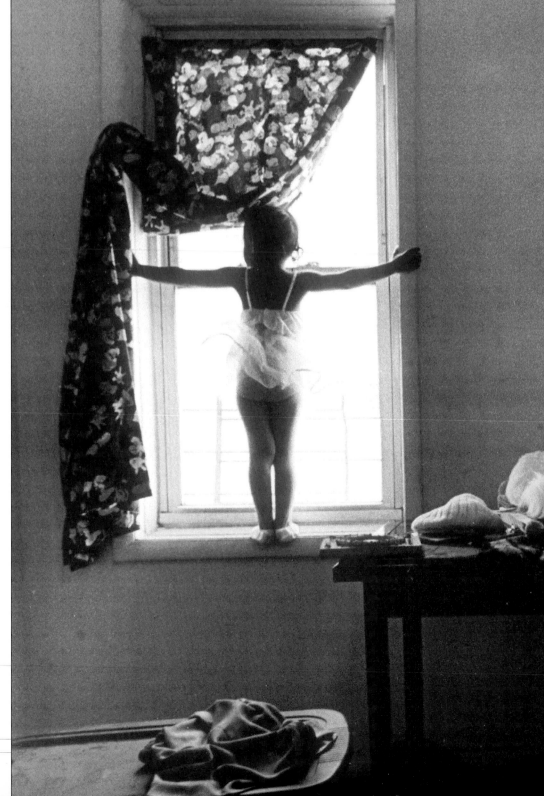

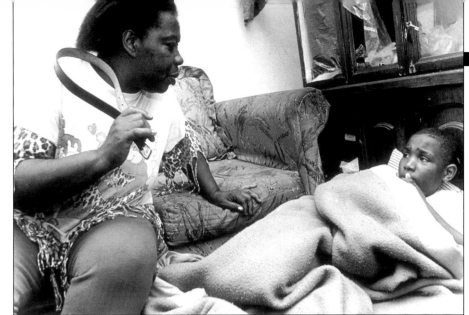

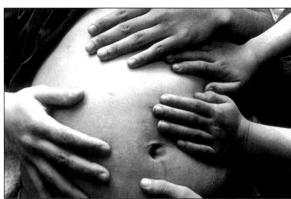

Above left ■ Evalina threatens Jasmar with the belt if he doesn't sleep.

Above ■ Mari and her two oldest boys wait to feel the baby kick. The sonogram says that the baby will be another boy.

Left ■ Zurie looks out over Dodsworth Street. It is too cold outside for the Barbie Ballerina outfit she received at a Christmas party from the shelter that her family used to live in.

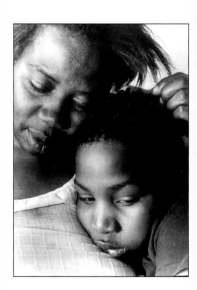

Above ■ Tisha's neighbor Evalina, left, is a recovering crack addict. Her son Jasmar was born with a learning disability as a result of her addiction.

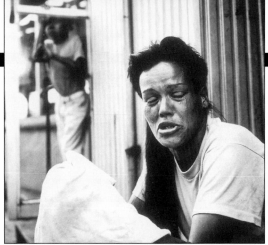

Left ■ **Sensa:** "I started shooting coke with Ralph and then after I started... he just stopped. So, he wanted me to stop. I said "you got me into this and now you want me to stop?" I guess I liked it and I just kept shooting... and then I didn't want to lose my kids, so I stopped..."

Right ■ **Ralph:** "Sensa got me sick. I knew Sensa was sick, but I didn't give a fuck. That's how much I love that woman..."

Below ■ Six-year-old daughter Sensita plays with a toy gun.

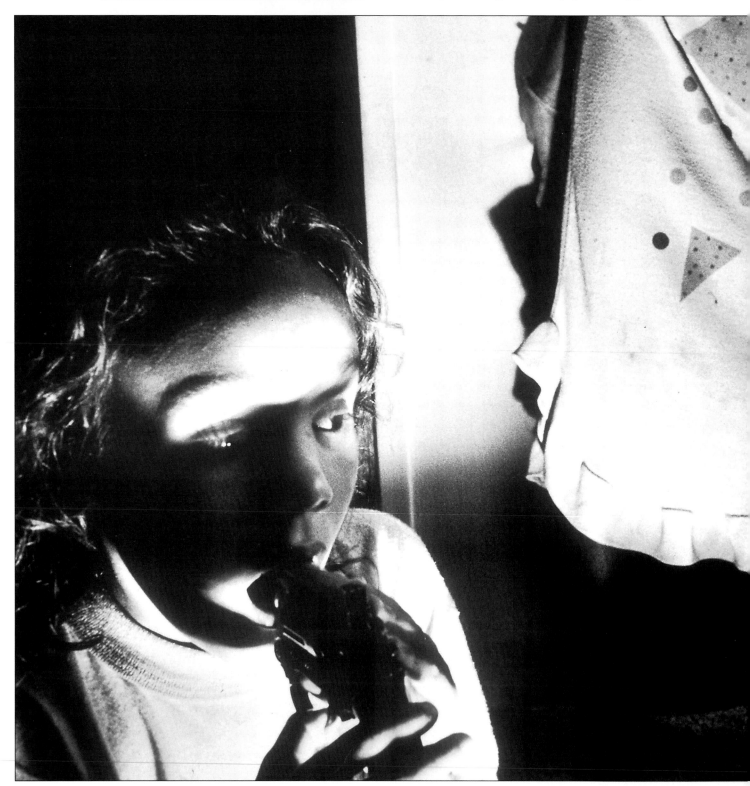

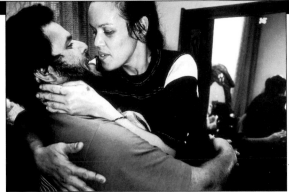

Steve Hart

COMMUNITY AWARENESS AWARD:
JUDGES' SPECIAL RECOGNITION

A Bronx Family Album:
The Legacy of AIDS

THE FOLLOWING ESSAY ACCOMPANIED STEVE HART'S ENTRY IN THIS YEAR'S COMMUNITY AWARENESS
COMPETITION. STEVE IS A FREELANCE PHOTOGRAPHER IN NEW YORK. HE ALSO RECEIVED FIRST PLACE
FOR BEST USE OF PHOTOGRAPHY/CD-ROMs FOR THIS SAME STORY.

A IDS breaks the rules of dying. It strikes predominately the young, not the old. It decimates families and communities in a relentless onslaught of loss that allows little time to grieve one death before being confronted by another. Its continuing stigma produces silent grievers who watch helplessly as death sweeps through families.

For the past seven years Steve Hart has documented one such family. In 1990 he began recording the lives of Ralph and Sensa Cartagena, a married Puerto Rican couple living in the South Bronx. This project records the effects of living with HIV/AIDS and the on-going emotional repercussions of the disease on surviving family members. ■

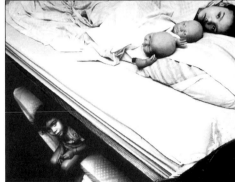

Above ■ Teenage daughter Cristina gave birth to a baby boy in June of 1995. "They told me I'm going to come out like my mom and thank God I had the strength to do what I had to do and not fall into those footsteps..."

Below ■ Sensa died from AIDS-related complications at the age of 35. Ralph and daughter Sensita say their goodbyes at Sensa's wake.

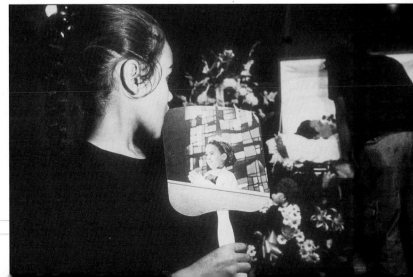

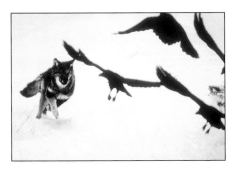

Above left ■ **Day 78, 8:40am.** Wolf chasing ravens.
Above middle ■ **Day 28, 12:15pm.** White-tailed doe and fawn.
Above right ■ **Day 27, 5:47pm.** White-tailed deer skull.
Below ■ **Day 10, 7:10am.** Common loons in Boundary Waters Canoe Area Wilderness after photographer removed imbedded fishhook line from young loon's neck and body.

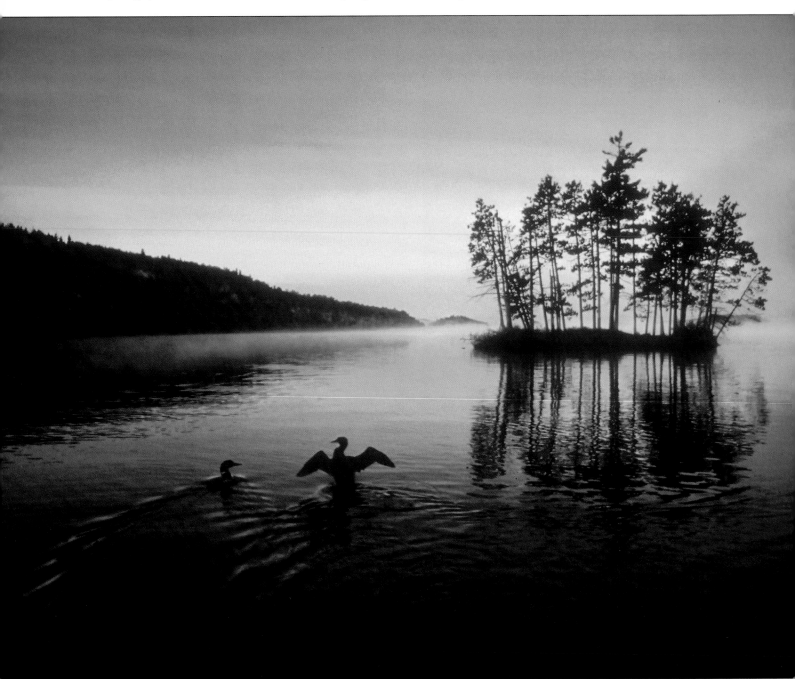

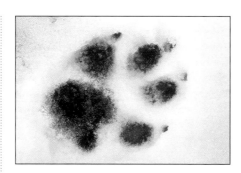

Jim Brandenburg

COMMUNITY AWARENESS: JUDGES' SPECIAL RECOGNITION

North Woods Journal

THE FOLLOWING ESSAY ACCOMPANIED JIM BRANDENBURG'S ENTRY IN THIS YEAR'S COMMUNITY AWARENESS COMPETITION. JIM IS A FREELANCE PHOTOGRAPHER IN MINNESOTA. HE ALSO RECEIVED A SECOND PLACE AWARD IN THE SCIENCE/NATURAL HISTORY PICTURE STORY CATEGORY FOR AN EDITED VERSION OF THIS ESSAY.

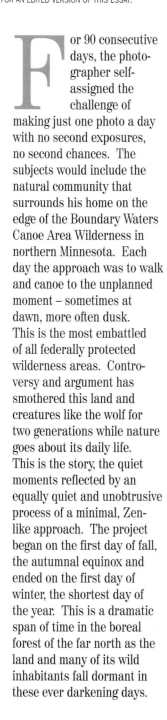

For 90 consecutive days, the photographer self-assigned the challenge of making just one photo a day with no second exposures, no second chances. The subjects would include the natural community that surrounds his home on the edge of the Boundary Waters Canoe Area Wilderness in northern Minnesota. Each day the approach was to walk and canoe to the unplanned moment – sometimes at dawn, more often dusk. This is the most embattled of all federally protected wilderness areas. Controversy and argument has smothered this land and creatures like the wolf for two generations while nature goes about its daily life. This is the story, the quiet moments reflected by an equally quiet and unobtrusive process of a minimal, Zen-like approach. The project began on the first day of fall, the autumnal equinox and ended on the first day of winter, the shortest day of the year. This is a dramatic span of time in the boreal forest of the far north as the land and many of its wild inhabitants fall dormant in these ever darkening days.

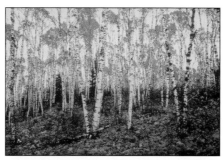

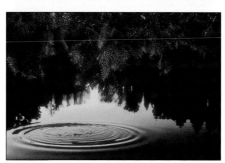

One ■ **Day 71, 4:26am.** Track of injured wolf.
Two ■ **Day 40, 7:42am.** Hard frost at dawn. Sedges had moved in after a beaver dam collapsed and the pond drained away.
Three ■ **Day 15, 4:30pm.** Paper Birch grove.
Four ■ **Day 36, 6:17pm.** Ravenwood waterfall.
Five ■ **Day 39, 8:04pm.** Judd Lake.
Six ■ **Day 25, 4:30pm.** Paper Birch.
Seven ■ **Day 22, 2:30pm.** Black ducks and mallards.
Eight ■ **Day 49, 8:22am.** Pancake ice at Ravenwood falls.
Nine ■ **Day 38, 4:04am.** Aurora Borealis.
Ten ■ **Day 57, 9:25am.** Ravens led me to the lifeless doe. Poachers had cut away the prized back loin, leaving the rest to scavengers.

1	2
3	4
5	
6	
7	8
9	10

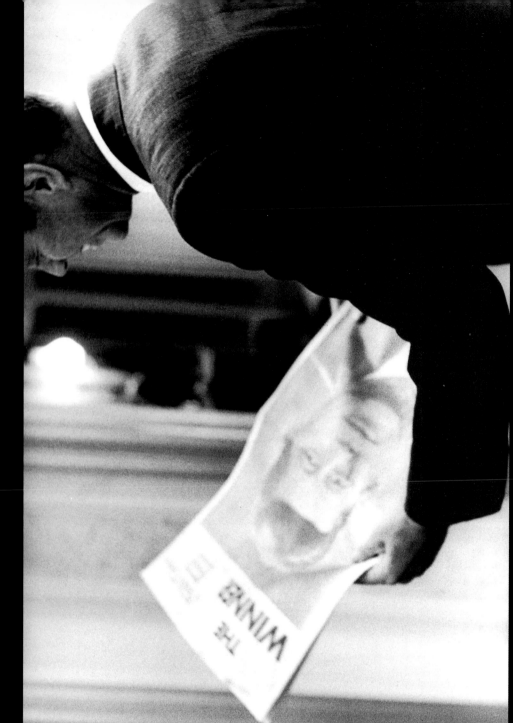

Official winners list from the 55th Annual Pictures of the Year

This year's competition, for work from 1997, was judged February 16th through March 4th, 1998 at The Missouri School of Journalism in Columbia, Missouri.

NEWSPAPER PHOTOGRAPHER OF THE YEAR
First Place: Nancy Andrews – The Washington Post
Second Place: Carol Guzy – The Washington Post
Third Place: Michael Williamson – The Washington Post
Award of Excellence: Dudley M. Brooks – The Washington Post

MAGAZINE PHOTOGRAPHER OF THE YEAR
First Place: Eugene Richards – Freelance
Second Place: Chien-Chi Chang – Magnum Photos
Third Place: Stephen Dupont – Contact Press Images
Award of Excellence: Colin Finlay – SABA

CANON PHOTO ESSAY AWARD
First Place: Eugene Richards – Freelance/Natural History, "Journey To Safo"
Judges' Special Recognition:
• Gideon Mendel – Freelance/Network Photographers, "A Broken Landscape: HIV And AIDS In Africa"

KODAK CRYSTAL EAGLE AWARD FOR IMPACT IN PHOTOJOURNALISM
Jacques Lowe – Jacques Lowe Photography, "The Kennedy Family"

COMMUNITY AWARENESS AWARD
First Place: Scott Lewis – Fox Valley Villages/60504, "Kids, Cul-de-sacs and the New American Dream"
Judges' Special Recognition:
• Jim Brandenburg – Freelance "North Woods Journal"
• Steve Hart – Freelance, "A Bronx Family Album: The Impact Of AIDS"
• Brenda Ann Kenneally – Freelance, "Off Broadway"

ANGUS McDOUGALL OVERALL EXCELLENCE IN EDITING AWARD
The Commercial Appeal (Memphis, Tennessee)

GENERAL DIVISION
SPOT NEWS
First Place: Dayna Smith – The Washington Post, "Fallen Friend"
Second Place: Doral Chenoweth III – The Columbus Dispatch, "Late Night Murder"
Third Place: Rick Loomis – Los Angeles Times/Orange County Edition, "Three Strikes, You're Out"
Award of Excellence: Bill Alkofer – St. Paul Pioneer Press, "Snowdrift"
Award of Excellence: Bernardo Alps – The News-Pilot, (Santa Monica, CA), "Whale Rescue"
Award of Excellence: Robert Cohen – The Commercial Appeal, "Costly Mistake"
Award of Excellence: Bob Larson – Contra Costa Times, "Chokehold"
Award of Excellence: Edward D. Ornelas III – San Antonio Express-News, "Bar Fight"
Award of Excellence: Anonymous – SIPA Press, "Algerian Massacre"

GENERAL NEWS
First Place: Steve Lehman – US News & World Report, "Half Mast"
Second Place: Jeff Widener – The Honolulu Advertiser, "Harboring Trouble"
Third Place: Aristide T. Economopoulos – The Herald (Jasper IN), "Remembering Cousin at the Wall"
Award of Excellence: Nancy Andrews – The Washington Post, "Laughing It Off"
Award of Excellence: Susan Biddle – The Washington Post, "Father Figure"
Award of Excellence: Jerome Delay – The Associated Press, "Pope Visit"
Award of Excellence: David Maialetti – The Philadelphia Daily News, "Under Dad's Care"

SCIENCE/NATURAL HISTORY
First Place: David Doubilet – National Geographic Magazine, "Sea Dragon"
Second Place: Dr. Mark W. Moffett – National Geographic Magazine, "A New World Discovered"
Third Place: Remi Benali – LIFE/Gamma Liaison, "Dolly the Sheep"
Award of Excellence: Nadia Borowski Scott – The Orange County Register, "3 lbs. 7 oz".
Award of Excellence: Chien-Chi Chang – Magnum Photos, "Elephants in Chains"
Award of Excellence: Kevin Horan – US News & World Report, "Fridge"

NEWS PICTURE STORY
First Place: Michael Williamson – The Washington Post, "Grave Yard Shift"

Second Place: Nancy Andrews – The Washington Post, "Historic Entrance"
Third Place: Carol Guzy – The Washington Post, "Legacy Of Love"
Award of Excellence: Nuri Vallbona – The Miami Herald, "Drug Hole Warriors"

SCIENCE/NATURAL HISTORY PICTURE STORY
First Place: Noah K. Murray – Asbury Park Press, "Body Of Knowledge"
Second Place: Jim Brandenburg – Freelance, "North Woods Journal"
Third Place: Stephen Siewert – Sydney Morning Herald, "The Elephants of Way Kambas"
Award of Excellence: David Doubilet – National Geographic Magazine, "Beneath The Tasman Sea"

NEWSPAPER DIVISION
ISSUE REPORTING
First Place: Marice Cohn Band – The Miami Herald, "Leftovers"
Second Place: Vicki Cronis – The Virginian-Pilot, "Home Again"
Third Place: Carolyn Cole – Los Angeles Times, "Where's Mommy"
Award of Excellence: Juana Arias – The Washington Post, "In The Waiting Room"
Award of Excellence: Susan Biddle – The Washington Post, "Listening Devices"
Award of Excellence: John Freidah – The Providence Journal-Bulletin, "Coffin Arrival"
Award of Excellence: Don Seabroob – The Wenatchee World, "T.V."
Award of Excellence: Joe Stefanchik – The Dallas Morning News, "Chain of Despair"

GLOBAL NEWS
First Place: Santiago Lyon – The Associated Press, "Clashes"
Second Place: John Moore – The Associated Press, "Clutch For Life"
Third Place: Debbi Morello – Freelance/Knight-Ridder/Tribune, "Last Farewell"
Award of Excellence: Nancy Andrews – The Washington Post, "We Didn't Spend Time on the Balcony"
Award of Excellence: Nancy Andrews – The Washington Post, "Free In The Streets"
Award of Excellence: Jean-Marc Bouju – The Associated Press, "Retribution"
Award of Excellence: David Guttenfelder – The Associated Press, "Relaxing Rebels"
Award of Excellence: Wendy Lamm – Freelance, "Hebron Shooting"
Judges' Special Recognition: Brian Walski – The Boston Herald, "Royal Goodbye"

FEATURE PICTURE
First Place: Carl D. Walsh– Freelance, "Our House"
Second Place: Mary Beth Meehan – Providence Journal-Bulletin, "Little Sisters"
Third Place: Jeff Widener – The Honolulu Advertiser, "Skirting Trouble"
Award of Excellence: Cloe Poisson – The Hartford Courant, "The Art of Dance"
Award of Excellence: Daniel Rosenbaum – The Washington Times, "Shooting Stars"

SPORTS ACTION
First Place: Khue Bui – The Washington Post, "The Pitch"
Second Place: Clarence Tabb Jr. – The Detroit News, "Sack Time"
Third Place: Preston C. Mack – Fort Lauderdale Sun-Sentinel, "That's Gonna Leave A Mark"
Award of Excellence: Danny Wilcox Frazier – Iowa City Press-Citizen, "Joy"
Award of Excellence: Christian Fuchs – Sun Coast Media Group, "Rodeo Splash"
Award of Excellence: Danielle P. Richard – The Record, "Mud Bowl"
Award of Excellence: Patrick Schneider – Charlotte Observer, "Eyes On The Ball"
Award of Excellence: Bill Zars – Daily Herald, "Three's A Charm"

SPORTS FEATURE
First Place: Nancy Andrews – The Washington Post, "Anticipation"
Second Place: George W. Miller III – Philadelphia Daily News, "Monarchs"
Third Place: Frank B. Johnston – The Washington Post, "Long Bow Hunter"
Award of Excellence: Karen Ballard – The Washington Times, "Eagle Eye"
Award of Excellence: Stephen D. Cannerelli – Syracuse Newspapers, "Cheap Seats"
Award of Excellence: Russell S. Costanza III – The Times-Picayune, "Legend of the Fall"
Award of Excellence: Richard Lipski – The Washington Post, "Everybody's 'Still' Talkin' At Me"
Award of Excellence: Bryan Patrick – The Sacramento Bee, "Workout"
Award of Excellence: Bryan Patrick – The Sacramento Bee, "Bicycle Hoop"
Award of Excellence: Lannis Waters – The Palm Beach Post, "You Can Do It!"

PORTRAIT/PERSONALITY
First Place: Marguerite Nicosia Torres – The Ithaca Journal, "Mastectomy"
Second Place: Michael S. Wirtz – The Philadelphia Inquirer, "Afghan Woman"
Third Place: Spencer Platt – Star-Gazette, "Train Delay"
Award of Excellence: Eric Grigorian – San Jose State University, "Thomas"
Award of Excellence: Carol Guzy – The Washington Post, "Faded Past"

Right ■ Destiny, age four, waits for her parents to come in from smoking a "blunt" in the hallway.

BRENDA ANN KENNEALLY, FREELANCE (BROOKLYN, NEW YORK)
(FROM HER JUDGES' SPECIAL RECOGNITION COMMUNITY AWARENESS AWARD. A SELECTION FROM THIS ESSAY BEGINS ON **PAGE 242.**)

Award of Excellence: David Longstreath – The Associated Press, "Flowers For Mother"
Award of Excellence: Peggy Peattie – Ohio University, "Generations in the March"
Award of Excellence: Steven Siewert – Sydney Morning Herald, "Saw"

PICTORIAL
First Place: Eric Mencher – The Philadelphia Inquirer, "Fisherman"
Second Place: Susanna Frohman – Providence Journal-Bulletin, "Summer Breeze"
Third Place: Stephanie Secrest – Alameda Newspaper Group, "Hillside"
Award of Excellence: Paul E. Rodriguez – The Orange County Register, "Morning Shadows"

PRODUCT ILLUSTRATION
First Place: Nita Lusk – Freelance, "Fruit"
Second Place: Martin Smith-Rodden – The Virginian-Pilot, "The Taste of the Town"
Third Place: Annie O'Neill – The Pittsburgh Pos -Gazette, "Once Is Not Enough - Body Piercing"
Award of Excellence: Michael McMullen – The Commercial Appeal, "Bride #2"
Award of Excellence: Jim Witmer – Dayton Daily News, "Biscotti"

ISSUE REPORTING PICTURE STORY
First Place: John Ranard – Freelance, "Inside A High Risk Community HIV in the Former Soviet Union"
Second Place: Susan Watts – New York Daily News, "Gloria"
Third Place: Steve Healey – Indianapolis Star-News, "The Nursing Home Dilemma"
Award of Excellence: Paul Kitagaki Jr. – The Oregonian, "Nike and Asia's Shoe Industrial Revolution"

GLOBAL NEWS PICTURE STORY
First Place: Nancy Andrews – The Washington Post, "Bosnia - A Hopeful Peace"
Second Place: Brian Walski – The Boston Herald, "Northern Ireland: On The Brink of Peace?"
Third Place: Debbi Morello – Freelance/Knight-Ridder/Tribune, "Haiti's Sorrow...Still The Same"
Award of Excellence: Santiago Lyon – Associated Press, "Albanian Unrest"

FEATURE PICTURE STORY
First Place: Peggy Peattie – Ohio University, "The Circle Remains Unbroken"
Second Place: Carol Guzy – The Washington Post, "A World Of His Own"
Third Place: Paul Carter – The Register - Guard, "Death Be Not Proud"
Award of Excellence: Nancy Andrews – The Washington Post, "Every Day Is Father's Day"
Award of Excellence: Vicki Cronis – The Virginian-Pilot, "On Beyer's Trail"
Award of Excellence: Barbara Davidson – The Washington Times, "Mobile Clinic"
Award of Excellence: Eric Mencher – The Philadelphia Inquirer, "Cuba On The Edge"
Award of Excellence: Suzanne Plunkett – The Jersey Journal, "Coming of Age"

SPORTS PICTURE STORY
First Place: Eric Mencher – The Philadelphia Inquirer, "The Anderson Monarchs"
Second Place: Dudley M. Brooks – The Washington Post, "Game of Life"
Third Place: Khue Bui – The Washington Post, "Field Of Dreams"
Award of Excellence: Craig Golding – Sydney Morning News, "Australian Grand Sumo Tournament"

SPORTS PORTFOLIO
First Place: Richard Hartog – The Outlook
Second Place: Bryan Patrick – The Sacramento Bee
Third Place: Bradley E. Clift – The Hartford Courant
Award of Excellence: Steve Healey – Indianapolis Star & News

ONE WEEK'S WORK
First Place: Wally Skalij – The Daily Breeze (Torrance, California)
Second Place: Richard Hartog – The Outlook
Third Place: Wally Skalij – Los Angeles Times

MAGAZINE DIVISION
ISSUE REPORTING
First Place: Paula Lerner – Freelance/Woodfin Camp, "Pressures Of Single Parenting"
Second Place: Nina Berman – LIFE Magazine/SIPA, "Starved Out"
Third Place: Ed Kashi– Freelance, "Burned Woman"
Award of Excellence: Brenda Ann Kenneally – Freelance, "Tisha Smokes A Blunt"
Award of Excellence: Justin Kilcullen – Newsweek/SYGMA, "Children/North Korea"
Award of Excellence: Andre Lambertson – SABA, "Injection"
Award of Excellence: Gideon Mendel – Freelance/Network Photographers, "Blossom"
Award of Excellence: Matthew Moyer – Egypt Today Magazine, "Working Boy"

GLOBAL NEWS
First Place: Roger Lemoyne – Freelance/Gamma Liaison, "Zaire Death Train"
Second Place: Francesco Zizola– LIFE/Matrix, "Burn Victim In Iraq"
Third Place: Roger Lemoyne – Freelance/Gamma Liaison, "Zaire - Begging Food"
Award of Excellence: Radhika Chalasani – SIPA Press, "Jungle"
Award of Excellence: Roger Lemoyne – Freelance, "Zaire - Refugee Train"
Award of Excellence: Eugene Richards – Freelance/Natural History

FEATURE PICTURE
First Place: Eugene Richards – Freelance/Natural History, "Dying Child"

Above ■ Four-year-old Preston Jackson III, and his dog Hercules get a good view from the family car during the Georgia Days Parade in Washington, D.C.

MICHAEL WILLIAMSON, THE WASHINGTON POST
FROM THE SECOND RUNNER-UP NEWSPAPER PHOTOGRAPHER OF THE YEAR PORTFOLIO ON **PAGES 230-231.**

Second Place: Jodi Cobb – National Geographic Magazine, "Colonial Burden"
Third Place: Andrew Holbrooke – Freelance, "Belfast Child"
Award of Excellence: Chien-Chi Chang – Magnum Photos, "Yes, I Do"
Award of Excellence: Christopher Johns – National Geographic Magazine, "Adrift In Thought"

SPORTS ACTION
First Place: Bill Frakes – Sports Illustrated, "Cart Before The Horse"
Second Place: Karim Shamsi-Basha – Freelance, "Jump"
Third Place: Al Bello – Allsport USA, "Wall Of Water"
Award of Excellence: John Kimmich – University of Iowa, "At The Horns Of A Dilemma"
Award of Excellence: Co Rentmeester – LIFE Magazine/Freelance, "Impact"

SPORTS FEATURE
First Place: John Kimmich – University of Iowa, "The Sacrifice"
Second Place: David Butow – U.S. News & World Report/SABA, "Airborne"
Third Place: Brenda Ann Kenneally – Freelance, "Crate Shot!"
Award of Excellence: Karen Kasmauski – Freelance/National Geographic Magazine, "85 Year Old Pole Vaulter"
Award of Excellence: Randy Olson – Freelance, "Amish Harness Racing"

PORTRAIT/PERSONALITY
First Place: Andrew Holbrooke – Freelance, "Hutterite Teenagers"
Second Place: Andrew Holbrooke – Freelance, "Hutterite Girl"
Third Place: Brenda Ann Kenneally – Freelance, "The New Kid On The Block"
Award of Excellence: Radhika Chalasani – SIPA Press, "Injured"
Award of Excellence: Jillian Edelstein – Network Photographers, "Thembinkosi Tshabe and Mxolisi Goboza "
Award of Excellence: Andrew Holbrooke – Freelance, "Hutterite Boys"
Award of Excellence: Andrew Holbrooke – Freelance, "Goose Boy"
Award of Excellence: Steve McCurry – National Geographic Magazine, "Red Face"

PICTORIAL
First Place: Larry Towell – NY Times Magazine/Magnum Photos, "The Felt Presence Of An Absence"
Second Place: Christopher Johns – National Geographic Magazine, "Bridge Of Colored Light"
Third Place: Randy Olson – Freelance, "Talent Show"
Award of Excellence: Andrew Holbrooke – Freelance, "British Soldier In Northern Ireland"
Award of Excellence: Christopher Johns – National Geographic Magazine, "Fire Of Dawn"

ISSUE REPORTING PICTURE STORY
First Place: Paula Lerner – Freelance/Woodfin Camp, "A Widow On Welfare: An Untold Story"
Second Place: Jane Evelyn Atwood – Freelance/LIFE Magazine, "Women Behind Bars"
Third Place: Ed Kashi – Freelance, "America's Aging Inmates"
Award of Excellence: Andrew Lichtenstein – US News & World Report/SYGMA, "Life In Prison"

GLOBAL NEWS PICTURE STORY
First Place: Roger Lemoyne – Freelance/Gamma Liaison, "Lost In Zaire – Hutu Refugees"
Second Place: Radhika Chalasani – SIPA Press, "Waiting In The Jungle: The Missing Rwandans"
Third Place: David Portnoy – U.S. News & World Report/Black Star, "Indonesian Forest Fires"

FEATURE PICTURE STORY
First Place: Randy Olson – Freelance/National Geographic Magazine, "County Fairs - Rural America's Last Hurrah"
Second Place: Larry Towell – LIFE Magazine/Magnum Photos, "The World From My Front Porch"
Third Place: Ettore Malanca – SIPA Press, "The Children of the New Stations"
Award of Excellence: Chien-Chi Chang – Magnum Photos, "Yes, I Do"
Award of Excellence: Michele McDonald – Freelance, "Stones To Heaven"
Award of Excellence: Viviane Moos – Freelance/Parents Magazine, "Joy Times Three"

SPORTS PICTURE STORY
First Place: Stephen Dupont – Contact Press Images Inc., "Wrestling In The Gambia"
Second Place: David Butow – US News & World Report/SABA, "Inner-City Sports"
Third Place: Lynn Johnson – Sports Illustrated/Aurora Agency, "Triumph Of The Spirit"

SPORTS PORTFOLIO
No awards given

EDITING DIVISION
SINGLE PAGE NEWS STORY
First Place: Anne Peters Providence – Journal-Bulletin, "Mother Teresa: 1910 - 1997"
Second Place: Thomas F. McGuire – The Hartford Courant, "My Conscience Is Clear"
Third Place: Norman Shafer, Lisa Cowen and Eric Seidman – The Virginian-Pilot, "Silent McVeigh Handed His Fate"
Award of Excellence: Babbette Augustine – Providence Journal-Bulletin, "The Winter That Wasn't Bites Back"
Award of Excellence: Bill Kelley III and Buddy Moore – The Virginian-Pilot, "Guilty"
Award of Excellence: Bob Lynn and Huy Nguyen – The Virginian-Pilot, "A Final Farewell"
Award of Excellence: Bonnie Jo Mount, Mark Reis, Stuart Wong and Jerilee Bennett – The Gazette, "Snowbound"
Award of Excellence: Doug Parker and Alex Brandon – The Times-Picayune, "One-Derful"
Award of Excellence: Norman Shafer, Steve Earley and Andrea Smith – The Virginia-Pilot, "Suffolk Sees Ex-Depot As Tech Park"
Award of Excellence: Tom Wolfe – The Hartford Courant, "A Day For The Family"

CONTINUED, NEXT PAGE

The 55th POY ...

■ CONTINUED FROM PREVIOUS PAGE

SINGLE PAGE FEATURE STORY
First Place: Leslie A. White – The Dallas Morning News, "The Lonely Life: Miguel, Son Of An Illegal Immigrant"
Second Place: Cecilia Prestamo – The Hartford Courant, "A New Holy Trail"
Third Place: Mark Edelson – The Palm Beach Post, "The Longest Days"
Award of Excellence: Mark Edelson – The Palm Beach Post, "I Take Life Very Seriously"
Award of Excellence: Bill Gugliotta, Pam Royal and Nikki Life – The State, "Magical New Mexico"
Award of Excellence: Sue Morrow and Patricia Yablonski – San Jose Mercury News, "Belles Of The Ball"
Award of Excellence: Doug Parker and Rusty Costanza – The Times-Picayune, "Legend of the Fall"

MULTIPLE PAGE NEWS STORY
First Place: Paula Nelson – The Dallas Morning News, "A Daily Menace"
Second Place: Todd L Winge, Caroline E. Couig, Robert St. John and Robert Kozloff – Detroit Free Press, "A Final Salute"
Third Place: Scott DeMuesy – San Jose Mercury News, "Rescued"
Award of Excellence: Scott DeMuesy, Mark Damon and GiuLiana Nakashima – San Jose Mercury News, "Mother Teresa: Her Final Calling"
Award of Excellence: Geoff Forester, Lucy Bartholomay, Peter Southwick, Ted Gartland and Beverly Crowin – The Boston Globe, "At The Helm Of History"
Award of Excellence: Cecilia Prestamo – The Hartford Courant, "Farewell To Diana"

MULTIPLE PAGE FEATURE STORY
First Place: Lynn Rognsvoog, Thea Breite, Lisa Newby and John Freidah – Providence Journal-Bulletin, "A Prayer For Maria"
Second Place: Ben Brink and Randy Cox – The Oregonian, "Albania: A Country In Need Of Adult Supervision"
Third Place: Lisa Waddell, Robert Cohen, Marc Riseling and Jeff McAdory – The Commercial Appeal, "Show Of Hands"
Award of Excellence: Michele Cardon and Jodie Steck – Orange County Register, "Cuba: Island Of Irony"
Award of Excellence: Larry Coyne, Lisa Waddell and Laura Kleinhenz – The Commercial Appeal, "Leaving LeMoyne Gardens"
Award of Excellence: Larry Coyne, Lisa Waddell, Leigh Daughtridge and Richard Robbins – The Commercial Appeal, "Doing Flips, Earning Tips"
Award of Excellence: Colin Crawford – Los Angeles Times/Orange County Edition, "In Their Own Words"
Award of Excellence: Richard Koci-Hernandez – San Jose Mercury News, "Summer Daze"
Award of Excellence: Robert Pope, David Spencer and David Ahntholz – The State Journal-Register, "An American Classic"

NEWSPAPER SERIES
First Place: Curt Chandler, Allan Detrich and Bill Pliske – Block News Alliance/Pittsburgh Post-Gazette, "Children Of The Underground"
Second Place: Lisa Waddell, Larry Coyne, Robert Cohen and Jeni Donlon – The Commercial Appeal, "Memphis In The Balkans"
Third Place: Jeff McAdory, Larry Coyne, Steven G. Smith, Lisa Waddell Dave Darnell and Mark Reisling – The Commercial Appeal, "Brazil: Exotic Land of Extremes"
Award of Excellence: Gail Fisher – Los Angeles Times/Orange County Edition, "Welcome to Land of Opportunities"
Award of Excellence: Bob Lynn, Ian Martin, Alex Burrows and Courtney Murphy – The Virginian-Pilot, "Three Missing After Leak On Carrier"
Award of Excellence: Lynn Rognsvoog and Mary Beth Meehan Providence Journal-Bulletin, "Heading For The Coast"
Award of Excellence: Leslie A. White – The Dallas Morning News, "View From Death Row"

NEWSPAPER SPECIAL SECTION
First Place: Brian Plonka, Tom Wallace, John Kaplan and Denise Crosby – Copley Chicago Newspapers, "Generations Under The Influence"

Second Place: Lynn Rognsvoog, Thea Michele McDonald and John Freidah – Providence Journal-Bulletin, "A Time To Die"
Third Place: Steve Fecht and Heather Stone – The Detroit News, "Shine: The Best and The Brightest"
Award of Excellence: Paula Nelson and Leslie White – The Dallas Morning News, "People In Motion"

NEWSPAPER PICTURE EDITING/INDIVIDUAL
First Place: Leslie A. White – The Dallas Morning News
Second Place: Mark Edelson – The Palm Beach Post
Third Place: Scott DeMuesy – San Jose Mercury News
Award of Excellence: Sue Morrow – San Jose Mercury News
Award of Excellence: Eric Strachan – Naples Daily News

NEWSPAPER PICTURE EDITING/TEAM
First Place: Paula Nelson and Leslie White – Dallas Morning News
Second Place: Jeff McAdory, Lisa Waddell, Larry Coyne and Dave Darnell – The Commercial Appeal
Third Place: Colin Crawford, Gail Fisher, Don Tormey, Steve Stroud, Larry Armstrong, Calvin Hom and Barry Fitzsimmons – Los Angeles Times/Orange County Edition
Award of Excellence: The Staff of The Virginian-Pilot
Award of Excellence: Michele Cardon, Lorren Au, Chris Carlson, Jebb Harris, Mike Pilgrim, Marcia Prouse and Jodie Steck – The Orange County Register
Award of Excellence: Laurie A. Jones, Scott Lewis, Kathy Plonka, Jon Lowenstein, Amanda Hamann, Anne Farrar, Matt Rauls and Thea Drew – Sun Publications/Copley Chicago Newspapers

MULTIPLE PAGE NEWS STORY
First Place: Bronwen Latimer – TIME Magazine, "Steve's Job: Restart Apple"
Second Place: Guy Cooper – Newsweek Magazine, "Farewell Diana"
Third Place: Guy Cooper – Newsweek Magazine, "Follow Me: Inside The Heaven's Gate Mass Suicide"
Award of Excellence: Kathy Ryan – The New York Times Magazine, "The Witnesses"

MULTIPLE PAGE FEATURE STORY
First Place: Kathy Ryan – The New York Times Magazine, "Times Square"
Second Place: David Friend – LIFE Magazine, "The World From My Front Porch"
Third Place: John A. Echave, Lynn Johnson and Dave Griffin – National Geographic Magazine, "Vincent Van Gogh: Lullaby In Color"
Award of Excellence: David Friend – LIFE Magazine, "Babies Behind Bars"
Award of Excellence: Elizabeth Cheng Krist, Lisa Lytton Smith and Vincent J. Musi – National Geographic Magazine, "Romancing The Road"
Award of Excellence: Elizabeth Cheng Krist, William H. Marr and Michael S. Yamashita – National Geographic Magazine, "Boom Times On The Gold Coast Of China"
Award of Excellence: Kathy Ryan – The New York Times Magazine, "Aging Behind Bars"

MAGAZINE PICTURE EDITING/INDIVIDUAL
First Place: David Friend – LIFE Magazine
Second Place: MaryAnne Golon – U.S. News & World Report

Above ■ Backstage at Maurizo Galante Fashion Show. Paris, France.

STEPHEN DUPONT, CONTACT PRESS IMAGES
PART OF THE SECOND RUNNER-UP MAGAZINE PHOTOGRAPHER OF THE YEAR PORTFOLIO.
SELECTS FROM THIS PORTFOLIO BEGIN ON **PAGE 236.**)

Third Place: Marie Schumann – LIFE Magazine

MAGAZINE PICTURE EDITING/TEAM
First Place: Elizabeth Cheng Krist, David Griffin and Bob Sacha – National Geographic Magazine
Second Place: Kathy Ryan, Sarah Harbutt, Jody Quon, Evan Kriss and Courtenay Clinton – The New York Times Magazine
Third Place: Kay Zakriasen, Bruce Stutz and Tom Page – Natural History
Award of Excellence: Peter Howe and Michaelene J. Wadolny – Modern Maturity

BEST USE OF PHOTOGRAPHY: NEWSPAPER CIRCULATION UNDER 25,000
First Place: Fox Valley Villages/60504, Sun Publications, Copley Chicago Newspaper
Second Place: Lawrence Journal-World
Third Place: Jacksonville Journal-Courier
Award of Excellence: Concord Monitor

BEST USE OF PHOTOGRAPHY: NEWSPAPER CIRCULATION 25,000-150,000
First Place: The Albuquerque Tribune
Second Place: The Spokesman Review
Third Place: The State
Award of Excellence: Naples Daily News

BEST USE OF PHOTOGRAPHY: NEWSPAPERS CIRCULATION MORE THAN 150,000
First Place: The Commercial Appeal
Second Place: Providence Journal-Bulletin
Third Place: The Palm Beach Post
Award of Excellence: The Pittsburgh Post-Gazette

BEST USE OF PHOTOGRAPHY: MAGAZINES
First Place: National Geographic Magazine
Second Place: LIFE Magazine
Third Place: US News & World Report
Award of Excellence: International Wildlife
Award of Excellence: Natural History

BEST USE OF PHOTOGRAPHY: CD-ROMS
First Place: Steve Hart – Freelance, "A Bronx Family Album: The Impact Of AIDS"

BEST USE OF PHOTOGRAPHY: INTERNET WEBSITE
First Place: Jay Colton – Time.com, "The Last Human Horses" http://time.com/ricksha2/
Second Place: Alan D. Dorow – Journal E, "Nonstop Sweat" http://www.journale.com/naval
Third Place: Jim Gensheimer – San Jose Mercury News, "Street Smarts," http://www.mercurycenter.com/clips/pocoway
Award of Excellence: The New York Times Electronic Media Co, "Assignment: Times Square" http://www.nytimes.com/specials/ts/home
Award of Excellence: Christina Holovach – Time.com, "Child Labor" http://time.com/reports/childlabor

Left ■ Jessica braiding her hair.

STEVE HART, FREELANCE, BROOKLYN, NEW YORK
FROM HIS JUDGES' SPECIAL RECOGNITION
COMMUNITY AWARENESS AWARD PORTFOLIO.
SELECTS ARE DISPLAYED ON **PAGE 244-245.**

THE **BEST** OF ...

Alphabetical list of all who entered the 55th Pictures of the Year

RED denotes winners of photography awards.
BLUE denotes winners in the editing categories.
GREEN denotes winners in the electronic categories.
ALL OTHERS are entrants in this year's competition.

David Aantholz Jeffrey Aaronson Sharon Abbady Jeff Abelin Joe Abell Peter T. Ackerman **Gabriel Acosta** Felix Adamo **Jonathan Adams** Michael D. Adaskaveg **Noah Addis** Leslie Adkins **Julia M. Adkisson** David Adornato **Michael Ainsworth** Eric Albrecht **Kael Alford** K.C. Alfred Bill Alkofer Carlo Allegri **Thomas Michael Alleman** Gary Allen **Jeffrey D. Allred** Bernardo Alps **Jennifer S. Altman** Taimy Alvarez **Milton Amador** Richard Y. Ambo **Elise Amendola** Hector Amezcua **Karl Ammann** Albert K. Amrhein Jr. **A. Amsinck** Chris Anderson **Christopher R. Anderson** Daniel A. Anderson **Jon Anderson** Karin Anderson **Kathy Anderson** Odon Anderson Scott Anderson Todd Anderson **Robert Andres** Nancy Andrews...**Anonymous James W. Anness** Kimberlee Aquaro **Charles R Arbogast** Charlie Archambault **Gilbert W. Arias** Juana Arias **Brad Armstrong Larry Armstrong** Mark Aronoff Patrick Artinian **Glenn Asakawa** Christopher T. Assaf **Tim Atherton** Lacy Atkins Jane Evelyn Atwood... **Lorren Au... Babbette Augustine** Bill Auth **Richard Avedon** Mark Avery **Robert Azmitia** Tony Bacewicz **Brian Baer** Craig Bailey **Brandy Baker** Greg Baker **Bobbie Baker Burrows** Beth Balbierz **Luigi Baldelli** Diana Baldrica Karen Ballard James Balog **Sandra Bancroft-Billings** Marice Cohn **Band Ellen M. Banner** Rebecca Barger **Terry Barner** Ralph Barrera **Kimberly Barth Lucy Bartholomay** Don Bartiletti James L. Bates **Stuart Bauer** David Bauman **Patrick Baz** Ernesto Bazan **John Bazemore** Mariana Bazo **John Beale** Paul Beaty **Robert Beck** Robert Becker **Al Behrman** Glenn Beil **Tina Beirne - Haas** H. Darr Beiser Al Bello... **Remi Benali Douglas Benc** Kathryn Bender **Dawn Benko** Daron Bennett **Jerilee Bennett** Sarah Bennett **Benjamin Benschneider** Harry Benson **P. F. Bentley** Wanda J. Benvenutti **David Bergman** Beth Bergman Nakamura **Talis Bergmanis** Bob Berlin Chuck Berman **Nina Berman** Alan Berner **Matt Bernhardt** John Berry **Bryan S. Berteaux** Renee C. Beyer **Debra Bicking-Byers** Susan Biddle **John Biever** Todd Bigelow **Chuck Bigger** Molly Bingham **Chris Birks** Dave Black **JoEllen Black** Mark Black **James M. Blair** John Blanding **Eileen Blass** Tony Blei **Willard L. Blevins Jr.** Rick Boeth **Gary Bogden** John Bohn **David Bohrer** Deborah Booker **Don Boomer** Lou Bopp **Karen T. Borchers** Nadia Borowski Scott **Roy M. Borroughs** Peter Andrew Bosch **Mark Boster** Gilbert R. Boucher II Jean-Marc Bouju Lelen Bourgoignie **Cris Bouroncle** Mark Bowen **Michael J.N. Bowles** G. Andrew Boyd **Thomas R Boyd** Tim Boyd **Adil Bradlow Jim Brandenburg... Alex Brandon** David Brauchli **Bernard Brault** Bob Breidenbach **Thea Breite** William Bretzger **Sisse Brimberg Ben Brink Robert Brodbeck** Paula Bronstein **Dudley M. Brooks** Jon M. Brouwer **Bob Brown** Jeffrey L. Brown **Jennifer Brown** Matt Brown **Milbert Orlando Brown** Paul Joseph Brown **Andrea Bruce** David Bruneau **Luca Bruno** Andrew Brusso **Simon Bruty** Michael Bryant **Chris Buck** Craig Buck **Robin Buckson** Khue Bui **Gregory Bull** Jeff Bundy **Edward J. Bunyan** Jr. **Joe Burbank John Burgess** Don Burk **David Burnett Alex Burrows** Chuck Burton Tom Burton **Ken Bush** Mary Butkus **Chris Butler** David Butow **Wade Byans** Beverly Bynum **Elizabeth Byram** Kathleen Cabble **Marty Calahan** Mary E. Calvert Gary A. Cameron **Erik Campos** Stephen D. Cannerelli **William P. Cannon** Jay Capers **Lou Capozzola** Michele **Cardon... Chris Carlson** Bryan Carpenter **Patrick J. Carroll** J. Pat Carter **Ovie Carter** Paul Carter **Kevin P. Casey** Bert Cass **Faith Cathcart** Terri Cavoli **Sharon M. Cekada** Lara Cerri **Anne Chadwick Williams** Radhika Chalasani **Bruce Chambers** Curt Chandler... Chien-Chi Chang Richard A. Chapman **Tim Chapman C. Richard Chartrand Adele T. Chavez** Ray Chavez Doral Chenoweth III **Ron Chenoy** Charles Cherney **Stepen Craig Cherry** Dianne Cheseldine **Paul Chesley** John Chiasson **Barry Chin** Mary Chind **Paul Chin** Sergei Chirikov **Michael Chow** Gregory Chrisochoidis **Milan Chuckovich** Laura Chun **andre F. Chung** Bob Chwedyk **Mary Circelli** John C. Citlumachi **Jason Clark** Kevin Clark **Marshall Clarke** Timothy Clary **Tim Clayton** Carol Cleere **Jay L. Clendenin** Bradley E. Clift... **Courtenay Clinton** Phil Coale **David Coates** Jodi Cobb **Rachel Cobb Jonathan Cohen... Robert Cohen** Susan Cohen Carolyn Cole Ernest T. Coleman **Jim Collins** Rick Collins **Jay Colton** Steve Connors Cary Conover **Eduardo Contreras** Michelle Conway **Charles E. Cook** Lori Ann Cook **Spencer D. Cook** David E. Cooper **Gary Cooper** Greg A. Cooper **Guy Cooper** Allison Corbett **Richard Corman** Charlie Cortez **Ronald Cortez** Russell S. Costanza III Jeremiah Coughlan **Caroline E. Couig... Lisa Cowen... Randy Cox Larry Coyne** J. Kristen Craig **Sherwin Crasto Colin Crawford** Christopher J. Crewell **Andy Cripe** Margaret Croft **Barton D. Cromeens** Vicki Cronis... **Denise Crosby** Beverly Crowin **Stephen Crowley Bruce Crummy** Mike Cuenca **Darron Cummings** Dan Currier **Chris Curry** Rodney Curtis **Anne Cusack** Candice C. Cusic **P. Casey Daley** Elizabeth Dalziel **Jim Damaske Mark Damon... Dave Darnell** Saurabh Das **Leigh Daughtridge** John Davenport **Barbara Davidson** Brian Davies **Amy Davis** Patrick Davison **Matt Dayhoff** Penny De Los Santos **Greg De Ruiter** Beatrice De-Gea **Jake Dean** Sam Deaner **Suzanne Dechillo** Manoocher Deghati **Lisa DeJong** Peter Dejong **Thomas Delany Jr.** Jerome Delay **Rick Delia** Louis DeLuca **Bob DeMay** Scott DeMuesy **Richard Derk** Hans Deryk **Steve Deslich Alan Detrich** Robert Deutch Nicole DeVito **Peter Diana** Sherry Dibari **Michael Dibari Jr.** Mary DiBiase **Blaich Albert Dickson** Dave Dieter **Brian K. Diggs** Dennis Dimick **Nuccio DiNuzzo** Jill DiPasquale **Jaime Dispenza** Lynne Dobson **Sonya Doctorian** Mark Dolan **Gino Domenico** Robin Domina Serne **Jeni Donlon** Marcus R. Donner **Ulrich Doring Alan D. Dorow** Greg Dorsett **David Doubliet** Sean Dougherty **Dick Doughty Mike Dowd** W. Garth Dowling **Larry Downing** Kirhmann F. Dozier **Eric Draper** Thea Drew **Annette M. Drowlette** Kort Duce **Karen Ducey** Pamela Duffy **Corinne Dufka** Liz Dufour **Emmanuel Dunand** Michael Dunlap **Christine Dunleavy** John Dunn **Suzanne Dunn** Stephen Dupont **Doug Duran** Robert Dyer **Steve Earley** Phelan M. Ebenhack **John A. Echave** Aristide T. Economopoulos **Joseph M. Eddins Jr.** Debbe Edelson **Mark Edelson... Jillian Edelstein** Claudio Edinger Michael Edrington **Jim Edwards** Steve Egan **Ruth Eichhorn** Deirdre Eitel **Scott Eklund** Justine Ellement **Sean D. Elliot** Laura Embry **Don Emmert** Robert E. Engelhardt **Douglas Engle** Eric F. Engman **Linda D. Epstein** Ronald W. Erdrich **Barbara Errickson** James Estrin **Cheryl Evans** Jim Evans **Melvin C. Evans Jr.** Michael Ewen Gary Fabiano Albert Facelly **Bob Falcetti** Richard Falco **Steven M. Fale** Gary P. Fandel **Eamonn Farrell** Robert H. Farley **Ronnie Farley** Melissa Farlow **M. Clayton Farrington** Anne Farrar **Andi Faryl Schreiber** Najiah Feanny **Steve Fecht** Todd J.K. Feeback **Mike Fender** Gina Ferazzi **Paula B. Ferazzi** Gloria Ferniz **Stephen Ferry** Stephen E. Ferry **Rudiger Fessel** Fred J. Field **Bob Fila** Steve Fine **Aaron Fineman** Lisa D. Finger **Colin Finlay** Robert Fish **Gail Fisher** Greg Fisher **Harry E. Fisher** Edward M. Fitzgerald **Deanne Fitzmaurice** Barry Fitzsimmons **Julie B. Fletcher** Elizabeth Flynn **Natalie Fobes** Lake Fong **Marvin Fong** Sam Forencich **Geoff Forester** Michael Forsberg **Rich Frenzen** Gregory Foster **Kim Kim Foster** David T. Foster III **Bert Fox** Charles Fox **Tom Fox** Bill Frakes **Jamie Francis** Ric Francis **Felice Frankel** Ross D. Franklin **Thomas E. Franklin** Jetta Fraser **Danny Wilcox Frazier** Luke Frazza **Matt Freed** John Freidah **Ruth Fremson** Jen Friedberg **David Friend...** Susanna Frohman... **Christian Fuchs** Karen Fucito **Kevin Fujii** Mariella Furrer **Michelle Gabel** Alice Gabriner **Alexander Gallardo** Michael J. Gallegos **Elizabeth Gallin** Chip Gamertsfelder **Katherine Ganter** John Gaps III **Alex Garcia** Daniel Garcia **Eugene Garcia** Joseph A. Garcia **Juan M. Garcia** Mark Garfinkel **Norma Jean Gargasz** Kim S. Garnick **Ted Gartland** C. Garofalo **John A. Gastaldo** Barbara Gauntt **Robert Gauthier** Brad A. Gaverson **Eric Gay** Jim Gehrz **Jim Gensheimer** Paul F. Gero **Vadim Ghirda** David P. Gilkey **Cameron Gillie** Greg Girard **Charlie Gisell** Seth Gitner **Dan Gleiter** Wayne Glowacki **Seth Goddard** Jay Godwin **Robert Goebel** Meredith M. Goldberg **Michael Goldfinger** Craig Golding **Gary Goldsmith** Scott Goldsmith **MaryAnne Golon** Shaul Golon **Julian H. Gonzalez** Roberto Gonzalez **Timothy J. Gonzalez** Marshall Gorby **Mark Gormus** David Gottschalk **Bert Goulait** Michael Goulding **Monika Graff** Tom Gralish **Christopher R. Granger** Alastair Grant **Gordon M. Grant** Ben Gray **David Greedy** Gary Green **John Green** Stephen Green-Armytage **Sarah L. Greenhalgh** Pat Greenhouse **David Grewe** Dave Griffin... **Eric Grigorian** Al Grillo **Lori Grinker** Jeffrey Gritchen **Jack Gruber** David B. Grunfeld **Bill Guglliotta** John Gugun **Paul Guillory** Dale Guldan **Jim Gund** C. J. Gunther **David Guralnick** Elli Gurfinkel **Vaughn Gurganian** John Gurzinsky **David Guttenfelder...Carol Guzy Bob Gwaltney** Dan Habib **Richard M. Hackett** Sean M. Haffey **Matt J. Hagen** Kelly Hahn **Johnson Jane** L. Hale **Peter Haley** Kari Rene **Hall Grant** M. Haller **Jeff Haller** Robert Hallinen **J. Andrew Hallowell** Thom Halls **Dirck Halstead Amanda Hamann** Ross Hamilton **Robbie Hammer** Robert Hanashiro **Mark A. Hancock David Handschuh** Harold Hanka **Christopher Hankins** Richard Alan Hannon **Jack Hanrahan** Geoff Hansen **Sarah Harbutt** Tony Hare **Kyndell Harkness** Nati Harnik **Jeb Harris** Julian Harrison **Charles W. Harrity** Steve Hart **Rick Hartford** David Lee Hartlage **Richard Hartog** Glenn Hartong **Nanine Hartzenbusch** Arthur Harvey **John Harvey** Cheryl Hatch **Ron Havin** Timothy H. Hawk **Jeff Haynes** Bruce Hazelton **Pamela Hazen** Steve Healey **Michael Heasley** Steve Heaslip **Eric C. Hegedus** Kurt Hegre **Gregory Heisler** Stephanie Heisler **Lisa Helfert** Kenneth A. Helle **Julie Henderson** Gerald Herbert **Steven M. Herppich** Gary Hershorn **Ralf-Finn Hestoft** Daniel Heuclin **Richard Hicks** Erik Hill **Shoun A. Hill** Ed Hille **Saed Hindash** Marie Hippenmeyer **David Hobby** Teun Hocks **Valerie Hodgson** Dean Hoffmeyer **W.D. Hogan** Eileen Hohmuth-Lemonick Andrew Holbrooke Jim Hollander **Philip Holman** Chris Holmes **Christina Holovach** Jerry Holt **Calvin Hom** Stan Honda **Chris Hondros** Kevin Horan **Beverly Horne** Boyzell Hosey **Eugene Hoshiko** Phil Hossack **Carol House** Stewart F. House **Peter Howe** Chris Anthony Howell **Rose Howerter** Red Huber **Jim Hudelson** Derek Hudson **Daniel Hulshizer** Laura Humpa **Mark Humphrey** E. Vasha Hunt **Julianna Hunter** Eric Hylden **Mitsuhiko Imamori** Walter Iooss Jr. **Michael Irvin** Lynn Ischay **Renee Ittner-McManus** Mary Iuvone **Joey Ivancso** Lange Iverson **Kakaaul Iwabu** Silvia Izquierdo **Zuzana Jackevicius** Bob Jackson **Lawrence Jackson** Ted Jackson **Timothy Jacobsen** Stephen Jaffe **Terrence James** Jay Janner **Jeff Janowski** Kenneth Jarecke **Ellen Jaskol** Ron Jenkins **Janet Jensen** Kurt Jensen **Steve Jessmore** Olivier Jobard **Christopher Johns** Aaron Johnson **Kim D. Johnson** Lynn Johnson **Mark E. Johnson** Nancy Jo Johnson **Taylor Johnson** Frank B. Johnston **Laurie A. Jones** Toby Jorrin **Ariane Kadoch** Eliot Kamenitz **Lisa Kan** Kaplan **Sylwia Kapuscinski** Doug Kapustin **Sergei Karpukhin** Ed Kashi... **Karen Kasmauski** Larry Kasperek **Carolyn Kaster** Stephen Katz **Doug Kaup** Chiaki Kawajiri **Toru Kawana Linda Kaye** Edward Keating **John Keating** Mark E. Keating **J. Kyle Keener** J. Mark Kegans **Christine Keith** Eric Keith **Toni Finch Kellar** Mary Kelley **Bill Kelley III** M. Kathleen Kelly **Patricia M. Kelly** Bryan Kelsen **Emily K. Kelsey** J. Brad Kemp III **Russ Kendall** Brenda Ann Kenneally **Chuck Kennedy** David A. Kennel **David Hume Kennerly** James Kenney **Mike Kepka** Michael Ketada **Jim Ketsdever** Cornelius Keyes **Kathleen Kieliszewski** Damon Kiesow Justin Kilcullen **Yunghi Kim** Chung **Paul Kim** Chuck Kimmerle **Hope L. Kinchen** Gary Kissel **Paul Kitagaki Jr.** Sam Kittner **Torsten Kjellstrand** Francisco Kjolseth **Stephanie Klein-Davis** Laura Kleinhenz **Susan M. Klemens** Heinz Kluetmeier **David E. Klutho** Gary Knight **Renee Knoeber** George Kochaniec Jr. **Richard Koci-Hernandez** Michael Kodas **Richard Koehler** James G. Koenigsaecker **Craig Kohlruss** Larry Kolvoord **Yevgeny Kondakov** Doug Kapustin **Tim Koors** Kevin P. Kreck **Suzanne Kreiter** Evan Kriss... **Elizabeth Cheng Krist Patrick J. Krohn** Charles Krupa **Karen Kuehn** Paul M. Kuehnel **Kim Kulish** Amelia H. Kunhardt **Ron Kuntz** Patrick M. Kunzer **Branimir Kvartuc** David Liam **Kyle Lisa Kyle** Vince LaForet **Kenneth K. Lam** Kenneth Lambert **Andre Lambertson** Rod Lamkey Jr. **Wendy Lamm** Nick Lammers **Gary Landers** David Lane **Nancy E. Lane** George Lange **Brian Lanker** Frans Lanting **Jenifer LaPolla** Geraldo Jerry **Lara Jeffrey** C. Larsen **Bob Larson** Frederic Larson **Robert Lasher** David Lassman **Bronwen Latimer** Greg Latza **Neal C. Lauron** Jim Lavrakas **M. S. Lawgilie** Lval Lawhon Jr. **M. Teresa Lawrence** Robin Layton **Jared Lazarus** Jim Leachman **Joe Ledford** Chang W. Lee **Craig Lee** John Lee **David Leeson** Steve Lehman... Roger Lemoyne **Paula Lerner** Alan Lessig **Pamela A. T. Lettie Heidi Levine** Jon Levy **Serge J-F Levy** Nancee E. Lewis Scott Lewis

Steven Lewis **Joseph M. Lewnard** James Leynse **Andrew Lichtenstein** Chuck Liddy **Nikki Life** Jessica Brandi Lifland **Ken Light** Stan Lim **Stephanie Grace Lim** Steven Line **Brennan Linsley** Howard Lipin **Richard Lipski** Nicholas Lisi **Steve Liss** Scott Lituchy **Xin Liu** Chris Livingston **Dana Lixenberg** Tammy Ljungblad **Gerald M. Lodriguss** Tina K. Loite **Mary Lommori Vignoles** Doug Loneman **John Long** Wendy Longlade **David Longstreath... Rick Loomis** Anthony Lopez Jose R. Lopez **Jackie Lorentz** Eugene Louie **V. J. Lovero** Greg Lovett **Jacques Lowe** Corey Lowenstein **Jon Lowenstein** Pauline Lubens **Dave Luchansky** Ellis Lucia **Kendra Luck** M. Jack Luedke **Efrem Lukatsky** John Luke **Cory Lum** Steve Lundy **Nita Lusk** Raymond J. Lustig **William Luther** Bob Lynn **Renee Lynn** Santiago Lyon **Kenneth D. Lyons** Roman Lyskowski **Lisa Lytton Smith** Kristy MacDonald **Preston C. Mack** Jeffrey MacMillan **Jim MacMillan** Jose Luis Magana **Chris Mageri** Evy Natalie Mages **James E. Mahan** James Mahoney **Joe Mahoney** David Maialetti **John Makely Ettore Malanca** Jay Mallin **Anatoly Maltsev** Jeff Mankie **Kevin Manning** Ray Manning **Roc Mar** Ben Margot Mary Ellen Mark **Brad Markel** Tina Markoe **Bullit Marquez William H. Marr** Lee K. Marriner **Dan Marschka** Michael Marshall **Woody Marshall** George M. Martell **Bob Martin Ian Martin** John F. Martin **Marc Martin Robert A. Martin** Rogelio Allepuz Martinez **Hector Mata** Mark Matson **Bebeto Matthews** Larry Mayer **Robert Mayer** Shelley Mays **Jeff McAdory** Robbie McClaran **Darren McCollester** Michael McCollum **Regina J. McCombs** Linda McConnell **John McConnico** Larry McCormack **Michael McCoy** Gerald McCrea **Steve McCurry** Dennis McDonald **Michele McDonald** John McDonnell **John W. McDonough** Denis McElroy **Rebecca McEntee** Rick McFarland **Ken McGagh** Denise A. McGill **Thomas F. McGuire** Allen McInnis **Tricia McInroy** Catherine McIntosh **Todd Lantz McInturf** Rick McKay **Kirk D. McKoy** Bryan McLellan **Lennox McLendon** William Mercer McLeod **Michael McMullen** Joe McNally **Michele McNally** Wally McNamee **Win McNamee** Tara McParland **Daniel Mears** Steven Medd **Mary Beth Meehan** Kent Meireis **Martin Mejia** Todd Melancon **Jayson Mellom** Steve Mellon **Eric Mencher... Gideon Mendel** Catherine Meredith J im Merithew **Jeff Mermelstein** Richard Messina **Bob Messina** John Metzger **Nhat Meyer** Sean Meyers **Walter Michot** Geralyn Migielicz **Paul J. Milette** Robert Milkowski **George Millener** Dan Miller **Ethan Miller** Peter Read Miller **Robert T. Miller II** George W. Miller III **Lester J. Millman** Doug Mills **Matthew Minard** Mark Mirko **Odell Mitchell Jr.** Kevin J. Miyazaki **Daud Mizrahi** David Modell **Ron Modra** Dr. Mark W. Moffett **Stephan Moitessier** Genard Molina Peter Monsees **Pablo Martinez Monsivais** T. R. Montauk **M. Scott Moon Buddy Moore...** John Moore **Shawn T. Moore** Viviane Moos **John Moran** Abelardo Morell **Debbi Morello** Francois Mori **P. Kevin Morley** Christopher Morris David Rae Morris **Mark Morris Sue Morrow** Paul Morse **Stephen Morton Bonnie Jo Mount** Bruce Moyer **Matthew Moyer** Clyde Mueller **Laura Mueller** Ozier Muhammad **Michael Mulrey** Colin Mulvany **Mike Munden** John Munson **Christian Murdock** Lance Murphey **Courtney Murphy** Mary Murphy **Richard Murphy** Patrick Murphy - Racey **Clem Murray** Noah K. Murray...**Vincent J. Musi** Kurt F. Mutchler **Vincent Muzik** Sanford Myers **James Nachtwey** Motoya Nakamura **GiuLiana Nakashima** Joyce Naltchayan **Robert A. Nandell** Jon Naso **Sol Neelman** Steven Nett **Charlie Neibergall** Scott Neilsen **Mike Nelson Paula Nelson** Zed Nelson **Charlie** Neuman **Lisa Newby** Paul L. Newby II **David Newman Huy Nguyen Zang** Jeremy Nichols **Michael Nick Nichols** Robert Nickelsberg **Stephen R. Nickerson** Dave Nielsen **Andrew Niesen** Larry Nighswander **Mike Nixon** Louise Noeth **Miles B. Norman** Ren Norton **John Nuhn** Christina Nunez **Jason Nuttle** Charlie Nye **John O'Boyle** Gary O'Brien **Mauteen O'Connor** Bill O'Leary **Annie O'Neill** Michael O'Neill **Paul O'Neill** Dennis Oda **Marilyn Odello** Vernon Ogrodnek **Randy Olson** Morgan Ong **Ray Onwuemegbulam** David Odds **Michael J. Orazzi** Edward D. Ornelas III **Francine Orr** Maz Ortiz **Charles Osgood** Gail Oskin **Glenn Osmundson** Jose Osorio **Shawn Patrick Ouellette** Tomas Ovalle **Bob Owen** Nobuko Oyabu **Nick Oza** Wally Pacholka **Manuello Paganelli** Tom Page **Rose Palmisano** Hayne Palmour IV **Todd Panagopoulos** Scott Panella **Angela Panerazio** Ken Papaleo **Sung Park Doug Parker** Nigel Parry **Eric Parsons** Joe Patonite **Bryan Patrick** Pascal Pavani **Robert J. Pavuchak** Peggy Peattie **Chris Pedota** Terry Peirson **David Pellerin** Randy Pench **Tom Pennington** John Perdygraft **Hilda M. Perez** Drew Perine **Lucian Perkins** Seth Perlman **Algerina Perna** Richard Perry **Ann Peters** Greg Peters **Sherry Peters** Donald E. Peterson **Angela D. Peterson** Brian Peterson **Chris Peterson** David Peterson **Mark Peterson** Skip Peterson **Per-Anders Pettersson David J. Phillip** Kent Phillips **Tom Pidgeon** Vince Pierri **Chris Pietsch Mike Pilgrim** Joanna B. Pinneo **Marc A. Piscotty Julie Plasencia** Spencer Platt **Bill Pliske** Todd Plitt **Brian Plonka... Kathy Plonka** William B. Plowman **Joseph Pluchino** Suzanne Plunkett **Dan Plutchak** Susan Poag **Brian Pobuda** Al Podgorski **Marie Poirier** Marzi Cloe Poisson **Susan T. Pollard Arthur Pollouck** Yoni Ponzer **Smiley N. Pool** Robert Pope **Wesley R. Pope** Brian Porco **Kent Porter** David Portnoy **Lisa Powell** Amy E. Powers **Dan Powers** Duane Prentice **Cecilia Prestamo** B.B. Price **Larry C. Price Thomas Price** David Proeber **Marcia Prouse** Richard Michael Pruitt **Karen Pulfer Focht** David Pulliam **Carlos Puma** Mark Pynes **Jay Quadracci** Alex Quesada **Jody Quon** Joseph Raedle **Susan Ragan** Raghu Rai **Chris Rainier** John Ranard **John Raoux** Anaceleto Rapping **Hillary Raskin** Steve Rasmussen **Laura A. Rauch** Anne Raup **Stephanie Rausser** Patrick Raycraft **Steve Raymer J. Bart Rayniak** Jaime Razuri **Laurent Rebouts** Matias Recart **B Patrick Reddy** Eli Reed **Mona Reeder** Robert A. Reeder **Tom Reese** Janet Reeves **Ken Regan** Lara Jo Regan **Marc Yves Regis** Sarah Reingewirtz **Bill Reinke Mark Reis** Jeanne Reisel **Rich Remsberg** Co Rentmeester **Seth Resnick** Tim Revell **Gary Reyes** Martha Rial **Danielle P. Richard** Eugene Richards **Paul Richards** Roger Richards **Nancy Richmond** Rick Rickman **Ken Riddick Jim Rider** Rich Riggins **Steve Ringman** Eric Risberg **Marc Riseling** Bob Rives **Tony Rivetti Richard Robbins** Jeff Roberson **David Roberts** Randy Roberts **Lisa Roberts Hahn** Michael Robinson-Cha'vez **Paul E. Rodriguez** James J. Rogash **Lynn Rognsvoog** David J. Rogowski **Ricardo Romagosa** Blanquart Romain **Robin Romain** Vivian Ronay **Bob Rosato** Carrie Rosema **Daniel Rosenbaum** Steven Rosenberg **Linda Rosier** John Rowland **Pamela Royal... W. Allen Royce** Susan Rushen Jarrett **Ken Ruinard** John Rumbach **B. A. Rupert** Chris Russell **J.B. Russell Carl Russo** Craig Ruttle **Zach Ryall** Anne Ryan **J. Patrick Ryan** Kathy Ryan **Susan F. B. Ryan** Rick Rycroft **Claire Rydell** Bob Sacha **Ed Sackett** Jill Sagers **Kyujiro Sakamaki** Paul Sakuma **John Sale** Mike Salisbury **T. J. Salsman** Amy Sancetta **Paul Sancya** David Sanders **Tom Sanders** Toni L. Sandys **Rod Sanford** Joel Sartore **Chris Sattlberger** Jeffrey M. Sauger **Mark Savage** Stephan Savoia **Andrew Sawyer** Don Scabrook **Jim Lo Scalzo** John Scanlon **Al Schaben** Howard Schatz **Mindy Schauer** Eliot J. Schechter **Eric Schenk** Meryl Schenker **Tom Schierlitz** Erich Schlegel **Ken Schles** Ken Schles **Charlotte Schmid-Maybach** Michael R. Schmidt **Terry Schmitt** Patrick Schneider **Jake Schoellkopf** Jeff Schonberg **Tim Schoon** David H. Schreiber **Mary Schroeder** Cindy Schultz **Richard Schultz** Peter Schumacher **Rob Schumacher Marie Schumann** J. D. Schwalm **Michael Schwartz** Andrew P. Scott **Kathryn M. Scott** Randall Scott **Thomas Scott David Scull** Don Seabrook **Eric Seals** Phil Sears **Stephanie Secrest... Eric Seidman Karen E. Segrave** Doug Sehres **Nell Seiler** Bob Self **William Serne** Gary Settle **John Severson** Chris Seward **Michael Evan Sewell** Susan Shacter **Norman Shafer** Stephen Shames **Karim Shamsi-Basha** Gerald P. Shanley **Scott Sharpe** Wendy Shattil **Rick Shaw** Bruce Sheils **Shepard Sherbell** Anne Sherwood **Jean Shifrin** John Shishmanian **Gayle Shomer** Nancy Siesel Stephen Siewert **Darron R. Silva Joao Silva** Tracy Lee **Silveria Barton Silverman** Denny Simmons **Meri Simon** Steve Simon **Chip Simons** Mike Simons **Stephani Sinclair** Luis Sinco **Jeff Siner Scott Sines** Tom Sistak **Wally Skalij George Skene** Laurie Skrivan **Lynne Sladky** Allen Slavin **Judy Sloan Reich** Brian Smale **Steven A. Smedley** Dana Smillie **Allison V. Smith** Andrea Smith **Brian Smith** Dayna Smith **Jack Smith** Kurt E. Smith **Mike Smith Steven G. Smith** Martin Smith-Rodden **Adrin Snider** Brian Snyder **Michael Snyder** William Snyder **Chuck Solomon** Harley Soltes Chip Somodevilla **Peter Southwick** Pete Souza **Alan Spearman** David Spencer **L. Todd Spencer** Stacia Spragg **Fred Squillante** Freida Squires **Robert St. John** Karen Stallwood **Chris Stanford** John Stanmeyer **Shannon Stapleton** John Starks **Andy Starnes** Suzanne Starr **Susan Stava** Larry Steagall **Bill Steber** Maggie Steber **Jodie Steck** Lynden Steele **Joe Stefanchik** Avi Steinhardt **Evan R. Steinhauser** Sharon M. Steinman **George Steinmetz** James M. Stem **John Stennes** Michele Stephenson **Susan Sterner** Melanie Stetson Freeman **Robert Stevens** Chris Stewart **Lane Stewart** Mike Stewart **Lauren Stockbower** Mike Stocker **Susan Stocker** Karl Stolleis **Heather Stone** Les Stone **Mark Stone** Sher Stoneman **Eric Strachan** Scott Strazzante **David Strick** Damian Strohmeyer **Bruce C. Strong** Larry Strong **Steve Stroud** David Allan Sturman **Bruce Stutz** Essdras M. Suarez **Rich Sugg** Mark R. Sullivan **Shawn Sullivan** Todd Sumlin **Robert Sumner** Michael Sundra **Shana Sureck -Mei** Chad Surmick **Norman D. Sutaria** Akira Suwa **Chitose Suzuki** Lea Suzuki **Kevin J.** Swank **Janice A. Swiatkowski** William Synder **Clarence Tabb Jr.** Gabriel B. Tait **Tuni Takahashi** Stuart Tannenhill **Karen Tapia** Eleanor Taylor **Patrick Tehan** George Teidemann **Al Teilemans** Susan May Tell **Donna Terek** R. Scott Terrell **Shmuel Thaler** Bob Thayer **Scott Thode** Tippi Thole **Christine Thompson** Irwin Thompson **Jim Thompson** Tim Thompson **Stephen B. Thornton** Bruce Thorson **Scott Threlkeld** Debee Thumacki **Jeffrey Thurnher** Audrey C. Tiernan **William Tiernan** Charles Tines **Jesse Tinsley** Virgil Tipton **Peter Tobia** Marie Tobias **Amy Toensing** Lou Toman **William D. Tompkins** Don Tormey... **Marguerite Nicosia Torres** Omar Torres **Brian T. Totin** Nico Toutenhoofd **Larry Towell** R. Jason Towlen **Robert S. Townsend** Adam Traum **Joseph R. Traver** Robert Trippett **David Trozzo** Rick Truax **Alexander Tsiaras** Mark Tucker **Martin Tucker** David Tulis **Tyrone Turner** David Turnley **Peter Turnley** Susan Tusa **Jeff Tuttle** Christopher Tyree **Betty Udesen** Erik Unger **Mike Urban** Abel Uribe **Gregory M. Urquiaga** Jorge Uzon **Paul Valade** Nuri Vallbona **Brian van der Burg** Pim Van Hemmen **Ben Van Hook** Frank Varga **Zan Vargas-Cunningham** William M. Vasta **Victor W. Vaughn** Santosh Verma **Jose Luis Villegas** Franklin J. Viola **Jim Virga** Dilip Vishwanat **Joann Vitelli** Richard Vogel **Ernie Volpe** Norbert von der Groeben **Tamara Voninski** Dino Vournas **Lisa Waddell** Al Alicia Wagner **Tom Wagner Mitchell Wadony** Judy Wagnon **Chris Walker** Diana Walker **George Walker IV Tom Wallace** Mark Wallheiser **Matt Wallis** Robert Wallis **Carl D. Walsh Susan Walsh** Brian Walski **Gary Walts** Emile Wamsteker **Ting-Lu Wang** Brant Ward **Shirley Ware** Steve Warmowski **Paul Warner** Bill Warren **Ted S. Warren** Eyal Warshavsky **Lannis Waters...** Susan Watts **Denis Waugh** Troy Wayrynen **Todd Weddle** Billy Weeks **Kevin W. Weinstein** Eric L. Welch **Annie Wells** David H. Wells **Doug Wells** Mark Welsh **John Wenck** Todd Wharton **Catherine Whipple** Amiran White **Daniel White** Jean H. White **Leslie A. White** Paul T. Whyte Kelly Wilkinson **Kathy Willens** Scott Willett **Charles Williams** Clarence Williams **John Williams** Luci S Williams **Michael Williamson** Aaron M. Wilson **Jamal Wilson** Rick Wilson **Spence Michael Wilson** Chuck Wing **Todd L Winge** Michael D. Winokur **Elana Wineberg** Roger W. Winstead **Damon Winter** Dan Winters **Michael S. Wirtz** Scott Wiseman **Jim Witmer** Patrick Witty **George R. Wolf** A. J. Wolfe **Tom Wolfe** Barry Wong **Darrell Wong** Lui Kit Wong **Stuart Wong** David Woo **David Wood** Mandi Wright **Richard A. Wright** Ron Wurzer **Roger J. Xu** Elsa Wyman **Lance Wynn Patricia Yablonski... Michael S. Yamashita** Cindy Yamahaka **Wendy Yang** Boris Yard **David Yee** Marilynn K. Yee Tina S. Yee **Dr. Bob Yen** Mike Yoder **Robert York** Christopher I. Young **Dale G. Young** David Zadig **Kay Zakariasen** David Zalazalik **Hocine Zaourar** Bill Zars **Magdalena Zavala** Jennifer Zdon **Barry L. Zecher** Mark Zaleski Sherman Zent **Tim Zielenbach** Francesco Zizola **Charlyn Zlotnik** Chuck Zouku **Fred Zwicky** Steven R. Zylius

■ **28,793** slides & tearsheets entered, for a total of **13,130** entries submitted, by **1,722** photographers & editors, from **16** different countries.

The Index

PHOTOGRAPHERS, EDITORS, PUBLICATIONS IN THIS ANNUAL

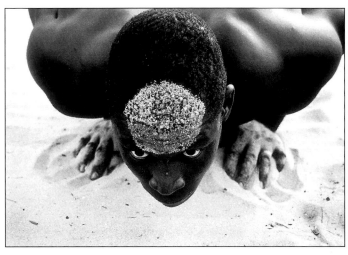

Above ■ A Sere Wrestler during a training session on Banju Beach.

STEPHEN DUPONT, CONTACT PRESS IMAGES, FIRST PLACE, MAGAZINE SPORTS PICTURE STORY THIS STORY WAS ALSO PART OF THE SECOND RUNNER-UP MAGAZINE PHOTOGRAPHER O F THE YEAR PORTFOLIO. SELECTS ON **PAGES 236-237.**)

PUBLICATIONS/EMPLOYERS REPRESENTED

At lightning speed, we bring you this book...

■ WE ACTUALLY STARTED THE EDITING AND DESIGN OF THIS BOOK ON THE EVENING OF FRIDAY, FEBRUARY 20TH, 1998. THAT WAS THE DAY THIS 55TH POY COMPETITION FINISHED ITS FIRST WEEK OF A THREE-WEEK JUDGING SCHEDULE. WORKING OUT OF THE BASEMENT OF THE J-SCHOOL, WE FINISHED A QUARTER OF THE BOOK IN COLUMBIA, MISSOURI BEFORE MOVING THE OPERATION TO MY BASEMENT IN PORTLAND, OREGON. THERE, AMIDST MY LAUNDRY AND WITH NPR ON MOST OF THE TIME, WE FINISHED THIS 256-PAGE ANNUAL ON THE MORNING OF WEDNESDAY, APRIL 22ND.

Okay, we'll try to make this short, sweet and sensible. This is the fourth annual I've been privileged to edit. And working on this book is kinda like the definition of the word *contrast*. It's been both great fun to edit the best pictures in the world from 1997. And, it's also one of the most intense and exhausting projects I've experienced in 45 years.

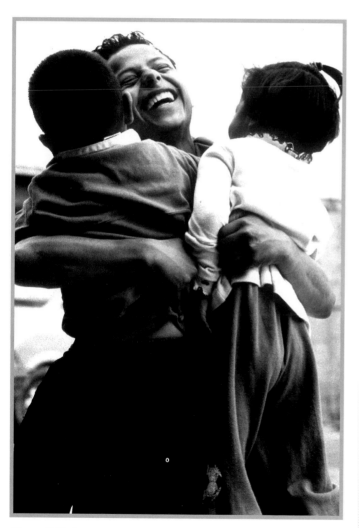

Above ■ Mario Vallentros, age 15, scoops up two children after playing with them one afternoon at Casa Hogar Elim, an orphanage in Nuevo Laredo, Mexico. The 82 children that live in the orphanage refer to each other as brothers and sisters.

PENNY DE LOS SANTOS, OHIO UNIVERSITY
ONE SELECT FROM A PICTURE STORY ENTITLED "INNOCENCE LOST," A PART OF HER 42-PICTURE COLLEGE PHOTOGRAPHER OF THE YEAR PORTFOLIO.

This year also marks two other milestones in the 23-year history of this annual.

For the first time ever, we've been charged with putting out this book in lightning speed. What a great idea! To have this book printed, bound and available at the annual POY awards ceremony *(early June, in Washington, D.C.)*. That's never been done before and we're quite pleased to do so this year, 23 years after this book project began.

And, second, is the depth and detail this book offers. That's possible this year primarily because of the work of one other fellow. Ian Malkasian, a Missouri graduate student, co-edited this book with me. And what a pleasure it was to work with him. He constantly pushed for the book to go deeper, to provide additional levels of detail, to ask better questions of the photographers and editors included herein. I can't say enough about Ian, his work ethic, his intelligence and how much better this book is because of him. *(And, I strongly urge you to hire him as quickly as possible.)*

In particular, Ian brought two very wonderful ideas to this year's annual. The first was in grouping the editing winners by **publication** instead of by **contest category**. The result makes so much more sense and, hence, is so much more educational. His second idea was to push the deadline envelope and include – as we have on this page – a photo from the portfolio of this year's College Photographer of the Year, **Penny De Los Santos of Ohio University**. The incredibly sped-up timeline for this year's book had, until we were right on deadline, precluded the inclusion of any work from the annual CPOY competition. That's unfortunate, but necessary, we lamented. But CPOY was judged in the nick of time. With Ian's strong connections to contest coordinators, we're able to offer you a glimpse – albeit a single photograph – into this year's CPOY competition, just as this annual has done the last three years.

Again, NPPA, I thank you for this privilege. It's been quite fun. And, as always, there are a few folks Ian and I need to thank:

■ **DANNY CORJULO,** THE MACINTOSH SYSTEMS MANAGER AT THE HARTFORD COURANT, WHO FOR THE FOURTH YEAR IN A ROW, DID ALL THE MOSTLY-MIDDLE-OF-THE-NIGHT HI-RES IMAGING. THIS YEAR, DANNY CAME TO MISSOURI DURING THE JUDGING TO HELP US GET STARTED AND HAS, THROUGH HIS APPLE CONNECTIONS AND TECHNICAL EXPERTISE, SPED THIS BOOK EVERY STEP OF THE WAY.
■ **BILL KUYKENDALL, DEB PASTNER, CATHERINE MOHESKY, ANN MARIE JOHNSON** AND THE MISSOURI POY CREW FOR THEIR CONSIDERABLE ASSISTANCE WITH THE BIG and LITTLE THINGS. THANKS TO **BRIAN LUKANIC** AND **JANEL RHODA** FOR "SOUND" ASSISTANCE ALONG WITH POY BOOK HELPERS **STACY ADDISON, JOHNNA FLAHIVE, HEIDI HURST, TRICIA MOSSER, BRAD PERKINS, JOSH RUBEN** and **SHANA WATKINS.**
■ A SPECIAL THANKS TO JENNIFER HARRELL AND PRISCILLA JONES OF APPLE COMPUTER. APPLE AGAIN PROVIDED US WITH THE LATEST HARDWARE AND SOFTWARE INCLUDING THE LOAN OF TWO POWERMAC G3'S RUNNING MAC OS8 AND COLORSYNC 2.5. WE COULDN'T HAVE MET THIS DEADLINE WITHOUT THEM AND THEIR GRACIOUS LOAN OF MACINTOSH COMPUTERS.
■ **JOANY CARLIN,** WHO PROVIDES SUCH WISE EDITING COUNSEL AND PATIENTLY ACCEPTS THIS YEARLY INTERRUPTION IN OUR LIVES.
■ **IAN'S PARENTS,** DOUG AND ANN MALKASIAN, FOR THEIR HELP AND FOR AGREEING TO TURN THEIR GUEST BEDROOM BACK INTO HIS OLD ROOM.
■ **THE OREGONIAN,** MY GENEROUSLY FORGIVING EMPLOYER. AND MY FRIEND AND COMPATRIOT, DIRECTOR OF PHOTOGRAPHY **PATTY REKSTEN,** FOR HER CONSIDERABLE FORBEARANCE WITH ME, AND HER MANY HELPFUL SUGGESTIONS.

That's it, folks. We're outta here...
Randy Cox, PJ23 editor, and Ian Malkasian, PJ23 co-editor
Portland, Oregon, 5:23am PDT, April 22nd, 1998
(btw, Vi Edom's 90th birthday)

RANDYCOX@NEWS.OREGONIAN.COM
IANMAL@IX.NETCOM.COM

And a special thanks...

TO THE FOLKS AT JOSTENS, OUR PRINTER, IN TOPEKA, KANSAS. COMMERCIAL SERVICE MANAGER DAVE KLENE, IN PARTICULAR, DESERVES A SPECIAL ROUND OF APPLAUSE FOR HIS ATTENTION TO DETAIL AND SHEPHERDING OF THE PRODUCTION DETAILS SO CAPABLY EACH YEAR. JOSTENS IS DOING US ALL A BIG FAVOR IN AGREEING TO PRODUCE THIS BOOK UNDER SUCH A TIGHT DEADLINE ESPECIALLY DURING THIS, THEIR PRIMARY YEARBOOK PUBLISHING TIME OF THE YEAR. THIS IS THE 18TH BOOK JOSTENS HAS PRODUCED FOR NPPA DATING BACK TO "THE BEST OF PHOTOJOURNALISM/6."

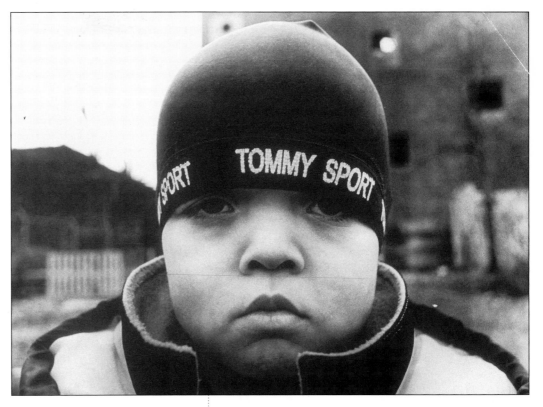

The New Kid on the Block

■ **BRENDA ANN KENNEALLY**
IS A FREELANCE PHOTOGRAPHER
BASED IN NEW YORK CITY. SHE
HAS BEEN DOCUMENTING THE
LIVES OF "JUNIOR" AND OTHERS
ON HER STREET AND IN HER
NEIGHBORHOOD FOR MANY
YEARS. THIS YEAR'S POY
JUDGING PANEL AWARDED HER
ESSAY, "OFF BROADWAY," A
JUDGES' SPECIAL RECOGNITION
IN THE COMMUNITY AWARENESS CATEGORY. THIS PHOTO, OF A BOY NAMED JUNIOR,
IS A PART OF THAT ESSAY. THE EDITORS OF THIS BOOK HAVE HAD JUNIOR WATCHING
US SINCE WE BEGAN PUTTING THIS BOOK TOGETHER IN LATE FEBRUARY OF 1998.
WE THOUGHT IT ONLY APPROPRIATE TO PLACE HIM HERE AS THIS BOOK'S **ONE LAST LOOK.**

Photographer Brenda Ann Kenneally:

It was the day after Thanksgiving and the kids were up at the crack of dawn playing in the vacant building behind Junior. I've never been able to confirm this but the kids say it's going to be a school and they think that some day they will go to school there.

Junior had only lived here a couple of months. He's the youngest kid on the block. He has an old face. He's the oldest living five-year-old. He knows everything. He talks like a teenager. He knows all the explicit lyrics to rap songs. His pet is the family pit-bull named Bandit. Today, he's still the youngest kid on the block. But, he's more confident now. Cooler. He is one of the seasoned kids. He's gone from a little kid to one in a "gang" really easily.

POY Judge Jose Azel:

"...the plumpness of the boy, the roundness of the face, the way it's accentuated by the way he's got his hat pulled way down, the roundness of the collar, the roundness of the band that says, *"Tommy Sport."* All those circular things that play into this wonderful sense of graphics in this photo coupled with the fact that what you get right away when you see it is: that's one tough little kid. Junior here is going to be a tough kid… he is a tough kid and he is going to be a tough guy and I get that… that's what I get… I get it right away from this picture and that's what I'm reacting to. Those graphic elements pulled together with this face that just says to me [laughing] I can hold my own. Even if it's a fake facade, even if this kid is really butter inside – which I don't think he is – but even if he was, he sure projects toughness. I don't think the photographer went, *"Hey, look tough for me kid. Alright? Look really tough for me, now."* I think she just looked down and said, *"Click. Got it."*

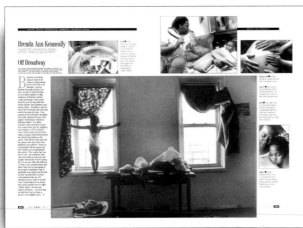

◄ THIS PHOTO OF JUNIOR WAS ALSO AWARDED THIRD PLACE, MAGAZINE PORTRAIT/
PERSONALITY AS WELL AS BEING A PART OF BRENDA ANN'S 40-PICTURE COMMUNITY
AWARENESS ESSAY. SELECTS FROM THIS ESSAY, ENTITLED "OFF BROADWAY,"
CAN BE SEEN ON **PAGES 242-243.**